Aubrey Beardsley, Dandy of the Grotesque

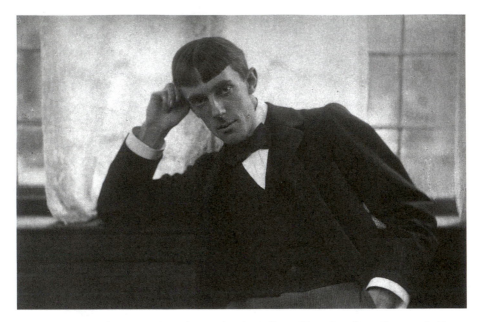

Photograph of Aubrey Beardsley by Frederick Hollyer. (Box 5, Albert Eugene Gallatin Collection, Princeton University Library, Princeton, N.J.)

Aubrey Beardsley, Dandy of the Grotesque

CHRIS SNODGRASS

New York Oxford
OXFORD UNIVERSITY PRESS
1995

Oxford University Press

Oxford New York
Athens Auckland Bangkok Bombay
Calcutta Cape Town Dar es Salaam Delhi
Florence Hong Kong Istanbul Karachi
Kuala Lumpur Madras Madrid Melbourne
Mexico City Nairobi Paris Singapore
Taipei Tokyo Toronto

and associated companies in
Berlin Ibadan

Library of Congress Cataloging-in-Publication Data
Snodgrass, Chris.
Aubrey Beardsley, dandy of the grotesque /
Chris Snodgrass.
p. cm.
Includes bibliographical references and index.
ISBN 0-19-509062-4
1. Beardsley, Aubrey, 1872-1898--Criticism and interpretation.
2. Grotesque in art. I. Title.
NC242.B3S66 1995 741'.092—dc20 94-18473

Portions of the following articles are reprinted with permission: "Beardsley's Oscillating Spaces: Play, Paradox, and the Grotesque,"
in *Reconsidering Aubrey Beardsley*, ed. Robert Langenfeld (Ann Arbor: UMI Research Press, 1989): 19–53; "Decadent Mythmaking:
Arthur Symons on Aubrey Beardsley and Salome," in *Victorian Poetry* 28, nos. 3–4 (Autumn–Winter 1990): 61–109; and "Aubrey
Beardsley and the Caricature of Meaning," in *Fin de Siècle / Fin du Globe*, ed. John Stokes (London: Macmillan, 1992), 178–209.
Every effort has been made to secure appropriate permissions for illustrations.

9 8 7 6 5 4 3 2 1
Printed in the United States of America
on acid-free paper

To my loving and supportive parents,
 Garrett and Evelyn Snodgrass

Preface

Aubrey Beardsley has long been acknowledged by scholars to be "the mentality most representative" of the Victorian Decadence (Muddiman 13). The exact nature of both the "mentality" and the representativeness, however, has remained, like so much of the Decadence, rather more categorized than explicated. This book analyzes a wide range of Beardsley's most characteristic works along with his implicit assumptions about the underlying nature of art and his world. In so doing it attempts to clarify why so many observers have considered Beardsley's art indispensable to an understanding of fin-de-siècle Victorian culture.

Karl Marx, Sigmund Freud, Jacques Lacan, Claude Lévi-Strauss, Marshall McLuhan, and numerous others have long since made clear that, inevitably, in the discourses of human meaning we "speak" less than we "are spoken" by the determinative political, economic, aesthetic, and other cultural forces of our personal and global societies. As Louis Althusser has explained, no culture exists without its implicit ideology—that is, its often "profoundly *unconscious*" way of perceiving and contextualizing the world, a mostly subliminal "system . . . of representations (images, myths, ideas, or concepts, depending on the case) endowed with a historical existence and role within a given society" (231–33). The Victorian Decadence of the 1890s was certainly no less a product of disparate historical and ideological forces, not least in its famous and often self-contradictory Religion of Art, which was one key attempt to order those historical and ideological forces, even if, in many respects, it only emblemized (not always consciously) all the prevailing contradictions and disharmonies of Victorian society itself.

As one of the most arresting expressions of the Decadence, and one of the most visible vehicles of the nineties' Religion of Art, Beardsley's paradoxically dandiacal yet grotesque pictures represent a complex, interlacing colloquy of various contending voices in the Victorian "age of transition." They are voices that represent two seemingly polar but mutually reinforcing strategies or impulses: on the one hand, an almost compulsive desire to violate, scandalize, and destabilize conventional boundaries of decorum, imposing an iconoclastic personal stamp on the old order; and, on the other hand, an equally strong need to affirm and incorporate the metaphysical certainty of traditional authority, particularly the absolute hegemony of art, style, and even moral truth. As if incarnating the fearful contradictions of the Decadence itself, Beardsley's various grotesque shapes, caricatures, and mutated figures—including the dandy, that icon of the Decadent Religion of Art—serve as visual emblems of

some monstrous metaphysical contortion. His grotesques suggest the ultimate impossibility of ever resolving the paradoxes such dislocations present, even as his elegant designs simultaneously control and implicitly recuperate those dislocations formalistically. In the end Beardsley's pictures effect what might be called a caricature of traditional signification, accenting in the process many of the more disorienting paradoxes of the Victorian fin de siècle.

Prefaces are problematical texts, running the risk—as a pre-"face" before the ostensible "real" face of the book—of being either redundant or disingenuous, either purporting to explain what should be clear from the book itself or attempting to reframe certain flaws as critical imperatives. Moreover, like everyone else scholars have their own conscious and unconscious assumptions and ideologies, the lenses through which we see our subjects, even if we sometimes write as if our keenest insights were timeless truths transcending value-shaping cultural and historical contingency. Part of what prefaces purport to do is to make "acknowledgment" of at least the most conscious of these shaping antecedents (sometimes hinting at the even more trenchant unconscious sources). It is probably especially incumbent on me, as a literary critic who presumably knows the ways language can be manipulated to turn thorny intellectual difficulties into apparently smooth and seamless logic, to try to acknowledge (however partially) the historical premises and teleology of my own work—if for no other reason than to keep conscious the context-dependent (and subtext-dependent) nature of all meaning.

Books on the Victorian Decadence (including books on Beardsley) are particularly vexing to write because, as the very label "the Decadence" implies, so much of the cultural mythology surrounding the art of the period is inseparable from a vast substructure of often facile and misleading moral assumptions that oversimplify or obscure altogether highly subtle and complex issues. Equally daunting has been the fact that, perhaps to avoid such implicitly moralistic criticism, many commentators have sought to classify fin-de-siècle tendencies according to a certain "neutral" or "ahistorical" critical taxonomy, as if defining the period by absolute aesthetic or rhetorical categories were not itself ideological. At its worst, this concern to narrow and sanitize the critical discourse, while providing some welcome precision, has often denuded texts of a certain human vibrancy, not to mention historical resonance, once again suppressing their rich subtlety and complexity. On the other hand, several recent scholars of the Decadence have avoided, for the most part, these and other traps, and I am indebted to their fine studies, even if my own may not always proceed as deftly or perceptively.

In writing this book my primary motive has been not to identify proper classifications of, or to offer a specific critical approach to, Beardsley's works or the Decadence but rather to look carefully (albeit eclectically) at the details of Beardsley's pictures and, within the personal and historical contexts of his life, to try to extrapolate the logic and thematic structures that informed those pictures. I have taken very seriously Holbrook Jackson's and John Dixon Hunt's admonition that Beardsley's drawings are intellectual constructs, "thoughts becom[ing] pictures," or "thoughtful analysis" explained "in visual terms" (Jackson 99–100; Hunt 203). Just what *is* the "story" of Beardsley's notoriously narrative art? What is the larger pattern or worldview that underlies all the various styles and tropes of Beardsley's pictures? And, implicitly, how is that vision especially representative, as so many contemporaries thought, of the Victorian fin de siècle? In short, my book attempts, first, to explicate more fully key works in Beardsley's oeuvre, many of which have not been treated extensively before, and, second, to

situate his works (and formulations) within their inescapable and dynamic personal and historical context, thus defining the degree to which they were icons of the Victorian Decadence and helping to explain their continuing significance as representations of cultural change.

Beardsley's art, like much of the art of the Decadence, *was* highly moral, even moralistic, and so I found that some ostensibly dated, morally based approaches to Beardsley's pictures, including questions regarding his personal character, when repositioned in a broader critical context, became particularly illuminating. Conversely, beyond the normal need for terminological precision and identification, I was less interested in classifying—labeling various levels of irony in the artist's work, differentiating between irony and parody, or situating his work within its proper aesthetic or theoretical category—than I was in analyzing what thematic elements were at work in a particular picture and to what cultural and historical forces Beardsley was responding. I do not wish to undervalue the usefulness of traditional taxonomy, but it was not of compelling interest to me beyond demonstrating that one of the central elements of Beardsley's method was precisely to confound traditional means of taxonomical definition.

Other choices I have had to make have been much more frustrating. Recognizing that it is absurdly naïve and compulsive to want to "get it all," I nevertheless find it particularly ironic that so many of the issues that first prompted my study, and about half the Beardsley works I originally wanted to treat, could not be fitted into the final framework of this particular book. The book ironically (though I hope not fatally) omits altogether or addresses only in passing many of the elements that initially gave rise to it. Among those elements were a fascination with Beardsley's treatment of women, his manipulation of his own ambiguous sexual identity, and the related role of his "family romance" with his mother and his sister—none of which I have been able to address, except superficially. In reducing this book to a manageable length, I had to accept that I could not discuss adequately such issues as Beardsley's depiction of women and the role of his ambiguous sexual identity without first establishing separately the underlying metaphysics of his work. I hope that I manage to outline clearly and convincingly what I believe to be the fundamental unifying logic of Beardsley's art and artistic temperament. If at times it appears that I have laid foundations for houses not yet completed, it is because I have. I hope future scholars can build further on these foundations. At least one of those additions will probably be mine.

Beardsley's work is by no means the least enigmatic element within the unusually complex and convoluted culture of the nineties. However, I do not believe that complicated problems need to be explicated in densely insular language, or that sophisticated critical analysis is best carried out in a rarefied jargon unintelligible to the educated public at large. Although many of Beardsley's pictures, and the matrix of interlaced constructs I see operating within them, are admittedly intricate, I have tried to find ways of explaining them—without sacrificing critical integrity and precision—in lucid and generally accessible language. I apologize for any instance in which I seem to join complexity with obscurity; that is quite literally the opposite of what I have sought to do in this book.

Researching and writing scholarly studies is almost never as straightforward a process as the final product sometimes suggests. Over the years I have been indebted to many persons, libraries, and institutions for helping to make this book a reality.

First, I wish to express my debt to my most important professorial mentors. Bert Stern taught me how to read thoroughly and specifically. He once stunned me by responding to one of my abstractly philosophical undergraduate papers with a key question: "How are we supposed to tell from your essay that all of these metaphysical constructs had their source in some real human being, with flesh and blood and lusts, as well as a creaky door to fix?" And Jan Gordon, my extraordinarily generous director in graduate school, stretched me intellectually in ways I never could have anticipated, showing me how to write and teaching me that the best practitioners of critical theory assimilate it seamlessly into the analysis of specific texts. Finally, not that long ago the late Ian Fletcher, who was ever willing to be fascinated by the offbeat connection, insisted that I talk to him about my views on Beardsley and, at a key point in my life, prodded me to begin putting those thoughts into publishable form.

To the often underappreciated staffs of the many libraries and museums that responded to my requests I am indeed grateful. I wish to acknowledge particularly the help of Christopher Webster, Gill Bennum, and Simon Wilson of the Tate Gallery; Edwin Wallace and Isobel Sinden of the Picture Library, Victoria and Albert Museum; Mike Bott and Francesca Hardcastle of the Department of Archives and Manuscripts, University of Reading Library; Jan Wallace and Joanne Harris of the Picture Library, National Portrait Gallery; and Charles E. Green, Margaret M. Sherry, and Alice Clark of the Rare Books and Manuscripts Division, Firestone Library, Princeton University (who facilitated my use of their extensive A. E. Gallatin and J. Harlin O'Connell collections); Elizabeth Fuller, Joan Watson, and Doug Parsons of the Rosenbach Collection in Philadelphia; Konrad Oberhuber of the Graphische Sammlung Albertina, Vienna; Jackie Oliver of the Barber Institute of Fine Arts, University of Birmingham; Eunice C. Gomes and Karen L. Otis of the Boston Museum of Fine Arts; C. Rhodes and S. Gallagher of the British Museum; James B. Graham of the Cecil Higgins Art Gallery; Elizabeth Gombosi of the Harvard University Art Museums; Peter McNiven of the John Rylands Library, Manchester; Midori Oka of the Spencer Museum of Art, Lawrence, Kansas; Sarah Murphy of the Art Gallery of Western Australia; and Frances Bowers of the Whiteworth Art Gallery, University of Manchester. I am grateful to have had access to the Lane Archives, now at the University of Texas at Austin; the Will Rothenstein Papers, Harvard University; and to materials at the Sterling Library, University of London. For permission to quote from manuscript material and to reproduce pictures or photographs, I am indebted to these and other libraries and individuals cited in the notes and captions accompanying illustrations. (I have respected the privacy of various individual collectors by citing their holdings under the generic designation "Private Collection.")

I wish to thank Melanie Davis and Sonya Tergas of the Interlibrary Loan Department and John Knaub and John Hermsdorfer of the Office of Instructional Resources at the University of Florida, all of whom responded to countless requests for their expert assistance and delivery of materials; much of this book would not have been possible without their talents and patience. I am grateful also to the Division of Sponsored Research at the University of Florida for awarding me two small summer grants that facilitated my research, and for help in defraying the cost of photography and reproduction permissions. And I would like to thank my colleague and former chairperson, Patricia Craddock, for the flexibility she permitted me

in my teaching schedule, as well as for her unswervingly genial interest and encouragement in my research pursuits. I am particularly grateful to my freelance copy editor, Judy Spear, and to Senior Editor Elizabeth Maguire, Associate Editor Henry Krawitz, and Editorial Assistant Elda Rotor of Oxford University Press, all of whom have been very helpful to me and have conducted themselves with the utmost professionalism and class.

To many others who sent me various materials over the years, responded to queries, or in other ways were unusually generous to me during my research I wish to acknowledge my deep appreciation. I am particularly grateful for the graciousness of Mr. and Mrs. Robert Muriel, Pimlico; Ronald Bullivant, David Wostenholm, and Mark Reynolds, Brighton; Malcolm Payne, Crowborough; Howard Park, Epsom; John Roles, Keeper of Local History and Archaeology, Brighton Art Gallery; Margaret Cannon, Macmillan Press; John Stokes, University of Warwick; Linda Zatlin, Morehouse College; William H. Shurr, University of Tennessee; Steve Scherer and Don Herring, Wabash College; Ted Chamberlin, University of Toronto; Jim Twitchell, Alistair Duckworth, Greg Ulmer, and Norman Holland, University of Florida; Faith Evans, Stratford; and Loraine and Genevra Fletcher, Reading.

I am especially indebted to Robert Langenfeld, John Leavey, Daniel Harris and Jane Buttars, David and Trish Safer, Mary Jermann, Rollie Steele, Christie Perry, and, above all, Carol Murphy in ways they well know and in more ways than I could possibly enumerate.

Contents

chapter 4 The Rhetoric of the Grotesque: Monstrous Emblems 161

chapter 5 The Beardsleyan Dandy: Icon of Grotesque Beauty 204

chapter 6 The Rhetoric of Parody: Signing and Resigning the Canon 243

Illustrations

N.B.: All art works listed are by Aubrey Beardsley unless otherwise stated. The reproduction of works for which no original has been located was from the line block.

Aubrey Beardsley, Dandy of the Grotesque

Aubrey Beardsley, Emblem of the Victorian Decadence

> Of a hundred important artists born within so many years, a certain number are indispensable. . . . They are themselves concentrated knowledge. Beardsley is one of them.
> —Julius Meier-Graefe, *Modern Art* 2: 253

> Was it that we lived in what is called "an age of transition" and so lacked coherence, or did we but pursue antithesis?
> —W. B. Yeats, *Autobiography* 202

AUBREY Beardsley's work was first published in the spring of 1893. He died in March 1898 at the age of twenty-five. Despite the extreme brevity of his career, probably no other artist or writer prior to the electronic age achieved more notoriety or exercised a more pervasive influence on his era in such a short time. Contemporary critic D. S. MacColl wrote that "the wild-fire speed with which his reputation spread" outran every previous example of rapid fame ("AB" 17).[1] Less than two years after Beardsley's work first appeared, Max Beerbohm could proclaim that he belonged to the "Beardsley Period" (*Works* 160), a designation Osbert Burdett would adopt as the title for his famous study of the age. A shaping force of the Art Nouveau movement, a profound influence on countless artists and designers, cited as the "real king" and "dominating artistic personality" of his time, "the one 'genius' of the 'Eighteen-Nineties' " (S. Wilson, *Beardsley* 5; Muddiman 6; Huneker 17), Beardsley was thought by numerous observers to have set the standard for the art of the period.[2] Arthur Symons summarized the case: "No artist of our time, none certainly whose work has been in black and white, has reached a more universal . . . fame; none has formed for himself, out of such alien elements, a more personal originality of manner; none has had so wide an influence on contemporary art" ("AB" 90–91).[3] As Holbrook Jackson put it in his classic book *The Eighteen Nineties,* "The appearance of Aubrey Beardsley in 1893 was the most extraordinary event in English art since the appearance of William Blake" (91).

The Age of Paradox

If Beardsley's impact was extraordinary, it may have been because no other figure emblematized to such a degree the striking complexities of the Victorian Decadence, the notorious "yellow nineties." Beardsley was for many contemporaries "the complete symbol of his age—an age of transition, spiritual uncertainty, decadence and exoticism" (Preston 431). His pictures were judged to be the visual equivalents of such unsettling aesthetic manifestos as Oscar Wilde's "The Decay of Lying" and "The Critic as Artist," or James Abbott McNeill Whistler's "Ten O'Clock Lecture"—graphic confrontations that ruthlessly called into question the presumptions, the tastes, and the smug "clean tradition in ethics" of Victorian bourgeois ideology (Jackson 99–100; Hunt 203; Armour 8).

The Decadent nineties, which Malcolm Bradbury has called the "first modern decade" (38), was the culmination of the Victorian age in many respects, not least in its self-contradictions. It was a period defined by paradox. In the very same year (1895) that the scandalous Wilde trials riveted London and such best-selling sensationalist novels as George du Maurier's *Trilby* and Marie Corelli's [Minnie MacKay's] *Sorrows of Satan* accented the dangers of willfulness, scientists were celebrated for proving that there were apparently fewer and fewer material limits to the human will: Wilhelm Roentgen isolated rays that could pass through seemingly solid matter, Guglielmo Marconi succeeded in transmitting wireless messages over great distances, and the Lumière brothers demonstrated that pictures could be made to move lifelike on a still screen.

For the most part, the denizens of the Decadence were entranced by the revolutionary "new" and cultivated the "fragile, transitional sensibility" of the evanescently "modern" (Bradbury 38–39), even though such revolutionary change turned their world topsy-turvy. While the nineties' fascination with the "new" struck at the heart of reactionary Victorian stodginess, it also seemed to herald an impending collapse of valued universal truths, rejecting as outdated and inauthentic both naturalistic realism and bourgeois moral idealism. John Rothenstein reported that the nineties were a time when the best artists often became patrons "only to their own moods, theories, and conceits" and the worst seemed but faddish vehicles for the very emptiness they were attacking—"not so much servants as slaves, not so much slaves as prostitutes, to the new industrio-commercial society" (*Pot* 19).[4] The art of the Decadence cannily (if not always intentionally) reflected such paradoxes in various metaphoric and stylistic distortions of conventional forms, even introducing the ugly, the evil, or the grotesque as agencies of beauty.

The times were ripe for cultural rebellion and redefinition. Even before the fin de siècle, philistine industrialism and revisionist classicism had sharply reduced, even inverted, artists' traditional role in society. The scientist-qua-technician, who had previously been considered an idiosyncratic and impractical creature standing apart from society, had become bourgeois society's essential shaman. On the other hand, traditionally eccentric artists, who had previously been a religious and political necessity, were now condemned by the ruling middle class as "decadent" threats to "true value." The frequent nostalgic moods, "immoral" themes, and generally nonutilitarian aestheticism of many nineties artists seemed to undercut healthy,

industrial-based, bourgeois "progress" (J. Rothenstein, *Pot* 6, 15–16). So it was that in the eyes of the ruling order the Decadents—an artistic coterie dedicated to a new Religion of Art that challenged middle-class romantic positivism—became "decadents," stigmatized and marginalized as the representatives of moral and aesthetic disintegration.

Yet, paradoxically, as Linda Dowling and others have explained, for all their obsession with being "new" and their supposedly "immoral" approach to art and culture, the Victorian Decadents were in fact a "deeply conservative avant-garde" ("Aesthetes," 359–60). Although often outrageously iconoclastic and ostentatiously eccentric, they were also surprisingly bourgeois in their own personal tastes and habits.[5] Given the cultural ideals they espoused, the Decadents might even be considered, ironically, the true "fundamentalists" of their age. After all, they supported nostalgic revivals of an idyllic past and appealed ultimately to the same correspondence theory of truth and classical principles of artistic unity that had been for so long the foundation of the bourgeois, ruling-class traditions they were attacking (Michelson 144). Against crass materialism and despiritualizing vulgarity, they located life's "true meaning" in the transcendent order of Art. Like priests on a holy mission, they steadfastly fought against the juggernaut of philistine insensitivity and the demise it brought to the artistic and metaphysical values that had traditionally been the bedrock of Western culture. They were iconoclasts but in the observance of a higher faith; they were "decadents," but in the service of true spiritual health. Indeed, if they were decadent at all, it was not by virtue of any intrinsic immorality but because they self-consciously highlighted what they took to be bourgeois society's own spiritual decay.

Even the strikingly paradoxical, "untidy" personal lives of many of the Decadents—characterized typically by a love of pure beauty enmeshed in the contradictory urge to "feast with panthers"—can be seen, in some degree, to be a logical extension of the broader social, philosophical, and linguistic crises of the period. While these figures continued to cling to High Victorian principles of noumenal truth, canonical tradition, and a poetics that named essentialist correspondences, they nonetheless sensed that they were on the precipice of modernist uncertainty and relativity, a world whose previously hallowed assumptions were about to be shattered and whose very language would come to be described as an arbitrary system of signs blindly obeying impersonal phonological rules (see Dowling, *Language*). Their lives were the incarnation of paradox.

It is the nature of paradox that it seems to present a final, unequivocal contradiction, even as its irony suggests ultimate irresolution, an ever-deferring postponement of closure. Perhaps it is not surprising that, facing the ostensible choice between stodgy-but-secure, bourgeois Victorian univocality, on the one hand, and liberating-but-frivolous, scandalous modern equivocality, on the other, much of Decadent art in effect declined to make such a choice. The implicit strategy of so many nineties artists seemed to be to redefine life inclusively as a rich banquet of plentifully meaningful, if ambiguous, possibilities, thus freezing contradictions in stylized irresolution. In this way, they could continue to affirm the existence of a logocentric world order, even if they constantly intimated the human impossibility of ever finally realizing such a certain and unified order. It was for the most part an unconscious strategy of denial, born out of general cultural anxiety and repressed personal insecurities, but it was a strategy

ingeniously faithful to both the revolutionary iconoclasm and the reactionary conservatism of the period.[6] It was also the paradox at the core of Beardsley's art.

Beardsley's Paradoxical Temperament

It would be difficult, without risking historical and cultural myopia, to assess Beardsley's works apart from the personal myths he so conscientiously crafted and around which he built his art. Led by Wilde and other notable aesthetes, the Victorian Decadence was a period that insisted on conflating the presumably separate categories of Art and Life, treating art as if it were an extension of personal temperament, living life "as if it were a work of art." Beardsley himself lived and worked in a fashion calculated to maximize his art as a cult of personality. It was a relatively obvious strategy since his arresting physical appearance and theatrical personality generally had an impact only slightly less extraordinary than his notorious pictures. Unusually thin and angular—approximately 5 feet 10 inches tall and weighing only some 120 pounds— he was described as having a "hatchet face, over which the tortoiseshell-coloured hair hung in a heavy fringe to the eyebrows" and as quivering "with the febrile vitality of the consumptive" (Cecil, *Max* 95).

Alternately salacious and reverent, Beardsley incarnated the jarring paradoxes of the fin de siècle. His art drew much of its intensity from the unusually striking antithetical tendencies in his personality—notably an urge to violate convention, offset by a craving for literary and artistic "fathers"; a taste for bizarre evils coexisting with an attraction to the Church; and a curiosity and an ambition that were both physically limited and psychologically intensified by daunting invalidism and a sexual-identity crisis.[7] He was both a notorious "pornographer" and a devout convert to Roman Catholicism. He sought to shock and disorient, yet he dressed impeccably, displayed well-bred bourgeois manners, and expressed disgust at bohemian uncleanliness or disorder. He created revolutionary and iconoclastic pictures mocking bourgeois Victorian culture, yet he worked at an altarlike work area and ritualistically imitated the styles of countless canonical masters. He exhibited "a strange mixture of industry and slackness," portrayed bizarrely modern men and women "in a convention as strict as that of an old Chinese artist," and conveyed "the craving without appetite, the animalism without animal health" (Raymond 727). His pictures joined "impeccable delicacy of form with gross indelicacy of feeling and presented "fantastic impressions treated in the finest possible outline" (Ironside 211; *Letters* 37).

Beardsley's basic personality was a study in self-contradictions, if we can judge from his contemporaries, whose descriptions of his temperament often formed polar oppositions. A litany of testimony depicts him as "generous to a fault," eager to help others, especially the careers of fellow artists, and having always "a most delightful and engaging smile both for friends and strangers" (Syrett 83; Salerno 270; R. Ross 16, 19). Although certainly Pucklike, Beardsley was apparently a gentle person, "shy, nervous, and self-conscious," having not "the least shadow of conceit," and being "utterly devoid of any malevolence towards his fellow-creatures, whether individually or collectively" (R. Ross 15; Scotson-Clark, "Artist" 160–61;

Gray, *Letters* v; see also Gray, "AB" 127). His "sweetness," "child-like simplicity," exuberant boyishness, and "simple and natural" character contributed to his "dear charming ways and kind sweet sympathy" (MacColl, "AB" 21–22, 28; E. R. Pennell, *Nights* 180; see also Hind, *UW* x; Strangman, ALS to Ellen Beardsley). He was "a touching and lovable figure," characteristically long-suffering and stoic even when personally attacked, a person whose character, despite slurs to the contrary, was without perversity (E. Beardsley, "AB" 1; W. Rothenstein, *Memories* 1: 187). He was reportedly so generous and "charmingly unsophisticated" that Robert Ross declared he had "never met anyone so receptive" as Beardsley, who was "always sensible about . . . criticism," recording "praise or blame of a particular drawing with equal candour and good humour" (18–19).

Certainly, Beardsley was capable of generosity. Although Hubert Crackenthorpe found the artist's work "altogether offensive" and had proposed steering the journal titled *The Savoy* away from the "Beardsley tradition" (Crackenthorpe 98, 131), Beardsley described Crackenthorpe's suicide in late 1896 as tragic (*Letters* 223). And Beardsley, who had never had great fondness for Charles Conder, expressed concern for Conder's health only weeks before his own death (*Letters* 404). Moreover, in January 1897 Beardsley evinced at least as much concern for the publisher Leonard Smithers's gout as for his own grave tuberculosis, even though Beardsley had just suffered a near-fatal relapse and Smithers had rarely fulfilled his financial contract with him (*Letters* 240–44). As Beerbohm summed up, Beardsley was "kindly, generous, and affectionate," "a devoted son and brother; a very loyal friend. . . . With all his affectations, he had that inborn kindliness which is the basis of all good manners" ("AB" 542).

On the other hand, however, we have at least as much testimony—often, ironically, from the very same sources—that Beardsley was less receptive than defensive, less unsophisticated than manipulative, less sweet than arrogant, less kind than malicious, less generous than vindictive. Acquaintances routinely reported that he possessed a "fondness for shocking the feelings of others" and had a "total absence in him of any of the larger sense of responsibility" (Strong 89). "[He] never forgot a slight. He was easily offended, and many of his friendships ended in feuds on account of slights which were fancied rather than real" (Longaker 185–86). While ostensibly he was "always very courteous and had great dignity," Beardsley was also "intensely vain" and "outspoken in his little tempers & naughtiness," no small measure of his dignity doubtless deriving from the fact that "no one ever took liberties with Aubrey" (E. Beardsley, "AB" 1; ALS to Mabel Beardsley, 10 December [1904]: 1–2; "Recollections" 4). It was Beardsley's willfulness that John Gray emphasized, even though he attempted to describe it as an admirable decisiveness: "This was a man who never hesitated. . . . He laid down his views. And, for him, the matter was settled, decided once for all" ("AB" 126). Indeed, Beardsley's pride and occasional petulance may have accounted for the fact that, even as a child, at least one set of family friends were very fond of entertaining his sister Mabel but "wouldn't have Aubrey; they thought he would be troublesome" ("Recollections" 5). His mother confessed that for all Beardsley's apparent kindness and generosity and the fact that he "was much sought after" as a brilliant conversationalist, "he cared very little for people" and "soon got weary and gave up people altogether" ("AB" 8).

His verbal brilliance notwithstanding, the "restless movements and the quick, hard, stac-

cato accents" of Beardsley's "modish . . . extravagance" of speech apparently "oppressed" and "strained" friends and acquaintances (Cecil, *Max* 95), especially when it was employed in the service of the dandy's fashionable but customarily biting sarcasm. Joseph Pennell was initially put off by Beardsley's pretentiousness, thinking him less an artist than a "swell" (*AB* 19–20); and MacColl, though he spoke of Beardsley's "sweetness," saw him mainly as "a young man full of his own ideas, and indifferent to everything outside them" ("AB" 22). Haldane MacFall, who was a leader in championing Beardsley's genius and one of the few critics whose opinion Beardsley sought out,[8] nevertheless forthrightly criticized what he called "the soul of the real Beardsley," who possessed "a hard, unlovely egoism even in his love-throes, without one noble or generous passion, incapable of a thought for his fellows, incapable of postulating a sacrifice, far less of making one, bent only on satisfying every lust in a dandified way that casts but a handsome garment over the basest and most filthy licence" (*AB* 81).[9] Yeats thought both Beardsley and his sister Mabel had a "pathetic gaiety," but Beardsley, unlike his sister, "was not I think loveable, only astounding and intrepid" (Yeats, *Letters* 575).

Beardsley's sense of humor tended to be aggressive, with a predisposition—evidenced in his notorious caricatures—to belittle his targets, even if they were friends or respected acquaintances. George C. Williamson related an episode from the time Beardsley worked as a clerk in the Guardian Insurance Office:

> [V]ery shyly he came forward, bringing with him a piece of blotting paper from his pad, on which he had sketched the portraits of many of his companions, and some exceedingly able portraits of one or two of the senior officials of the office, all of them slightly tinged with caricature. One was so amazingly clever that Aubrey retreated to a darker corner of the office before he would show it to me, . . . and I warned Beardsley that it was dangerous work upon which he was engaged in his spare moments. (278)

However genial and charming Beardsley often was, he was inclined to harbor resentments and often felt the need to exact revenge, even beyond impish caricatures. He went out of his way to try to embarrass and cause financial harm to John Lane (who had fired him from *The Yellow Book* in the wake of the Wilde debacle) by importuning the new publisher Leonard Smithers to advertise Beardsley's Venus and Tannhäuser story under the false title *The Queen in Exile*, so that Lane would not recognize it as the same book Lane had already advertised and still assumed Beardsley was going to publish with him (*Letters* 97–98).[10] Granville Hicks suggested that Beardsley was really "even more hated than Wilde" as the central "exponent of decay" in the nineties, partly because the public sensed that, in contrast to Wilde's grace and frivolity, there burned within Beardsley a meaner and more fearful "passion of indignation" (218, 242, 247).

Perhaps one of the most noteworthy examples of Beardsley's paradoxical temperament—showing particularly how his spiteful iconoclasm existed side by side with attempts to succeed in canonical artistic circles—involved the running battle over the prospectus and the cover design for the first issue of *The Savoy*.[11] Both Beardsley and the publisher Smithers intended

the new quarterly to rival The Bodley Head's prestigious *Yellow Book*. The original prospectus had the announcement for the magazine carried by a corpulent and amusingly cherubic Pierrot, stepping out on a footlighted stage (Figure 1–1). Smithers objected that Pierrot, who traditionally tripped onstage—and Beardsley's Pierrot in particular, with its extended wings, foppish gait, and tiny top hat—was too flippant to symbolize *The Savoy*'s important literary contents. "John Bull," Smithers said, referring to the traditional personification of England, needed something more serious. Beardsley probably found being lectured on decorum by the notoriously licentious Smithers ridiculously impertinent. But whatever the reason, he responded devilishly by replacing Pierrot with a pompous and preening John Bull figure having many of the same characteristics, except even more misshapen and ludicrous, adding for ironic resonance a tiny erect penis surreptitiously bulging from his breeches (Figure 1–2). Beardsley even reproduced the picture, which Beerbohm called "the very best drawing . . . Beardsley ever did" (Beerbohm, *Letters* 94), on pink paper as a contemptuous parody of *The Yellow Book*, from which, as everyone knew, he had been peremptorily dismissed as art editor only months before. Smithers did not notice the prurient penis, but George Moore certainly did and ordered Edgar Jepson to call a meeting of several prospective contributors—Herbert Horne, Selwyn Image, Jepson, Bernard Shaw, and Alexander Teixeira de Mattos, among them—in Jepson's rooms in King's Bench Walk, to deal with what Shaw labeled Beardsley's "puerile mischievousness" (Jepson 286; Weintraub, *Imp* 156). Although the randy Smithers confessed to being actually delighted by the prospectus, and almost all eighty thousand copies had already been released, Moore and his cohorts (led by Shaw as the elected "fighting man in chief") forced Smithers to get Beardsley to expunge the picture's offending sexual feature (Shaw 572). Beardsley did so (the damage, after all, was already done), but only to continue the battle of wills, even more expensively as it happened, at the next stage.

To try to ensure a strong send-off, the premiere issue of *The Savoy*, its cover bearing a distinctive Beardsleyan design (Figure 1–3), was publicized to appear in time for the all-important 1895 Christmas trade. Using the opportunity to vent a bit of personal revenge against Lane, Beardsley not only instructed that the cover be produced once again on the satiric pink paper; he also designed it as a not overly subtle double-edged allegory, joining stylized high culture and vulgar iconoclasm in the same design. Here a statuesque young woman, deliberately drawn to evoke the liberated New Women of Beardsley's preceding *Yellow Book* period, looms above a fleshy little naked putto, who is waggishly skipping over and urinating on a copy of *The Yellow Book* (in fact, Beardsley originally drew a graphic trajectory of the urine). While this dignified young woman is fashioned to be elegant and alluring, her stolid and confining clothes (along with the stylistic similarity to Beardsley's *Yellow Book* sirens) mark her tacit sexuality, even as they conceal and make it inaccessible. Such ironic reticence contrasts sharply with the brazen nudity, elaborate hat, open flowing robe, and erect feather of the undisciplined imp, whose antics the young woman's whip is presumably intended to check.

The waggish putto notwithstanding, the overall atmosphere of the picture tends to convey a sense of secure tradition and placid assurance. The customarily confident, self-possessed bravado of Beardsley's *Yellow Book* woman is, in this incarnation, rigidly muted by the engloved

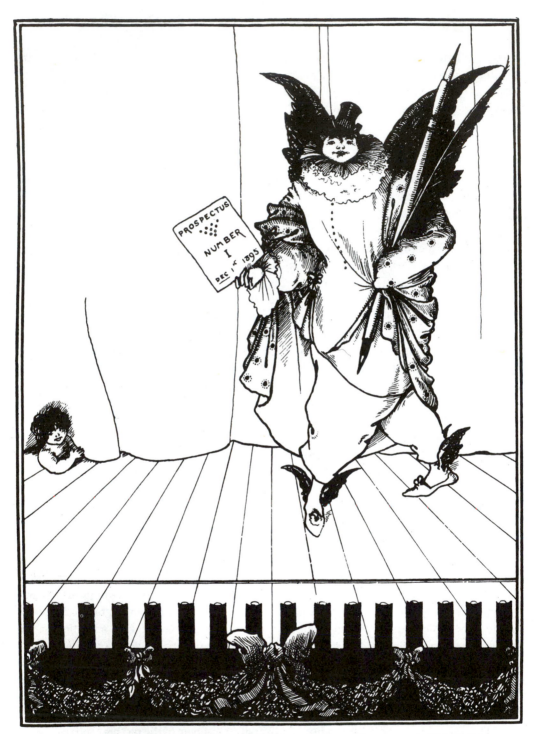

1-1 Design for the front cover of the prospectus of *The Savoy*, no. 1 (first version). (E.2-1900 [neg. no. HD746], Victoria and Albert Museum, London)

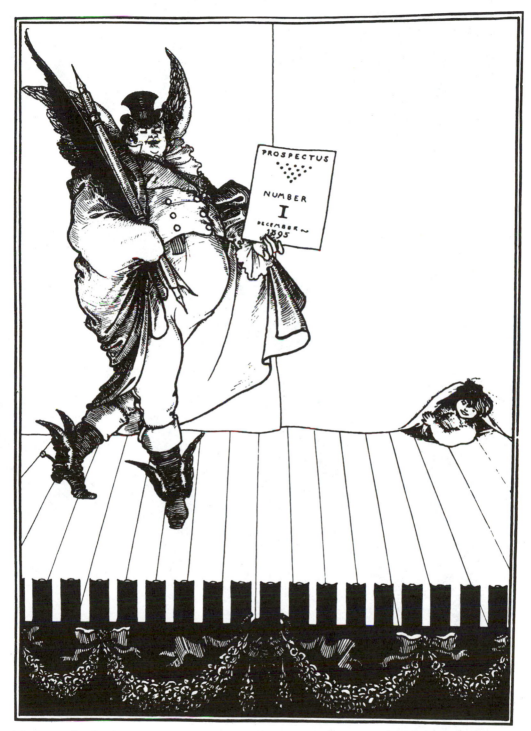

1-2 Design for the front cover of the prospectus of *The Savoy*, no. 1. (1986.674, Schofield Thayer Collection, Courtesy of The Fogg Art Museum, Harvard University Art Museums, Cambridge, Mass. Also E.1-1900 [neg. no. HD745], Victoria and Albert Museum, London)

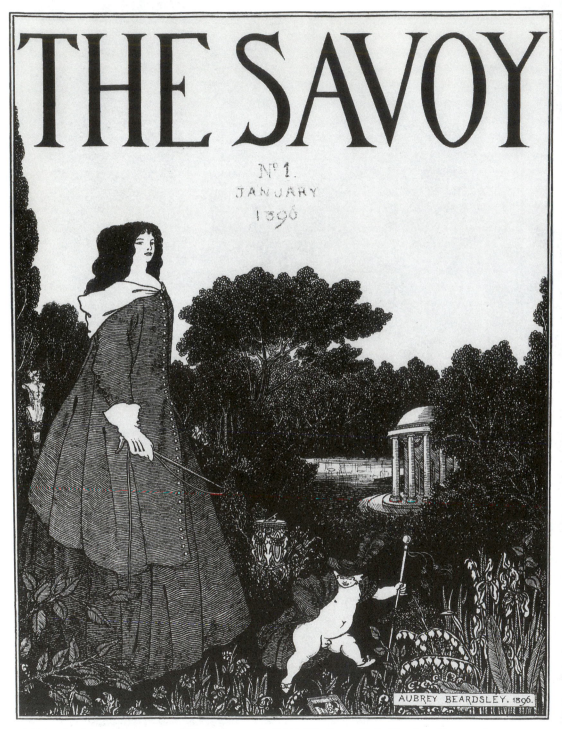

1-3 Design for the front cover of *The Savoy*, no. 1. (1943.629, Grenville L. Winthrop Bequest, Courtesy of The Fogg Art Museum, Harvard University Art Museums, Cambridge, Mass. Also E.365-1899 [neg. no. HD747], Victoria and Albert Museum, London)

hand and forearm, the severe buttoned coat, and the heavy drapery of the woman's voluminous skirt—which are thus made symbolic of repressive Victorian attitudes toward sex and, by extension, Beardsley intimates, editorial censorship of artistic expression. However, twisting the irony yet again, Beardsley also suggests that just as Mrs. Grundy was ultimately unable to restrain the sexual passions of the age, so this artificially inhibited damsel cannot (and, judging from her unraised riding whip, secretly may not wish to) control her rebellious child-errant— or, for that matter, the surrounding world of the drawing. Behind her stands the herm of a notoriously licentious god, and before her rests a sundial supported by three satyrs. The imaginary line connecting these figures passes through (symbolically negating) her riding crop to the putto, implying that any attempt at sexual (or artistic) repression cannot ultimately succeed. Indeed, compositionally balancing the young woman in this garden is a pagan temple. Furthermore, all the figures in the drawing seem about to be overwhelmed by the unkempt, luxuriating, and often distinctly pubic vegetation.

As Beardsley was generally too tickled with such impish details not to boast of them, word soon leaked out about the mocking cover design. Again, Smithers was amused; but faced with the prospect of another internal revolt, he quickly ordered the putto and the defiled rival magazine removed (either not comprehending or not wishing to alter the other ironic elements). It was not in time, however, to avoid delaying the first *Savoy* until after the crucially important Christmas season, a delay that probably predestined the magazine's ultimate financial failure (Weintraub, *AB* 148–50). As an editor, Beardsley was surely not unaware of the cost his scampish retaliation might carry to the success of an already risky venture—and one on which much of his own livelihood depended—but apparently his personality and his own psychological needs were such that this consideration was not sufficient to deter him.

Beardsley's mother confirmed that her son often behaved "like a naughty boy, and especially if one attempted to interfere with certain expressions of his work" (Lane, "Notes" 1). Even as an untested artist on his first commission, Joseph Mallaby Dent's edition of Malory's *Morte Darthur*, Beardsley found it difficult to check his willfulness. Despite Dent's kindness to him, Beardsley stated that he "hated working for him, because he had to work to order" and needed more "rein to his fancy" (Lane, "Notes" 1). As a rule, any effort to censor Beardsley's work only inspired him to produce a more sophisticated, and often more bitingly mocking drawing—the cunning "revision" creating an intertextual, self-justifying dialogue with the censored original.

Oscillating Iconoclasm and Reverence

Max Beerbohm argued, regarding the perplexities in Beardsley's life and art, that he was a figure who "forces us to rëadjust all our ordinary scale of judgment" ("Ex Cathedra" 30). Henry Harland (among others) sought to attribute the numerous paradoxes and self-contradictions in Beardsley's character to the fact that he was "a boy of genius, indeed, but still a boy" who delighted in the "mischievous humour" or "deviltry" of "[giving] solemnity a shock"—in Bernard Shaw's words, "a diabolical reveller in vices of which he was innocent" (Harland,

"AB" 437–38; quoted in Brophy, AB 16). But while Beardsley was young and his "arrival" precocious (he received his first commission before he was twenty), he nevertheless earned within a very short time a position of unusual responsibility—as art editor of two prestigious journals—and had considerable influence among a highly sophisticated circle of older companions. Thus we cannot satisfactorily explain his status as an icon for his age as being a function of boyish "mischievous humour" or "diabolical" fantasies.

As might be suggested by the resonant ambiguities (and implicit ambivalence) of Beardsley's *Savoy* cover design, the paradoxes underlying Beardsley's art are nearly inseparable from basic self-contradictions reflected in his life—most vividly, his paradoxical attraction to the outlandish, iconoclastic, and scandalous, on the one hand, and the conventional, traditional, and even ecclesiastical, on the other. Ironically, at the same time that the presumably irreverent Beardsley was creating outrageous visual practical jokes, he was also taking regular long walks with parish priests, reading pious texts assiduously, and preparing to convert to Roman Catholicism.

However opprobrious Beardsley's iconoclasm, there was always evidence of an underlying attraction to and reverence for hierarchical authority. Henry Harland maintained that, for all the "mischievousness," "Aubrey Beardsley's temperament was essentially . . . religious" ("AB" 438). Lionel Johnson (who knew firsthand about living a life of self-contradictions) concurred that "despite all wantonness of youthful genius, and all the morbidity of disease, [Beardsley's] truest self was on the spiritual side of things, and his conversion was true to that self" (quoted in Gallatin 12). But however sincere Beardsley's religious sympathies, they seemed never entirely divorceable from a certain black-humored perversity. In one rather typical letter, for instance, Beardsley first wryly turns the horrific fire at a Parisian charity bazaar into a social annoyance—"[Jacques-Emile] Blanche writes to me this morning that several of his friends were burned, and consequently puts me off a second time for lunch"—then jokes, regarding Callot's painting of the martyrdom of Saint Sebastian, that what is "singularly interesting" is "a charming soldier in the background picking up the arrows that have missed the Saint" (*Letters* 314). His fellow artist MacColl concluded that Beardsley had the classic paradoxical temperament of the Decadent—one who, suffering from "nerve-disturbance" and seeking "nightmare intensity," "strangeness," and "oddity of sensation," fell, like Joris-Karl Huysmans, to "oscillating between curiosity in sensation and in asceticism" ("AB" 28). Indeed, the myth of Venus and Tannhäuser may have had such a powerful and enduring appeal for Beardsley in part because it represented the pressing together of jarring metaphysical oppositions—flesh and spirit, heaven and hell, love and criminality: "It incorporated his own attraction towards a luxurious sinfulness and diabolism, and at the same time his feeling (justified in the event) that he would in the end return to the consolations of religion" (Lucie-Smith, "AB" 8).

Even during his boyhood days at Brighton Grammar School, such self-contradictory oscillations between a willful urge to be outrageous and a yearning for validation by some higher authority had already become the rather conspicuous pattern of his life. Beardsley's schoolmates thought "he cared a little too much for himself," "was . . . naturally disputatious," and was "perhaps a trifle wicked"; yet at the same time they also described him as quiet and often sad, very reserved, and exceptionally keen on winning the approval of his masters (Williamson 278; Hopkins 307; anon., *West. Budget* 9).

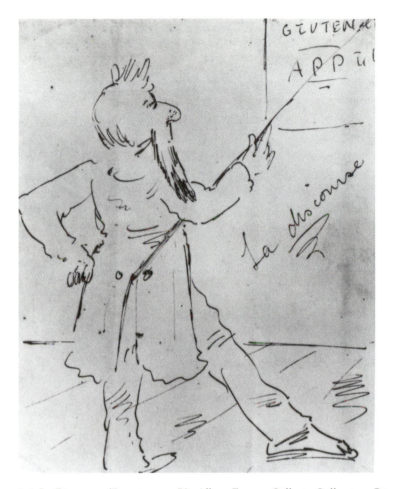

1-4 *La Discourse*. (Drawing no. 72, Albert Eugene Gallatin Collection, Princeton University Library, Princeton, N.J.)

On the one hand, Beardsley was the scampish ringleader of misrule, "up to all sorts of mischief" and devising clever schemes to raise money in order to "steal off to the theatre" (Scotson-Clark, "AB" 1–4; "Artist" 159). He routinely astonished his classmates and masters with fantastic and whimsical stories, arrogant and defiant boasts, impromptu mock illustrations of the classics, and numerous pranks (King 24–29; Benkovitz 24–25; Brophy, AB 35–36). Undeterred by the headmaster Ebenezer J. Marshall's reputation for dealing harshly with troublemakers, Beardsley once stuffed a corner of Marshall's academic gown into an inkpot, causing great commotion when the headmaster upset the pot and splattered ink over the classroom (Hopkins 307). We have evidence of such mischievousness in early, provocative, violet-ink caricatures. In *La Discourse* (Figure 1–4), for example, the stern, lecturing headmaster becomes a devil, his hair sticking up in the shape of two horns; and *Flavouring the Apple Tart* (Figure 1–5) depicts Marshall falling seat-first onto a chair containing an apple tart.

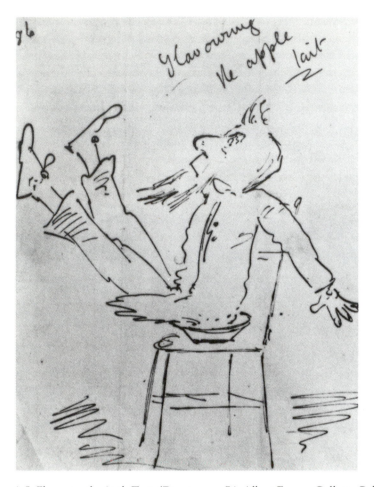

1-5 *Flavouring the Apple Tart.* (Drawing no. 74, Albert Eugene Gallatin Collection, Princeton University Library, Princeton, N.J.)

On the other hand, during the same period that Beardsley was thumbing his nose at authority, he was paradoxically also forming close and deferential relationships with many of these same authorities, especially Arthur William King, his science and mathematics master (as well as house master), and Father George Chapman, the exceptionally conscientious priest-in-charge of Brighton's Church of the Annunciation of Our Lady and a fellow consumptive whom one schoolmaster even mistook for "Beardsley's guardian" (W. G. Good, quoted in Easton 161, 162). Beardsley went to rather extraordinary lengths to attend the rather popish religious services at Chapman's high Anglican church (Figure 1–6), which was built as an unrecognized Catholic church in 1864 and was one of several Catholicized churches established by the noted vicar Arthur Douglas Wagner. Indeed, despite the fact that the Parish

Church of St. Mary's the Virgin stood only a few doors from his residence (at his aunt Sarah Pitt's house at 21 Lower Rock Gardens) and despite his respiratory troubles and weak legs, Beardsley undertook—twice each Sabbath and often several times a day on certain feast days and festivals—an unusually arduous, steeply uphill trek (part of it by chalk path) crosstown from the old Chain Pier area of "Kemp Town" to "The Annunciation" at 95 Washington Street (E. Beardsley, "AB" 2; Brophy, *AB* 33–34; Easton 160–61).[12] Only shortly before this period (between 1881 and 1883), Beardsley's tubercular condition had grown so severe that he had been forced to take a leave of absence from school altogether. Yet now he insisted on taxing his health well beyond what his family thought wise, in order to attend perhaps the most ritualistic and authoritarian church available to him. Beardsley made much the same choice later, when he moved to London. Thomas Gardner's lodging house at 32 Cambridge Street, Pimlico, where the Beardsleys lived from late 1888 to early 1891, was directly opposite

1-6 Church of the Annunciation of Our Lady, Brighton. (Photograph by C. Snodgrass)

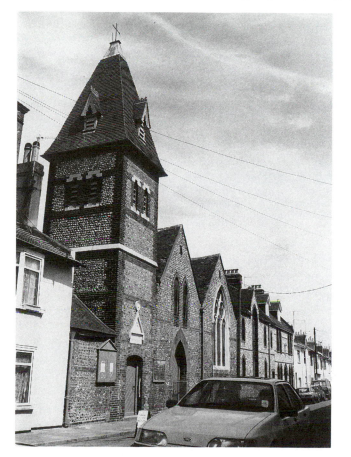

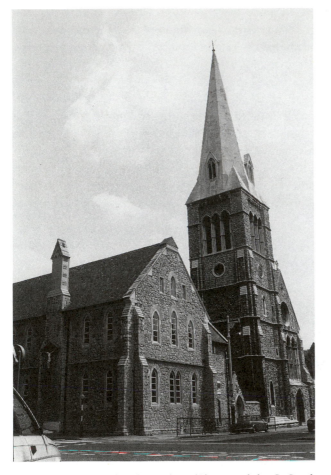

1-7 St. Barnabas's Church, Pimlico. (Photograph by C. Snodgrass)

a well-established Anglican church, St. Gabriel's, but Beardsley chose to attend the considerably more distant but "higher" St. Barnabas's (Figure 1–7) (Brophy, AB 42).

One might be inclined to attribute such self-contradictions to the normal vagaries and attachments of unformed youth. However, these accentuated polar impulses continued unabated to the end of Beardsley's life, when he cultivated two highly disparate friends and benefactors simultaneously—Leonard Smithers, the libidinous solicitor-turned-publisher whose iconoclasm and risqué self-indulgence delighted Beardsley and more than one of whose vices Beardsley reputedly investigated, and Marc-André Raffalovich, the reserved and fastidious Russian expatriate who answered Beardsley's numerous requests for religious texts and was most directly responsible for finally bringing him into the Catholic church. Aside from his economic reliance upon them, Beardsley had genuine affection for both men, and for good reason. Leonard Smithers (Figure 1–8), although he retained a thick Yorkshire accent from

his native Sheffield, was the image of well-bred modern elegance—neat, nattily dressed, often monocled, immaculate and clean shaven in an age of dubious hygiene and unruly beards, and at ease in virtually any company. Yet he was also well known as the publisher who would print "anything the others are afraid of" (O'Sullivan, *Wilde* 102) and as an entrepreneur whose schemes often obliged him to keep one step ahead of the police.[13] In order to produce pornography and, it was claimed, execute blackmail plots, he furnished the felt-fitted back room of his shop with sophisticated photographic equipment and a double-crown Wharfedale printing-press (Easton 66, 74). It is alleged that he once had himself photographed while copulating with the wife of a friend in Shepherd's Bush (Pearsall 391).[14] But for all Smithers's reputed lack of character, he was unusually considerate and self-sacrificing where Beardsley was concerned. Although he certainly knew of the artist's precarious health when he rescued him from the *Yellow Book* humiliation (and unemployability), Smithers nevertheless took the un-

1-8 Photograph of Leonard Smithers. (Box 4, Albert Eugene Gallatin Collection, Princeton University Library, Princeton, N.J.)

usual and unnecessary step of placing Beardsley on an exclusive retainer at the exceptionally handsome salary of twenty-five pounds a week, in an effort to free him from all monetary worries. Indeed, Vincent O'Sullivan claimed that Smithers started *The Savoy* "chiefly to give Beardsley a chance, without much hope of making money out of it," and kept the magazine going beyond the point of prudent business practice, even though it meant "raising money on his furniture" to do it ("Literature" 53). Consoling Smithers upon Beardsley's death, Wilde judged that "you, and you alone, recreated his art for him, gave him a new and greater position" (*More Letters* 170). Beardsley's own letters make it clear that he considered Smithers an intimate friend, as well as an employer, and appreciated his efforts. He frequently asked about Smithers's health, sought his company, and, though disappointed at the partial payments and occasionally fearful about his publisher's financial capabilities, never once claimed their agreement was not being honored.[15]

There is every evidence that, paradoxically, his friendship with André Raffalovich (Figure 1–9) was equally deep and genuine, despite Beardsley's occasional tendency to make gentle fun of "the Russian prince" to Smithers (See *Letters* 254). A framed photograph of Raffalovich was one of the totemic objects Beardsley always kept with him, and prominently displayed, as part of his essential furnishings (Weintraub, *AB* 233; Easton 57). Once when, short of ready cash, he instructed Smithers to sell most of his books, Beardsley was careful to ensure the safety of the books Raffalovich had given him and (despite his apparent financial straits) even had one such volume expensively rebound (*Letters* 432). In February 1897, when suspecting that his doctors were not being entirely candid with him about the severity of his condition, Beardsley asked Raffalovich to intervene in this most personal matter (253). When Beardsley came to believe he might ultimately recover his health, he wrote to Raffalovich of their friendship, "I wish I could see you soon and speak my gratitude. As I get better I realize more and more the tremendous debt I owe you" (365).

Beardsley was apparently undaunted by the balancing act necessitated as a result of having two such disparate confidants, but the irony is nonetheless jarring. For example, he would write to Raffalovich, thanking him at length for his many gifts, religious guidance, and spiritual counsel, calling him "a brother . . . out of a fairy tale" and signing his letters "With much love, / Ever yours very affectionately" (e.g., *Letters* 343, 316–17). Yet during the identical period Beardsley would direct to Smithers entreaties "for Satan's sake," write bawdy letters about "another wet dream" and self-induced "cockstands," claim to have walked the streets "as pertinaciously as a tart," eagerly accept such "scandalous" commissions as *Lysistrata*, and even volunteer to make additional erotic drawings (*Letters* 99, 231, 138–56, 298, 307, 328). In the case of the controversial *Lysistrata* project, Beardsley was obviously enchanted on more than purely aesthetic grounds. He gave one of the drawings the code name "Pisspots" and mischievously noted about another that "if there are no cunts in the picture, Aristophanes is to blame and not your humble servant" (*Letters* 140, 142, 139). Yet he was also careful to delay telling Raffalovich anything whatever about the *Lysistrata* commission until he had completed all of the drawings. In fact, on the same day that he broke the news of the *Lysistrata* drawings to his more pious benefactor, he wrote Smithers wryly: "In a letter to Raffalovich

1-9 Photograph of Marc-André Raffalovich. This is the photograph that Beardsley displayed prominently in his room during the last months of his life. (Published in *The Scotsman*)

to-day I told him that I had completed a set of illustrations to *Lysistrata*. I wonder if he will take any notice of it" (150).

Surely any tendency the youthful Beardsley had to indulge in paradox was intensified by still another trait he shared with the fin de siècle—a "macabre and tragic" sense of impending death and the concomitant Paterian urgency to get "as many pulsations as possible into the given time" (Wilde, *Letters* 719; Pater, *Ren* 190). The consumptive Beardsley was always associated with disease. Beerbohm remembered: "When I first saw him I thought I had never seen so utterly frail a creature—he looked more like a ghost than a living man. . . . When I came to know him better I realized that it was only by sheer force of nerves that he contrived to sustain himself" ("AB" 539). As a consequence of this "force of nerves," Beardsley "never

rested. He worked on always . . . with a degree of force and enthusiasm that is given only to the doomed man" (539). In the words of Symons, he had "the fatal speed of those who are to die young; that disquieting completeness and extent of knowledge, that absorption of a lifetime in an hour, which we find in those who hasten to have done their work before noon, knowing that they will not see the evening" ("AB" 91). As early as 1894 Beardsley well understood that his fragile health would not long support the energy his work demanded. He bantered lightly in the press about having "not long to live" and even contrived to have a human skeleton seated next to him when he played the piano (Schmutzler 174), but he recognized all too well that his increasingly poor health was no joke. In 1896 he wrote to Smithers, "My genius for work possesses me in an extraordinary degree just now. Pray God it continues to do so," only to experience repeated outbreaks of hemorrhaging that left him "laid out like a corpse" and "quite paralysed with fear" (*Letters* 168, 171, 194). By early March 1897 he cursed his "ignoble existence" and confessed, "I know the disease cannot be cured," telling both Raffalovich and Smithers that he could count his life "by months now" (265, 287, 268, 269).

It is possible, especially under the near certainty of an early death, that the contradictory impulses and polar dichotomies in Beardsley's life and art—the reckless iconoclasm and inclination to outrageous behavior and the counterbalancing reverence for authority and attraction to tradition and stable conventionalism—were less a reflection of lingering adolescent immaturity than a subconscious recognition that hovering death did not give him the customary time to rationalize his vexing self-contradictions into a more "mature" and logical expression. In this respect, too, the hyperconsciousness of his own imminent death put Beardsley in a position not so different from the Victorian Decadence, which saw itself—in the wake of radical social, economic, and political change, and Victorian science's ideological tendency to link antibourgeois traits with national and global "devolution"—living out the decay of a civilization. As an artist, Beardsley did what we naturally expect artists to do: he communicated the tensions and contradictions central to his life in the most forceful and effective means of expression available to him, treating the subjects and ideas of his art "in terms of his own deepest instincts, working, that is to say, out of his unconscious mind" (S. Wilson, "AB" 9). Beardsley's pictures constantly inscribed the discordances of his paradoxical life, usually illuminating in the process key issues of the equally paradoxical age. To apply Matthew Arnold's famous formulation, Beardsley's art was perhaps a classic case of the fortuitous historical convergence of "the power of the man and the power of the moment" (*Works* 3: 261). In a fundamental sense, as Wen Yuan-ning put the case, "not to understand Beardsley is to miss altogether the meaning of the 1890's" (451).

Beardsley's Fin-de-Siècle Irony

If Beardsley was widely considered "the mentality most representative" of the Victorian Decadence (Muddiman 13), it was precisely because his art served as a kind of cultural lightning rod, channeling and incarnating in ironic tropes both the ideological conflicts and latent

anxieties of that frenetic and highly self-conscious era—a period, after all, that sought to burst the chains of philistine hypocrisy only to feel itself trapped in a residue of guilt, that championed an art of personality only to view itself isolated from human intimacy, that established Art as the unifying order and spiritual principle of life only to experience that life as a disordered, perverse, self-contradictory paradox.

That is to say, the world of Beardsley's art, like the world of the Decadence, was perforce a world of fundamental metaphysical irony. It was irony's world of the *eiron* (Greek for "dissembler"), where consequence does not necessarily follow intention, where what is intended is often at variance with what is expressed, where expression is often different, even opposite, from reality (assuming that meaningful distinctions are possible among such categories). Traditionally classical metaphysics (and a "classic" style in art) had assumed that a word or image, for all its rich connotations, had essentially one clear, logical meaning in any one context and was thus at some fundamental level free from ironic confusion. Moreover, where irony did exist, it was for the most part what Alan Wilde has called a relatively Romantic "*mediate* irony," which satirizes the degree to which the world has lapsed from—and can implicitly be restored to—some ideal "whole" of "harmony, integration, and coherence" (9). But, as we know, within a few short years of the "Beardsley Period" modern art—heralded by such figures as Alfred Jarry, Henri Rousseau, Erik Satie, and Guillaume Apollinaire—would self-consciously create the potential for endless (and ultimately unrecuperable) irony, expressing two or more meanings in a single symbol or sound, making not only the content but the very surface and structure of a work the site for ambiguity or equivocal interpretation (Shattuck 35–36).

Although Beardsley was thoroughly of the nineteenth century in most of his aesthetic assumptions, he anticipated and routinely employed what has been termed "*conjunctive* ambiguity," or modernist "*disjunctive* irony," a rhetoric "especially suited to the expression of ambivalent attitudes" (Kris 247). Disjunctive (or conjunctive) irony, unlike mediate irony, confronts an "inherently disconnected and fragmented" world and seeks to control those disconnections aesthetically by shaping them conjointly into an equipoise of opposites, "an unresolvable paradox," substituting a fabricated aesthetic paradise for the no longer efficacious notion of some real paradise to be regained (Kris 247; A. Wilde 9–10).[16] Paralleling the Decadence at large, much of the modern rhetoric and techniques of Beardsley's art thus worked to call into question the very nineteenth-century aesthetic and metaphysical principles on which his art rested. In fact, Beardsley's ambiguous, stylized grotesques—one of his favorite tropes for symbolizing fin-de-siècle dislocation—prefigured many of the same deforming and decentering elements that were to be manifested in Cubism, Op art, and other modernist movements. His pictures came to signal, in the only means available before the final stylistic fracturing of the mimetic tradition, what was, in effect, a visual-arts equivalent of Einstein's relativity theory and Heisenberg's "uncertainty principle"—those theories, we recall, that revealed the impossibility of establishing simultaneously both an object's position and its definitive identity, thereby annulling the laws of noncontradiction and ushering in a potentially absurdist world of constantly shifting, logically self-contradicting meanings and values. Beardsley's shocking but fundamentally equivocal art not only captured the central metaphysical

contradictions and basic paradoxical vision of the Victorian Decadence itself; it also represented in its very modernity a striking example of the Decadence's attempt to forestall what it sensed to be the approaching metaphysical deluge of the twentieth century.

Whatever the specific reasons, Beardsley was clearly drawn to (and delighted in) all kinds of irony, as if he conceived life itself as a palimpsest of self-contradictions. It is indicative of Beardsley's paradoxical sensibilities that even as he gravely read biographies of saints and referred to the ostensibly pious *Ascension of Saint Rose of Lima* as "the best of my later drawings," possessing a "charm . . . that I have never given to any other drawing," he also boasted to sister Mabel of having acquired "delicious" ancient erotic engravings and other "dreadfully depraved things" (*Letters* 176, 123, 309).

Of course, it is also indicative of Beardsley's divided sensibility, and the self-contradictions of the Decadence as a whole, that part of the very "charm" of *The Ascension of Saint Rose of Lima* (Figure 1–10)—an illustration for Beardsley's semipornographic novella *Under the Hill*— is that its pious affirmation of familiar Baroque and Counter Reformation conventions is highly equivocal. In this imitation of the Assumption of the Virgin theme, the saintly young Peruvian maiden, who had "vowed herself to perpetual virginity when she was four years old" (*UH* 2: 187–88), is being transported to heaven in the arms of the crowned Madonna. The model for the Virgin Mary was the Madonna of Victory in London's Brompton Oratory (Figure 1–11), with which Beardsley was affiliated and which, not incidentally, also contains a statue of Saint Rose of Lima, depicted in a heavily pleated dress and a veil (Heyd 186–87). Beardsley's drawing gives the Ascension an unexpected twist, however. The intimate embrace, the eyes closed in erotic ecstasy, the negligeelike wedding dress, the two roses that have fallen from Saint Rose's hair—one of which hikes up her wedding frock—and the sensual smile on the saint's face (a perverse parody of the ecstatic smile of Bernini's Saint Teresa[17]) all suggest more lesbian earthiness than asexual transcendentalism. Indeed, as Brigid Brophy has noted (*Black* 24–25), the passage from the novella that the drawing illustrates (*UH* 2: 188) has the Madonna literally save Rose from an earthly bridegroom, transporting her on the very morning of her wedding day, in response to Rose's direct prayer "calling tenderly upon Our Lady's name." Moreover, as Ian Fletcher has suggested, the second rose on the tail of the Madonna's robe extends the lesbian theme (and perhaps reflects some of Beardsley's own sexual anxieties) by turning the tail "into a monster that threatens male sexuality with open mouth" (*AB* 156).

In fact, the historical Santa Rosa of Lima did not, as depicted in the drawing, ascend to heaven with the Virgin Mary; she became a Dominican nun and dedicated herself to a life of mortification and self-abasement (Heyd 186). Beardsley went out of his way to call attention to his waggish revisionism by concocting a highly amusing, all too "precious," and utterly bogus footnote, whose camp in-joke irony and arch double entendres highlight the artist's transformation of asexual self-denial into lesbian self-indulgence:

> All who would respire the perfumes of Saint Rose's sanctity, and enjoy the story of the adorable intimacy that subsisted between her and Our Lady, should read Mother Ursula's "Ineffable and Miraculous Life of the Flower of Lima," published shortly after the canonization of Rose by Pope Clement X. in 1671. "Truly," exclaims the

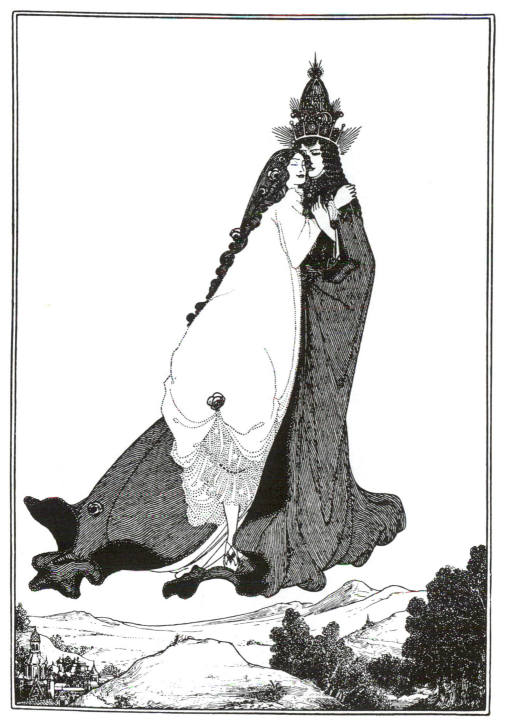

1-10 *The Ascension of Saint Rose of Lima.* (Published in *The Savoy* 2 [April 1896]: 190)

1-11 *The Madonna of Victory*, Brompton Oratory. (Photograph by C. Snodgrass)

famous nun, "to chronicle the girlhood of this holy virgin makes as delicate a task as to trace the forms of some slim, sensitive plant, whose lightness, sweetness, and simplicity defy and trouble the most cunning pencil." Mother Ursula certainly acquits herself of the task with wonderful delicacy and taste. A cheap reprint of the biography has lately been brought out by Chaillot and Son. (*UH* 2: 188)

As if to underscore more bluntly his predilection for splicing the scandalous with the sacred, Beardsley wrote of his "pious" drawing of Saint Rose in a (presumably facetious) letter to Smithers:

> A lady has just written to ask me if I would be kind enough to send her a copy of verses upon any of my pictures. Whereupon I wired the following chaste thing.
>
> > There was a young lady of Lima
> > Whose life was as fast as a steamer.
> > > She played dirty tricks
> > > With a large crucifix
> > Till the spunk trickled right down her femur.
> >
> > (*Letters* 236)

Such impish urges are all the more striking for the ironic fact that pictures like *The Ascension of Saint Rose of Lima* owe much of their beauty and power to their conventional elegance of line and form—an elegance that counterbalances (and often disguises) their grotesque and subversive elements. Indeed, the mellifluous style of Beardsley's drawings has seduced countless viewers into misreading or overlooking altogether their outrageous details. This ambiguous (and inherently ambivalent) internal dialogue between conventional harmony and grotesque irony becomes one of the most distinctive characteristics of Beardsley's art, again paralleling many of the same self-contradicting rhythms of both his life and his age.

Grotesques, Dandies, and Caricatures

In an age that was both attracted to and repelled by the possible mutation and deformation of meaning, the grotesque naturally became a prevalent stylistic metaphor for fundamental metaphysical dislocation. The alien, the misfit, the monstrous, the Other—in short, the heterogeneous and paradoxical—has always been expelled by science, philosophy, religion, and society's other institutions in order to rationalize life's odd, pluralistic elements and enforce a sense of the harmonizing Divine.[18] On the other hand, the grotesque has flourished especially in periods of spiritual unrest and crisis (e.g., the end of antiquity, the Middle Ages, the Renaissance). Capitalism's erosion of the traditional structures of nineteenth-century society as well as an increased interest in prehistory, alchemy, and the occult combined to make the Victorian fin de siècle fertile ground for fantastic and monstrous elements.

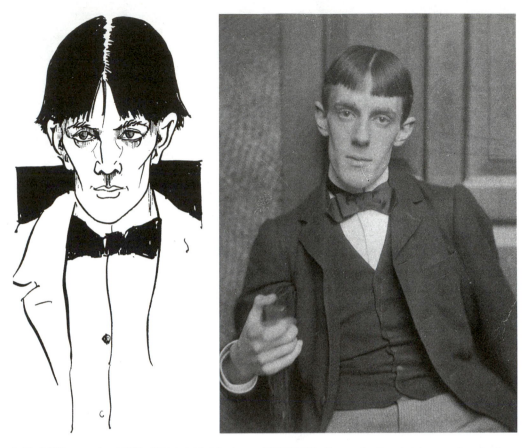

1-12 *Self-Portrait* (c. 1892). (1906-4-23-1 [neg. no. PS209795], Copyright British Museum, London)

1-13 Photograph of Aubrey Beardsley by Frederick Hollyer. (Box 5, Albert Eugene Gallatin Collection, Princeton University Library, Princeton, N.J.)

Beardsley was fascinated and unusually preoccupied with the grotesque—not surprisingly, perhaps, for someone who as a child was nicknamed "Weasel" and whose physical appearance was generally mocked throughout his life (Hopkins 306; Scotson-Clark, "AB" 3–4). He frequently depicted himself as grotesque, as in a cadaverous 1892 *Self-Portrait* (Figure 1–12) and in a July 1891 report to his former house master A. W. King: "I am now eighteen years old, with a vile constitution, a sallow face and sunken eyes, long red hair, a shuffling gait and a stoop" (*Letters* 23). While such characterizations may not have been wholly unwarranted during those periods when his chronic illness proved particularly grueling (Figure 1–13), at least one early-nineties photograph (Figure 1–14) suggests that they were extreme.

From his early childhood the grotesque was an integral part of Beardsley's life. He grew up captivated by the bizarre arabesques of the Brighton Royal Pavilion; and his first extant drawings were "a long series of grotesque figures" (E. Beardsley, "AB" 1; Derry [Walker] 3–4).

Among his boyhood enthusiasms were such masters of the grotesque as Poe and Dickens, whose more eccentric characters he made into dinner place cards for Lady Henrietta Pelham (Weintraub, *AB* 7), and he was particularly keen to mimic the colorful pirate jargon of the juvenile book *Lives of All the Notorious Pirates* (Hopkins 306). At Fred Brown's South Kensington art school he chose to work from "the grotesque cast" and spent most of his time on "curious grotesque Burne Jonesy effects gradually becoming Japanesy" (Scotson-Clark "AB" 14). In 1893 in Paris, despite his tubercular condition, he insisted on making the arduous climb up the tower of Nôtre-Dame cathedral—three separate times—to get a better view of the gargoyles (and to caricature Joseph Pennell as one, sitting in place of Méryon's Stryge) (J. Pennell, *Adventures* 204, 216).

In his art, whether as a self-conscious defense against his own insecurities or a metaphoric representation of a paradoxical world, Beardsley developed a gallery of grotesque figures— including, notably, his foetus/old man, dwarf, Clown, Harlequin, and Pierrot—which function as a visual incarnation of metaphysical paradox and suggest the ultimate impossibility of ever

1-14 Photograph of Aubrey Beardsley. (P43, by courtesy of the National Portrait Gallery, London)

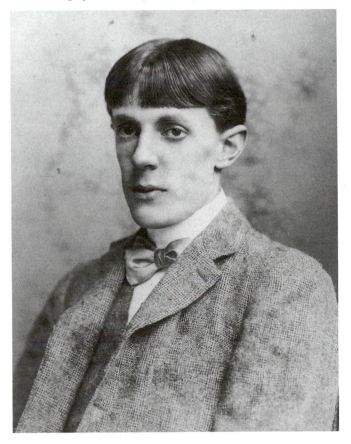

resolving it. Following the nineteenth-century tradition of associating the artistic imagination with things fantastic—even linking fantasy to madness and monsters particularly (Prickett 6, 9, 14)—Beardsley's grotesques reflect the disorienting contradictions we find difficult to assimilate, incarnating not comprehensible reality but the absurd, the unnatural, a fundamental dissolution of meaning itself.

Surely one of Beardsley's more cunning uses of the "disorienting" grotesque appears in *L'Education Sentimentale* (Figure 1–15), the picture the *Westminster Gazette* wanted "a short Act of Parliament to make . . . illegal" (18 April 1894: 3). It is not difficult to see why contemporary reviews found the picture "imaginative but horrible" (*Queen*, 21 April 1894: 628), since both the older tutor and the young pupil undercut traditional Victorian conventions of feminine angelic beauty and moral instruction. The delicate young ingenue clasps her hands decorously behind her "in a simulation of innocence and servitude" (Zatlin, *AB* 107), yet her slightly risqué snug black dress, shifting eyes, lush hair, cocked hip, and bemused, worldly wise expression all suggest that she has more in common with Decadent demimondaines than sequestered bourgeois damsels. The ingenue is being tutored by a gross, imposing governess—Aymer Vallance called her a "procuress" (368)—whose expression seems wizened in cynicism and whose vaguely "castrating" domination, as Fletcher has suggested, could not help but represent to many bourgeois Victorian male viewers a return of the authoritative female overseer whose power he thought he had escaped with the coming of puberty ("Grammar of Monsters" 159). Ironically, the corruption that is presumably being imparted by the old "pro," who appears in "priest-like garb" (Zatlin, *AB* 107) and whose hat bow Beardsley waggishly forms into the butterfly of Whistler's famous signature, seems already manifest in the young woman. Beardsley conveys the sense that these two figures represent parallel threats—and not a conventional good/evil dialectic—through clever stylistic manipulation, specifically by the insistent balance of black and white counterpointing, the parallel rough edging on their clothing, their similarly pointed feet, and the subtle restatement of the tilted nose and ogival mouth of the governess in the face of the younger woman.[19]

Indeed, Beardsley's subtle grotesqueries signal the corruption of univocal order and epistemological innocence to an even greater degree than is readily apparent. If we look closely at the grotesque features of the governess (Figure 1–16), some of which I have shaded here, we see that, like the proliferating perspectives of Cubist portraits, her face is in fact a combination of three monstrous faces, the one in three-quarter view fragmenting to create two adjacent, right-facing profiles, signifying perhaps multiple facets of a schizoid personality. Likewise, examining the head of the ingenue (Figure 1–17), we find that an insidious grotesqueness has been encoded into this stylish beauty. The incongruous bun at the back of her head can become in another aspect the huge warted nose of an upturned face. Similarly, the waves of the far-left hairline can be seen to form the forehead, nose, upper lip, and chin of an open-mouthed hag. For that matter, the hair encroaching on the other side of her face forms another face, or more likely, the profiled breast and the unsteady legs of yet another version of corrupted femininity. Once again, Beardsley orchestrates the grotesque elements of his picture—some of which the viewer may not consciously discern—so as to unhinge traditional meaning, causing it to oscillate among dissonant, even contrary, possibilities.

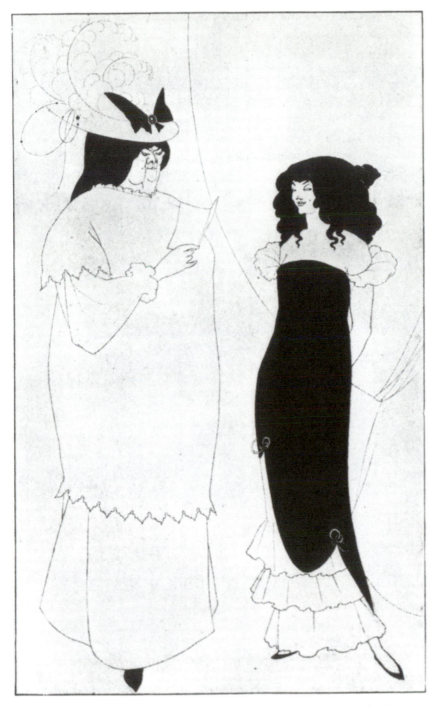

1-15 *L'Education Sentimentale*. (G.28 B.31 [neg. no. FF147], Victoria and Albert Museum, London)

Among Beardsley's most dissonant and "oscillating" representations of the grotesque were his numerous dandified figures, which were also a reflection of his commitment to fin-de-siècle dandyism. According to Brian Reade, of all the English artists of the nineteenth century, Beardsley most distilled the traits of the Baudelairean dandy ("AB" 14). Always "outwardly conforming to the conventions which make for elegance and restraint," he was one "of the best-dressed young men in town," scrupulously clean and meticulously attired, usually in discreet Baudelairean black or in his "dandiacal uniform of gray coat, gray waistcoat, gray trousers, gray suede gloves, gray soft felt hat, and gray tie knotted wide and loose in the approved French manner: a small triumph of underplayed affectation" (Symons, "AB" 92; Syrett 78; Fletcher, AB 8). So committed was Beardsley to his dandiacal persona that he even

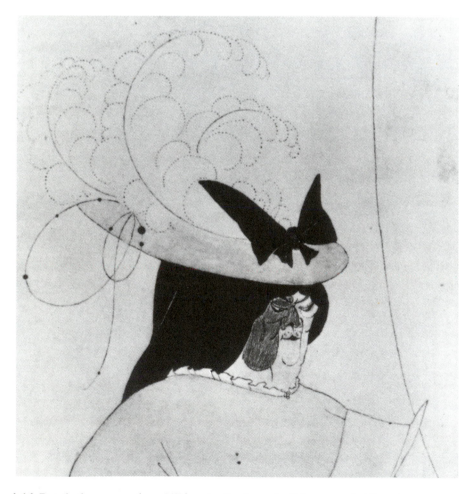

1-16 Detail of governess from *L'Education Sentimentale*. (Victoria and Albert Museum, London. Also 1943.399, Grenville L. Winthrop Bequest, Courtesy of The Fogg Art Museum, Harvard University Art Museums, Cambridge, Mass.)

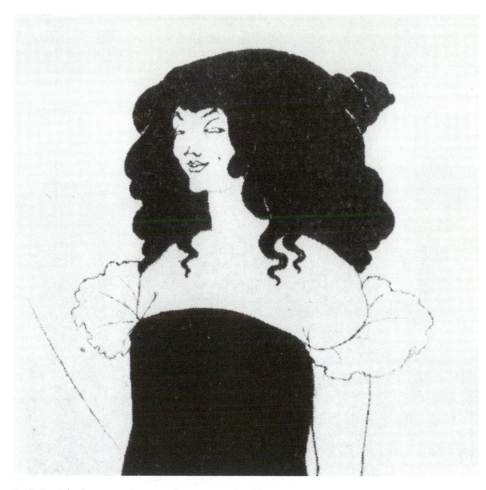

1-17 Detail of ingenue from *L'Education Sentimentale*.

subordinated his health to it. On one occasion, he was found standing on the steps of the opera house on a bitterly cold winter night without an overcoat, despite his tubercular condition. When an alarmed friend expressed shock and concern, Beardsley replied, "Oh, no, I never wear an overcoat. I am always burning" (Burdett 98). It was an allusion to Pater's suggestion that the aesthete must "burn always with this hard, gemlike flame" and a motif, among others, that Beardsley exemplified visually in such illustrations as *The Fourth Tableau of "Das Rheingold"* (Figure 1–18).

While the avant-garde dandyism Beardsley encoded into his art was clearly designed, as in *Under the Hill*, to scandalize the philistine sensibilities of the ruling order, it was also a highly disciplined and conventionalized attack, its premises being, ironically, perhaps even more hierarchical than those of the culture it challenged. The dandy, the supreme and hyper-controlling maestro of his art, embodies a "military spirit" that parsimoniously bends every

1-18 *The Fourth Tableau* of *"Das Rheingold."* (E.307-1972 [neg. no. GC.3564], Victoria and Albert Museum, London)

meticulous detail to his very own "carefully cultivated temperament" (Beerbohm, "Dandies" 10, 6). As Baudelaire proclaimed, the dandy is a true hero, one "who is immovably centered," "concentrating the whole of one's spiritual powers on a given point" (*SW*372; *AR* 18), but his "burning desire to create a personal form of originality" must necessarily still operate "within the external limits of social conventions" (*SW*420; *AR* 89).[20] Without established social rituals within which, and against which, to define himself and his art, the dandy would

1-19 Vignette on page 23 of *Bon-Mots* (1893) by Charles Lamb and Douglas Jerrold.

not exist. For that matter, the irony so central to Beardsley's art is itself a kind of dandyism of style, perhaps one of the most ascetic styles in that it produces "supreme effect through means the least extravagant" (Beerbohm "Dandies" 2; see Muecke 52). Just as Beardsley's art was revolutionary in rather traditional and highly canonical ways, so the ironical dandyism of his art was equally wedded to the culture it wished to reform.

The Beardsleyan dandy's oddly hybrid, authoritarian iconoclasm made it a "monstrous" anomaly in the eyes of many bourgeois Victorian viewers, a perception the impish Beardsley was, needless to say, all too happy to reinforce. In his vignette on page 23 of *Bon-Mots* (1893) by Charles Lamb and Douglas Jerrold (Figure 1–19), Beardsley fashions the head of a tuxedoed dandy as a grotesque fetal cranium. The dandy's jutting frontal lobe and formal attire suggest its precocious intellectual superiority and social refinement, even as its scowl testifies to its alienation within normal human society.

Perhaps inevitably, Beardsley's fascination with the grotesque and his interest in dandyism

1-20 Caricature of Queen Victoria as a Ballet Dancer. (E.39-1948 [neg. no. Y383], Victoria and Albert Museum, London)

came together in caricature. As a form of visual punning that uses indecorous distortions to pervert contemporary artistic conventions, caricature became a natural vehicle for Beardsley's dandiacal irony. Like dandyism itself, irony semantically inverts normative meaning as an indirect way of invoking a judgment, usually a pejorative one (see Hutcheon 53). So for the dandy Beardsley, irony led almost inevitably to caricature, a genre of the ambivalent—the distortion that evokes truth, the alienating form that curries sympathy.

That Beardsley so often used caricatures to further his highly paradoxical art is logical for more than the obvious personal and political reasons. After all, like dandyism, caricature itself represents a metaphysical and rhetorical paradox. On the one hand, it assumes the ability, in a minimum number of pen or brush strokes, to capture the essence of a subject, distilling that subject to its critical signifying characteristic or quality—the artistic process, in effect, mirroring the philosophical assumptions it illustrates. On the other hand, ironically, the vehicle for this essential meaning is not some central beauty and unity, but a swerving from or eruption of classic signification—that is, the grotesque, a deformation or mutation of traditional signs. In his Caricature of Queen Victoria as a Ballet Dancer (Figure 1–20), for instance, Beardsley turns the national emblem of prudery—a quality emphasized by the queen's glowering countenance, accentuated famous nose, pointing finger, and the legend "Fidei Defensor" (Defender

of the Faith)—into a performer in a music hall; worse, he turns her into a French performer, given that Degas's name is invoked. The deforming irony is even more scandalous than it seems, since Beardsley's comic portrayal associates the moralistic queen not only with one of the era's most morally suspect of female professions but also with a notorious rendezvous for illicit trysts.

Was Beardsley conscious of the myriad contradictions in his art? To some degree, perhaps, but probably no more than most of us, allowing that however much we may pride ourselves on being intellectually rigorous, we may never manage to fully account for, or often even identify at all, the countless repressed, suppressed, or self-deceptive contradictions in our own thoughts and actions. The Greeks believed that the need to make sense of things was what differentiated human beings from the lower orders of life, and that as a logical extension of that innate quest for understanding, to know the good is to do the good. Late-twentieth-century heirs of Freud, Saussure, Lacan, Lévi-Strauss, McLuhan, and many others have come to other conclusions, however: first, that even separate from our personal idiosyncrasies, innumerable social, political, linguistic, and other cultural structures shape over time our perception of the sense of things, and second, that these historical forces, together with our very personal, psychological imperatives, inescapably create at least some disparity or perceptual blind spot between what we may see or understand and what language or personal sanity will permit us to make explicit or even consciously acknowledge. Hermeneutically we have long recognized—the intentional and/or positivist fallacies notwithstanding—that meaning exists far beyond the limits of what any author or age may intend, recognize, or have a perspective or critical vocabulary to explain. What makes Beardsley's pictures so fascinating is the degree to which they seem to capture so many of the paradoxes and contradictions of the late Victorian Decadence, paradoxes and contradictions that Beardsley and his age were often either unable to articulate or all too eager to repress, except in the form of artistic images.

John Stokes has noted incisively that many of the great aesthetic debates in the nineties "took their shape from the interaction between minority and majority, elite and mass, margin and centre" (*Nineties* 28). In Beardsley's art, too, we find—historically, politically, formalistically, and metaphysically—similar dialogical oscillations (not unlike the cultural dialogue of intertextual discourses Mikhail Bakhtin described only a generation later) between the avant-garde and the ruling order, idiosyncratic iconoclasm and canonical tradition, mass appeal and elite codes, ambiguity and univocality, the marginal and the central.

Since, as in the Decadence itself (whose predominant mythos sought to merge life and art), so many of these paradoxical oscillations reflect vexations not only aesthetic and philosophical but societal and personal, I have framed my analysis of Beardsley's art by first investigating the basic ways his life and art converged. Indeed, there is at the core of Beardsley's work the same subtle interlacing dialogue and ultimately unresolved dialectic that was central to his life. Chapter 2, "The Urge to Outrage: The Rhetoric of Scandal," examines the most obvious pole of this dialectic, Beardsley's almost compulsive desire to violate and destabilize conventional boundaries of decorum. Chapter 3, "The Craving for Authority: Rescue and

Redemption," investigates the opposite pole of the Beardsleyan dialectic, the equally strong and often simultaneously demonstrated need to affirm and incorporate traditional authority. Beardsley's notorious urge to outrage, the need to shock his audience, was certainly a rhetorical imperative in his art. He delighted in iconoclastically altering traditional forms and establishing his distinctive, personal signature on the old order. At the same time, paradoxically, he felt the need to affirm the metaphysical certainty of authorized authority, the absolute hegemony of Art, style, even moral truth—if for no other reason than to validate his position in the canon and his status as a true artist. Beardsley's debt to countless literary and artistic father figures is as graphically obvious in his art as it was emotionally indispensable in his life. But beyond that, his pictures reveal an almost compulsive allegiance to order, to the extent of suggesting that order can be created artistically, even if it exists nowhere else, through relentless symmetry and hard, powerful lines. However much it may "defamiliarize" its world, Beardsley's art always argues implicitly for the ultimate hegemony of Art itself, the redemptive power of artistic order.[21]

In fact, Beardsley's ostensibly iconoclastic deviance often proves to be an ironically conservative strategy. Like the idiosyncrasies of the dandy he emulated, the shocking elements of Beardsley's art not only throw into question the mores of Victorian society; paradoxically, they also fortify the foundations of those mores. They either reinforce a "healthier" (albeit Decadent) variation of the old order or distinguish its failures so as to suggest implicitly a more valid succeeding order. In this regard (although perhaps not to the degree of some of his Decadent compatriots) Beardsley was ironically a moralist. As Arthur Symons observed of Beardsley's pictures, "The consciousness of sin is always there, but it is sin first transfigured by beauty, and then disclosed by beauty; sin, conscious of itself, of its inability to escape itself, and showing in its ugliness the law it has broken" ("AB" 98–99). Beardsley's "pornographic" images do not annul spiritual values; on the contrary, by highlighting various exotic incarnations of the spirit and the limitations of religion's traditional forms, his art serves forcefully to bring spiritual values back into the cultural consciousness.

Yet it is part of the precarious balance in Beardsley's art that neither iconoclastic disorder nor cultural authority is able to supersede the other entirely, always leaving the viewer with some degree of intractable paradox. If his urge to outrage belies an intrinsic reverence for authority, the converse is also true: every (frequently parodic) affirmation of authoritative "truth" carries in it the traces of equivocality. The constantly sliding connotative twists of Beardsley's ambiguous designs and salacious hidden images intensify the schisms and elisions of traditional readings, making difficult any clear resolution of meaning. Although his drawings aspire to a consummate Decadent merging of style and content, their meaning is rarely univocal or unequivocal. Meaning slides ambiguously and without probable synthesis—frightening as that prospect was for the traditional Victorian hierarchical sensibility—among several varying and ostensibly equal possibilities, immersing the viewer in a continuing whirlpool of irony. The "real" has suddenly threatened to become but a function of the scene of its reading, the world being merely a tissue of highly self-reflexive discourses. No longer able to distinguish unequivocally the narrator from what is narrated, or the degree and limits of irony in the

narration, the viewer is thrust into a world without closure—until, that is, Beardsley seems to recuperate the disorder by once again invoking the Decadent supremacy of form and line.

Chapter 4, "The Rhetoric of the Grotesque: Monsters as Emblems," extends the basic paradox of Beardsley's art to another level, analyzing how the grotesque becomes for him an emblem for, or a kind of objective correlative of, life's potentially "monstrous" metaphysical contortion. It is, in effect, his metaphor or figurative expression for the inexorable and unresolvable personal and metaphysical paradoxes revealed in chapters 2 and 3. As if combining all the fearful contradictions of the Decadence, Beardsley's grotesque shapes and mutated figures conflate violently, and inevitably throw into question, a multitude of apparent oppositions—male/female, culture/nature, ethereal/animal, sacred/profane, good/evil, victimizer/victim, freedom/imprisonment, unity/estrangement, comedy/tragedy.

Not surprisingly, given Beardsley's flamboyant aestheticism, the figure of the dandy, that emblem of the Decadent Religion of Art, comes to serve as Beardsley's favorite icon of the grotesque, incarnating most vividly his paradoxical iconoclastic authoritarianism. Chapter 5, "The Beardsleyan Dandy: Icon of Grotesque Beauty," demonstrates how the dandy (and all it historically represented) orchestrates both the disorientations of the grotesque and the healing elegance and control of art, paradoxically symbolizing both scandal and stylized authority.

Finally, chapter 6, "The Rhetoric of Parody: Signing and Resigning the Canon," pulls together the various parallel planes—both personal and figurative—of the previous chapters to show how Beardsley's dandiacal sensibility employs the grotesque not only figuratively but rhetorically. Utilizing the grotesque in the service of parody, Beardsley radically realigns canonical meaning itself, creating a style of canonical "deformation" and recuperation—in effect, a "caricature" of signification. Beardsley's basic approach of grotesque caricature becomes the rhetorical equivalent of paradox, a kind of stylistic synecdoche of his entire view of the world.

Max Beerbohm argued that "all the greatest fantastic art postulates the power to see things, unerringly, as they are" and that, in that regard, "no man ever saw more than Beardsley" ("AB" 544). It is remarkable that, given the bizarre and perverse shapes through which he caricatured life, Beardsley himself claimed his work to be "realistic":

> I am afraid that people appear differently to me than they do to others; to me they are mostly grotesque, and I represent them as I see them. . . . [S]trange as it may seem I really draw folk as I see them. Surely it is not my fault that they fall into certain lines and angles. I think most people who know anything of the subject will admit that my figures are anatomically correct. (anon., *To-Day* 29)

If Beardsley was being truthful here, even metaphorically, then his vision of life was indeed "grotesque" in a fundamental way. Although he was an aesthete devoted to the Religion of Art, he nonetheless presents a world that is inescapably "de-formed" even in its elegance, a world whose meaning resists any universal reading, sliding or oscillating precariously among unstable alternatives, even opposing poles—what most Victorians would have defined as the destruction of meaning itself. The world of Beardsley's art teeters on the brink of Einsteinian

relativity and Heisenbergian uncertainty, giving the appearance of logocentricity even as its images and designs undercut the very possibility of such an order. In Beardsley's works, as in the works of so many of his fin-de-siècle compatriots, the transubstantiation of the Religion of Art renders a world that is not holistic, logocentric, comforting, and nurturing but split, paradoxical, vexed, and monstrous. He was quintessentially a Dandy of the Grotesque, incarnating all the vexing ambiguities and paradoxes that were the Victorian Decadence.

The Urge to Outrage:
The Rhetoric of Scandal

> Yet is it not most important to explore especially
> what has been long forbidden, and to do this not only
> "with the highest moral purpose," like the followers
> of Ibsen, but gaily, out of sheer mischief, or sheer
> delight in that play of the mind?
>
> —W. B. Yeats, *Autobiography* 218

BEARDSLEY "was never really bad," Aymer Vallance once tried to explain, "He had a sort of impishly mischievous pleasure in shocking people—that was all" (Hind, *UW* xxii). The Victorian public may well have disagreed with Vallance's assessment of Beardsley's character, but it certainly did find Beardsley's designs shocking. *Leslie's Weekly* thought his art a "revolution" that stood for "the apotheosis of the ugly, the exaltation of the grotesque"; he had "undoubtedly struck out boldly for himself, with the determination to abjure all the new gods as well as the old" (90). The *Westminster Review* found "everywhere" in Beardsley's work "the cynic leer of fin-de-siècle decadence" (596). While Beardsley may not have been quite as avid a disciple of the revolutionary Friedrich Nietzsche as many of his compatriots (such as Havelock Ellis, whose articles on the nineties' favorite philosopher had been given a prominent place in *The Savoy*), his defamiliarizing pictures championed the perspective of Nietzsche's "new aristocracy," whose duty it was to effect a general "transvaluation of values."[1] Indeed, Yeats attributed the sad fate of most nineties avant-garde artists to having been lashed in the public mind to Beardsley's scandalizingly disconcerting images (*Autobiography* 216).

Impish Temperament

Will Rothenstein claimed that Beardsley's "perversities" were "largely an attitude he adopted *pour épater les bourgeois*" (*Memories* 1: 237), a view apparently shared by an exasperated Henry Harland when he asked Edmund Gosse, "What is one to do with a capricious boy whose ruling

passion is a desire to astonish the public?" (Harland, *Trans.* 231). But however much Beardsley clearly wanted to "flabbergast the bourgeois," he also continued his "astonishing" poses even when in the company of only his family and friends. D. S. MacColl related how during a jaunt with friends to Saint Cloud in May 1893, Aubrey and his sister "worshipped" before the cast of a drowned girl's head, obtained from the morgue and hung on a tree by their table ("Beards-leys" 3). Drinking with colleagues, Beardsley would often improvise vividly detailed stories, some of which, according to the French portraitist Jacques-Emile Blanche, were "so daring that it would have been better had he told them in Greek" (*Portraits* 95). He engaged Aymer Vallance to paint the rooms of the family's first real home at 114 Cambridge Street, Pimlico—which Beardsley shared with his mother and sister Mabel—a "violent orange" with black doors, bookcases, fireplaces, and skirtings, and with black pillars that spread out at the top into conventional interlacing twigs and branches (Vallance 367; W. Rothenstein, *Memories* 1: 134; Fletcher, *AB* 10). It was a decor that not only echoed the color scheme (orange and dark indigo) of Des Esseintes's rooms in Huysmans's notorious Decadent classic *A Rebours* (1884) but also, not incidentally, was in symbolic contradistinction to the Christian primitive decor of The Grange, Burne-Jones's famous house in West Kensington. As if to underscore further what he called Beardsley's taste "for the bizarre and exotic," Rothenstein relates how, embarrassed, he once gave away to a delighted Beardsley an "outrageous" Japanese volume, *The Book of Love*, containing sexually explicit pictures, only to discover to his horror that Beardsley "had taken out the most indecent prints from the book and hung them around his bedroom," despite the presence in the house of his mother and sister (*Memories* 1: 134).[2]

In fact, Beardsley was well known for going out of his way to be "scandalous" (especially by sexual reference), even when it was hardly a case of "astonishing the bourgeois." Once when trying to explain to the rakish Smithers the various maladies that had caused him to delay work, he wrote particularly of a tooth that had to be extracted, making a drawing of the tooth with three long roots, under which he commented, "You see even my teeth are a little phallic" (*Letters* 219–22). In the last weeks of his life, when according to his mother he was leading an ever more "saintly" existence, Beardsley nevertheless retained his bawdiness, ex-pressing delight at Smithers's story of "opening the suppository box at Mabel's" (411). Even Frank Harris, whose crudeness was legendary, expressed shock at Beardsley's cavalier attitude toward pornographic particulars: "Looking a mere boy, Beardsley would point to this scabrous detail and that: 'I see nothing wrong with the drawing; do you?' as if pudenda were [merely] ears to be studied" (Weintraub, *AB* 68). In addition to his controversial extant work, Beardsley reportedly also brought to Smithers "truly awful" pornographic drawings, including a set of illustrations to the Book of Leviticus, which, Beardsley bragged, "suits me admirably" and which Smithers's son Jack described by quoting Leviticus 18: 23: "Neither shalt thou lie with any beast to defile thyself therewith" (*Sketch*, 10 April 1895: 562; Smithers 28, 39). Of all his work Beardsley claimed his scandalizing *Lysistrata* illustrations to be "the best things I have ever done" (*Letters* 147, 150), illustrations so sexually explicit that they could only be published for private distribution among clientele who were presumably less subject to "astonishment" than the normal Victorian reader. Beardsley's desire to violate cultural boundary lines obvi-ously went far beyond a need "*pour épater les bourgeois.*" After all, he not only fashioned

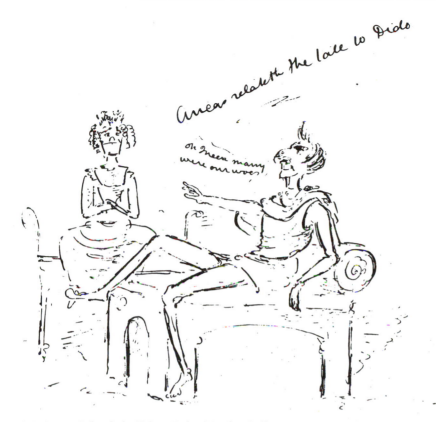

2-1 *Aeneas Relateth the Tale to Dido*. (Hartley Collection, Museum of Fine Arts, Boston)

drawings that deliberately tested the censor; he also created designs that he knew beforehand would not, and could not, be published in their original form—indeed, drawings the normal bourgeois Victorian public would never see.

This urge to be outrageous seems to have grown in part out of the same "boisterous sense of fun" that, as a schoolboy, led Beardsley to cherish Gilbert à Becket's iconoclastic *Comic History of England* and to make *Lives of All the Notorious Pirates* the source not only for weeks of roguish pirate games but for several tales and ballads for the school magazine (Hind, *UW* viii; Hopkins 306). Arthur William King, senior house master at Brighton Grammar School, had encouraged Beardsley to make illustrations of the classics, and "Johnny" Godfrey, a rather liberally minded instructor at the school, prepared hectograph and lithograph perspectives for the eager student to copy. Neither King nor Godfrey envisioned that most of Beardsley's illustrations would turn out to be "racy little drawings" (Scotson-Clark, "AB" 1; King 27–28), like the irreverent *Aeneas relateth the Tale to Dido* (Figure 2–1). In this drawing, which Beardsley produced under the tweakingly pretentious nom de plume "Beardslius de Brighthelmstonunsis," a lounging Aeneas has been given the same facial features, including a distinctly unheroic bulbous nose, that Beardsley regularly used to caricature Headmaster E. J. Marshall, neither

Aeneas nor Marshall being flattered in the process. The adoring Dido is here made to grimace in acute discomfort; whether out of embarrassment or boredom it matters little. Perhaps the most elaborate lampooning is in another illustration of Virgil's *Aeneid*, Book 2 (1886) (Figure 2-2), which shows a pipe-smoking Aeneas escaping Troy by means of a balloon fastened to his helmet. Mocking officious civic (and presumably academic) authority, Beardsley labels presumed landmarks—the "Walls of Troy" and the "Highest Roof" (complete with warnings to trespassers)—as if ancient Troy were but a modern tourist attraction. Indeed, the modern roof in the foreground further supports this implication. Attached to the drawing as an appropriately flippant commentary is one of Beardsley's earliest literary efforts (signed "A.V.B." within a laurel wreath):

I

Aeneas once thought
He'd have some sport,
So he tied a balloon to his topper;
And he soared up so high
In the beautiful sky
That all thought he'd come down a great flopper.

II

If he did, no one knows,
But I really suppose
That the hero still hangs in the air,
Or has gone for a turn
To the moon with Jules Verne,
And will write if his time he can spare.

(Payne, ALS 3–5)

Beardsley's playfulness was hardly mitigated by the restless theatricality in what a classmate described as an "odd, fantastic, brilliant" personality, which "impressed itself strongly" upon people even at the first meeting (Cochran, *Showman* 4; "AB" 103). A skillful and "particularly quick talker," Beardsley gestured emphatically in a way that demonstrated a clear "feeling for the stage" (Cochran, *Showman* 4; R. Ross 30). Having from an early age performed drawing-room recitations and piano duets with his sister (E. Beardsley, "AB" 1–2), Beardsley "preferred Congreve and Wycherly to the ordinary books of boyhood" and was soon giving almost weekly theatrical house concerts at Brighton Grammar School with G. F. Scotson-Clark and Charles B. Cochran (who became a noted professional actor). He recited prologues, poems, and scenes from Dickens, and played mock-heroic roles in operettas turned out for the school by Fred Edmonds and C. T. West, such that his fame there rested on his acting and recitations far more than on his drawings (Cochran, *Showman* 4–5; Hopkins 305).[3]

Beardsley's irony was generally linked to his sense of the theatrical, his view that at the heart of both art and life lay the "mask." Max Beerbohm recalled how once, when Yeats was

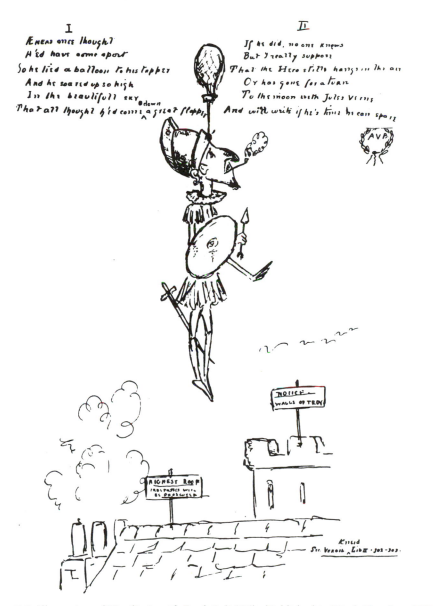

2-2 Illustration of Virgil's *Aeneid*, Book 2 (1886). (Published in Hind, *Uncollected Work* 157)

droning on pretentiously about "Dyahbolism," Beardsley responded with facetious euphoria, "Oh really? How perfectly entrancing! . . . Oh really? How perfectly sweet!"—irony that Yeats luckily missed ("Yeats" 16). On another occasion, when a perspiring Smithers was obviously worn out grinding the handle of the player piano in his Effingham House flat, Beardsley, whose musical tastes were highly sophisticated, facetiously pressed him to go on, pleading insistently, "The tone is so beautiful" and "It gives me such deep pleasure" (Yeats, *Autobiography* 220).

Beardsley's art was in significant degree a bantering extension of his distinctly theatrical approach to life—"*play . . . a kind of gesture native and irresistible to him*" (MacColl, "AB" 25). In many respects the adult Beardsley was at heart a "naughty school-boy" who took "an almost spiteful delight in snatching the mask from the face of conventionality" by "a wilful exaggeration of what offends" (Preston 430; Strong 88). He gloated to Scotson-Clark that the figures in his drawings were "quite mad" and that the ones for Lucian's *Vera Historia* in particular "are most certainly the most extraordinary things that have ever appeared in a book both in respect to technique and conception. They are also the most indecent" (*Letters* 43–44). Beardsley's interest in turning the Tannhäuser legend into a racy novel was not least because "it will simply astonish everyone" (*Letters* 72). Exhibiting a "spirit of sheer mischief," he showed no "sense of respect," even "immense contempt," for the public, desiring only "to kick that public into admiration, and then to kick it for admiring the wrong thing or not knowing why it was admiring"—an urge to scandalize that "led him into many of his most outrageous practical jokes of the pen" (Beerbohm, "Ex Cathedra" 33; Symons, "AB" 93, 94).

2-3 "*The Bullet-Proof Uniform: Tommy Atkins Thinks it Rather Fun.*" (Published in *Pall Mall Budget* [30 March 1893]: 491)

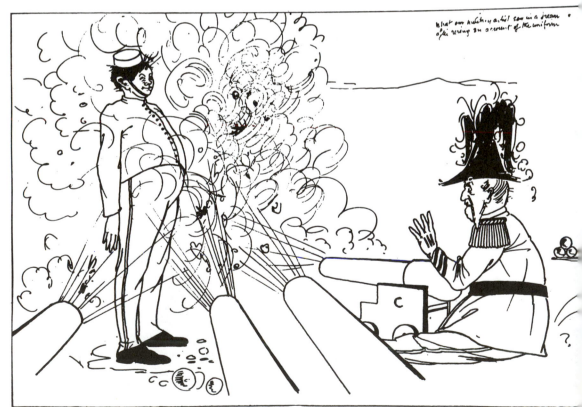

Most publishers, while they admired his wondrous talent, clearly found reason to dread the practical joker who showed "little reverence for existing institutions, or for authority" and delighted in shocking philistine mentality (J. Lane, "Notes" 1; "Publisher's Note" viii; Hind, "Memories" 3). John Lane claimed (only a little facetiously) that he had to place Beardsley's drawings "under a microscope, and look at them upside down" in order to catch details that might be too outrageous for publication ("Publisher's Note" 22).

But, more than rebellious mischief, these "practical jokes" are an integral part of the deconstructive rhetoric of Beardsley's art. Even in such blatant broadsides as *"The Bullet-Proof Uniform: Tommy Atkins Thinks it Rather Fun"* (Figure 2–3), which lampoons the military's utilitarian perspective, the incongruent irony at the heart of the picture's satire suggests that the modern world exists in a kind of logical warp between traditional sign and real value. In the 1894 poster advertising Singer sewing machines (Figure 2–4) Beardsley's joke ostentatiously jangles the conventional distinction between culture and nature. Invoking an obvious pun is a singer accompanying herself on a piano situated in an open field, suggesting among other things that the demarcations the bourgeoisie make between nature and refined culture are usually, alas, short of the mark. Beardsley even heightens the contradiction by using double lines throughout much of the drawing, providing the impression that life (or at least bourgeois culture's "suturing" of life) has actually become the equivalent of a cartoon cutout. In an amusing postscript to this singer-in-the-field theme, Beardsley seized on the hostile reception given his very similar title-page for *The Yellow Book*, vol. 1 [April 1894] (Figure 2–5), in order to extend his willful confusion of culture and nature, and to ridicule the smug bourgeois preoccupation with the "authentic." Responding mischievously in *The Pall Mall Budget* to a charge that his picture was unintelligible, a mere decadent affectation, Beardsley feigned righteous indignation and defended himself against the charge by employing still greater affectation: he fabricated a history lesson (from a fictional source, no less) about how the eighteenth-century composer Christoph Willibald von Gluck, with a champagne bottle on either side, routinely composed at a piano sitting in the middle of a field. "I tremble to think what critics would say had I introduced those bottles of champagne," speculates a straight-faced Beardsley, "And yet we do not call Gluck a *décadent*" (*Letters* 68). It was Gluck's music, we may recall, that Beardsley would later have the protagonists play in his *Savoy* poem "The Three Musicians"—with the predictable effect of "fill[ing] the tweeded tourist's soul with scorn" (l. 25).

In fact, the Victorian mania for the naturalistically "real" and rigidly "appropriate" often induced Beardsley to emphasize the intertextual nature of his satire, that it was based not merely on life but on recycled impressions of life. For example, the elegant, romanticized maidservant of the Design for front cover and title page of *The British Barbarians* (1895) by Grant Allen (Figure 2–6), who is about to serve tea (that most bourgeois of British customs), is transformed in the Design for front cover and title page and key monogram of *The Barbarous Britishers* (1896) by Henry Duff Traill (Figure 2–7) into a gruff, no-nonsense cleaning woman (a caricature of Ada Lundberg, according to Vallance [R. Ross 84]), who lugs about her cleaning implements. Her suspicious frown is reinforced by a strategically placed question mark on her apron, perhaps begging the question of just what she is to be used for, or even of what use all this service is. Knavishly, Beardsley expands the voyeuristic eyes on the trees of the first design into a full face and smug smirk in the second.

2-4 Poster advertising Singer sewing machines. (Reproduced in *The Poster* 1 [October 1898]: 132. Private Collection)

The Yellow Book

An Illustrated Quarterly

Volume I April 1894

London : Elkin Mathews
& John Lane
Boston : Copeland &
Day

2-5 Title page for *The Yellow Book*, vol. 1 (April 1894).

2-6 Design for front cover and title page of *The British Barbarians* (1895) by Grant Allen. (Drawing no. 38, Albert Eugene Gallatin Collection, Princeton University Library, Princeton, N.J.)

2-7 Design for front cover and title page and key monogram of *The Barbarous Britishers* (1896) by Henry Duff Traill. (Drawing no. 52, Albert Eugene Gallatin Collection, Princeton University Library, Princeton, N.J.)

Pour Épater les Bourgeois

Part of the purpose for Beardsley's *provocateur* rhetoric was to gain quick recognition (Williamson 279), "to fill his few working years with the immediate echo of a great notoriety" (Beerbohm, "Ex Cathedra" 33), in short, to distinguish himself as rapidly as possible—especially given his precarious health—as a prominent force (preferably, a revolutionary force) in the artistic world. As J. E. Chamberlin has explained, even the chic revolutionaries of the Decadence understood that if they wanted to be taken seriously, they needed to convey "a sense of brotherly blasphemy" in the truths they espoused, "to give offense, to turn the screw, as it were, and be not only foolish but outrageous, and not only outrageous but perverse" ("Decadence" 592-93).

Needless to say, offense is given as often by subject matter as by rhetoric, and the subject matter most likely to strike bourgeois Victorians as outrageous and perverse, as Beardsley well knew, was that which played on the culture's sexual fears. Beginning with his earliest published pictures, which appeared in the inaugural issue of *The Studio* in April 1893, Beardsley exploited the scandalizing potential of sexual content. In fact, his original cover design for the magazine was expurgated for being too phallic (Gordon, "Dilemmas" 176). The more shocking designs that appeared within, what the artist called "my weird pictures" (*Letters* 38), were denounced by the press as "flat blasphemies against art" (*London Figaro*, 20 April 1893: 13), most particularly the spectacular *J'ai Baisé Ta Bouche Iokanaan* (I Have Kissed Your Mouth, Jokanaan) (Figure 2–8). From the time Wilde first published his *Salomé* in Paris in 1893, Beardsley had been fascinated with the play and especially the climactic severed-head scene (which the original *Salomé* manuscripts suggest was also the inspiration for the play itself and the first scene Wilde wrote [Fletcher, AB 60]). *The Pall Mall Budget* had originally solicited Beardsley's Iokanaan drawing, but its editor "nearly had a fit" when he saw the final product, refusing it with the claim that the journal "would lose its circulation if the picture was published" (Smith 16). It was not a surprising response, since the drawing introduced Beardsley's new "japonesque" style, and, according to Kenneth Clark, "aroused more horror and indignation than any graphic work hitherto produced in England" (70). Subsequently C. Lewis Hind, the initial editor of *The Studio*, whom Aymer Vallance had introduced to Beardsley in Alice Meynell's drawing room, persuaded his publisher, Charles Holme, that Beardsley was precisely what was needed for a "sensational send-off" issue (Gordon, "Dilemmas" 176). Then, hoping to provide necessary balancing respectability, Hind commissioned the highly regarded Joseph Pennell to do a restrained introduction: "A New Illustrator: Aubrey Beardsley."

But Pennell's laudatory article could not mitigate the scandalous impact of this "transported," sensuous-lipped femme fatale suspended in midair amid a maze of hairline filaments and peering obsessively at the decapitated head of her martyred male victim. Aside from the disturbing psychological and sociological resonances that viewers clearly found in its content are stylistic disjunctions: Beardsley's picture creates a profoundly disorienting world (revisited in the *Salome* illustrations) of "groundless earth," "floating figures," and "reckless lack of perspective" (MacFall, AB 50), a world whose elements have no objective reality. The eerie effect of this classic "castration" scene is conveyed all the more powerfully by the drawing's cunning

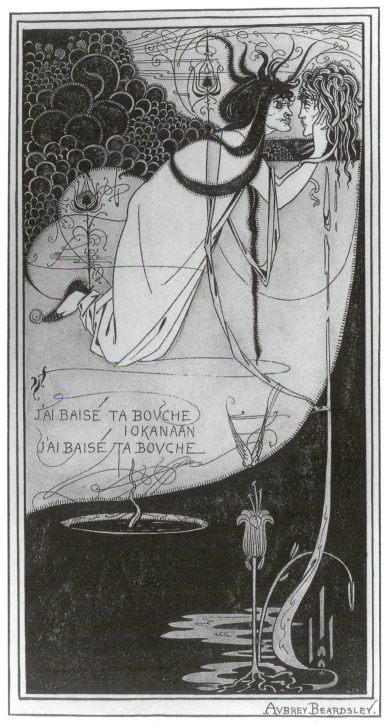

J'AI BAISÉ TA BOVCHE
IOKANAAN
J'AI BAISÉ TA BOVCHE

AVBREY BEARDSLEY.

2-8 *J'ai Baisé Ta Bouche Iokanaan*. (Drawing no. 97, Albert Eugene Gallatin Collection, Princeton University Library, Princeton, N.J.)

design: the placement of the two key figures at the top of the frame maximizes the long line of blood that, equivocally, either unnaturally defies gravity, like Salome, to rise hostilely upward, reinforced by the oppressive upward curve of the black ground, or, flows in macabre fashion from the severed head into a pool feeding lilies at the bottom of the picture. Similarly equivocal, the lilies could either symbolize Iokanaan's fatal chastity ("Ton corps est blanc comme le lis d'un pré que le faucheur n'a jamais fauché" [Thy body is white like the lilies (*sic*) of a field that the mower hath never mowed], *Salomé* 27; *Salome* 403)[4] or allude perversely to the corrupted purity of Adonis, the lover of Venus, from whose blood sprang an anemone (Kuryluk 237).

The nineties was a particularly fortuitous time for an opportunist with Beardsley's "decadent" interests—particularly his obsession with sexuality—not only because few subjects were more fascinating to Victorians than sexuality (especially in light of the continuing "Woman Question") but also because the massive expansion of print journalism (and its interest in prurient crime) soon helped make Victorians' sexual concerns almost inseparable from their fears of degeneracy. In fact, in matters of sexuality, as Sander Gilman has explained, the pathological—routinely documented in the press by the most sensational examples of deviance—intrigued Victorians considerably more than the normal, which was generally defined simply as whatever was not "degenerate" ("Sexology" 191, 214).

Probably the most influential fin-de-siècle study of sexuality—following on such tomes as Heinrich Kaan's *Sexual Pathology* (1844), Jakob Santlus's *Psychology of Human Drives* (1864), Eduard Reich's *On Immorality* (1866) and *Degeneracy of Man: Its Sources and Prevention* (1868), and J. J. Bachofen's study of sexual degeneracy as a political force in *Mother Law* (1870)—was Richard von Krafft-Ebing's 1888 *Psychopathia Sexualis* (Gilman, "Sexology" 191). Tracking the logic of his predecessors, Krafft-Ebing conceived human history in highly moralistic terms, its stages of social development reflecting stages of sexual development. From the shameless swamp of universal promiscuity humans presumably progressed to the "logical" (and necessarily male-directed) world of human law, made possible when Christianity enabled moral principles to govern human sexual activity (Krafft-Ebing 25–26). But where there is growth, there can also be decay. Thus degenerate sexuality was considered an omnipresent danger in advanced cultures, ever threatening to turn normality into perversity (Krafft-Ebing 27–28; Gilman, "Sexology" 198). In response, and to assuage middle-class fears of sinking into such degeneracy, Victorian science classified sexual deviants as a special, "absolutely self-contained . . . group solely at risk," thus safely sequestering such deviants as constitutionally Other (215).

One of the things Beardsley's iconoclastic art insistently did was to challenge these mythic boundary lines, to refuse to sequester the Other as a safely separate social and sexual category. His ubiquitous visual practical jokes exposed the "degenerate" everywhere, thrusting into public view what had hitherto been relegated to the back shelf of diseased pornography. In the process his scandalous drawings constantly reminded viewers that the line separating them from the Other may be dangerously thin and that, as Freud would confirm, they might in fact already *be* the Other they prayed to avoid.

Close on the heels of Beardsley's *Studio* shocker appeared another exposition of foreign perversity, *Of a Neophyte and how the Black Art was revealed unto him by the Fiend Asomuel*

(Figure 2–9), which ran in *The Pall Mall Magazine* in June 1893. Here a "neophyte" of provocatively indeterminate gender is encompassed by a plethora of icons the Victorian middle class associated with diseased satanic evil: a fecund hothouse flower; a glaring, bare-breasted femme fatale whose areolas bear hexagrams, symbols the satanic tradition adopted from the Cabala; molten candles and candlesticks bearing demonic, horned grotesques (the left one having a phallus rising from an evil eye); the detached, intruding head of the fiend itself; alchemical flames; curling smoke; cancerous growths; horns; scales; sickles; and other bizarre arabesque shapes. The drawing stands in arresting contrast to the rather tedious article about alchemy it illustrated, "'The Black Art,' Part 2," by James Mew. In alchemical tradition the furnace whose flames unite sulphur, salt, and quicksilver "symbolizes the fusion of the male and female principles resulting in the birth of the philosopher's stone" (Heyd 159–60). So it is with impish logic that in front of the spot where the furnace would be Beardsley places the androgynous neophyte figure, whose black turban, ensnared black-on-white robe, and trance of malignant horror all suggest that ironically he/she may have been corrupted even before the fiend's "revelations." Vallance suggested that, ever on the alert for an opportunity to goad authority, Beardsley concocted the fiend's name Asomuel, meaning insomnia (from the Greek *alpha*, the Latin *somnus*, and the Hebrew *el*), as a facetious comment on Mew's wearisome article (R. Ross 81; Reade, *AB* n. 262).[5] While that was probably true (and Vallance may have been quoting Beardsley directly), Heyd points out that Beardsley typically proceeded to carry the waggish wordplay to even greater lengths, conflating through both sound and satanic images one of the subjects of Mew's text, Elias Ashmole—the collector of rare books on alchemy after whom Oxford's Ashmolean Museum was named—with Samuel, the king of the Ashmodai devils (159).

Even beyond his penchant for playing on Freudian castration themes, Beardsley "enjoyed frightening people" with his presumably "intuitive knowledge of evil and secret things" (Birnbaum, *Jacovleff* 131). Having subjected themselves to countless tales of fantastic, aberrant, transgressive sexuality dissolving the rule of law, Victorians found in the Orient and the Middle East virtual "free play for shamelessly paranoid constructions, dreamlike elaborations of western traumas" (Wollen 17). The myth of oriental despotism, historically connected to the Salome legend, had for some time served as a repository for Western European fears of the chaotic and sexually ruinous Other—deriving from such influences as Montesquieu (who feared that the glory of Louis XIV would fall prey to Middle Eastern "degeneracy"), Byron, Delacroix, Flaubert, Gérôme, Whistler, and the nineteenth-century imperialist conflicts in the Crimea, Africa, and India (15). Not surprisingly in one who found Moreau's exotic fantasies "perfectly ravishing" (*Letters* 218), Beardsley capitalized on such fears by investing his images of evil and "sexual anarchy" with a distinctly Eastern flavor. His most notorious drawings in this vein were the ones he did for Wilde's *Salome*, which conceived of the play "as a Japanese fantasy, as a bright Cockney would conceive Japan" and included "more 'erotic' details than had ever been seen before in a book openly published and distributed in England" (MacFall, *AB* 49; Weintraub, *AB* 69). It was mainly on the basis of these illustrations that Roger Fry dubbed Beardsley the "Fra Angelico of Satanism" (236), and that MacFall judged him to have "run riot" in an eroticism that "became the dominant emotion and significance in life for him,"

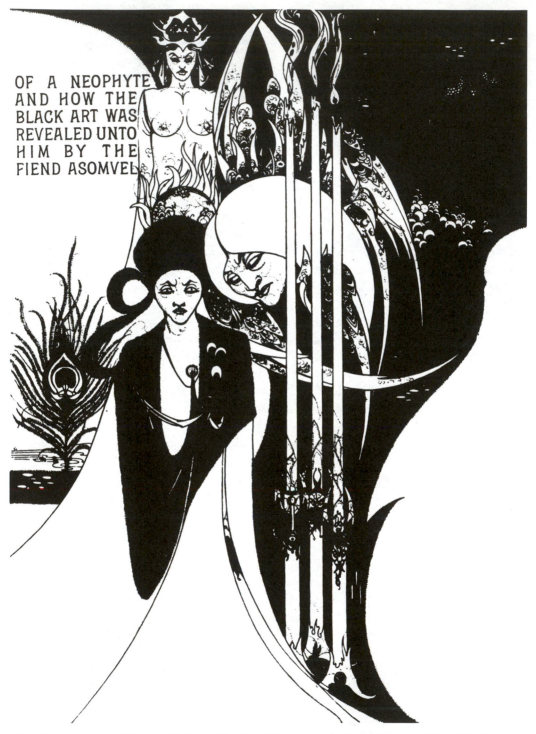

OF A NEOPHYTE
AND HOW THE
BLACK ART WAS
REVEALED UNTO
HIM BY THE
FIEND ASOMVEL

2-9 *Of a Neophyte and How the Black Art Was Revealed unto Him by the Fiend Asomuel.* (Published facing page 174 of *Pall Mall Magazine* 1 [June 1893]. Private Collection)

binding him to "those leering features and libidinous ecstacies that became so dominating a part of his Muse" (*AB* 19, 39, 48).[6]

The end result was that Beardsley's success was certainly a *succès de scandale*. The public press ascribed his drawings to "libidinous . . . and asexual schools" (the contradiction notwithstanding), their attraction being "the charm of degeneration and decay" in things that "do not belong to the sane in body or mind" (*Public Opinion*, 24 November 1893: 660). *The Times* (8 March 1894: 12) found Beardsley's *Salome* drawings to be "fantastic, grotesque, unintelligible for the most part, and so far as they are intelligible, repulsive . . . in the style of the Japanese grotesque as conceived by a French *décadent*." His work in *The Yellow Book* was judged to be "meaningless and unhealthy" (*Academy*, 28 April 1894: 349), "a combination of English rowdyism with French lubricity" that "intended to attract by its very repulsiveness and insolence" (*Times*, 20 April 1894: 3). It was "vulgar in idea and offensive" (*Daily Chronicle*, 12 July 1894: 3), "thoroughly morbid" (*Academy*, 28 July 1894: 67), and "freakish" (*Saturday Review*, 27 October 1894: 469). *The National Observer* (21 April 1894: 588–89) could only express its "amazement at the audacious vulgarity and the laborious inelegance." The reaction was much the same, regardless of Beardsley's style. His later *Rape of the Lock* illustrations were found to be similarly "limited and diseased" (*Saturday Review*, 17 April 1897: 426), revealing once again that "beneath all their elegance and refinement there lurks that same expression of vice" (Strong, *Westminster Review* 154: 92). *The Westminster Gazette* (18 April 1894: 3) appeared to sum up the general consensus when it claimed, "Mr. Aubrey Beardsley achieves excesses hitherto undreamt of. . . . [W]e do not know that anything would meet the case except a short Act of Parliament to make this kind of thing illegal." As one might suspect, Beardsley "enjoyed the excitement immensely," crowing to Robert Ross of his "amusing notices" and proudly noting in an official biographical sketch that his *Salome* drawings had "produced a very strong and disagreeable impression upon the critics" (*Letters* 58, 76). "I suffer my critics gladly," he once told *The Sketch* (10 April 1895: 561) . . . "Their inconsistences and futile hypocrisies fill me with amusement." Beerbohm claimed that, far from being perturbed "by the contempt with which his technique was treated" by angry critics, Beardsley generally "revelled in his unfavorable press-cuttings," especially the most extreme "thunderbolts," and even penned witty replies ("AB" 544).

One of the most riveting drawings, which shows both the confrontational blatancy and guileful subtlety in Beardsley's salacious instincts, is the original (and subsequently censored) version of the infamous title page for *Salome* (Figure 2–10). The ostensible focus of controversy was the terminal god's conspicuous genitalia, which were omitted in the published version. Even Beardsley acknowledged that booksellers could not put the "impossible" drawing in their shop windows (*Letters* 52). The scandalizing qualities of the picture go far beyond these graphic details, however. To start with, Beardsley perverts the customarily elegant Renaissance title-page design (revived by the Century Guild circle of Selwyn Image and Herbert Horne; Fletcher, *AB* 75) by joining it to a highly disorienting, even sacrilegious, composition. As Karl Beckson notes, Beardsley's scene of bacchanalian worship, its pattern of repeated triads suggesting the "crucifixion tableau" of a god fixed between sacred candles, becomes "a grotesque parody of the traditional icon of Christ's passion. Instead of a grieving figure at the foot of the

cross, a leering winged figure of indeterminate sex is at prayer at the foot of the priapus" ("Artist" 214).[7] Although the adoring acolyte at the bottom of the picture holds his out-stretched hands in an attitude of Christian worship, he actually seems to be inviting (or daring) us to share in some secret and depraved satyric rite. Heyd points out that the type for Beards-ley's terminal god—armless torso, smiling face, gaping toothless mouth, horns, a body seem-ingly crucified against foliage—is virtually identical to the one used in a painting Beardsley certainly knew, Poussin's *Bacchanalia before Pan's Statue* (c. 1650), except for one very signif-icant difference: Beardsley turns the classical and generally sympathetic Pan into a satanic hermaphrodite, thereby mocking adoration itself (160–61).

Beardsley frequently depicted Pan as hermaphroditic or coupled him with hermaphrodites (see Heyd 150–55). In fact, in an age that revered classical culture, the ways in which Beardsley played on the rich classical tradition of phallic worship—and particularly how he joined it problematically with androgyne/hermaphrodite figures—may have been subconsciously as dis-concerting to Victorian sensibilities as the more obvious "sacrilege" in his pictures. The an-drogyne—from the Greek *andro*, meaning male, and *gyne*, meaning female—had generally been employed, particularly in the early and middle part of the nineteenth century, as a benefic metaphor for ideal sexual union and for the reunion of the soul with God, a return of hu-mankind from "evil" division to its former androgynous, prelapsarian immortality (as in Ar-istophanes' myth in Plato's *Symposium*). The figure drew not only on the Gnostic tradition that considered Christ an androgyne, the marrying of Logos and Christianity, but also on the Madonna myth's sanctification of women and on the general perception of the female form as purer, more ethereal, and less animalistic by virtue of its relatively more delicate structure (Busst 67, 64; Bataille, *Death* 138–39; see also Collins 91–99). Indeed, artists like Joséphin Péladan in France and Edward Burne-Jones in England employed the androgyne as "less a being in whom the sexes are combined than a creature without any sexuality at all" (Pierrot 131–32).

But especially as the century waned, the androgyne gave way increasingly to the her-maphrodite, a sterile self-enclosed monster that became a symbol not of communion, perfec-tion, and virtue but of selfishness, corruption, and sin (Busst, 10–11, 38–39). Hermaphroditus was, after all, the son of Aphrodite, the ruthless goddess of love, and Hermes, the cunning, deceitful, and slyly erotic patron of thieves, who scattered his phallic herms/terms throughout the countryside. Furthermore, Salmacis's prayer to merge with Hermaphroditus was a gesture both destructive and self-destructive: the sterile unity she gained was at the cost of Hermaph-roditus' virility and her own individual identity (Collins 194).[8] The Decadents' mingling of phallic worship (originally a tribute to the "natural" generative power of the garden god Priapus) with the androgyne/hermaphrodite icon became increasingly a sign of sexual inversion rather than procreative power. In its unrealizable quest for complete unity, the hermaphrodite was, in effect, a cruel parodic critique of the "ideal" androgyne. Far from evincing romanticized resolution, the anatomically explicit hermaphrodite emphasized starkly graphic self-contradic-tion. Sexually self-enclosed as both male and female, the hermaphrodite became the conven-tional icon of "pure" eroticism associated with those less than pure late-nineteenth-century lovers who presumably could achieve no sexual satisfaction in reality (only in lecherous fan-

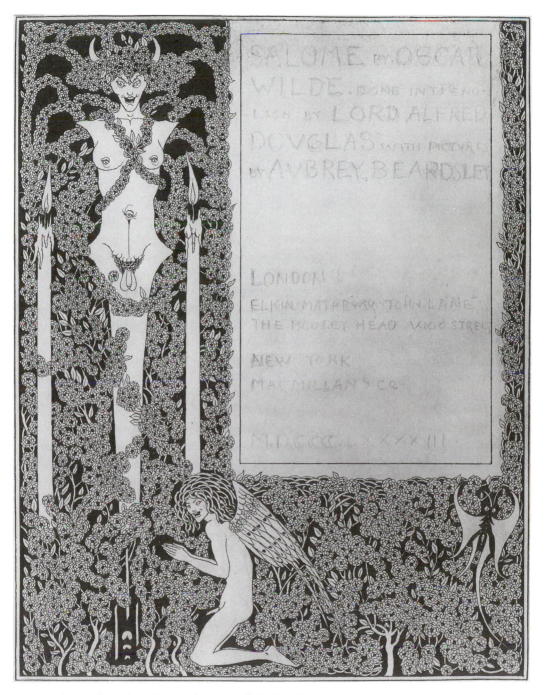

2-10 Title page for *Salome*. (1943.653, Grenville L. Winthrop Bequest, Courtesy of The Fogg Art Museum, Harvard University Art Museums, Cambridge, Mass.)

tasies) and whose desires only increased for not being physically fulfilled (Busst 42, 44). In the process the hermaphrodite's graphic sexuality exposed the blatantly carnal foundation of the age's "spiritual" myths.

In Beardsley's art the hermaphrodite, certainly one of his favorite figures, became this emblem of solipsistic, unfulfilled desire—particularly homosexuality, onanism, and that *vice suprême* cerebral lechery, all of which characterized to Victorians decadent disillusionment and withdrawal from practical life. In the heading for chapter 26, book 9 (page 226) in *Le Morte Darthur* (Figure 2–11),[9] for example, Beardsley shows a hermaphroditic youth (with male genitalia and female breasts) gazing with intense severity into the black center of the rose-gem mirror it holds, suggesting the solipsistic nature of the figure's adoration. Its hair is drawn to connote the furrowed folds of an enlarged brain, reinforcing the connection with cerebral lechery. Appropriately, Beardsley depicts the figure as entangled in the sharp, sexual

2-11 Heading for chapter 26, book 9 (page 226) in *Le Morte Darthur*.

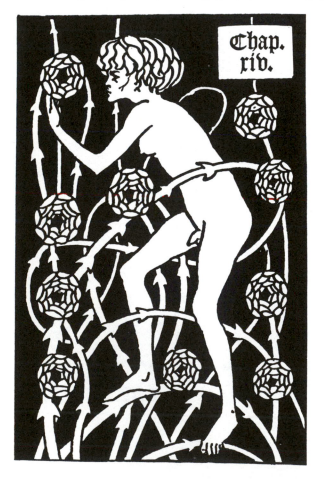

overfecundity of the clematis bower, as if its perverse inversion is a kind of bestial reversion, its nature dictating that it be mired among the baser forms of life.

Beardsley often presents his hermaphrodites as a combination of beauty and beast, of aesthetic refinement and bestial nature—in short, a joining of the male with not merely the female but the animal: satyr, snake, monster. In his title page for *Salome* (Figure 2–10) Beardsley gives the attending acolyte insectlike wings and snakelike Medusan hair; and the term-mounted god has horns and cat's eyes. The term's savage characteristics are reinforced by the grotesque melted-wax shapes on the candles that flank it, the Dionysian transformation of foliage into hair, and the fact that Beardsley mirrors the terminal god's snarling, ravenous mouth in its pubis, whose elements taken together approximate the gaping maw and panting tongue of an animal. Clearly this animal-god has fewer benefic qualities and more sinister attributes than the frolicking classical Pan. Furthermore, in this transmogrification Beardsley also invokes the fin-de-siècle belief that a "contamination" of the male by female traits produces something monstrous, leading, virtually by definition, to wanton lasciviousness and animalistic sexuality. Needless to say, this conventionally misogynistic moral polarity provides no real comfort in the drawing but only intensifies the developing paradoxes.

As it happens, it is precisely the hermaphroditic, indeterminate quality of Beardsley's figures—and the clouding of related distinctions which disseminates from them—that ultimately makes the drawing so unrelentingly disturbing. Part of the very foundation of the paternalistic, ruling Victorian culture consisted of an acceptance of traditional gender characteristics (both anatomical and behavioral), which differentiated male from female absolutely. Such presumably inviolate categorizations—installed through such myths as "the Angel in the House" and the identification of "manly" with sports and commerce—were also part of what was under attack by various reform movements associated with the "Woman Question" and, not incidentally, by Decadent aestheticism. Certainly the confusing figures of Beardsley's title page for *Salome* only throw into question such comfortable polarities. The sexuality that appears to be blatant and unequivocal turns out to be highly problematical. The term (or herm), which dominates the upper left of the picture, possesses the aforementioned, controversially graphic male genitalia, whose phallic quality is enhanced by the unmarked pillar that descends below them and by the long grotesque candles that flank them. Yet the term is also given a slender frame, large female breasts, and an unusually long, highly suggestive slit running from its pubis to its navel-eye, which is drawn to include an equally suggestive orifice—all of which make the god's gender ultimately undecidable.[10] The same is true for the attending acolyte, whose girlish body and thick Medusan hair seem to contradict the gender suggested by its semierect penis. The phallic imagery in the picture is not undercut by the female coding; rather, the two genders simply coexist, their implications oscillating without closure, within the same figures.

In Beardsley's pictures the androgyne/hermaphrodite figure, originally a mythic expression of the longing for a harmonized world free from jarring dualities, often becomes a figure that only accentuates the vexing conundrum of gender similarities and differences. We are made to confront the splicing of what we thought were polarities—male/female, nature/culture, complete/incomplete, love/death, sacred/profane, ethereal/animal. The genders do not blend

into a Burne-Jonesian asexuality, which allows the voyeuristic viewer to see in the figure whatever gender he/she desires (or no sex at all)—and thus also to mask the bestiality of sexual desire. On the contrary, each gender is grotesquely accentuated, set off in sharp paradoxical conflict within one body, thus emphasizing bestiality as well as confusing taxonomic distinctions and making impossible the repression of either gender, even exposing the fact that the viewer may be attracted to both. The inherent contradictions, far from blending or being dissipated, rupture in an intense, if highly stylized, violence.

For that matter, the ambiguities Beardsley encodes into his sexually conspicuous figures also throw into question the presumably unequivocal moral principles Victorians prized and linked so closely with sexuality. For example, it was a law of the Victorian moral universe that elements of satanic lust should call forth shame and result in "emasculating" suffering. Yet Beardsley's drawing conveys iconoclastic joy and even suggests the possibility that lust could bring unadulterated fulfillment. The acolyte's erect penis seems to imply that, whatever else may be involved, the secret rites he invites the viewer to share have not emasculated him or even made him guilty. Indeed, to most viewers the elegant formal details of the picture, such as the garlands of roses that blend so organically in forming the god's hair, are far too stylized and symmetrical to convey disorder or impending disaster. Significantly, however, neither does the drawing definitively authenticate such loves as the gods may be inviting. The term's phallic pillar and flanking candles appear, upon inspection, to float mysteriously on the page, not clearly grounded. The acolyte's penis, while erect, is only partially erect (so, in fact, we cannot really tell whether he is in the process of attaining, or rather losing, his erection). Whatever the case, compared with most of Beardsley's oversized phalluses, the supplicant's member is made to appear a rather puny validation of lust. The traditionally sterile and self-contradictory hermaphroditic form is itself a daunting image, hardly promising consummation of desire. Nor can it be comforting for the viewer to discover peering, sensuously lidded eyes where the terminal god's areolas and navel should be. It is as if those eyes are mirroring back the leering gaze of the voyeur, suggesting that eroticism may be but the narcissistic onanism of an entire world of self-anointed (and self-implicating) animal-gods.

In this regard Beardsley's playful indeterminacy even goes to the point of self-consciously implicating himself. In contrast to its customary position at the lower right of his drawings, the emblematic japonesque-mark signature is moved in this picture to a place in the rose-briars in front of the praying angel, in a direct line with the angel's penis as well as with the terminal god's hanging genitals and descending phallic pillar. On the one hand, such a unique positioning may have the effect of symbolically affirming Beardsley's sexual potency, not to mention his sexual identity, both of which were frequently impugned. On the other hand, occupying such a position could be perilous in several different respects, almost all of which would have the effect of throwing into question his sexual potency and identity.

The real and subversive decadence of such Beardsley pictures as the title page is not merely that they manifest "strange sins"—and so, in the process, actually reaffirm bourgeois moral distinctions—but, more dangerous, that they work to suspend and defer ceaselessly both traditional hermeneutic categories and metaphysical closure, confusing and disorienting the very bases by which Victorian society made such distinctions.

His desire to scandalize notwithstanding, Beardsley also crafted less flagrant affronts, especially if in so doing he could succeed in one-upping the censor, even slyly substituting for a censored picture an "acceptable" drawing that, while passably less lewd, was in some other respect just as objectionable. This delight in surreptitious revenge may explain why he paradoxically claimed that the picture he sought to substitute for the rejected title page, the less overtly indecent border for the List of Pictures for *Salome* (Figure 2–12), was "to my mind a great improvement on the first" (*Letters* 52).[11] His reconstituted title page retains the same metaphoric rose patterns but replaces the ostentatiously naked term and acolyte with a fully clothed Salome and a less lurid "little grotesque Eros" (52). However, just as the ostensibly unequivocal figures of the title page turn out to be highly ambiguous, so the apparently more subtle and elegant design of the List of Pictures turns out to be almost equally perverse and scandalous. By substituting for the hermaphrodite god (flanked by two candles) a woman (with one candle), Beardsley seems to have addressed a key problematical element, in effect splitting the hermaphrodite in half. But, of course, Salome is shown to be no ordinary woman but a dangerous seductive siren, made even more massive than the terminal god she supplants and in one sense more immediately threatening, since she looms rather phallically (arms hidden) in clinging modern dress. Indeed, in seemingly simplifying the god's sexual identity, Beardsley actually only intensifies the anxiety, invoking the fin-de-siècle fear of the phallic (i.e., male-robbing) femme fatale and underscoring the misogynistic identification of her with animalistic sexuality. Here the dominating Salome snarls and casts an over-the-shoulder leer, posing lasciviously (torso self-consciously cocked, adjacent to a monstrous butterfly) alongside, once again, the grotesque molten wax on the phallic candle. Moreover, the encompassing foliage, which still forms the deity's hair, has now expanded chaotically and even mutated to form the hothouse shapes on her gown. This aura of autonomous animalistic lasciviousness is in no way lessened by the downward and inward angle to Salome's (hidden-from-view) arms, a position Beardsley repeatedly employed in other pictures to suggest masturbation (Zatlin, AB 113–14).

The kneeling "angel," too, has for the most part lost its male components and has had accentuated, even made monstrous and perverse, its female and animal components: while it has the same insect wings, it has acquired the horns and lower body of a satyr, whose traditionally male gender coding is here overridden by a feminine upper body, sagging female breasts, and a mask that presumably connotes feminine deceit. The angel-satyr's link with the female Salome is all the more emphasized by the fact that its hair comprises the same hothouse roses woven into Salome's tresses, and its left hand points her out to the viewer with the sign of the evil eye. Finally, as in the title page, Beardsley includes an amusing personal note, which in this case serves as a response to his earlier one. In mocking acknowledgment of having been chastened (forced to redo the title page), Beardsley shifts his japonesque signature from its previously prominent and licentious position in the former work, now hiding it at the far right in the List of Pictures, such that its shafts and inverted hearts are virtually invisible as part of the briars and leaves of the border. On the other hand, whereas in the title page Beardsley had relegated the butterfly trademark of Whistler—his former idol and now a troublesome antagonist—to the far right of the drawing, ignored behind the supplicant angel's back, here,

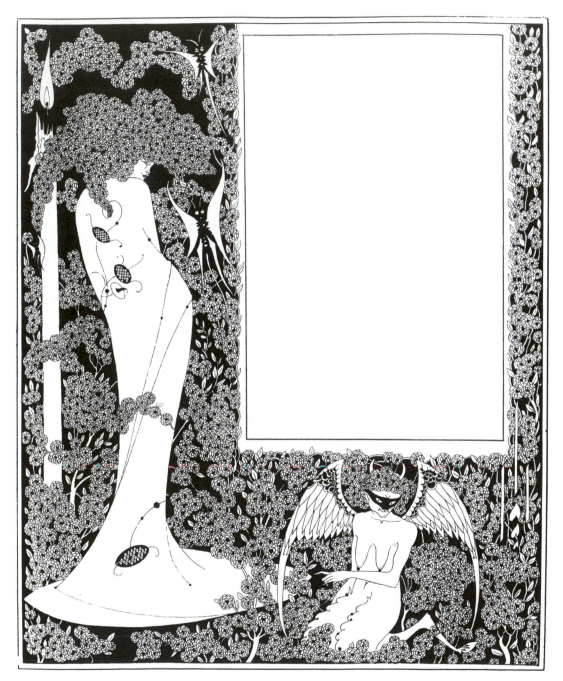

2-12 Border for the List of Pictures for *Salome*. (1943.640, Grenville L. Winthrop Bequest, Courtesy of The Fogg Art Museum, Harvard University Art Museums, Cambridge, Mass.)

in feigned deference to his more mature betters, he multiplies Whistler's "signature" into three butterflies and gives them the dubious distinction of occupying key positions around Salome's head, the largest butterfly being fixed, rather uncomfortably, directly under the stare of the scornful femme fatale.

The dangerously insolent nature of Beardsleyan "degeneracy" is again evident, if a little more subtly, in the expurgated *Toilet of Salome* (first version) (Figure 2–13), which contains a surfeit of cunningly disguised sexual "perversions." Jutting from Salome's Godwinian cosmetics stand, which holds such "decadent" books as Baudelaire's *Fleurs du Mal* and Zola's *La Terre*, is an ominously bladelike shelf, on which sits a grotesque enshrouded fetus. The phallic (or phallus-castrating) shelf, the fetus, the bow of the double bass at the left, and the seated youth's legs all point toward the genitals of the hermaphroditic youth (with male genitals but feminine hair, rounded abdomen, and budding breasts) stationed at the far right, whose teapot is in turn pointing phallically at Salome. It may be that this naked attendant is singularly "pointed out," because he/she appears the only figure who is *not* engaged in masturbation. Salome herself, proportionally larger than her attendants and ostentatiously nude except for her loosely draped dressing gown, seems rapt in an erotic dream, her left hand curling between her thighs in onanistic manipulation. The supposition that she is immersed in sexual reverie gains support from the attending Pierrot, the fingers of whose left hand mimic a masturbatory position while the index finger of his right hand penetrates Salome's hair in imitation of a penis. The clothed androgynous (female?) youth at the far left is ostensibly playing a double bass, but her closed eyes, stiffened right leg, suggestively configured left hand (the double bass, after all, was for Freud a symbolic image of masturbation [Beckson, "Artist" 215]), strategically positioned right hand, and the inverted-heart shape on the bass all imply that she is fiddling in a more private manner. The inverted heart (a common Beardsley emblem for perverted love) rests directly above the lap of the naked youth seated at the lower left of the picture, and for good reason, we discover. Not only does he gaze, perhaps longingly, at the naked attendant opposite but his pubic hair, stiff arms, hidden hands, and barely visible penis extending between his wrists all convey masturbation; moreover, he possesses the buckling spine traditionally associated in the Victorian mind with what results from seminal fluids being wasted in autoeroticism (Webb 183–84; Fletcher, *AB* 76). Mischievously Beardsley sets the masturbating youth on a Moorish ottoman replete with phallic details, including—ambivalently—a phallus with jaws about to devour another inverted heart.

Ḥide-and-Seek Sexual Iconography

Beardsley's delight in shocking the sensibilities of the bourgeoisie was even greater when he felt he was surreptitiously "putting one over" on them. It was not an accident that he routinely encoded female-breast shapes into the trunks and limbs of trees (e.g., Figures 2–6 and 2–7; Reade, *AB* 67, 120, 140). He titled his pornographic romance of 1896 *Under the Hill*, which was very likely not only a salacious pun on *mons veneris* (the genital "hill" of Venus) and a sly in-joke reference to the homosexual More Adey's family home, Under-the-Hill, but also a

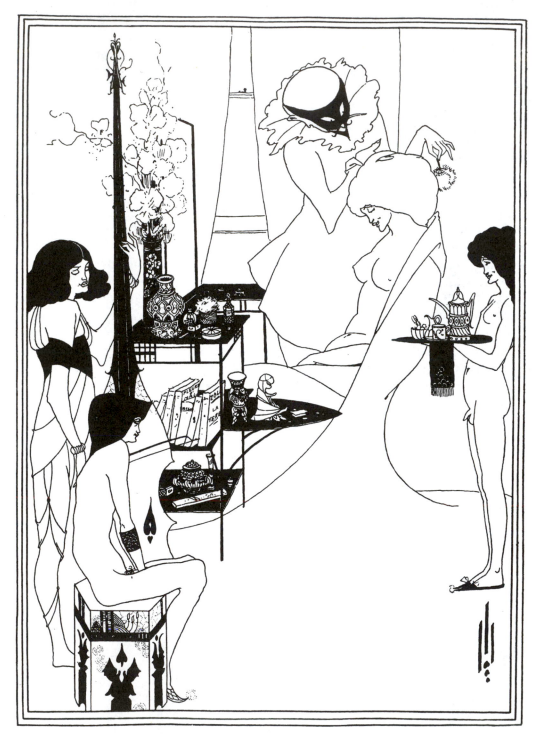

2-13 *The Toilet of Salome* (first version) for *Salome*. (Private Collection)

clandestine play on the title of a favorite (but hardly risqué) late Victorian children's book, Kate Greenaway's *Under the Window* (Wilde, *Letters* n. 533; Weintraub, *AB* n. 6). Such leg-erdemain is manifest in *La Beale Isoud at Joyous Gard* from chapter 52, book 10 (following page 300) in *Le Morte Darthur* (Figure 2–14). Beardsley frames the picture with a border of pears, which turn out to form a metonymic visual pun. Each pear is marked with strategically placed indentations, protuberances, and dots intimating grotesquely misaligned breasts on a conventionally pear-shaped female body, the forms being augmented by double-lined contours and a distinctive cleft at the base, all of which suggest dilated genitals.[12] Beardsley even in-tensifies the joke by drawing the "breasts" so that they may serve equivocally as voyeuristic eyes (that is, as both the gazing eye and an object of the gaze). In whatever incarnation, these oversexed women-pears (in at least one case, the body possesses an additional "breast") blur the traditionally separate categories of human and plant, just as the foreground foliage blurs the categories of natural and artificial; as John Rothenstein noted, "several of the branches of the small trees in the foreground do not belong to them, but have been tied on with string" (*Pot* 174). Beardsley even designs the white band in the background ambiguously, making unclear whether it represents a natural lake (or river) or a man-made garden wall.

The irony cuts a good deal deeper. In the "primary" inner scene (which the sexualized border tends to re-place as "secondary") the notoriously vexed and star-crossed lover (Isoud) is ironically depicted as placid and joyous. This thematic dissonance is subtly amplified by the physical misalignment of the pear-breasts, a skewing traditionally attributed to witches, who, like Isoud, know the magical arts. But, of course, the sexually charged border also reinforces the eroticism of the voluptuous Isoud, whose sexuality is accentuated by her own full breasts, hooded eyes, sensuous full lips, dangling bracelet tassel, symbolic "peacock" cloak riddled with holes (or "pea-cock eyes," as Beardsley punningly called them), and by the position of her hand, which seems about to grab one of the unusually long-trunked phallic trees flanking her. That is, while she seems to be demure in a "natural" setting, Isoud is in fact highly concupiscent within an "artificial" one.[13]

Beardsley elevated the status of the subtly hidden, the playfully masked, by routinely describing the evasive and mysterious as "glorious," an identification that is, for all his icon-oclasm, ironically conservative and traditionally metaphysical in its allegiance to the age-old notion of art as a revelation, an uncovering of hidden mimetic truths. Beardsley's concealed visual (and verbal) jokes do assume a privileged truth: the perceptive elite share in the joke, while philistine outsiders miss it, or mock themselves by being able to see only the most obvious aspects of it. In this respect, Decadent elitism, which held that brilliance should not be wholly accessible to the vulgar masses, converged nicely with bourgeois prudery, which demanded that the salacious elements of life be kept out of sight or disguised as respectable.

In fact, Beardsley delighted in employing supposedly ancillary or marginal details to skewer philistines' sexual phobias (and hypocrisy) and to confirm simultaneously his victims' denseness—that is, their inability to see even the degree to which they were being lampooned. He is devilishly misdirecting, for example, in the design for the heading of chapter 21, book 1 (page 21) in *Le Morte Darthur* (Figure 2–15). The central focus of the drawing is a griffin set against a background of familiarly ambiguous Beardsleyan sexual emblems, such as the

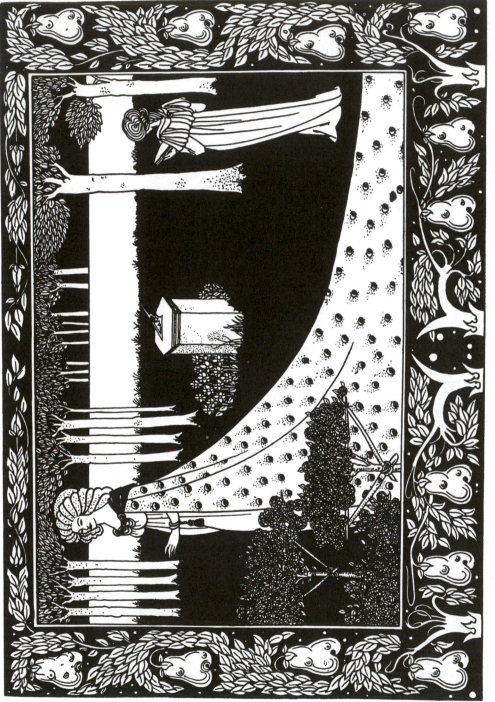

2-14 *La Beale Isoud at Joyous Gard* from chapter 52, book 10 (following page 300) in *Le Morte Darthur*. (Private Collection)

2-15 Design for the heading of chapter 21, book 1 (page 21) in *Le Morte Darthur*. (Private Collection)

egglike follicles in the lower right quadrant, the twisted vines or ropes (or snakes) in the upper left, and the similarly twisted tail at the lower left. The griffin is looking ferociously across its back, diverting our line of vision from the amusing female figure at the bottom right, who seems to be a winged angel, angry and frustrated at being ostensibly trapped by the griffin's hooves and the pile of "eggs." But on further examination we see that the "angel" is herself a highly sexual being (her hair partly covering bare breasts); that she is not an angel at all but a female satyr (which, according to the traditional classification of satyrs as male, would be a taxonomic self-contradiction); and, finally, that she is about to be mounted by the sexually aroused griffin, whose erect penis is "hidden" in his groin.

Perhaps one of the most elegant, if diabolically outrageous, examples of Beardsley's sexual in-jokes appears in the illustration for "At a Distance," a poem by Justin Huntly M'Carthy (Figure 2–16), which was printed in *The Daily Chronicle* in 1895. In the guise of presenting

2-16 Illustration for "At a Distance," a poem by Justin Huntly M'Carthy. (G.28 B.30 [neg. no. FF145], Victoria and Albert Museum, London)

"A Suggested Reform in Ballet Costume," Beardsley executes a guilefully concupiscent tour de force. The female "dancer" is paradoxically immobile, seemingly encased by a series of frothy, egglike rosebuds and exotic hairlike fig leaves that crowd tightly and somewhat ironically around her patrician face and trail in clusters down the oddly shaped, asymmetrical costume. Lacking arms, her body appears to rise stiff and phallic from the expanse of her lower gown. We soon discover that such libidinous connotations are altogether fitting, since the

dancer's lower gown turns out to be a sort of erotic hermaphroditic mutation: the right side is a gargantuan breast and the left side an enormous penis, hemmed underneath by "pubic" foliage and above by large but drolly inadequate fig leaves. Stylized and ostensibly reserved high art has come to cloak unbridled prurience. Beardsley's brazenness is all the more amusing in this instance, since the drawing was solicited by his circumspect friend Joseph Pennell (under the auspices of the *Chronicle* editor H. W. Massingham) for one of the advertisements supporting the incumbent Progressives in the 1895 London County Council elections. In a rare example of self-restraint, Beardsley was evidently reticent about the salacious content of the drawing, and Pennell mentioned no awareness of it, noting only that he was told Beardsley "lost us a lot of votes" (J. Pennell, *Adventures* [249]–55). Apparently equally oblivious to Beardsley's practical joke, Pennell's wife, the actress Elizabeth Robins, explained that some feared this drawing's attempt "to elevate the Music Halls" might alienate the suburbs, but Beardsley, having been "appealed to," revised the drawing into the one we see, "and all was well" (E. Pennell, *Pennell* 292). In the end, the Progressives lost twenty-five seats.

"Scandal" comes from the Greek word *skandalon*, meaning a snare, trap, or stumbling block (Shipley 313; Partridge 28), and it was indeed a consistent part of Beardsley's iconoclastic strategy not only to appall Victorian sensibilities but also to befuddle, misdirect, and entrap them regarding just what it was that was so disconcerting. Surely one of his more clever successes in this regard is the title page for *The Girl from the Farm* (1895) by Gertrude Dix (Figure 2–17). It seems at first that the design implies all farm and no girl, until we recognize that the central white shape below the title, encompassed by twining vines, is Beardsley's abstract depiction of a uterus and vagina, reinforced by the white seedlike or egglike dots that form the background and conceivably even by the flanking pair of spiraled leaf-tipped vines that in this context suggest ovaries. Indeed, we discover that the fertility motif extends even further, as Beardsley has made the book's title, *The Girl from the Farm*, into a playful inverted pun, the "farm" literally growing from the girl, as the curving vines rise from parallel white female torsos. The point is accentuated all the more slyly by Beardsley's customary broken symmetry, which in this case provides the right-hand hemispherical "breast" with a clearly defined nipple but leaves the left-hand "breast" without one. Here we find the artist at his most playful and ideologically cunning. In effect, his deliberate asymmetry manipulates Victorians' well-known rage for harmony and balance as precisely the means for upsetting their moral equanimity: they discover the "flaw" in symmetry only to expose simultaneously the unifying but scandalous key to the design. What better way to undercut bourgeois smugness than to hoist it on its own petard?

Beardsley's elaborate efforts to astonish and poke fun at Victorian bourgeois sensibilities were by no means confined to trying to slip outrageous visual details past the censors. As Linda Gertner Zatlin has brilliantly pointed out, Beardsley also drew heavily on a broad and subtly sophisticated English tradition of furtive bawdy iconography, which was practiced by such eighteenth-century printmakers as William Hogarth, James Gillray, and Thomas Rowlandson and was ultimately even detailed in Farmer and Henley's seven-volume 1896 dictionary *Slang and its Analogues* (Zatlin, "AB" 1–6; AB 156–63).[14] It is inconceivable that the bibliophilic Beardsley was not familiar with the tradition of sexual iconography, and his friend and pub-

THE GIRL

FROM THE FARM

BY GERTRUDE DIX

LONDON: JOHN LANE, VIGO ST.

BOSTON: ROBERTS BROS., 1895

2-17 Title page for *The Girl from the Farm* (1895) by Gertrude Dix. (Private Collection)

lisher Smithers could not have resisted sharing such handbooks of erotic coding with him. Through Smithers's massive stock of pornographic titles—and from the supplier Edward Avery's notorious Soho shop at the corner of Greek and Bateman streets—Beardsley had ready access to a broad range of underground material, including photographic "pinups" (see Rider 10; Kearney 120; Webb 196–99). For that matter, Beardsley was well known in his own right as "an outstanding connoisseur of the erotica of world literature," having "explored the courts and alleys" of pornography and the "strange and forbidden bookish realms of any and every age" (Schmutzler 183; W. Rothenstein, *Memories* 1: 136; Jackson 101).[15] It was no accident that one of his first significant pieces was a pen-and-wash sketch of (now demolished) Holywell Street, which was a notorious "home of Victorian pornography" (F. Harrison 52; Reade *AB* 13).

Even separate from specific pornographic coding, there existed in the Victorian period a

well-known and long-honored tradition of typology—most often referencing the Bible—that made "secret" iconography an almost standard part of Victorian reading.[16] Years of exposure to these various kinds of typological interpretations had virtually conditioned in most people "a habit of mind, an assurance that everything possessed significant meaning if only one knew how to discover it" (Landow 118). It was only logical, therefore, for an artist of Beardsley's sensibilities, to graduate from the familiar "language of flowers," for instance, to surreptitious sexual iconography, especially when it meant he could occasionally utilize the former in the perverse service of the latter. For that matter, in contrast to some of the blunt language and simple euphemisms of earlier decades, the nomenclature of sexual erotica in the fin de siècle was becoming increasingly metaphoric and stylized (Pearsall 411–12). The bilingual Beardsley took specific delight in the fact that French had become more or less the unofficial "secret" language of erotica, the inclusion (with insolent ease) of certain French slang terms and phrases being one means by which aficionados could separate the knowledgeable elite from the vulgar hordes (387).

As Zatlin has alerted us, Beardsley was eager to incorporate covert sexual iconography into his poetry and fiction as well as his drawings ("AB" 3–6), as we see in "The Ballad of a Barber" (*Savoy* 3 [July 1896]: 90–93). The inspirational source for the poem seems to have been a rather typical Beardsleyan conflation of the violent and the sexual—first, the familiar ballad of Sweeney Todd, the demon barber of Fleet Street, who cut his victims' throats to supply his mistress with fillings for her meat pies; and, second, John Gray's poem "The Barber" from *Silverpoints* (1893), a sexual fantasy of a barber coiffing and fondling his young female clients (Weintraub, *AB* 175). Beardsley naturally sought to stylize the violence (and psychosexual desire) in a rich tapestry of surreptitious iconographic elegance. Carrousel's confrontation with the virgin princess is signaled by such stock sexual emblems as, on the female side, candelabra, a candlestick, a box of jewels, a vase with tight rosebuds and fully blown blooms, and a lock of the window fastening; and, on the male side, a razor, a comb, curling irons, scissors, bees, and the line of birds flying toward the lock. As Zatlin makes clear ("AB" 5; *AB* 154), the description of Carrousel's admirable skill at managing the hair of "reigning belles" and "bees" also serves as a description of the barber's sexual prowess. The profession of barber itself conventionally signified sexual intercourse, and Beardsley reinforces the pun with Carrousel's name, which means "joust," yet another conventional term for intercourse (Farmer and Henley 3: 207, 6: 25; Rudigoz 187, 321, 635, 205, 255). So the perspicacious reader can hardly be surprised to learn that for the experienced Carrousel

> The curling irons in his hand
> Almost grew quick enough to speak,
> The razor was a magic wand
> That understood the softest cheek.
> (ll. 21–24)

The drama heightens as we discover that in the presence of the pretty, presumably virginal, thirteen-year-old princess, "as joyous and as wild / As spring flowers when the sun is out" (ll.

39-40), the barber became sexually aroused—"stumbled" and "fumbled" were metaphors for coitus (Rudigoz 296, 313)—and yet ineffective: his "fingers lost their cunning" (l. 49), his "ivory combs obeyed no more" (l. 50), his sight dimmed (l. 51), and he became impotent, "feeble as a pointless jest" (l. 56). However, he quickly "snatched" a bottle of cologne, and "broke the neck between his hands" (ll. 57–58)—slang for masturbation (Farmer and Henley 6: 25; *Pearl* 77)—thereby restoring his confidence: "He felt as if he was alone, / And mighty as a king's commands" (ll. 59–60). Thus, the seemingly illogical (and compositionally undeveloped) murder that appears so abruptly in the text is in fact a logical sexual "murder" of virginity (i.e., rape), "sharp" being slang for erection (Rudigoz 202):

> The Princess gave a little scream,
> Carrousel's cut was sharp and deep;
> He left her softly as a dream
> That leaves a sleeper to his sleep.
>
> He left the room on pointed feet;
> Smiling that things had gone so well.
> They hanged him in Meridian Street.
> You pray in vain for Carrousel.
>
> <div align="right">(ll. 61–68)</div>

Beardsley makes doubly amusing that our prayers are "in vain for Carrousel," hanged in Meridian Street, because not only did the "jousting" barber misread that "things had gone so well" but also "Meridian Street" was well-known slang for the genitalia of both sexes (Rudigoz 502). That is, the artist slyly (and perhaps self-referentially) suggests that the crime of the bisexual Carrousel (who shares much with sexually ambiguous Cosmé of *The Story of Venus and Tannhäuser*, on which Beardsley was working at roughly the same time) may have been the crime of relinquishing sexual equanimity and indeterminacy. Whereas previously Carrousel had bestowed "equal care" (l. 29), "And nobody had seen him show / A preference for either sex" (ll. 31–32), now, by virtue of his decisive act, he has sinned against that aesthetically perfect equipoise.

Beardsley's manuscript revisions, reproduced in R. A. Walker's *Beardsley Miscellany*, confirm that he intended Carrousel's sin to be a sexual one and, moreover, a sin against an "aesthetic" homosexual-heterosexual balance. In stanza eight (ll. 31–32) Beardsley changed "He never called a spade a spade / And always seemed to know his place" (*Miscellany* 110)—phrasing that would have been suitable enough for the ostensibly crude crime—to the far more explicit "And nobody had seen him show / A preference for either sex," which is confusing unless we see that it foreshadows Carrousel's deeper and far more subtle "aesthetic" sin against sexual equivocality. Beardsley then altered the ending of the poem, negotiating a fine line that made the sexual violation iconographically clear yet retained it as a hidden joke. In stanza fourteen (ll. 53–54), he changed the entire emphasis from "The flowers on the toilet table / He plucked & stuck them in her breast" (*Miscellany* 110) to "He leant upon the toilet table,

/ His fingers fumbled in his breast." The phallic symbolism of the original language was in effect too phallic—inappropriately literal—and did not work iconographically, as flowers were emblems of *female* genitalia. So Beardsley deferred the "thrust" of the poem, instead having Carrousel onanistically "snatch" and "break" a bottle (that is, masturbate), restoring his courage (and, in a conventionalized sense, momentarily restoring the homosexual-heterosexual balance), before his fatal "fall." Beardsley also revised the key final two stanzas (sixteen and seventeen) to bring them into line with this sexual emphasis. In stanza sixteen he changed what was trivial, unphallic, and too literal,

> The Princess gave a little scream,
> Her maids of honour hurried in,
> And laughed like people in a dream,
> And wiped the red off from her chin.
> (*Miscellany* 110)

into something much more ominous and equivocally subtle:

> The Princess gave a little scream,
> Carrousel's cut was sharp and deep;
> He left her softly as a dream
> That leaves a sleeper to his sleep.
> (ll. 60–64)

Indeed, the revised stanza is made even more equivocal with the use of the masculine pronoun in "his sleep," which intimates that the sleeper may in fact be the self-deceived Carrousel. Finally, in a clever culminating touch, Beardsley retains the fatal conclusion, "They hanged him in Meridian Street. / You pray in vain for Carrousel" (ll. 67–68), but drives home not only the sexual motif but also the subtextual theme of ironically oblivious misunderstanding. Replacing the immediately preceding lines (65–66), he turns "Ah Carrousel the indiscreet! / What you have done I may not tell" into "He left the room on pointed feet; / Smiling that things had gone so well." In this way Beardsley both underscores the sexual content one final time, evoking his familiar satyric "pointed feet," and also reinforces the fact that Carrousel, in his sleep, is deluded that "things had gone so well"—that is, that Carrousel too becomes, along with the myopic uninitiated reader, blissfully unaware of the real significance of the barber's "fall."

Beardsley's "Ballad of a Barber" reminds us that, however much he delighted in scandalizing the middle classes, he also understood both temperamentally and politically—as a precarious (and sexually ambiguous) Decadent in the mid-nineties—the need for a certain prudent decorum. While it was necessary that brilliance be recognizable, it was also necessary for the artist to know, as the case of Beardsley's barber suggests, the catastrophic consequences of losing mystery, balance, and ultimately control. It was a lesson that Oscar Wilde had not learned, and it was one to which Beardsley was even more sensitive after the 1895 Wilde

disaster had unjustly smeared him and almost brought him to ruin along with Wilde. Thus Beardsley often measured the success of his rhetoric of scandal by the degree to which he could effectively steer the delicate course between leaving enough clues to make his cleverness known and yet not enough to be too easily or too completely found out.

Oscillating Spaces and Blurred Distinctions

Sexuality is, of course, a potentially revolutionary force in the sense that it attacks a culture's sense of control and emotional economy (see S. Wilson, "Decadent Art" 176), and certainly Beardsley's highly sexualized pictures mounted a flamboyant challenge against Victorian bourgeois limitations on sexual expression. Even more dangerous, however, was the way his art subtly destabilized the ruling culture's more implicitly accepted values. Repeatedly in Beardsley's art we confront such anomalies as gleeful faces of satyrs interspersed with scowling faces of angels (e.g., Reade, *AB* 88), anomalies that jumble conventionally different environments, not to mention the customarily distinct characters of the angelic and the demonic.

In the 1892–93 heading for chapter 11, book 19 (page 488) in *Le Morte Darthur* (Figure 2–18), Beardsley creates a taxonomic monstrosity above the watchful eye of yet another of his voyeuristic tree trunks, fusing the nude upper body of a beautiful young woman to the lower body of a traditionally male (and implicitly lustful) satyr. This hybrid creature is raising a finger as if to pose some question, such as (most obviously) am I female or male, beauty or beast, chaste or wanton? Or perhaps the creature is only calling our attention to the fact that such polarities are here inextricably joined, wiping out and making utterly undecidable the taxonomic distinctions that customarily separate them. Ambiguity now seems rooted in the very structure of things, ambivalence being no longer a psychological condition but a kind of noumenal property.

In the Full-page border and initial *I* with the text for the beginning of chapter 1, book 3 (page 43) in *Le Morte Darthur* (Figure 2–19), two knights (presumably Arthur and Lancelot) at the right and the stylized Whistlerian peacock at the bottom and lower left are entwined in suffocating foliage. The foliage includes a serpentine, highly convoluted Burne-Jonesian briar, which is transformed by bentwood lines and Celtic interlacings so that it appears rigidly severe, even metallic, almost more sword than vine. As if to suggest the pride and solipsistic desire that will undermine Camelot, the knights and the peacock—itself an emblem of narcissistic pride—seem ensnared by the surrounding foliage. The peacock's feathers (some of which mimic tulips) are forced to twist around the side of the text; the roots of the two trees that vertically span the drawing are cut off completely by the bottom of the border; the tree trunks are obscured by the text and initial; and the leaves and branches at the top seem artificially pressed down against that text. The initial "I" is in the shape of a tree (in fact, at first glance it almost seems to be an extension of one of the border trees), but it is strangled by foliage and by what appears to be the body of a snake. The armor of Arthur and Lancelot in the right border is elaborated in ornate detail, yet the lines so approximate the shape and veins of the foliage that the knights seem not only entrapped but about to be absorbed by

2-18 Heading for chapter 11, book 19 (page 488) in *Le Morte Darthur*.

their surroundings. Their shields, which wrap around their bodies in a fashion mirroring the oversized body-length leaves beside them, resemble insect-chewed leaves or stems.

This implicit violence and threatened extinction stand in metaphoric relation to the text that the drawing decorates, which speaks of the need for Arthur to establish lineage in order to halt the corroding civil strife in his kingdom. Moreover, the frame of the text has the appearance of having been superimposed over the drawing, cutting off parts of it and obscuring all but the details in the border and those pushing through around the initial. The effect is to intensify the general feeling of discomfort, violation, and imprisonment, an effect that is itself intensified by the fact that everywhere our comfortable perceptual categories are blurred—the "outside" constantly threatens to become the "inside," border and text encroach into each other's space, the natural world produces mutant animal-plants or appears artificial, and artificial objects mirror nature, such that we can never be entirely certain whether we are viewing

Book iij. Chapter j.

HOW KING ARTHUR TOOK A WIFE, AND
WEDDED GUENEVER, DAUGHTER TO LEODE-
GRANCE, KING OF THE LAND OF CAMELIARD,
WITH WHOM HE HAD THE ROUND TABLE.

N the beginning of Arthur, after he was chosen king by adventure and by grace; for the most part of the barons knew not that he was Uther Pendragon's son, but as Merlin made it openly known. But yet many kings and lords held great war against him for that cause, but well Arthur overcame them all, for the most part the days of his life he was ruled much by the counsel of Merlin. So it fell on a time King Arthur said unto Merlin, My barons will let me have no rest, but needs I must take a wife, and I will none take but by thy counsel and by thine advice. It is well done, said Merlin, that ye take a wife, for a man of your bounty

2-19 Full-page border and initial *I* with the text for the beginning of chapter 1, book 3 (page 43) in *Le Morte Darthur*. (Drawing no. 91 [without insert], Albert Eugene Gallatin Collection, Princeton University Library, Princeton, N.J.)

briars or ironwork, thorns or swords, leaves or shields, feathers or flowers. As the Art Nouveau *architecte d'art* Hector Guimard did with his famous "orchid lamps" and plantlike lampposts, Beardsley places "flowers" where we expect shields or feathers, and vice versa, creating a defamiliarized alien environment of conceptually threatening hybrids.

We should remember that the Decadence sought to turn naturalistic detail into ornamental decoration in part because Darwinian nature was thought to be only savage and unfulfilling. Ironically the Art Nouveau movement Beardsley so influenced was originally designed to liberate the Romantic sensibility from the cluttered details of nineteenth-century naturalism by creating a rhythmic, curvilinear, "maidenhair" decoration that combines the naturalistic with the geometric. It was a form that, while naturalistic, also reflected the gracefully urban, transitional, and individualistic quality of eighteenth-century Rococo. But while trying to alleviate the denseness of nineteenth-century naturalism and English Arts and Crafts medievalism, Art Nouveau in fact turned out to reflect another side of urban organicism—a world that such pre-Freudian French medical minds as Jean-Martin Charcot of the Paris Salpêtrière and Hippolyte Bernheim of Nancy had characterized as a psychologically smothering collection of sensitive nervous mechanisms (D. Silverman 8–9). Under Beardsley's hand particularly, the effect was often to accentuate, not ameliorate, the sense of suffocation and imprisonment. Spirals being a characteristic shape of budding life, his stylized floral arabesques come to symbolize the blind omnivorous sexual dynamism of incessantly reproductive nature.[17]

Such Beardsleyan arabesques are but another incarnation of an "anarchic upsurge of concealed layers of the sensibility" (Pierrot 231), which fin-de-siècle writers like Eugène Grasset in *Méthode de composition ornementale* (1894) thought essential to express but which overruns and obliterates human achievement and even entangles human beings themselves in some proliferating organic prison. At times it is a force that even the artist himself seems powerless to limit or control. In Beardsley's Heading for chapter 11, book 12 (page 368 in the 1927 and 1988 editions) in *Le Morte Darthur* (Figure 2–20), the hopelessly entangled foliage, which we find "absorbing" (or replicating) the twisted and compressed form of a dragon, overgrows the frame of the drawing itself. In fact, the vines that extend beyond the border appear to be sprouting forms that are as much animal as plant—an owl near the lower left corner and, below that, the head of a ferocious dog—figures that overrun not only the frame of the drawing but our neatly segregated categories of different life forms. The viewer seems threatened with being swallowed in the maze of curves whose superabundance saturates the gaze and whose omnivorousness envelops, eclipses, and transmogrifies all solid entities. Beardsley intensifies the natural sexuality of life—deliberately "perverting" it, in effect—not only by transforming the superfluously ornamental back into the functionally sexual but also by conflating and confusing "lower" and "higher" (plant and animal) forms. His flower-feathers and shield-leaves become flower-feather vaginas and shield-leaf penises. Furthermore, the "undecidable" paradox is not isolated in a specific plant, animal, or man-made object; it "disseminates" the compositional structure of the entire picture in the new relationships reproduced by the juxtapositions of these hybrid figures.[18]

Given the restless Beardsley's acute awareness of his worsening tuberculosis, it is hardly surprising that an air of suffocation and imprisonment, the sense of being trapped or inextri-

2-20 Heading for chapter 11, book 12 (page 368 in the 1927 and 1988 editions) in *Le Morte Darthur*. (Drawing no. 26, Albert Eugene Gallatin Collection, Princeton University Library, Princeton, N.J.)

cably entangled, should become a persistent strain in his art. But for his fin-de-siècle audience (as well as for Beardsley himself), this sense of suffocation surely also symbolized the anxiety of losing control in an even broader sense, because the effect of Beardsley's aesthetic recontextualization was to shake meaning loose from the hegemony of traditional societal and cultural classifications. As John R. Reed observes, Beardsley's sinuous line leads "the eye away from any secure focus in the design" and reduces human beings to elaborate artificial designs that in the end connote not a nurturing world or a dependable order but utter emptiness (Reed, *Style* 159; see also 9, 15, 84).

As with Art Nouveau generally, Beardsley's success in using "decoration" to attack bourgeois sensibilities was attributable in part to the long-standing logocentric prejudice that considered style as something added onto "content," ornament (or illustration) being a superfluous

overlay of "substance" (or the subject illustrated). As Reed reminds us, the etymology of *ornament* suggests that it has always been *both* essence and enhancement, its meaning lying "between 'order' and 'adorn,'" the one indicating fundamental organization, the other signifying an addition to an existing order." Even this latter, less privileged denotation (to adorn) turns out to collapse the traditional distinction between surface and substance, meaning "less 'to embellish' than 'to adjust' or 'equip' in the older sense of providing additional substance of some kind" (*Style* 222).[19] Like the exponents of Art Nouveau, Beardsley sought to turn logocentric prejudice back on itself, creating "decoration" that was an integral part—and even an indispensable structuring element—of the "content" of his pictures, both an addition to and a substitute for what the picture was ostensibly about.

Beardsley carries his satiric effect through composition and style alone in the autobiographical 1892 *Le Débris* [sic] *d'un Poète* (Figure 2–21). The title appropriates a phrase from Flaubert's *Madame Bovary* to the effect that inside many a notary is the stunted wreckage of a poet (Slessor 23). The picture commemorates Beardsley's own begrudging, illness-interrupted stint as a clerk in the Guardian Life and Fire Insurance office from 1889 to 1892, a job made all the more "terrible," Beardsley joked, by having to sit daily in front of a poster by Sir Edward Poynter, Burne-Jones's brother-in-law and director of Art Training Schools at South Kensington (Scotson-Clark, "AB" 5). Adhering to his conception of himself as a "man of letters," Beardsley here conveys "the wreck of a poet" by rendering his dreary existence in an oxymoronically avant-garde "japonesque" style. Compositionally he restricts the poet figure within a work area of perpendicular lines and bars, accentuated and sealed by the compressing, elongated frame of the drawing itself. Even the sunflowers on the rug at the bottom, the one "natural" decoration in the picture, are flattened out perpendicular to the vertical flow of vision, as if under the weight of the drudgery. Unlike most nineteenth-century painters, who were not at all concerned with individualizing the frame enclosing their works (the Impressionists, for instance, continued to use Baroque or Rococo frames for their paintings), Beardsley shared the Art Nouveau passion for bringing the "frame" of his design into harmony with the picture itself as a part of its entire field of approach, making clear that "ornament" is something inextricably tied to theme (Schmutzler 76).[20]

In fact, Beardsley seemed to sense that the sharpest attack on a self-satisfied, bourgeois ethos grounded in the absolute hierarchical distinction between substance and surface, sincerity and frivolity, lay in a visual rhetoric that vitiated that distinction. Again and again, in his ornamental designs, as well as in his lascivious "immorality," Beardsley seizes on the "borderline," the "marginal," in order to wrench apart the foundations of the status quo. His decorative marginalia, salacious ancillary details, repeated sexual in-jokes, subtle asymmetrical symmetry, and jarring defamiliarized forms all work iconoclastically to destabilize customary signification, to disseminate ambivalence, undecidability, paradox. Just as Beardsley's "illustrations"—the marginal decorations for the text—invariably supplanted in the public's attention the actual texts they illustrated, indeed necessarily altered the very meaning of those texts in the reader's mind, so within each picture his ornamental details supplant even the notion of absolute structure or preeminent meaning, defining a structurality more than any secure structure.

2-21 *Le Dèbris* [sic] *d'un Poète.* (E.195-1934 [neg. no. 71676], Victoria and Albert Museum, London)

Implicit in Beardsley's ornamental logic is a tacit understanding that fact, the foundation of the Victorian faith in naturalism and empiricism, comes from the same etymological root as *factitious*—the Latin word *facere*, to make, do—so the real and the artificial, even the natural and the decadent, may ultimately "in fact" be but two sides of the same spinning coin. We find such a destabilizing foundation in *How Sir Tristram Drank of the Love Drink*, from chapter

25, book 8 (facing page 180) in *Le Morte Darthur* (Figure 2–22), based on Wagner's version (from Gottfried von Strassburg's thirteenth-century variation) of the Tristan and Isolde story. The subject itself is fundamentally ironic: Tristan has killed the Irish champion, Isolde's fiancé, but much to her anguish, Isolde has been unable to avenge her lover's death, because when she was about to slay the sleeping Tristan, he awoke, and his loving gaze plunged her inexplicably into the impossible dilemma of both loving and hating him. Worse, the dutiful and selfless Tristan is now coldly delivering her to be the bride of his uncle, King Mark, thereby humiliating her and making a lie of his love for her. Trying to escape her torture, Isolde instructs her servant to prepare a poisoned drink, which she gives to Tristan before drinking it herself. Tristan, equally in despair, agrees to drink the poison in symbolic atonement, neither of them realizing that Isolde's servant has substituted for the poison a love potion so powerful that those who drink it are forever bound to each other with a desire so overwhelming that it can never be wholly fulfilled in earthly life. Expecting an escape into death, Tristan and Isolde are about to be plummeted into the living torture of an inescapable passion.

The drawing goes to some lengths to suggest a union, or at least a complementarity, between the two lovers. Two parallel Japanese curtains, treated as screens and each displaying a clematis flower and a flowered black base, serve as the backdrop. The lovers' faces, their expressions varying only slightly, seem to be but two versions of the same face. The body shapes, though very different, are both exotic and broadly complementary, Tristram's being broad at the shoulders and narrow at the feet and Isoud's being narrow at the shoulders and widening toward the ground. And both figures convey a sense of being imprisoned by their fate: Tristram's wrist is wrapped, and the black border of his cloak is drawn so as to appear almost as a separate strip of cloth knotted and bound to him; Isoud is drawn without arms, as if wrapped and bound tightly in her garment.

Yet this suggestion of univocality, even if in tragedy, is simultaneously undercut by many of the same elements that foster it. The matching clematis flowers, which were presumed to represent "mental beauty" iconographically (Haass 242, 256), are nevertheless poised ominously over each lover's head and are attached to lurching grotesque and arabesque stalks that contrast sharply both with the serenity of mental beauty and with the stylized elegance of the lovers' dress. Furthermore, while Tristram's gesture and bearing may be thematically ironic—he makes a willing toast to their death (the goblet itself seems adorned with painted snakes)—the elements are consistent. Indeed, his arm is parallel to the phallically surgent clematis stalks, a gesture which—ironic as it is—only reinforces the association of consummated love with death. On the other hand, Isoud's bearing is neither consonant (overtly) with Tristram's nor even self-consistent. She seems to be recoiling from him, in contrast to his gesture toward her and to other components of her manner: the stylized, pointed passion-flower tulips that adorn the skirt connote sexual enticement, not aversion. Her entire shape, after all, is pronouncedly phallic, accentuated by her lack of arms and the scrotumlike widening of her lower skirt. Snakelike Medusan hair reinforces her menacing connotations but contradicts her averting posture. While, if Brian Reade (*AB* n. 104) and Simon Wilson (*AB* n. 5) are correct, her bearing may well be psychologically accurate—haughtily triumphant in revenge while simultaneously shrinking from the horror of death—it raises the question why Tristram is not also

vexed and generally undercuts what at first appears to be the logical theme. Isoud's ambiguous expression further compounds the problem: whether we are inclined to believe it is primarily a look of bitter triumph (S. Wilson, AB n. 5), or apprehension, or scorn, or a number of other possibilities, none of these interpretations can in fact be ruled out. The meaning of her expression defies hermeneutic closure, sliding among several subtle alternatives.

The compositional "framing" of the drawing only reinforces the undecidability. Even though we know that this scene is supposed to be taking place on board a ship (the floorboards, as well as the sea and gull-dotted sky in the center, confirm that it is), the Japanese curtains nevertheless trick us at first glance into assuming that the scene is taking place indoors. Certainly logic suggests that the curtains would not be on the deck of a ship, could not in fact be suspended as they are. Furthermore, the very narrow opening to the prospect, with the poison goblet set within that "prospect" (against the sky and above birds in flight), seems to highlight symbolically the scene's central ambiguity. In light of the fact that the cup actually contains a love potion and not poison, is the aperture symbolically widening or narrowing? Are we to understand that the love drink will liberate the lovers from death (the curtains, in effect, opening to spiritual freedom)? Or are we to understand that the love drink will in fact only imprison them anew (the curtains closing out the freedom death would have provided)? Or is it, rather, as in the case of the depicted seagulls—we cannot tell whether they are flying toward or away from the lovers—that meaning equivocates without closure among the alternatives? It connotes freedom, imprisonment, both, neither. Indeed, this underlying sense of dislocation and thematic ambivalence is subtly but surely intensified by the fact that Beardsley does not provide the drawing with the traditional vanishing point. If we examine the floorboards that presumably ground the scene, we discover that rather than being designed to converge (theoretically) at a central unifying locus, they are drawn so that, if extended, they would intersect absurdly at a variety of different angles.

The border outside the central scene simply "frames" the paradoxes once more. Like Beardsley's other borders, it is a decoration that turns out to be yet another thematic illustration. Undulating around the right and top of the scene is a large restless snakelike stem (or is it a whip?) to which is attached the clematis-tulip that Beardsley used to conflate iconographically passion, mental beauty (or its decadent equivalent, cerebral narcissism), and hopeless love (tulip) (Haass 251–56). Around these flowers and the snakelike stem are also scattered Beardsley's hybrid rose-gems, mirrored in the Japanese curtains. The passion flowers and the stem are huge, appearing to create perceptually an almost gravitational pull on the lovers, particularly Isoud. Reade notes that the "delicate tensed-up petals" of the blossoms counteract the restlessness of the border (AB n. 104). But this is not the only paradox in the border; the overall design is inverted. The huge tensed-up blossoms in the wide right-hand border are offset in the much narrower left-hand border by their dwarfed, limp, moribund version, in which the erotic tension and hope of fulfillment have drained completely away, leaving the shrunken and drooping petals to their inevitable death and leaving the "final" meaning of the scene even more unresolved.

Echoing Paul Bourget's famous discussion of the decentralizing character of Decadent style, Richard Le Gallienne asserted in Herbert Horne's *Century Guild Hobby Horse* (7 [1892]: 80–81) that under the Decadence "the old ideal of synthesis" was yielding to the anarchic

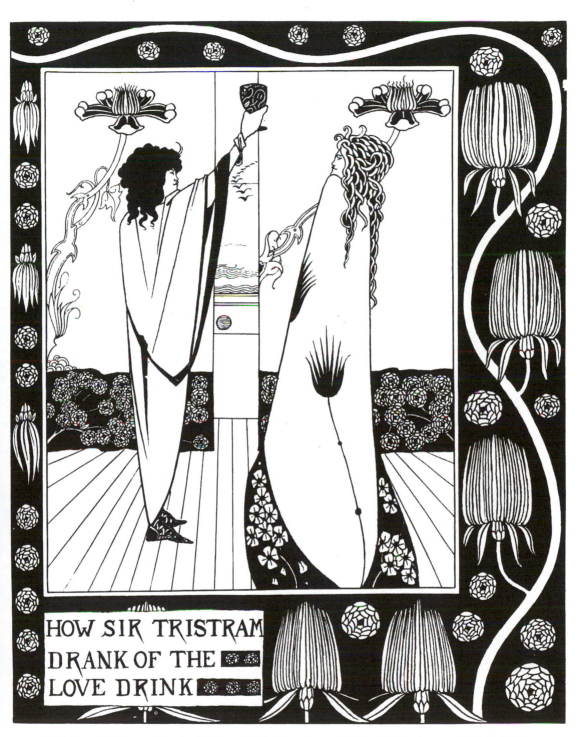

HOW SIR TRISTRAM
DRANK OF THE
LOVE DRINK

2-22 *How Sir Tristram Drank of the Love Drink*, from chapter 25, book 8 (facing page 180) in *Le Morte Darthur*. (G.29 E.21 [neg. no. FF164], Victoria and Albert Museum, London. Also 1986.681, Scofield Thayer Collection, Courtesy of The Fogg Art Museum, Harvard University Art Museums, Cambridge, Mass.)

demand to specialize. As we have seen, there is certainly in Beardsley's "decadent," icono-clastic, Art Nouveau elevation of the exotic fragment an anarchic impulse, an independent and decomposed transvaluing of nature that shatters the bourgeois viewer's desire for (and classical vision of) integrated closure or any ordered logocentric unity of subordinate parts. In his art, however, it seems less a case of the part dominating the whole than a fundamental deconstruction of the traditional, hierarchical opposition of such dialectical terms—and a corresponding accentuation of the paradox of joined contradictions, of sliding signifiers. It is a world in which organic liberation may become but another form of organic decay (and imprisonment). Beardsley's paradoxical, hybrid shapes turn the Victorian faith in nature against itself, elevating in its place an artificial nature that is but a parody of it. His pictures usher in an unstable epistemology whose oscillating figures present a new meaning even as they simultaneously retain the traces of an opposing old one. Like the visual "shuttle motion" of two overlapping but not quite matching grids (similar to Op art's manipulation of geometric forms, color dissonance, or kinetic effects), so the images in many of Beardsley's pictures oscillate, hermeneutically if not visually, among dissonant, if not contrary, meanings.[21] The self-contradicting sets of coded associations and meanings carried by Beardsley's ambiguous images and relationships create a similar logical "flicker," or "trembling" oscillation, when the viewer tries to "read" them univocally—and they signal thereby the fundamentally unresolved paradoxes underlying the drawing. In the process of recontextualizing any number of dis-courses, Beardsley suggests that reality exists only in signs and their manipulation. It is the bourgeois Victorian's ultimate nightmare—a free play of signification in a design that seems to dispute the very existence of solid values.

Perhaps nowhere is this profound disorientation more evident than in one of Beardsley's most famous pictures, *The Peacock Skirt* for *Salome* (Figure 2–23). Here the extreme beauty of line and balance in composition disguise countless countervailing spatial and thematic ten-sions. In the first place, even before we entertain the question of what the scene signifies generally, we have the more specific problem of identifying the two central figures—that is, which figure represents which character from Wilde's play. In this case, it seems more than reasonable to assume, as historically most viewers have, that the figures symbolize Salome and Jokanaan. Certainly, such an identification seems logical in light of the picture's focus on the transfixed stares of the two figures and the play's emphasis on the dangers of looking at objects of desire, particularly Salome and Jokanaan. But reasonable assumptions are not always safe in Beardsley's pictures, and Ian Fletcher makes a strong case, taking the same thematic em-phasis on the fatal "look," that this scene actually depicts Salome's encounter with Narraboth, the Young Syrian, Captain of the Guard, in which Salome cajoles and seduces the Syrian captain into granting her wish to see Jokanaan face to face (*AB* 78–79). Fletcher's reading is strengthened by the fact that the Salome-Narraboth episode occurs early in the play, and Beardsley placed his drawing facing page two of the text. Moreover, there is little clear evidence in Wilde's text that Jokanaan gazes directly at Salome, or that they confront each other closely in the fashion Beardsley's picture depicts. Indeed, the stage directions specify that at their meeting "Salomé le regarde et recule" (*Salomé* 22) ["Salomé looks at him and steps slowly back" (*Salome* 401)], and the play generally turns on Jokanaan's (problematical) *refusal* to look

at Salome. On the other hand, such a close eye-to-eye confrontation clearly does occur be-
tween Salome and Narraboth. The stage directions indicate that Salome is "s'approchant du
jeune Syrien" (*Salomé* 20) ["Going up to the young Syrian" (*Salome* 399)] and "souriant"
["smiling"] (*Salomé* 21; *Salome* 400), as depicted in Beardsley's picture, whereupon she declares,
"Regardez-moi, Narraboth. Regardez-moi. Ah! vous savez bien que vous allez faire ce que je
vous demande" (*Salomé* 21–22) ["Look at me, Narraboth, look at me. Ah! thou knowest that
thou wilt do what I ask of thee" (*Salome* 400)]. And, in response, he does look at Salome and
does do immediately what she asks.

That is, even at the most elemental level Beardsley heightens from the outset the am-
biguity, undecidability, and latent tension of his picture, making deliberately unclear—he
provided no clarifying tags or inscriptions, as he does in most of the other *Salome* illustrations—
just who is the subject, who it is we are viewing. In one sense this blurring of distinctions is
scandalously appropriate. By deviously posing Narraboth, the pagan suicide, as an emblematic
character in every way sufficient to substitute for Jokanaan, the martyred Christian prophet,
Beardsley only accentuates the profound subversiveness of one of the play's themes: that the
catastrophic potential of desire and egoistic arrogance recognizes no boundaries, entrapping
and destroying both the small and the great, the hedonist and the ascetic, the pagan and the
Christian, the guilty and the innocent, as if there were no real difference between them. Even
more subversive, perhaps, just as Beardsley's "illustrations" were said to supplant Wilde's text,
so in finding—contrary to our reasonable assumptions—that a minor character is the thematic
locus of perhaps the most prominent and striking *Salome* illustration, we are provided the
additional "grotesque" metaphysical proposition that in all significant respects the "ancillary"
can be substituted for what is presumably central, impugning the very hierarchy of center and
circumference, primary and marginal, original and derivative.

But that is only the beginning of the hermeneutic and metaphysical dislocation. Even if
we accept the proposition that the figures in the picture represent Salome and Narraboth, not
Salome and Jokanaan, we are still left with the seemingly perfunctory but problematical ques-
tion, which is which? Logically, of course, we assume the more aggressive "attacking" figure
on the left is Salome, and the more passive, "threatened" figure on the right is the Syrian
captain. But once again such a logical assumption is almost immediately thrown into question.
Ostensibly, the left-hand "Salome" figure appears "coded" as the classic femme fatale, its
femininity seemingly confirmed by the long ornate hair, the delicate features of its leering
face, the elegance of its lines, and the billowing skirt. On the skirt itself are depicted dozens
of the fertility emblems of which Beardsley was so fond, and had slyly encoded into cover
designs, including egg shapes that may also serve as icons of the moon, associated in the play
with Salome and death. There is also the teeming, poisonous headdress of the female Medusa
(the customary snakes replaced in this instance by decadent hothouse flower-hearts), Medusa
being in Freud's conception the archetypal "castrating" female. Yet, paradoxically, the figure's
threatening character is most forcefully conveyed by the fact that its armless, elongated, ser-
pentine body and its scrotum-shaped lower skirt are blatantly phallic. It is, after all, the male
peacock that has the beautiful plumage, and the skirt is thematically mirrored in the elaborate
peacock emblem perched at the back of (and metaphorically reinforcing) the Salome figure's

phallic shape. Like Whistler's Peacock Room that inspired it (see note 20), the skirt is in fact a miniature self-sufficient cosmos. But its self-sufficiency is the self-fertilizing solipsism of the hermaphrodite: the shapes that intimate the "feathers" of the peacock skirt also intimate not only ovaries and eggs, but tailed spermatozoa, this latter connotation being reinforced synecdochically by the meticulously spaced fila added around the border of the skirt. According to the traditional cultural codes that define for us *woman* and *femme fatale*, most of the elements composing the left-hand "Salome" figure are female, but its most defining characteristics code it as male. We are left with a figure that slides across our neat ontological categories.

The right-hand "Narraboth" figure dislodges our coded expectations even more. Our focus is drawn naturally to the area around the stare-locked faces. From that perspective particularly, the right-hand figure appears to be female, which is illogical, in the sense that it ought to be representing Narraboth, a male, and yet simultaneously logical, in the sense that it is being threatened by a distinctly phallic, "castrating" figure. Also, Narraboth is in Wilde's text the love object of the homosexual male page of Herodias (a fact Beardsley illustrates in A *Platonic Lament*), which further acts to destabilize traditional gender identity. Beardsley in fact goes out of his way to accentuate the feminine characteristics of the right-hand "Narraboth" figure: the stylized hair (or headdress—another blurring of distinctions); the delicate and sensual facial features; the especially elegant layered gown; and the ultrafeminine stance, one hand on the lower hip, the other poised delicately in the air, and the hips cocked slightly in sexual suggestiveness. But once again we find our univocal perception overturned. As we lower our eyes toward the point where the hermaphroditic peacock skirt intersects the Narraboth figure, we find first that the elegant, perfectly symmetrical gown shreds into a frayed and ragged hem, highlighted by the concentric circles of dots Beardsley regularly used to suggest decadent phosphorescence—itself a perversion of the Renaissance practice of using a series of luminous dots to connote the infinite (Gombrich 219)—and second that this delicate feminine figure has the muscular legs and knobby knees of a man (notably, too, it has no discernible breasts).

What we have to this point is a confrontation between two self-contradictory figures. While one may seem aggressive and intense, and the other restrained and passive, both at first glance appear to be female and elegant. Yet, on second glance we see those feminine and elegant qualities undercut by their opposites—the male and, just as significant, the vulgar. This paradoxical dislocation, or despoiling, of logical meaning is reinforced by the fact that in both figures Beardsley deliberately mars the cleanness of their lines with tiny blots of black ink. We are made to confront the probability that nothing is "pure," clear, unalloyed, unequivocal. The figures are hermaphroditic, which in itself makes them paradoxes, and the polarities they embody are not harmonized but starkly demarcated, so that they deliberately jar our sensibilities, rupturing the smooth logic of traditional categories and associations. In this regard the hermaphroditic figures become themselves oscillating texts: they do not blend opposing meanings but pose those contradictions simultaneously, or (if we cannot hold both poles in a single glance) in rapid alternation, so that their meaning(s) "flicker," each pole implying (indeed, including) the other without supplanting it, and also without superseding it. The "essence" of the figures becomes in effect a suspension, a void—uncertain, undecida-

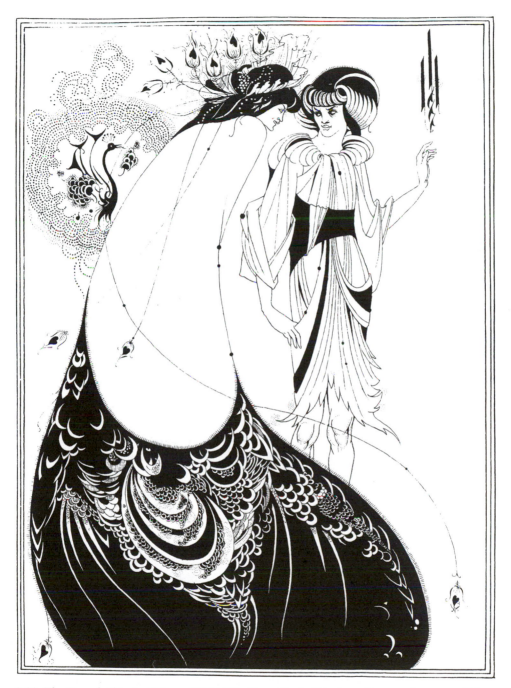

2-23 *The Peacock Skirt* for *Salome*. (1943.649, Grenville L. Winthrop Bequest, Courtesy of The Fogg Art Museum, Harvard University Art Museums, Cambridge, Mass.)

ble—through which each alternative meaning passes in turn, oscillating, with no one meaning establishing supremacy.

The rationale that the left-hand Salome figure is becoming more virile and "castrating" while, conversely, the right-hand Narraboth figure is made more effeminate and "castrated" may indeed provide us with a subterranean psycho-logic to help unravel the paradoxes and reach some interpretive closure. But such an interpretation does not come close to sublating the visceral aesthetic and ontological shock we are made to experience in viewing the figures. In fact, the picture proceeds to undercut even this interpretation, continuing in its hermeneutic oscillation to resist a definitive reading. From the psychoanalytic perspective, the coiling, serpentine curve of the body, the leering face, and the Medusan headdress of the Salome figure on the left clearly identify it as ominous and aggressive, curling tightly into the Narraboth figure on the right, invading its space, even thrust forward spatially by the "cocky" peacock emblem at its back. The hair of the Salome figure even partially overlays and obscures a portion of the headdress of its right-hand "victim." Moreover, the Medusan headdress comprises a shell-like casing with sharp jagged edges, highlighting its dangerous aspect, and a swarm of hothouse flowers (formed out of inverted hearts, Beardsley's suggestion of perverted love), whose poisonous, perfumed decadence is accentuated by swirling stems and filaments and an arabesque of concentric dots. Emanating along varying paths from this poisonous source are four long filaments or lashes, whose tips are the same poisonous flower-hearts. These lashes symbolically heighten the erotic tension provided by the Salome figure, as they recall the flagellation fantasies popular in the Decadence. Flagellation is presumed, in the logic of sadomasochism, to provoke orgasm; thus, the "whips" reinforce still further the phallic incursion of the Salome figure. There is also the oblique connection between flagellation and androgyny, in that Leopold von Sacher-Masoch described the algolagniac as the "new man without sexuality" (Palmer 94). Visually our attention is first drawn to the androgyny of the right-hand Narraboth figure because one of the lashes from the Salome figure cuts across its masculine knees. And just as the left-hand figure seems clearly the dangerous "attacker," so the right-hand figure seems the endangered "victim." Its stationary posture, its posed effeminate stance, its slightly recessive tilt, and the fact that the kinetic left-hand figure seems spatially to overpower it—all contribute to this initial impression.

But almost immediately these alignments begin to encounter dissonance. First, the face of the Narraboth figure shows no fear; in fact, it seems to express fearlessness, even scornful self-assurance, its eyes fixed on its adversary in an unflinching glare. Its masculine, knock-kneed legs even seem to reinforce this sense of firmness and resolve. The left hand, poised delicately in the air, which through another perspective might be interpreted as a sign of tentativeness or imminent flight, actually rests under Beardsley's "japonesque mark"—the signature he suggested was itself an equivocal emblem representing (presumably depending on one's mood) his talismanic Empire ormolu candlesticks, sexual penetration and the dripping aftermath, or the familiar obscene hand gesture. In this instance the Narraboth figure's poised hand seems to be holding (or about to grasp) the "candlestick," either to shed light on its attacker or as a weapon. But either of the other symbolic meanings Beardsley encouraged for his signature undercuts equally the perception of the right-hand figure as passive and defense-

less. Indeed, in this context, the figure's posture, particularly the cocked hips, seems much less restrained, more openly sexual, seductive, even arrogant. As the elements of the picture realign, we may begin to wonder whether what we have here is victimization or entrapment. The real coup de grâce comes when we suddenly recognize that the black waistband and connecting black line extending down the front of the gown of the right-hand figure form the shape of an ax, pointing directly at the phallic-shaped aggressor. Suddenly the valences of the figures are reversed: the "castrating" Salome is in imminent danger of being castrated; the "castrated" Narraboth is potent after all.

In the play, too, the destructive force of desire is reciprocal and symbiotic. While Salome has the power to seduce the normally dutiful Syrian captain, it is Narraboth's command alone that can bring forth Jokanaan, intensifying the cycle of desire and violence that results in all their deaths. Salome can unleash destructive violence, but she cannot escape having it ultimately rebound on herself. And the same is true of "defensive-aggressive" Narraboth in that the ax encoded into his gown symbolizes not a specific but a thoroughly disseminated violence, undercutting the picture's ironic reversal even as it affirms it. Thematically the ax-waistband is a graphic prefiguring of the literal ax that beheads Jokanaan, but even prior to the prophet's execution, the violence attendant to it will claim both Narraboth, who in calling forth Jokanaan precipitates the events that lead to the execution, and Salome, who will be inextricably entrapped in the ensuing maelstrom of desire and retribution. Indeed, Wilde originally intended to title the play *La Décapitation de Salomé* (Carrillo Gomez 16: 214)—that is, he was inclined to have the deaths/castrations of the two main characters literally mirror one another in deconstructive symmetry.

Compositionally, too, Beardsley suggests that the two figures in his picture may be only mirror images of one another. In addition to the elements already noted, the headdresses of the figures, while different, are both in the shape of a shell. Furthermore, the conch shape of Narraboth's headdress in the upper right is mirrored in the skirt at the lower left of the picture; and the fila bordering the skirt are duplicated on the border of Narraboth's headdress. Similarly, the concentric dots of "phosphorescence" around Salome's headdress at the upper left appear also around Narraboth's hem in the lower right. Compositionally and thematically our coded polarities do not stay in their culturally assigned places but shift and slide among chameleon signifiers. The "outside" aggressor who seeks to invade the "inner purity" of his/her victim discovers that there is no purity, that outside is inside, and that, in fact, the aggressor is but a double of the victim.

There is ultimately in the world of Beardsley's drawings no way to resurrect stable categories, to put the encroaching "intruder" back "outside," to return the world to its "proper" place, in part because to put the "intruder" back "outside" would necessitate expelling an integral part of what is also "inside," the dynamic of desire that drew the intruder in the first place. Hermeneutically the world of Beardsley's picture also resists any recuperative reading of it. Although we may read the picture incrementally, "progressively," our second or "deeper" reading does not in fact sublate or "correct" the first. It is *not* the case, for instance, that what we first thought to be the passive "castrated" Narraboth figure (or is it, thematically, Jokanaan as well?) turns out "in truth" to be the "castrator"; he/she is both, and more. We may wish to

dispel the anxiety or discomfort the picture creates by crafting a univocal reading, which would impose logocentric closure. But our second, "deeper" reading does not finally "put it all together" any more than the first, nor is it even necessarily an improvement on it. Neither reading supersedes the other, because the second reading itself is also partial, contingent in the midst of inescapable oscillation. The "flicker" effect we see in each hermaphroditic figure is in fact disseminated throughout Beardsley's world and our reading of it. It is a world that at first appears to split into polarities; then each element seems to incarnate both halves of the polarity, until the polarities themselves are thrown into question, each pole seeming to take on the characteristics of its opposite. Our traditional dialectical formulations no longer seem applicable. There is no fixed and stable frame of reference. Polar opposites are no longer opposites; they may be also complements, or even variations of the same element.

In many of his drawings Beardsley goes to great lengths to convey a sense of uncontrollable metaphysical violence being released, or about to be released, within a space from which there is no escape. In *The Peacock Skirt* we find that through an artificial framing of the scene Beardsley intensifies the sense of compacted space the scene itself has created. He sets a frame around his central drawing, actually makes the frame a part of the drawing, leaving an expanse of white "negative space" all around the frame to make the central action seem compressed, the figures "trapped." (Beardsley was careful to have his pictures reproduced surrounded by this negative space.) In fact, he draws not one but three concentric frames, which create the optical illusion of increasing constriction. To accentuate this feeling still further, Beardsley has the frames appear to cut off artificially parts of the picture itself—part of the peacock skirt at the bottom, part of the peacock emblem at the left, part of the Salome figure's headdress at the top. The overall effect is to highlight and intensify the sense of existential suffocation the picture conveys, particularly the hothouse erotic tension attending the two central figures. We are imprisoned in a world whose surface is rupturing, boiling with erotic heat that cannot escape but can only be turned back upon itself. It is not a tension playing back and forth between opposite poles, because it is not a world stable enough to produce fixed poles. It is a world whose locus is ultimately a void, desire ever deferred, signifiers whose signifieds are but other signifiers receding (or mirroring) endlessly. It is the imprisonment of overfilled space, the decadent hothouse, in which every meaning is overdetermined, every element crossed by many floating signifiers, whose pattern coheres only to be ruptured by the next shifting realignment, a world where meaning itself is constantly dislodged, dislocated, thrown into question.

D. J. Gordon defines the case well when he suggests that the central difficulty in Beardsley's art is that his pictures demand to be "read," yet by deliberate ambiguity they often defy a definitive reading: their meaning stands "*Between the puzzle and the clue* Objects are neither one thing nor another, or they are two things at once," the terrain between the puzzle and the clue being "the terrain of the indeterminate and of alternatives" ("AB" 14, 15). Challenging the law of noncontradiction, the classical principle that two (or more) objects cannot occupy the same space at the same time, Beardsley's hybrid figures and paradoxical realignments create hermeneutically what Georges Bataille characterized as the most radical moment of cultural crisis—semiotic "auto-mutilation" or "nonlogical difference," in which

two seemingly necessary but incompatible positions meet impossibly, generating a sense of the world as purely parodic, deceptive, without true origin except in revolving, substitutable hypotheses (*Visions* xiii, 5).

Clearly the scandalous property of Beardsley's art lay not just in its libidinous content, or even in the fact that it was so impudently confrontational in its brazen attempts to "slip one over" on the presumably thick-headed Victorian public. His art was a scandal also because both directly and indirectly it struck at the very root of Victorian faith in logocentric meaning, in the notion of any subject as a coherent and continuous source of privileged signification. Not only did his illustrations obviously fail to follow the presumably sacrosanct text, but their irony flatly overturned the principle of semantic univocality. His lascivious shapes and iconoclastic juxtapositions ridiculed the smugness and questioned the veracity of any belief in absolute value (prudish or otherwise).

Beardsley implicitly understood that the Victorian ruling culture depended for its hegemony on a sense that its fortifying conventions were "natural" and thus permanent. By heightening our awareness of the context-dependent nature of meaning—the fabricated, culturally conditioned nature of all "nature"—Beardsley's highly stylized renderings surely furthered the Decadent argument for the supremacy of the artificial. But, in so doing, they also worked to undermine such sacred bourgeois Victorian myths as "the empire," the "Angel in the House," and a predominating "best self," all of which needed to be perceived as "natural law" in order to justify ruling-class ascendancy and superiority and, not incidentally, the popular press's continuing reinforcement of those principles.

Beardsley's overdetermined images, juxtaposing wildly clashing codes, generated a surplus of meanings that defied easy recuperation. They forced the reexamination of the myths they defamiliarized, radically disorienting viewers accustomed to the ready-made clichés of homogenized, ruling-class readings. If Beardsley's work, like much of nineties art, shows us "nature watching art's narcissistic absorption of itself," a nature so stylized that it is "alien and unknowable" (Dowling, "Nature" 164, 165), it is mainly because his "antipodes of naturalism" (Jackson 114) seek to defamiliarize smug bourgeois assumptions about life's presumably naturalistic interrelationships. Beardsley's relentlessly ironic tropes make the metaphoric case that philistine culture has distorted—even perverted—the world, and that, logically, Art's real truth can appear only as alien and unknowable in relation to that distortion.

Media, Messages, and the Politics of Desire

Late Victorian ruling-class culture had other, if less obvious, reasons to find Beardsley's art "outrageous" and dangerous. Despite Robert Ross's disingenuous claim that Beardsley was "charmingly unsophisticated," nearly everyone recognized Beardsley's entrepreneurial skills. From an early age, acting and playing the piano for public and private patrons, Beardsley learned how to cultivate potential sponsors and generally manipulate an audience (see *Letters* 21–23, 26, 37). As an adult he had certainly taken note of the stunningly successful self-promotions of such dandy-artists as Wilde and Whistler. As a consequence he labored "fe-

verishly by night" so that he could pose as a social butterfly all day, making "good copy for the reporters" and establishing the notion that "nobody knew the art of self-advertising better than he" (Blunt 645). Elizabeth Robins Pennell observed that Beardsley, knowing that people hoped he would live up to his drawings, was clever enough "to assume the pose expected of him": "Strange, decadent, morbid, bizarre, weird, were adjectives bestowed upon [his drawings], and he played up to the adjectives for the edification or mystification of the people who invented them and for his own amusement" (*Nights* 180). Walter Crane related how he once suggested, regarding Beardsley's proposed trip to the United States, that "the Americans doubtless would 'make much of him,'" whereupon Beardsley "replied with a smile that he 'certainly hoped to make much of *them*'" (*Reminiscences* 416).

It was generally the case in the Decadence that "the virtues of clarity and openness were transformed . . . into the habits of confession and display" (Chamberlin, "Decadence" 591); and indeed, a hundred years before the rock icon Madonna, Beardsley too created art that thrived, even depended, on the "gossip" of civic outrage. Highlighting the licentious both thematically and rhetorically, each Beardsley "disgrace" provoked an incensed public to anticipate the next one, even heightening the desire for it through word-of-mouth denunciations of it. Underscoring their roles as unwitting collaborators, some of his detractors even magnified Beardsley's notoriety by parodying his style (and his style of attack), as evidenced in the numerous spoofing references the press made to "The Yellow Boot," "The Bilious Book," and the "Blodey Head."

Gossip itself, as if validating its etymological root of being "God-related," has been historically a time-honored and effective means of publicity, and was in Beardsley's case a symbolically appropriate vehicle. Just as gossip voyeuristically encroaches on the society's presumably private preserves, making enemies ridiculous even as it throws into question the ultimate veracity of the language it uses to ridicule, so Beardsley's aggressive visual puns breached the culture's conventional artistic boundary lines, mocking ruling-class values and throwing into question the culture's place as a conserving reservoir of truth. Like gossip, the ever-oscillating signification of Beardsley's pictures functioned as a language that could not finally be controlled, that ostensibly sought truth (even as it critiqued it) while simultaneously scattering or disseminating that truth among varying interpretations. Also like gossip—the lingua franca of both private club and street corner, creating a demand for the very information its users ostensibly disdain—Beardsley's "publicizing" art effected a democratization of previously privileged erotic spaces.

In the 1880s, and for the first time in history because of mechanical mass reproduction and especially the new photographic line block, the visual image was becoming virtually as powerful a medium of communication as the written word.[22] Mass reproduction of art was hardly new, of course, the process of lithography having been invented in 1798 by the Austrian Alois Senefelder By 1848 it was possible to print ten thousand sheets per hour, and by 1866 Jules Chéret was producing color lithographic posters from his own press in Paris (Slessor 72). The first line block (a map) was printed in 1876, the first half tone in 1884, and by the early eighties color printing could accommodate the complex tones of an oil painting, allowing artists and publishers to mass market engravings of previously unavailable "high art" (Thorpe 11). In 1879 John Everett Millais exhibited *Cherry Ripe*, a portrait of a little girl in fancy dress,

and the following year *The Graphic* sold six hundred thousand color reproductions of it, receiving orders for over a million. In 1885 Millais's *Bubbles* became the landmark poster and label advertisement for Pears soap (F. Harrison 75–77). However, it was not until the late eighties that the photographic line block made mass reproduction of prints such an enormously economical enterprise. The demand for such drawings increased markedly, and many artists began to devote their time and talents entirely to illustrations designed for photographic mass reproduction.

As the high-cultural establishment soon discovered to its increasing shock and dismay, Beardsley managed to exploit, like no one before him, a mode of black-and-white design that reproduced easily and faithfully, thus enabling him to expand in unprecedented fashion the sensational effects and seductive allure of his equally unprecedented subversive images. In his *Studio* introduction Joseph Pennell conceded that Beardsley, although very young and at the outset of his career, had already developed a method of drawing that produced "one of the most marvellous pieces of mechanical engraving, if not the most marvellous, that I have ever seen" (14). The critic D. S. MacColl wrote, "Even in the curious devices he adopted to enrich the line and spot, . . . by which he arrived at an effect of greater tenuity and lighter tone than by his finest lines, he seemed to have a guiding instinct for what would turn out lucid in reproduction" ("AB" 25–26). Holding no exhibitions but creating drawings solely "to be beautiful in reproduction," Beardsley became, more than any previous artist, a "creature of the printed book" (A. J. A. Symons 96). Moreover, whereas under the custom of earlier methods of reproduction most of Beardsley's erotic details and many of his stylistic features would not have survived the professional engraver's discreet "improvements," there was with the photographic line block no middle man (beyond the publisher's conscience) to impede him, thus permitting the most direct and accessible communication with the public that any artist had hitherto known (Aswin 369–70). The result was, in the words of another contemporary, "an art so astoundingly new . . . so startling and arrestive" that it was "worthy of remark even in an age which is glutted with sensationalism of all kinds" (Strong 86).

Judged by High Victorian standards of cultural propriety, the strategic gossip-provoking rhetoric of Beardsley's art was virtually as controversial as its irreverent themes and style. The exceptional adaptability and reproducibility of his drawings—the fact that they could appear with almost equal effectiveness in private prints, deluxe editions, magazines, posters, or anywhere—tacitly undermined Victorian society's identification of value with restricted supply. It specifically challenged the supreme authority and truth of the one "original," unique (and exclusively owned) work of art, which could be appropriately displayed and appreciated only in select and decorous circumstances. Walter Benjamin, of course, has described how innumerably reproduced copies shatter the traditional elitist "aura of the work of art." Mass process reproduction is by its nature more independent of the original work than manual reproduction, since it invariably places copies of the original in venues where the original itself would never appear ("Mechanical Reproduction" 220–21). Paradoxically the capitalist quest for ever-cheaper forms of production impelled artists like Beardsley to develop a style that would undermine ever more effectively basic bourgeois assumptions about art and its function.

Many of Beardsley's Decadent compatriots believed mechanical mass reproduction leveled distinctions and inverted key values—implicitly impugning such ideas as "essence," "nat-

ural light," or "original" art. But Beardsley seemed to view modern technological production techniques as enabling the very kind of total integration of personality and moment the Decadents sought, and making that experience infinitely reproducible. In his aesthetics of "violation," Beardsley effectively utilized the new mass-reproduction principles, particularly photographic line-block technology, to attack the foundations of Victorian bourgeois culture itself and erode the very structure of conventional meaning. In so doing he politicized art in a way and on a scale rarely, if ever, witnessed before: as Benjamin explains, once it "makes no sense" to "ask for the 'authentic' print," what was formerly a matter of unthinking ritual now becomes a matter of unstable politics ("Mechanical Reproduction" 224).

Unquestionably, much of the hostile reaction to Beardsley's art stemmed, as Bridget Elliott has noted, from this demythologizing of art's traditional "aura"—the effort "to break down barriers separating art and popular culture" (93). Victorian critics had routinely considered high art and popular culture to be mutually exclusive categories, but in an interview for *The Sketch* (11 April 1894) Beardsley and his coeditor, Henry Harland, made it clear that they intended *The Yellow Book* to blur the distinction between the two, offering works that would be both "distinctive" and "popular in the best sense of the word" (557)—a goal *The National Observer*, for one, judged to be a self-contradiction (21 April 1894: 588). Beardsley's enticing, eye-catching, almost infinitely reproducible pictures did politically and sociologically what the content and style of his art did psychologically—invaded previously privileged territory, blurring traditional semantic distinctions, democratizing both authority and "sin." Regarding sexuality, ruling-class convention had long dictated that sexual power could only be depicted, as in the paintings of Leighton and Burne-Jones, through classical poses and other antiseptically elitist modes that were under the "safe" auspices and clear control of the upper classes. But Beardsley's shocking images trespassed across these previously secure and relatively homogenous cultural boundary lines, releasing the shifting sands of semiotic equivocality.[23] Far from conveying a sense of timeless permanence, Beardsley's transitory "poster art" was a virtual caricature of traditional painting, an "art of the day and hour," as Arthur Symons said, "meant for the street, for people who are walking fast. It comes into competition with the newspapers, with the music-halls; half contemptuously, it popularises itself" ("AB" 95). In a sense, Beardsley's iconoclastic pictures and "jolting" rhetorical strategy were logical responses to an era in which the aristocracy sacrificed its "purity" to morganatic marriages, litigation became the normal means of establishing honor, and newspapers advertised literary and artistic events in their gossip columns. He proceeded impudently, and with rather self-fulfilling justification, as if an "art of scandal" was the only art likely to be noticed in such a cynical and histrionic age.

That Beardsley was acutely aware of both the value and the subversive implications of creating demand artificially (and simultaneously impugning the "aura" of "high art") is apparent from his witty remarks about aesthetic prejudice in the essay "The Art of Hoarding," which he modeled after Whistler's supercilious and confrontational style in *The Gentle Art of Making Enemies* (1890):

> Advertisement is an absolute necessity of modern life, and if it can be made beautiful as well as obvious, so much the better for the makers of soap and the public who are likely to wash.

The popular idea of a picture is something told in oil or writ in water to be hung on a room's wall or in a picture gallery to perplex an artless public. No one expects it to serve a useful purpose or take a part in everyday existence. . . .

Now the poster first of all justifies its existence on the grounds of utility, and should it further aspire to beauty of line and colour, may not our hoardings claim kinship with the galleries, and the designers of affiches pose as proudly in the public eye as the masters of Holland Road or Bond Street Barbizon (and, recollect, no gate money, no catalogue)?

Still, there is a general feeling that the artist who puts his art into the poster is *déclassé*—on the streets—and consequently of light character. . . . the public find it hard to take seriously a poor printed thing left to the mercy of sunshine, soot, and shower, like any old fresco over an Italian church door. . . .

Happy, then, those artists who thus escape the injustice of juries and . . . the world of worries that attends on those who elect to make an exhibition of themselves. (53–54)

Beardsley's clever pun on the word *hoarding*—denoting both the temporary wooden fence around a structure under construction or repair and a process by which the ruling class artificially increases value—shows his cognizance of how his mass-produced, "advertising" poster art undercut the foundations of the bourgeois value system even as it "claim[ed] kinship" with (and used the conventions of) that system. Ironically the very barriers designed to wall out the masses and prevent them from hindering or despoiling the "recuperation" of ruling-class edifices become vehicles for perverting and heralding the demise of the ruling-class cultural authority those edifices symbolize.

Holbrook Jackson, who usually demonstrated uncanny insight into the nineties generation, was surely wrong to call Beardsley's art "decoration in the abstract" and lacking "the rhythm of relationship" (104). As we have seen, far from being "abstract," even the most purely decorative motifs of Beardsley's ornamental compositions seem almost compulsively attached to some broader meaning, even if sometimes only to throw that meaning into question. His drawings are normally so topical, allusive, and symbolic, that they could hardly exist without the "rhythm of relationship," each element being defined by its relation to—or by the way it critiques or satirizes—some other element. In a parallel sense, like satire (and irony) generally, Beardsley's implicitly satirical, irony-laden art appealed to and was ultimately driven by the society it satirized. Paradoxically, as much as he ridiculed the Victorian establishment, the ambitious Beardsley also actively sought acceptance by that ruling-class culture—particularly assimilation into the canonical pantheon. As John Stokes has shown was the case with the new journalism of the nineties, which paradoxically wanted to be associated with the avant-garde even as it repudiated it (*Nineties* 22–23), Beardsley, too, wished to critique canonical tradition, but primarily so that he might earn his place within it.

Indeed at least part of what Beardsley found so attractive about the avant-garde was precisely the very security of being *unable* to eradicate the traditional. It is significant that in the summer of 1893, when every other man attended the Salon at the Champ de Mars in a

top hat, Beardsley demonstrated his eccentricity by wearing "his little straw hat" (Pennell, *AB* 26). Yet, even more significant, the straw hat he wore was in every detail the same "boater" Whistler had made famous, and Beardsley knew the emulated master would be in attendance to witness the implicit homage he was paying to him. For that matter, Beardsley's frequent baiting of critics was designed in no small part precisely to establish his merit as a traditional craftsman, often according to the ruling class's own cultural standards. When he perpetrated the famous fraud of introducing into the October 1894 issue of *The Yellow Book* his own (but stylistically disguised) "drawing[s] of merit" under the pseudonyms "Philip Broughton" and "Albert Foschter," he carried the joke by appealing to tradition: both "Broughton" and "Foschter" treated conventional subjects—the former, a bust of the Renaissance artist Mantegna, set against a background of classical ruins; and the latter, an impressionistic portrait of a French-woman. To Beardsley's delight, while the critics judged his nonpseudonymous pictures to be "as freakish as ever," they also inadvertently validated his traditional technical artistry by advising him "to study and profit by the sound and scholarly draughtsmanship" of his aliases (see *Saturday Review* 27 October 1894: 469, and *National Observer* 13, 17 November 1894: 23).[24] If anything was more satisfying to Beardsley than gulling the establishment's arbiters of merit, it was to have them, in the process, anoint him as meritorious. That is, even as he mocked the traditional canon, he did so in a fashion calculated to remind his viewers of its value and implicitly establish himself as worthy of inclusion in it.

Beardsley's hero Baudelaire seemed to forecast his invalid disciple's use of art as both scandalous play and redemptive healing when he hypothesized that "genius is no more than childhood recaptured at will," that the "pure artist" is in fact "perpetually in the spiritual condition of the convalescent" who redeems himself by achieving a playful "return to child-hood" (*SW* 397–98; *AR* 59–60). Certainly Beardsley's art is nothing if not playful. Once when Lewis Hind caught the "Puck spirit" in the studio, "pirouetting about in a yellow dressing gown and wearing red slippers turned up at the toes," the artist proclaimed to him that life was "a great game" (Hind, "Memories" 3). Yet Hind also noted of this incident that when Beardsley afterward moved to his drawing board, "his mobile face became tense. That was the real Beardsley" (3). It is part of the paradox of Beardsley's art that just as a certain prankish frivolity seems ever to be breaking through even his most "noble" designs, so tension and uneasiness always seem to haunt his impish, idiosyncratic images. Indeed, if Susanne Langer is correct that at the core of all organic life is an "underlying feeling of comedy," a self-correcting "life rhythm" that struggles to restore "a new balance of functions" (327–28), then we should not be surprised to find, as I will now try to demonstrate in chapter 3, that under-neath Beardsley's playful "travesties"—his urge to outrage—lay a countervailing craving for authenticating authority.

The Craving for Authority: Authentication and Redemption

> [W]ith him vice always wears the brand, its own con-
> demnation stamped unmistakably upon its face. He
> drew Messalina and a whole menagerie, but their
> vices he has never depicted as attractive—strongly
> the reverse; and frequently when we speak of the re-
> pulsive nature of his drawings we mean rather the
> repulsiveness of the sins they so effectually condemn.
> —A.K., "Aubrey Beardsley,"
> *Outlook* 3 (8 April 1899): 323

> The thing must be edited with a savage strictness.
> —Beardsley to Leonard Smithers,
> *Letters* 413

BEARDSLEY clearly demonstrated, in the words of one contemporary, "an almost spiteful delight in snatching the mask from the face of conventionality and coming down with an unqualified bang on the most tender of Mrs. Grundy's toes" (Strong 89–90). But at the same time, paradoxically, he manifested an equally strong need to affirm (and be affirmed by) some higher authority, whether it was canonical father figures, a Religion of Art, or the tradition-steeped Catholic Church. His friend and one-time studio mate Will Rothenstein testified that although Beardsley ridiculed conventionality and "*spoke* enormities," his "startling" cynicism was an affectation (*Memories* 1: 134). However much he paraded his ostentatious iconoclasm, other aspects of his personal temperament and aesthetic tastes— including a reverence for the elitist eighteenth century and a preference for a reticent (even quasi-puritanical) style of dandyism—placed him on the more conservative side of fin-de-siècle artistic revolutions. In fact, certain French sympathies notwithstanding, Beardsley's highly ironical art was, according to Holbrook Jackson, more "art for the sake of life" than the detached "art for art's sake" he ostensibly espoused (33).[1]

Roland Barthes has reminded us that, for all its subversive characteristics, irony is a conservative, tradition-affirming discourse—reinforcing the tacit hierarchy of "true and false,"

seeking to "correct" or at least mirror back perceived "flaws" in human behavior and attitude (*S/Z* 44–45). Contrary to his reputation, Beardsley's own daily behavior adhered to "a pattern of moral decorum" (Marillier 442), and his status as "the satirist of an age without convictions" (Symons, "AB" 101) rested in no small measure on a highly moralistic sensibility. Mabel Beardsley told Yeats that her brother "hated the people who denied the existence of evil He had a passion for reality" (Yeats, *Letters* 575). Even Beardsley's salacious pictures apparently stemmed from a desire not to glorify but "to chastise" sensuality (A.K. 323). When his mother once called one of his femme fatales "dreadful,"

> he replied "Vice is dreadful and should be [so] depicted" and then he added "there is hardly a week that some comic paper does not contain a picture more corrupting than anything I have ever drawn." On another occasion when there was something in some paper furiously abusing one of his drawings and I showed it to him he said "Of course they are furious, they hate to see their darling sins." (ALS to Lane, n.d. [1920s])

As Stephen Prickett has put the case, while Beardsley's art may have depicted sexuality with revolutionary license, its effect remained "peculiarly Victorian," exhibiting "a tension between convention and personal feeling quite as much as that of the deeply inhibited Lewis Carroll. Beardsley was frequently immoral, he was incapable of being amoral" (111). We shall see that in his personal life Beardsley was surprisingly authoritarian, which in turn influenced many of the formalistic assumptions of his art. In fact, his "revolutionary" art turns out to reinscribe many of the same canonical, ruling-class values it undercuts, carefully showcasing the same traditional aesthetic that Victorians (and their forebears) had customarily extolled—organic form, harmonious lines, unified narrative, integrating symmetry, and other elements associated with "aristocratic style." Insofar as many of Beardsley's strategies reflect a deep need to identify himself with authenticating authority, in order to understand the inscribed authoritarianism in the artist's work we need first to examine some of the sources for it in his life.

Ontological Insecurity

Virtually all of Beardsley's biographers have suggested that his almost compulsive pursuit of validating authority—in great books, father figures, artistic movements, or religion—developed in no small part from the relatively rootless circumstances of his personal life. His parents were estranged from his early youth, his father usually living apart from the rest of the family members and seldom mentioned by them. Beardsley's mother and father both felt they had married beneath their station and were never quite respectable as a result (Brophy, *AB* 14–15).[2] Money troubles were constant. The family moved frequently, and Beardsley's mother was forced to try to make ends meet by taking jobs as governess, French teacher, or piano teacher, commuting to London when necessary. The result was nagging instability and an ongoing sense of failure, no doubt accentuated by the fact that, except for two years between June 1893

3-1 Photograph of Sarah Pitt, Beardsley's maternal great-aunt. (MS. 160/8/18, University of Reading Library, Reading, Eng.)

and July 1895, the Beardsleys never had a home of their own but always resided in temporary lodgings or were forced by financial difficulties to share someone else's quarters (Brophy, *AB* 68–69; Benkovitz 19). During periods when Beardsley's parents were unable to support him and his sister, the children were temporarily lodged with friends or relatives, such as their mother's relatively wealthy maiden aunt Sarah Pitt (Figure 3–1), a very strict, humorless, and eccentric old woman with Gradgrindian opinions regarding children (Benkovitz 22–23).[3] Indeed, Beardsley's passion for music may have stemmed in part from the fact that, for a brief period in his early childhood, his mother's nightly six-piece piano "programmes" provided one of the few occasions when the entire family—mother, father, sister, and son—came together happily (see E. Beardsley, "Recollections" 1).

Beardsley's sense of dislocation and insecurity was hardly lessened by his chronic tuberculosis, which from age seven necessitated still more shifts of residence and placed him almost constantly under the care of various physicians and pulmonary specialists, many of whom predicted full recovery while prescribing bizarre, painful, and often contradictory remedies.[4] It was this kind of frequent relocation and generally unsettled life-style that may have prompted

Beardsley to observe that "change in residence is I know one of the most painful ordeals in this life" (*Letters* 348). It may also help account for contemporaries' description of Beardsley as "rudderless" and a "soul-ship seeking harbourage" (Rothenstein, *Memories* 1: 317; Jackson 96–102).[5]

From their first meeting Robert Ross remembered Beardsley as "shy, nervous, and self-conscious, without any of the intellectual assurance and ease" he would later display to the world (15). Even at the height of his success, Beardsley was self-protective and insecure: he "detested an eyewitness to his craftsmanship and barred the door to all inquisitive eyes"; "none of his visitors ever found him at work, never saw any of his rough sketches nor even so much as his pen, ink, and paper"; and "if interrupted he would thrust the sheets hastily out of sight" (MacFall, *AB* 29; Beerbohm, "AB" 539; Clarke 552). He reputedly went almost nowhere without his black, gilt-hinged, Louis XIV–period portfolio of drawings and notes, which was thought to serve as a kind of security blanket or talisman investing him with instant authority and position (MacColl, "Beardsleys" 3; Weintraub, *AB* 143). Yet even when armed with his portfolio, "he always entered a room cautiously, as if expecting to be kicked violently from behind" (MacFall, *AB* 78). A. W. King once urged Beardsley to show his work to W. E. Henley, editor of *The National Observer*, but when Beardsley mounted the stairs to Henley's Great College Street rooms and saw an abject young man being harangued by a loud, angry, "large red man" behind a desk, he turned and raced down the stairs, never to approach Henley again (E. Pennell, *Nights* 139).

Beardsley's poor self-image was evident throughout his life. Routinely he would lament his "impossible" temperament and express unaccountable concern that some customary action, such as having his picture taken, might offend (*Letters* 354, 400, n. 401). He showed an "almost desperate urgency in his search for companionship," and, even at the height of his fame, he dreaded being alone, as his letters make abundantly clear (Weintraub *AB* 142; Blanche, *Portraits* 94, *Sous la Colline* 19; see also *Letters* 312–14, 339, 351–417). In October 1896 Beardsley confessed to Raffalovich that his progressive weakness left him "quite paralyzed with fear" (*Letters* 194); but as death approached more certainly in the last year and a half of his life, he seemed much less afraid of dying than of being abandoned. He had written to Mabel from Paris, "I don't know when I shall return to London—filthy hole where I get nothing but snubs and the cold shoulder" (118). Joseph Pennell and friends once went to visit Beardsley in Dieppe but forgot the number of his lodging and passed by it unknowingly, whereupon a paranoiac Beardsley became convinced that they "did not want to see him" (J. Pennell, *Adventures* 221).

Fear of abandonment may have been behind much of Beardsley's well-known craving for publicity and his lifelong eagerness to be the witty center of attention—regardless of whether he was gratifying or exasperating his mother, whether he was pleasing or scandalizing his schoolmasters, whether his work earned him fame or notoriety. His schoolmasters were alternately amused and vexed by the fact that the less than studious Beardsley, despite a delicate constitution, nevertheless demonstrated "unflagging industry" on numerous projects that thrust him into the limelight among his peers (MacFall, *AB* 5). He never tired of "holding court" to dazzle his classmates, "referring in grandiose language, with a twinkle in his eye, to the time 'years ago' when he composed nocturnes and gave high-class London concerts, re-

gretting the while that he had so wasted his time" (King 23). As an adult, although always rather distant even to his friends, Beardsley was said to be truly happy in only three places— the Brighton Royal Pavilion, the Domino Room at the Café Royal, and the Casino in Dieppe:

> He loved dining out, and, in fact, gaiety of any kind. His restlessness was, I suppose, one of the symptoms of his malady. He was always most content where there was the greatest noise and bustle, the largest number of people, and the most brilliant light. The "domino room" at the Cafe Royal had always a great fascination for him: he liked the mirrors and the florid gilding, the little parties of foreigners and the smoke and the clatter of the dominoes being shuffled on the marble tables. (Deghy and Waterhouse 62; Beerbohm "AB" 546; see also Symons, "AB" 88)

In fact, the theatrical Beardsley, whom Haldane MacFall called "a born poser" (*AB* 30), was typically seized by loneliness precisely when he was *not* immersed in "society," when he was *not* "performing." Although he was painfully self-conscious when stared at as a child, the adult Beardsley confessed, "I still wish to be stared at"; and his sister even suggested of his celebrity that "he could not work without that stimulant and fell into despondency" when his illness kept him from public view (Yeats, *Memoirs* 90). Beardsley was reportedly at his best at his and Mabel's Thursday afternoon Cambridge Street salon, where there "were always three or four new drawings of his passed from hand to hand" while the vivacious artist circulated hors d'oeuvres, made bon mots, "every now and then making great play with his wonderful hands," and generally delighted in being the focus of attention (Beerbohm "AB" 542; Syrett 75, 79).

MacFall argued that underlying all the contradictions in Beardsley's conduct was the fundamental fact that he desperately wanted to be liked and, driven by fear of rejection and "the loneliness of his own conceit," he adopted behavior (even outrageous behavior) that he thought might win him approval, or at least respect (*AB* 19). Beardsley's mother attributed "all the naughty things he ever did, & ever said" to an intense vanity: "I am quite sure that if he wrote to a godless person whom yet he admired for cleverness, & who he thought w[oul]d admire <u>his</u> cleverness, he w[oul]d have made himself out Satan himself rather than not shine" (ALS to Mabel Beardsley 2). Beardsley's own claims to the contrary notwithstanding, his friend the American illustrator Penrhyn Stanlaws observed, "Perhaps one [of] his most peculiar traits was his dread—I was going to say terror—of adverse criticism. He took all criticism very seriously, and some of the onslaughts made upon him almost broke his heart" (213). Thus much of Beardsley's iconoclastic "devilishness," as well as the sometimes spiteful malice he would show when criticized, may have been only the obverse side of a fundamental craving for security.

Absorbing the Canon

One of the ways Beardsley sought authenticating security was to root himself as much as possible in the traditional canon of Western art and literature. While it is perfectly natural for artists to imitate past masters, the extraordinary number of often contradictory influences

Beardsley sought out during his short career was remarkable. In his introductory *Studio* article Pennell testified that Beardsley, even at only twenty years of age, had already "drawn his motives from every age, and founded his styles . . . on all schools" (14). Indeed, so obsessive was Beardsley about mimicking canonical masters that it was said "he never looked at landscapes and the sea, but stole all his impressions out of the National Gallery" (Preston 424).[6] His most recognized masters were Rossetti, Morris, Burne-Jones, Whistler, Mantegna, and Dürer, but contemporary critics also cited appropriations from such diverse sources as Botticelli, Michelangelo, Watteau, Blake, Cochin, Crane, Crivelli (who in turn led Beardsley to study Japanese kakemonos), Utamaro, Debucourt, Eisen, Saint-Aubin, Moreau, Rops, Greenaway, Scwabe, Colonna, Claude Lorrain, Longhi, Pollaiuolo, and Bell, as well as fifth-century Greek-amphora drawings by the Brygos and Douris painters, Renaissance friezes, old French and English furniture, Chinese porcelain paintings, rare enamels, medieval illuminated manuscripts, and even the book *Greek Vase Painting* (1893) by D. S. MacColl and Jane Harrison (see R. Ross 44–46, 53; Fry 232; MacFall, *AB* 16, 28, 55).

But as obviously as Beardsley borrowed from the visual arts, he owed an even greater debt to literature. As D. J. Gordon has stated, the majority of Beardsley's drawings are virtually "indivorceable" from literature—treating literary subjects, suggesting narratives rather than merely presenting images, or otherwise demanding "immediate reference to some body of extra-visual material" ("AB" 14). It was a logical bias for Beardsley, because, after all, his original passion (after music) was for literature, not drawing. He had written plays for himself and his sister since early childhood, and while at Brighton Grammar School, he frequently wrote for and performed in the traditional "Entertainments at the Dome"; moreover, as a teenager he succeeded in publishing several of his literary works.[7] When he was a clerk during his first adult years in London—roughly from the end of 1888 through summer 1892—he willingly traded his drawings for arcane books at Frederick Evans's (of Jones and Evans) well-known bookshop on Queen Street, Cheapside, where he was an almost daily visitor (MacFall, *AB* 10–11; Hind, *UW* xv). Even after Beardsley was established as a visual artist, he still insisted on identifying himself as a man of letters and preferred to talk about books (R. Ross 11, 16, 19–20). He took intense pride in his poetry; and one of his most cherished projects was his unfinished Tannhäuser novel, which Yeats rather eccentrically called "a Rabelaisian fragment promising a literary genius as great maybe as his artistic genius" (*Autobiography* 216). He made plans to translate *Les Liaisons Dangereuses*, write a book on Rousseau, and publish essays on George Sand, among others (Blanche, *Portraits* 94, *Sous la Colline* 16–17; Stanford, *Vision* 44). The last piece on which he worked—and about which he expressed great enthusiasm—was not a drawing but the critical introduction to Ben Jonson's *Volpone*, which he intended to publish also as a separate article (*Letters* 403, 409). From his earliest youth Beardsley "lived in books—saw life only through books"; his "life was 'literary,' his voice was 'literary,' and most of his emotions and viewpoints had their foundations in some book or other" (MacFall, *AB* 11; Preston 424).[8]

For Beardsley literature was not only a pleasure in itself but an essential component of high culture, representing (perhaps even more than the visual arts) a validating place in history. Despite receiving little direct encouragement for his literary pursuits (except perhaps from Leonard Smithers and André Raffalovich), Beardsley wanted desperately to be accepted

as a person of acute literary tastes and talent (Symons, "AB" 89; Weintraub, AB 159–60). As the art editor of *The Yellow Book* and *The Savoy*, he did not hesitate to offer his opinions on the literary side, presenting himself always as a discerning and demanding critic (MacFall, AB 105–106). He insisted on setting unusually high (and notably Neoclassical) literary standards for *The Peacock*, Smithers's contemplated successor to *The Savoy*, lamenting the dearth of "anybody with something to say" (*Letters* 413). Among the books he illustrated he even took care to denigrate those he thought might reflect badly on his taste. Having designed the frontispiece for Vincent O'Sullivan's *Book of Bargains*, a volume of short stories he assessed to be very weak, the normally publicity-mad Beardsley pointedly instructed Smithers, "I want you *particularly not* to put my name on the title page" (*Letters* 167). He likewise protested his assignment to Dowson's *Pierrot of the Minute*, which he called "Dowson's filthy little play," the "foolish playlet"; he even took pains to explain that the stylized "Y" he drew for the cover of Dowson's *Verses* symbolized the question, "*Why* was this book ever written?" (*Letters* 205; Weintraub, AB 198–99). Beardsley took an even stronger stand regarding Charles Conder, on similar grounds of artistic conscience:

> I have been thinking over the cover for Conder's book and I feel that the relations that exist between us (humanly and artistically) stand very much in the way of any collaboration in *La Fille aux Yeux d'Or*. Whatever may be my private feelings against him, my artistic conscience forbids me to add any decoration to a book which he has illustrated. (*Letters* 192)

Far from wishing to debunk conventional artistic authority, Beardsley was keen to establish himself as having rigorous standards of a fairly traditional kind, rooted particularly in literary history (even if weighted toward periods of recognized "decadence"). He had a well-known passion for rare and exotic books (in English or French) of virtually any period of literature, history, or philosophy; he was constantly asking Smithers and Raffalovich to send copies of some new classic or old standard, allusions to many of which he was eager to encode into his pictures.[9] He was said to have "cover to cover" knowledge of his "idol" Balzac, whose characters, as Blanche said, "Aubrey les connaissait comme des membres de sa famille" ["Aubrey knew as if they were members of his family"] (Rhys 148; W. Rothenstein, *Memories* 1: 136; R. Ross 16; Blanche, *Sous la Colline* 17). Beardsley self-consciously modeled his work habits after those of Joris-Karl Huysmans's Des Esseintes (habits that may themselves have been modeled on Eugène Sue's)—working in somber darkness and seclusion, by candlelight, behind two heavy tapestry curtains designed in France, at a table made to approximate an altar or priest's desk, and sitting in a tall wicker chair with padded wings (Weintraub, AB 27–28; Moers 133; Smith 16; Stanlaws 212). Even in his scandalous "modernity" he sought authenticating models, as when he patterned his witty "pornographic" treatment of Wagnerian legends (among others) after Jules Laforgue's *Moralités Légendaires* (Weintraub, AB 166–67). Indeed Beardsley's inspiration was so apt to be literary that "his friends instinctively examined his art to see what Beardsley had been reading" and often delighted him by guessing the arcane references (107–8).

The consensus among his contemporaries was that Beardsley's "knowledge of English and

French literature was astounding" (Stanlaws 212). Certainly his facility with both old and modern French was well known—he claimed to read French as easily as he did English (*Letters* 18)—and his discussions of such figures as Molière, Racine, and Corneille were judged "scholarly and quite beyond the general level of interest at the time" (J. Pennell, *Adventures* 220; Blanche, *Portraits* 94, *Sous la Colline* 16–17). He once astonished a collector by being the only person able to identify some drawings by Constantin Guys, the subject of Charles Baudelaire's celebrated manifesto *Le Peintre de la Vie Moderne* (Barnam 2). Confident enough of his knowledge of French literature to voice his views in A. L. Willette's weekly *Courrier Français* (Blanche, *Portraits* 94, *Sous la Colline* 16), Beardsley was not loath to offer his expertise in such matters on other occasions, as when he corrected the authority Andrew Lang on a quotation of Villon and when he chided Zola for failing "to attribute well-known passages to their right authors" (J. Pennell, *AB* 40; *Letters* 235). While Arthur Symons had reservations about Beardsley's own literary work, he had no doubts about the breadth of Beardsley's knowledge of literature: "He seemed to have read everything, and had his preferences as adroitly in order, as wittily in evidence, as almost any man of letters; indeed, he seemed to know more, and was a sounder critic, of books than of pictures" ("AB" 91). As Beerbohm said, "Certainly, he seemed to have read, and to have made his reading into culture, more than any man I have ever met" ("AB" 539).

Beardsley's intense desire to steep himself in a knowledge of (and to imitate) so many different canonical authorities in both painting and literature was surely indicative of more than the wish to acquire a solid technical foundation. His iconoclastic tendencies notwithstanding, Beardsley showed a surprising willingness to defer to traditional authority, even seeking out advice on style from the priggish critic Haldane MacFall (MacFall, ALS to Walker 1, 3; *AB* 69). In one notable instance he subordinated a preference to illustrate Congreve's *The Way of the World* in order to "obey" being "set to task" on Pope's *Rape of the Lock* and Jonson's *Volpone* by the somewhat pontifical Edmund Gosse, who, although a close friend of Swinburne's and having some reputation for a biting *mauvais langue*, was distinctly a member of the bourgeois establishment (Gosse, ALS to Gallatin 5–6; Weintraub, *AB* 112; Beckson, *Harland* 48). Beardsley clearly valued Gosse's friendship and counsel. He frequently attended the writer's Sunday soirées, treated him with respect, and expressed a "great wish" to illustrate Gosse's *Secret of Narcisse*, working on the illustrations off and on for six months before the project fizzled (Charteris 237, 275; see also ALS Gosse to Gallatin 3–4). Beardsley dedicated both the deluxe and the subsequent "bijou" editions of *The Rape of the Lock* to Gosse, and sent with a copy of the former edition a letter addressed to "Mon cher Maître" (*Letters* 131).

In many respects Beardsley's sensibilities were conservative, even hierarchical. When asked by a foreigner whether he had completed his military service, the notoriously impish young artist surprisingly answered that he was "quite ashamed to confess that we were not expected to do anything at all for our country" (*Letters* 325). Ross reported that, despite possessing little formal training and having a reputation for being notoriously undisciplined, Beardsley defended the staid Royal Academy "with enthusiasm," and that his literary and artistic tastes, far from being bizarre, were in fact "severely classic" (17, 21). While Beardsley seemed to exhibit little concern for classical draftsmanship or accurate renderings of anatomy—Lord Leighton once remarked that Beardsley had a "wonderful line . . . , if he could

only draw" (J. Lane, "Publisher's Note" 21)—we find him pleading for traditionalist manuals: "But ye gods how in want of art books I am. A good, clear and inexpensive handbook of perspective, and a ditto of anatomy would soothe me much just now" (*Letters* 424). His conservatism shows up again in a late letter to his sister, in which he expressed little sympathy for the indecorous life-style that many of his fellow Decadents embraced: "The more society relaxes the less charm and point there is in Bohemianism. Flourishes in France because society is so rigid. Will never quite die in England as it is the refuge and consolation of the unsuccessful" (429).

Even the frauds Beardsley fabricated to ridicule smug critics implicitly reaffirmed traditional institutional authority, appealing to scholarly authorities—even inventing a musicologist to confirm that open fields could be appropriate environments for pianos (figure 2–5; *Letters* 68)—and invoking canonical subjects and styles in *The Yellow Book* "Broughton-Foschter" hoax. For that matter, Beardsley's unspoken (albeit campy) assumption in *Under the Hill*—filling it with smuggled foreign words, elaborate footnotes, recondite words like *spellicans* and *vallance*, and countless references to "obscure (and often nonexistent) books, technical (and often invented) minutiae, and altogether fantastic (and sometimes accurate) knowledge" (Weintraub, *AB* 167)—was that ornately phrased, antiquarian erudition is but another sophisticated strain of aesthetic beauty. While ostensibly making fun of tradition-rooted scholarship, he bases the effectiveness of his novella on a recognition and acceptance of it, just as he does in the constant allusiveness of his drawings. He implicitly affirms that even in a camp world, authority (or its absence) is the foundation on which meaning rests. For all his outwardly wayward eccentricity and individualism, Beardsley obviously felt a compelling need to ground himself in artistic and literary tradition. MacFall even suggested that whenever Beardsley faced a particularly severe personal crisis, such as his dismissal as art editor of *The Yellow Book*, he sought authentication and strength by returning stylistically to the specific influence of some canonical master (*AB* 78).

Old Masters and New Fathers

Beardsley's rather extraordinary attempts to absorb traditional Western cultural history reflect an implicit craving for affirming authority; but this need for validation is perhaps even more obvious and telling in his almost endless appropriation of numerous father figures—substitutes, according to several scholars, for his own chronically absent father.[10] Milly Heyd even argues that Beardsley had his fabricated alter ego "Philip Broughton" draw a virile profile of Mantegna, whose overt masculinity contrasted sharply with Beardsley's hermaphroditic figures, in order to depict the unambiguous male sexuality that he could not personally attain and to choose "the type of father he never had, strong and determined" (191–92). Not coincidentally, perhaps, numerous reproductions of Mantegna drawings were among the works Beardsley had hung on the walls of the room in Menton, where he ultimately died (Lucie-Smith, "AB" 12). Much of the logic of authority in Beardsley's art can be traced to the nature of his relations with his various substitute fathers.

Perhaps the most intriguing and emblematically all-inclusive of Beardsley's surrogate fa-

thers was the last one, Marc-André Raffalovich, who was, significantly, so much of what Beardsley became (or posed as being)—poet, novelist, essayist, book collector, estranged son, aesthete, Francophile, converted Catholic, sharp-tongued critic, homosexual—and whose framed photograph Beardsley always kept on prominent display. Beardsley's responses to Raffalovich show genuine friendship but also suggest that their relationship was more that of guardian and ward, or sponsor and protégé, than a bond of equals. He wrote to Mabel, "I don't like referring to my work in my letters to A. He will only scold me. But of course I must if it is really necessary" (*Letters* 426). Significantly, in the first months of their relationship, Beardsley addressed Raffalovich in his letters as "Mentor" and signed his own name as "Télémaque" (84–91). The pseudonyms allude to Telemachus, Odysseus's son, who went to great lengths to find his father, and to Mentor, faithful friend of Odysseus and adviser to Telemachus. Besides possessing a punning name, Mentor may have seemed to the waggish (and occasionally transvestite) Beardsley to be an ironically appropriate model for the homosexual Raffalovich, since it was in Mentor's form that the female goddess Athena appeared to Telemachus. Even more interestingly, however, in light of Raffalovich's earnest efforts to convert Beardsley to Roman Catholicism (and Beardsley's own periodic ambivalence about the moral status of his art), the two pseudonyms also allude specifically to François de Salignac de la Mothe-Fénelon's novel *Les Aventures de Télémaque* (1698), which adopts Homer's characters but makes a point of adding social morality to the lessons Mentor gives Telemachus (Brophy, AB 88–89).

Beardsley's relationships with established older artists suggest a similar craving for the approval of "fathers," even though many of them were pillars of the same moralistic Victorian establishment he so often ridiculed. George Frederick Watts was by no means an avant-garde force in art, but when Beardsley moved to London after graduating school, he was eager to gain an audience with Watts (Scotson-Clark, "Artist" 159). Even more paradoxically, Beardsley revered the longtime president of the Royal Academy, Frederic Lord Leighton, an artist who espoused using "noble" models of idealized classical beauty as a means of moral edification. Beardsley was thrilled to receive a personal five-pound commission from Leighton to do two small drawings (since lost), and it was Leighton whom Beardsley sought out to be his leading contributor (with two drawings) to the initial *Yellow Book* (Ormond 117–18). Surprisingly, Beardsley even asked Lord Leighton to read his cherished (and highly risqué) prose romance *Venus and Tannhäuser* (Leighton, ALS to Beardsley).

Less surprising, perhaps, but equally indicative of his desire for fatherly approval was Beardsley's deference to the illustrator Joseph Pennell. Early on, referred by Aline Harland, an anxious Beardsley sought out Pennell's verdict on his work and "was radiant" upon having it praised (E. Pennell, *Nights* 178). Beardsley made a habit of taking his work and "schemes" to Pennell for critique, "taking him off for confidences . . . intimate and long" (179, 184), even well after the young artist had become a celebrity. Beardsley was a frequent companion of Pennell's whenever they were in Dieppe or Paris together, or when he visited Pennell in Rouen; he was also a regular at the Pennells' Thursday evening Buckingham Street soirées, where much of the design for *The Yellow Book* "was thought out and talked out" and where Beardsley was thought to be "never . . . more simply himself" (J. Pennell, *Adventures* 210; E. Pennell, *Nights* 177, 179, 183).[11] As one of his mentor-fathers, Pennell was among the first

people Beardsley told about the actual establishment of *The Yellow Book,* bursting in on him one evening at the Hogarth Club (J. Pennell, *AB* 36), and Beardsley insisted on Pennell's figuring in *The Yellow Book*'s first number. Furthermore, when Pennell was away in Dalmatia and unable to attend the journal's celebration dinner at the Café d'Italie in Old Compton Street, his wife was given, as his representative, a seat of honor between the editors Harland and Beardsley (E. Pennell, *Nights* 184–86; *Pennell* 1: 273–74).

While any politic new artist might be expected to seek the advice of established masters, Beardsley was more than usually unabashed in his hero worship of those who inspired him, none more than Edward Coley Burne-Jones and Pierre Puvis de Chavannes, both of whom had given him personal encouragement and letters of recommendation and both of whom (perhaps as a result) he acclaimed "immortal" (*Letters* 22, 28, 37, 43–44). In fact Beardsley's courting of Burne-Jones and Puvis took the form of meticulously planned campaigns.[12] His pivotal meeting with Burne-Jones at the latter's Kensington home (Grange End House, 49 North End Road) on 12 July 1891 became a keystone of the Beardsley legend. Beardsley reported to his former house master Arthur William King that "by the merest chance I happened to have some of my best drawings with me" (*Letters* 22). But we know that chance had little to do with it. Before going to see Burne-Jones, Beardsley had first traveled to Brighton to receive assurances from E. J. Marshall that the headmaster would help him if he could, and only after being thus encouraged did Beardsley "take the bull by the horns and go and ask Burne-Jones' advice," working purposefully "to get sufficient drawings together to make it worth B J's while" (Scotson-Clark, "AB" 7, 10; *Letters* 20). The audience Beardsley engineered with his idol had a "remarkable" impact:

> His kindness was wonderful as we [Beardsley and his sister Mabel] were perfect strangers, he not even knowing our names. . . . I can tell you it was an exciting moment when he first opened my portfolio and looked at the first drawings. . . . After he had examined them for a few minutes he exclaimed, "There is *no* doubt about your gift, one day you will most assuredly paint very great and beautiful pictures." . . . Then as he continued looking through the rest of them . . . he said, "All are *full* of thought, poetry and imagination. Nature has given you every gift which is necessary to become a great artist. I *seldom* or *never* advise anyone to take up art as a profession, but in *your* case *I can do nothing else.*" (*Letters* 21–23)

The effect was particularly remarkable in that for a considerable period afterward Beardsley's "enthusiasm for Burne Jones knew no bounds" (Scotson-Clark, "AB" 13), and he sought virtually to transform himself into the older artist:

> Beardsley plunged into the aesthetic conventions of the mediæval academism of Burne-Jones to which his whole previous taste and his innate gifts were utterly alien. At once he became intrigued over pattern and decoration, for which he had so far shown not a shred of feeling. For the Reverend Alfred Gurney, the old Brighton friend of the family, Beardsley designed Christmas cards which are thin if whole-

> hearted mimicry of Burne-Jones, as indeed was most of the work on which he
> launched with enthusiasm, now that he had Burne-Jones's confidence in his artistic
> promise whereon to found his hopes. Not only was he turned aside from his eigh-
> teenth-century loves to an interest in the Arthurian legends which had become the
> keynote of the Æsthetic Movement under Morris and Burne-Jones, but his drawings
> in the kindred atmosphere of the great Teutonic sages, Tristan and Tannhäuser and
> the Götterdämmerung, reveal that he was also now in the seventh heaven and back
> at his beloved operas and music again. (MacFall, *AB* 14)

It is an indication of his hero worship that nearly two years after the initial Burne-Jones
meeting and after his art had already taken a very different, "japonesque" turn, Beardsley
proclaimed "I still cling to the best principles of the P.R.B.[Pre-Raphaelite Brotherhood] and
am still the beloved of Burne-Jones" and twice boasted that his *Siegfried, Act II* (Reade 164)
occupied "a place of honour in [Burne-Jones's] drawing-room" (*Letters* 44–45).

Beardsley's adoration of Burne-Jones was apparently more the need for an authenticating
father figure than an admiration for some specific vision or technique. Although Beardsley
imitated many of the master's conventions and adopted one express element of his method,[13]
he ignored or discarded almost all of the practical counsel Burne-Jones gave him, including
the recommendation of a school to "learn the grammar of your art" (TLS to Beardsley; *Letters*
24). Toward the end of the *Morte Darthur* project Beardsley and Burne-Jones became estranged
in an episode in which Beardsley claimed to hate all things medieval and generally seemed to
Burne-Jones "stupid and conceited," guilty of the most "pitiful exhibition of vanity" (Smith
16; Lago 174–75). Burne-Jones, as could have been predicted of one who admitted having "a
dread of lust," came to see Beardsley's art as "empty of any great quality and detestable . . .
more lustful than any I've seen," the Beardsley female figure looking "like a mere lustful
animal" (Lago 187). Perhaps also predictably, Beardsley responded to the falling out with
Burne-Jones much like a rejected son, declaring in a newspaper interview, "I used to think
there was nobody like Burne-Jones. But later—well I don't admire Burne-Jones so much. He
is a weak imitation of the Italian masters" (Smith 16). Yet, even as he denigrated him, Beards-
ley tried tacitly to recuperate himself in the elder's eyes: in the very same interview, after
mentioning Burne-Jones's "disgust" at the "immoral side" of the young artist's work, Beardsley
sought to excuse those immoral elements as "only my present mood" (16).

Part of Beardsley's imitation of canonical masters, as when he signed many of his early
pictures with a monogrammed "A.B." so obviously modeled on the "A.D." monogram of
Albrecht Dürer, was actually self-authenticating emulation. Beardsley was anything but the
cocky iconoclast when Frederick Evans pointed him out to J. M. Dent as "your man" to do
the Morris imitation of *Le Morte Darthur*: ". . . shaking hands with Frederick Evans at the
shop-door, [Beardsley] hesitated and, speaking low, said: 'It's too good a chance. I'm sure I
shan't be equal to it. I am not worthy of it'" (MacFall, *AB* 26). The drawing done on approval
for Dent, *The Achieving of the Sangreal* (see Figure 3–19), shows that, for all his revisionist
individuality, Beardsley relied heavily on his near idolatry of a Burne-Jonesian Pre-Raphaeli-
tism to achieve the desired effect. Dent's ecstatic reception of the drawing not only boosted

Beardsley's confidence but no doubt also subtly reinforced the artist's predilection for en-thralled hero worship—imitation of established masters had given him his first commission. Furthermore, the following year spent on the Dent project, during which he tediously mim-icked Morrisian woodcuts and refined Burne-Jonesian and other influences, soon led to flashier jobs, thus providing proof that such emulation was wise, affirming the appeal—the aura—of "fathers," and confirming the paradox of basing his unique individual style on a modeling of them.

The first person Beardsley wrote to about his momentous initial meeting with Burne-Jones was yet another of his father figures, Arthur William King, who had allowed the school-boy Beardsley to roam freely about his library and had encouraged him in his artistic and theatrical interests. In the same letter in which Beardsley reported the Burne-Jones meeting, he wrote gratefully to King, "If I ever succeed I feel that it is very very much owing to you. At a time when everybody snubbed me you kept me in some sort of conceit with myself. I shall *never* forget our evenings together in the old room" (*Letters* 22–23). With symbolic appropriateness, it was to King that Beardsley gave his Burne-Jonesian *Hamlet Patris Manem Sequitur* [Hamlet following the ghost of his father] (Figure 3–2), which King published in November 1891, as the frontispiece to *The Bee* (vol. 2, pt. 2), the journal of the Blackburn Technical Institute, of which King was then secretary (Reade, *AB* n. 22). The drawing, which Beardsley thought a "stunning design" (*Letters* 25) yet which surely reflected his own nerv-ousness and insecurity at the outset of his new career, depicts a frail Hamlet, peering appre-hensively into a thick wall of seemingly impenetrable trees. Dark saplings surround him and threaten to entangle and imprison him, as he appears to search futilely for his father in the direction of the ghostly voice. As Karl Beckson has shrewdly observed, Beardsley dresses Ham-let in what appears to be a shroud, indicating that death is his inevitable fate, and the figure's hand is placed on his chest, the source not of Hamlet's affliction but Beardsley's ("Artist" 208). Beardsley's absentee biological father was also tubercular, and in presenting this drawing to King, Beardsley may have been, in effect, replacing a deficient father with a more nurturing one.[14] When King published Beardsley's *Hamlet* with an introductory note saying that the artist was "destined to fill a large space in the domain of art," Beardsley was effusively grateful, writing on Christmas Day 1891 an unusually bombastic, if typically ironic and punning, re-sponse: "Of all things received on Christmas morn, none more pleasant than the *Bee*. On reading your 'notice on the illustration,' I scarcely knew whether I should purchase to myself a laurel wreath and order a statue to be erected immediately in Westminster Abbey; or whether I should bust myself" (*Letters* 31, 32 n. 1).

A rather uncharacteristic, self-deprecating modesty typified Beardsley's dealings with most of his "fathers." We know that Beardsley set much store in *The Litany of Mary Magdalen* and *The Triumph of Joan of Arc* (*Letters* 27; MacFall, *AB* 18), yet in his letters to King he char-acterized them as only "fairish designs" that he hoped King could "dispose of." He went to the trouble of enclosing an encouraging letter from Burne-Jones himself, only to disclaim, "it doesn't prove much" (*Letters* 28). His insecurity apparently eased eighteen months later, as he exulted at length to King about his "new method" and boasted of gratifying associations with and approval from the "establishment"—Puvis, *The Studio*, Leighton, the New English Art

3-2 *Hamlet Patris Manem Sequitur*. (1912-11-9-8 [neg. no. PS233983], Copyright British Museum, London)

Club, and Fred Brown, Beardsley's instructor at the Westminster School of Art, whom he wryly described as "the new Slade Professor, a great admirer of mine." But at the end of this communication, too, Beardsley caught himself and added a self-conscious appeal, "Pray forgive this outrageously egotistical letter" (38). It was perhaps a measure of Beardsley's ingrained privileging of authority that even after he was well established as a famous artist, he disingenuously insisted to the press that he "had no idea of going in for black-and-white work professionally when I began studying the subject" but did so only "on the recommendation of Sir Edward Burne-Jones" (A. Lawrence 192). The fact is that Burne-Jones recommended no such

thing; when he advised Beardsley to dedicate himself to art, he almost certainly meant for him to pursue *painting*, assuming that the drawings Beardsley first showed him were only preliminary sketches for planned oil paintings.

If Beardsley waxed enthusiastic whenever he gained approval from his idolized "fathers," he also sulked petulantly whenever he felt rejected by them, as is most apparent in his radical change of attitude toward William Morris. Originally Morris figured only slightly in Beardsley's Pre-Raphaelite fascination—Beardsley had not even looked at one of Morris's Kelmscott Press books until 1892 (Preston 425). Morrisian medievalism soon became one of his passions, however, since Morris was a close friend of and influence on Burne-Jones. Beardsley wrote Scotson-Clark that he found *The Earthly Paradise* "simply enchanting" (*Letters* 25); and he was too overwhelmed to take seriously the initial suggestion of Aymer Vallance, a member of the Morris circle, that he seek a commission from the Kelmscott Press. In the spring of 1892, Morris had repeatedly complained of being unable to get "suitable illustrations" for his reprint of Wilhelm Meinhold's *Sidonia the Sorceress*, which happened to be one of Beardsley's favorite books. In a classic example of enthusiasm eclipsing common sense—and possibly with the encouragement of Oscar Wilde, who recommended Beardsley as illustrator for *Sidonia* (Wilde, *Letters* 290 n. 3)—Vallance seized the opportunity to take untested (and at that point very un-Morrisian) Beardsley in tow to Hammersmith in the early summer of 1892 to have an audience with Morris. Morris, finding Beardsley's japonesque grotesques neither suitable nor pleasing, responded condescendingly, "I see you have a feeling for draperies, and I should advise you to cultivate it." Beardsley was insulted and "bitterly disappointed," feeling he had been "repulsed." He left Morris's "with a fixed determination never to go there again," and he never did (Vallance 363; MacFall, *AB* 23). Significantly, Beardsley later tried to revise the "Sidonia" drawing, presumably to overcome its presumed deficiencies, but he finally destroyed it in frustration (Hind, *UW* xiv).

According to acquaintances, Beardsley was as a rule even more anxious for people to like him personally than to have them like his work, and regarding the Morris episode he was reportedly far more wounded "by being repulsed and 'not liked' " by a recognized master, whose work he admired, than about the reception of his drawings (MacFall, *AB* 23). Whatever the source of his bruised feelings, Beardsley was so hurt that even six months later, at year's end, he refused Vallance's repeated entreaties to see Morris a second time. Only after extended coaxing did he finally agree to let Vallance show Morris a single printed proof from *Le Morte Darthur*—specifically, the striking illustration *The Lady of the Lake Telleth Arthur of the Sword Excalibur* from chapter 25, book 1 (facing page 25) in *Le Morte Darthur* (see Figure 6–5). On seeing the print, Morris exploded in front of Vallance and several of Morris's gathered friends, accusing Beardsley of "an act of usurpation not to be allowed" and fuming that "a man ought to do his own work" (Vallance 363–64; Hind, *UW* xiv). When he heard, Beardsley was hardly more charitable in return, retorting that "while *his* work is a mere imitation of the old stuff, mine is fresh and original" and adding with amazing unself-consciousness, "Anyhow all the good critics are on my side" (*Letters* 44). Upon publication of the Morris *Sidonia*, Beardsley judged it "impossible," but significantly, he purchased a personal copy, despite its high cost (*Letters* 71). Moreover, when he began work on the crucially important *Savoy* in late 1895,

long after he had presumably left behind the stuffy Morris and after years of being content to use type in his panels, Beardsley returned to the Morrisian practice of using hand-drawn lettering. It is not inconceivable that one of the reasons he continued to trudge through the *Morte Darthur* project after the originally agreed number of drawings had been executed, and long after his interest in the project had waned, was that psychologically he still wished to prove himself worthy beyond all doubt to one of his artistic "fathers"—one who had, after all, rejected him not once, but twice.[15]

Wilde and Whistler

Two of Beardsley's most significant, if also most problematical, father figures were Oscar Wilde and James Abbott McNeill Whistler. The nature of his ambivalent relationship with the two noted dandies establishes clearly the degree of his psychological dependence on them and on authority figures in general.

Beardsley has always been linked with Wilde, that other icon of the Victorian Decadence and his collaborator in the *Salome* project. Although Beardsley was leery of Wilde's undisciplined nature and never cultivated a close friendship with him, he was nonetheless clearly drawn to the older artist and relished his approbation. Wilde had established himself as the *divus* of the drawing-room set, the self-proclaimed high priest of the Decadence. He held court regularly in the Domino Room (or at his familiar chipped marble table near the Grill section) of the legendary Café Royal at 68 Regents Street, off Piccadilly Circus, owned by the French-born entrepreneur Daniel Nicols, who was also leaseholder of the famous Empire Theatre in nearby Leicester Square (Deghy and Waterhouse 58, 61, 35; Crawford, "Nineties" 22–23). Beardsley admired Wilde's flair and set about imitating his legendary verbal skills, playful instincts, dandiacal style, fascination with erotic danger, and, not least, genius for self-advertisement.

Beardsley's attraction to Wilde was virtually assured from their first meeting in July 1891 at Burne-Jones's house, where the "charming" conversationalist was a guest on the same day as Beardsley's fateful audience with the master and even drove Beardsley and his sister home afterward (*Letters* 22). Less than two years later, Robert Ross showed Wilde Beardsley's *J'ai Baisé Ta Bouche Iokanaan* (see Figure 2–8), which Wilde praised lavishly, and persuaded Wilde (and John Lane) to give Beardsley the *Salome* commission (Bird 75). It apparently took little to persuade Wilde, since in March 1893, upon seeing Beardsley's *Studio* drawing, he had sent Beardsley a copy of *Salomé* (now in the University of London's Sterling Library), inscribed "For Aubrey: for the only artist who, besides myself, knows what the dance of the seven veils is, and can see that invisible dance" (Wilde, *Letters* 348 n. 3).

While Beardsley had reservations about Wilde, the two men nevertheless spent considerable time together. Both were frequent guests at Ross's parties (W. Rothenstein, *Memories* 1: 187) and at The Vale, the home of Charles Shannon and Charles Ricketts (Benkovitz 82; McCormack 25); they once planned to go to Paris together (*Letters* 47); and they dined together numerous times at the Café Royal, the Savoy, Willis's Restaurant in the theater

district, and Kettner's in Soho, Beardsley often arriving—not to be outdone by Wilde—in lemon gloves and a cutaway coat (Deghy and Waterhouse 62). Wilde took Beardsley to the theater and introduced him to actresses the young artist admired, such as Mrs. Patrick Campbell, and interesting socialites, such as Ada Leverson, whom Wilde had affectionately christened "The Sphinx" and who soon made Beardsley another of her favorite guests (Weintraub, *AB* 59, 71, 73; Wilde, *Letters* 353). Wilde entertained Beardsley in his private box on several occasions, including the closing performance of *A Woman of No Importance* (Beerbohm, *Letters to Turner* 52–53) and the celebrated opening of *The Importance of Being Ernest* (Fletcher, *AB* 12). It is possible that one of the reasons Beardsley so admired Meinhold's *Sidonia the Sorceress* and wanted to illustrate it was that "Speranza," Wilde's mother Lady Jane Wilde, had made an important translation of it. For a time Beardsley kept (and pointed out with pride) an autographed photograph of Wilde—in a fur coat, no less—prominently displayed over his fireplace (Reade, "AB" 6; Smith 16).

But Wilde eventually found a little irksome Beardsley's incessant attempts to imitate (and then top) his wit and dandyism—exacerbated no doubt by such gauche annoyances as Beardsley's inelegantly noisy eating habits and the fact that Beardsley would sometimes brazenly mock Wilde's affectations (Jepson 216; Deghy and Waterhouse 62; Williamson 279). In order to keep his young follower in his place, Wilde began proclaiming, "I invented Aubrey Beardsley" (MacFall, *AB* 61; Weintraub, *AB* 63) and devising equally galling witticisms about Beardsley's ambiguous sexuality, aped dandyism, or francophile mannerisms. Once he compared Beardsley's pictures to the exciting qualities of absinthe, only to add that, like Beardsley's drawings, the drink "gets on one's nerves and is cruel" (Harris, *Wilde* 89). Knowing that Beardsley adored Alexander Pope above all other English poets, Wilde stunned him (perhaps disparaging in the process Beardsley's lack of university-educated refinement) by observing that there were two ways of disliking poetry: one was to dislike it, and the other was to like Pope (Douglas 197). While Beardsley claimed to be flattered and amused by attacks from philistine journalists, it was quite another matter to receive patronizing personal barbs from a fellow celebrity-artist and adopted "mentor"—especially involving topics about which he was particularly sensitive and self-conscious.

Perhaps the most significant twist in Beardsley's relationship with Wilde—prior to his sacking from *The Yellow Book*—occurred when a contorted series of events led Wilde to spurn Beardsley's translation of *Salomé*, implicitly demeaning Beardsley's cherished self-image as a man of letters. In late August 1893 Wilde had returned from Dinard and Jersey to find his lover, Alfred Douglas ("Bosie"), waiting with what turned out to be a very poor *Salomé* translation, which Wilde characterized as full of "schoolboy faults," wholly "unworthy . . . of the work it sought to render." Wilde's unflattering assessment launched Douglas on a series of recriminating tantrums, ending in a breach between the two. Eventually, Douglas, fearful of losing Wilde, importuned Ross to intercede on his behalf. Wilde relented, only to have Douglas once again refuse to do the necessary, extensive revisions. In the meantime, Beardsley, having learned from Ross what Wilde thought of Douglas's translation, read it himself in October or early November 1893, found it deplorable, and eagerly pressed Wilde to let him translate the play. An exasperated Wilde seemed to welcome the offer as a convenient alternative to having

to do it himself, but then had second thoughts about losing Bosie, and for that matter found Beardsley's translation no more to his liking than Douglas's. So he finally decided to use Bosie's work, editing it himself where necessary, and dismissed Beardsley's translation in the process, all of which ignited an acrimonious four-way dispute among Wilde, Beardsley, Douglas, and Lane (Ellmann 403–4). Caught in an awkward squabble with his lover (Douglas), it is unlikely that Wilde intended to offend Beardsley, but Beardsley felt humiliated nonetheless. He railed against the "very dreadful people" with whom he had to associate, substituted "irrelevant" drawings in the *Salome* project out of spite, and even gave momentary thought to withdrawing his illustrations from the book altogether (*Letters* 58; Benkovitz 87). Indeed, the timing may have been coincidental, but following the translation row, after a long respite of relatively good health, he once again began suffering severe episodes of blood spitting and "abominable bilious attack[s]" (*Letters* 54–56).

Beardsley's response suggests once again the kind of overreaction one might more logically expect from a parent's scorned child. In the following months Beardsley not only castigated Wilde in letters but made certain Wilde's work would not appear in the forthcoming and widely anticipated *Yellow Book*, even suggesting superstitiously that anything with which Wilde was associated would bring bad luck (Weintraub, *AB* 96; Borland 39).[16] That a writer of Wilde's celebrity was not asked to contribute to a highly visible new artistic forum—produced by his own publisher, no less—clearly rankled him, and Wilde may have suspected Beardsley's involvement, judging from the characterization he gave Beerbohm of Beardsley's cover for the first issue: "Oh, you can imagine the sort of thing. A terrible naked harlot smiling through a mask—and with ELKIN MATHEWS written on one breast and JOHN LANE on the other" (Beerbohm, *Letters* 94).

Beardsley's most obvious response to what he considered Wilde's lack of appreciation for him took the form of caricature, most notably in the *Salome* series and other drawings but also in *The Story of Venus and Tannhäuser* where Beardsley mocked Wilde in the figures of Priapusa and Spiridion (Dowling, "V and T" 29–30; Fletcher, "Verse and Prose" 241). The rogue in *Ali Baba* (Figure 3–3), for example, is modeled very much along the lines of Frank Harris's description of the corpulent Wilde—"fat and pouchy" with "heavy, chiselled, purple-tinged lips," wearing "a great green scarab ring on one finger," and generally looking "like a Roman Emperor of the decadence" (63–64). Taking a swipe at Wilde's reputation for sensuality (reinforced by the evil-eye hand gesture), Beardsley makes ambiguous whether the uncloaked portion of Ali Baba's huge white form is a gown or his naked body. Beardsley was usually even more blatant in his caricatures, as we see in the unpublished *Oscar Wilde at Work* (Figure 3–4), which lampoons Wilde's boast that in writing *Salomé* in French he never had to look anything up (hence the legend "Il ne faut pas le regarder" [No need to consult]). The francophile Beardsley always thought of Wilde's *Salome* in its original French version, invariably spelling it *Salomé*, and surely one of the reasons Beardsley was so offended by Wilde's rejection of his *Salomé* translation was that he felt his French was superior certainly to Douglas's but also to Wilde's own, which had been questioned on occasion. The drawing shows a smug playwright in his study, working at a desk piled high with large volumes, including a "Family Bible," *Dorian Gray*, *Trois Contes*, volumes of Swinburne and Gautier, the histories of Josephus,

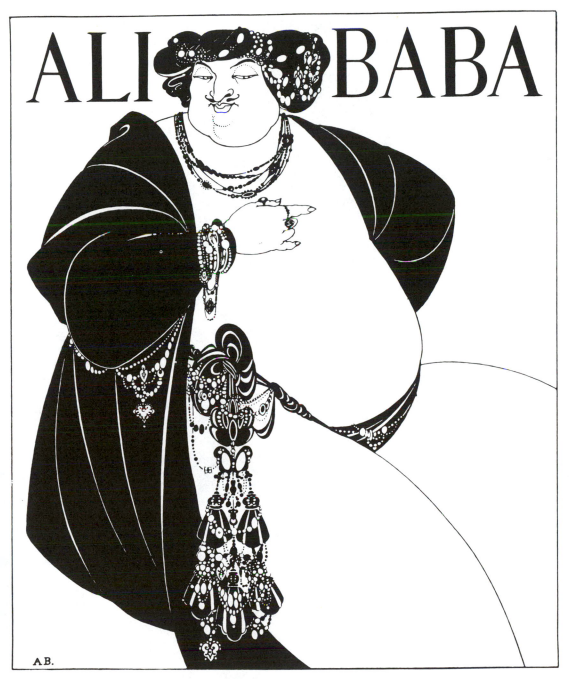

ALI BABA

AB.

3-3 *Ali Baba.* (1943.647, Grenville L. Winthrop Bequest, Courtesy of The Fogg Art Museum, Harvard University Art Museums, Cambridge, Mass.)

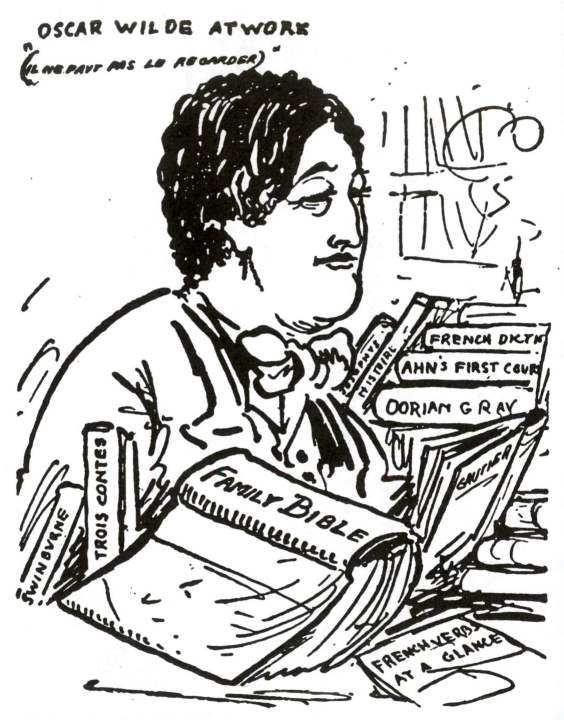

3-4 *Oscar Wilde at Work.* (Published in Hind, *Uncollected Work* 48)

and most notably a French dictionary, a "First Course" in French, and "French Verbs at a Glance." It may also have been during this period that Beardsley scribbled the page in his Sketchbook that reads "Oscar Wilde The Swine," framing that characterization with the invective "[nailed] to the cross" (Hind, *UW* 47)—a response, by the way, that intriguingly conflates Beardsley's obsession with "fathers" with his not inconsiderable religious sensibilities.

Symons believed that it was mainly because Beardsley both "admired and hated Oscar Wilde" that he "created a Salome of his own fashioning" ("Cornwall" 131). Yet even in the notorious *Salome* caricatures (analyzed at length in chapters 5 and 6), there is evidence that Beardsley's anger with Wilde never wholly supplanted his need for recognition from him. Brian Reade suggests that the several caricatures in *Salome*—executed for the most part well before the translation calamity (some perhaps as early as June 1893) and less aggressive than many of Beardsley's other caricatures—may have been intended originally as a sincere attempt to impress Wilde, a sophisticated (if wrong-headed and misjudged) mischief that he "thought Wilde of all people would enjoy" ("AB" 6). While Beardsley's mother may have been right that the mocking beauty in the drawings was too delicate for Wilde not to admire (E. Beardsley, "AB" 5), Wilde might have admired them more had they not linked him so obviously with lubricity—a common interest between the artist and his mentor but a public connection Wilde had made at least a passing effort to avoid. As it was, Wilde joked—nervously and with revealing sharpness—that the pictures were "like the naughty scribbles a precocious boy makes on the margins of his copybooks" (though, as we have seen, not as naughty as what Beardsley actually did scribble in his copybook), "cruel and evil, and so like dear Aubrey, who has a face like a silver hatchet, with grass-green hair" (Pearson 230).

Despite their strained relations and mutual petulance, Beardsley's attraction to Wilde, or need for his approval, led him to continue as Wilde's companion, dining and going to the theater with him virtually up until the time of Wilde's arrest. It was during this same post-*Salome* period that Beardsley made Wilde a gift of his famous profile drawing of Mrs. Patrick Campbell, which appeared in the first number of *The Yellow Book* and which Wilde proudly hung in his library study (Hyde, *Wilde* 96, 166). Evidently Beardsley's family felt the relationship was warm enough to warrant asking Wilde for significant favors. In 1894, through Ross, Beardsley's mother solicited Wilde's help in furthering Mabel's career, which Wilde gave, even to the point of getting her cast as Lady Basildon in one of the productions of *An Ideal Husband*. And in mid-February 1895, only a few weeks before Wilde's world collapsed, Beardsley accepted an invitation to sit in Wilde's prominent box (with Wilde and Ada Leverson) for the first performance of *The Importance of Being Ernest*. In fact, it was not until Wilde's disgrace and Beardsley's summary firing as *Yellow Book* editor that any break was apparent between them.

Ostracized and humiliated by his abrupt, ignominious expulsion from *The Yellow Book*, Beardsley "writhed at the injustice" of being besmirched with, as MacFall overstates, "an association of which he was wholly innocent" (E. Beardsley, "AB" 5; MacFall, *AB* 63). Suffering the consequences of such a dangerous association, Beardsley clearly understood the need to separate himself from the person he saw as the source of bad luck (Mix 147). He even created yet another new style, far different from the Byzantine-Japanese worlds of *Salome* and

the blatant, demimondaine eroticism of *The Yellow Book*. Furthermore, when Smithers proposed establishing *The Peacock*, Beardsley was eager to contribute and be art editor, but only "if it is *quite agreed that Oscar Wilde contributes nothing to the magazine anonymously, pseudonymously or otherwise*" (*Letters* 409; Beardsley's italics). And yet, even after his *Yellow Book* humiliation, Beardsley exhibited ambivalence about his former "mentor." Paradoxically, his unjust firing, which only reinforced his contempt for social hypocrisy, may have actually strengthened his subconscious bond with the scapegoat Wilde. Surprisingly, Beardsley clearly did not appreciate the publisher John Lane's well-meaning (if partially self-serving) attempts to separate him from Wilde and whitewash his reputation (MacFall, AB 70). In the aftermath of the Wilde debacle, Lane claimed that Beardsley was actually an enemy of decadence:

> I remember being interviewed in New York [during the Wilde debacle] regarding the alleged decadence in Beardsley's work. I said then, and I repeat now, that he merely lashed the follies of his time, that he was the Hogarth of his day, and that he had no more sympathy with decadence than Hogarth had for the vices depicted in "The Rake's Progress" and "Marriage à la Mode." Knowledge must never be confounded with sympathy. I will go farther, and declare that Beardsley, by his grotesque and powerful pictures of several hideous phases of life, dealt a death blow to decadence. ("Publisher's Note" 22–23)

As fearful as Beardsley was of being linked with Wilde, he would have nothing to do with such recuperation efforts and, in fact, resented Lane's argument that he was not really a Decadent (which was, in several respects, not far from the truth).[17] But perhaps the most astonishing evidence of the strong pull Wilde continued to have on Beardsley was the fact that in late August 1895, in a bizarre act of symbolic identification, Beardsley took the self-destructive risk (given his circumstances) of establishing residence in Wilde's old rooms at 10–11 Saint James's Place, an address made public at the trials as the scene of some of Wilde's homosexual liaisons.

Even though the need to distance himself completely from Wilde was obvious, Beardsley continued, despite the fact that most of his friends and acquaintances wanted no part of Wilde, to ask about his former mentor and even expressed an interest in once again illustrating his work. Beardsley was "much struck" by Wilde's "Ballad of Reading Gaol" when Smithers showed it to him and, while his deteriorating health made it "hopeless to try and get any connected work out of him," nevertheless "promised at once to do a frontispiece for it" (Wilde, *Letters* 635 n. 2; Beardsley, *Letters* 366 n. 1). Beardsley did not follow up on his offer, but he did voice the hope that Wilde's poem would soon appear publicly and later communicated an interest in knowing when it would (*Letters* 371, 397). Moreover, in a letter to his sister Mabel (24 November 1897), Beardsley joked in a manner that demonstrates his empathy for Wilde. Discussing what Mabel might do to prepare for her upcoming role as a "London tart," Beardsley made the sarcastic suggestion that she solicit coaching from Charles Brookfield, the actor and playwright who contributed to Wilde's downfall by hunting up evidence against him, including the testimony of a prostitute who blamed her falling business on Wilde's activities (*Letters* 396–97).

After Wilde was released from prison in the summer of 1897, Beardsley voluntarily spent time with him on several occasions, despite the fact that Wilde was the sworn enemy of Beardsley's benefactor Marc-André Raffalovich, who had vowed that no one could be Wilde's friend and his simultaneously ("Wilde" 701). Referring to Wilde, Beardsley wrote to Raffalovich from the Hôtel Sandwich in Dieppe on 26 July that "some rather unpleasant people come here" and that he feared "some undesirable complications may arise if I stay" (*Letters* 351–52). Yet Beardsley did stay, although he assured Raffalovich on 3 August that "the unpleasant people come and *go*" (354). In fact, Wilde's stay in Dieppe—even at the same Hôtel Sandwich—had predated Beardsley's own, and far from finding Wilde unpleasant and undesirable, Beardsley was apparently very responsive to him. On 19 July he had a cordial dinner with Wilde at Villa des Orchides, the famous home (and magnet for artists) of the Norwegian landscape painter Fritz von Thaulow and his family in the faubourg de la Barre, overlooking the Dieppe citadel and the Arques valley (Ellmann 536; Blanche, *Portraits* 99–101). He saw Wilde again, accompanied by Leonard Smithers, on 24 July and received another dinner invitation from Wilde for 27 July (Wilde, *Letters* 627). On 3 August, the same day Beardsley wrote to Raffalovich of Wilde's departure, Wilde was writing to Reggie Turner, "I have made Aubrey buy a hat more silver than silver: he is quite wonderful in it" (Wilde, *More Letters* 151).

We should not forget that Beardsley was seeing Wilde despite the fact that during this period he was (off and on) a virtual invalid in the last stages of a consumptive illness and living with his mother, who by now found Wilde despicable, as did most of the other English guests at the hotel. Beardsley clearly wanted his benefactor Raffalovich to think that he was trying conscientiously to avoid the hated Wilde, but in fact he was not. For all his apprehensiveness, Beardsley did not move from Dieppe until mid-September. He apparently did stand Wilde up for dinner, perhaps yielding to Raffalovich (his new "Mentor") or admonitions from his mother, but only after having seen Wilde intermittently for more than two weeks.[18] Vyvyan Holland, Wilde's second son, reported going with his father, as a boy of eleven or twelve, to visit Beardsley during his last months at Menton and being struck by the singularly kind things Beardsley said about Wilde (Easton 76). Beardsley's unusual effort was perhaps a natural courtesy, in the presence of Wilde's son, but given Beardsley's notorious pride and especially his extraordinarily weakened condition (atypically, he had not shaved in many days), it was a courtesy he could have withheld easily and blamelessly, had he so desired. That he did not, and that he agreed to see Wilde at all, even though he was gravely ill and hardly presentable, suggest the authority Wilde still represented to him and the degree to which Beardsley respected such authority.

Another powerful surrogate father—perhaps, all things considered, even the most powerful—was Whistler. Like Wilde, Whistler was a highly accomplished, crassly commercial entrepreneur, his arresting experiments with asymmetry, minimalism, and typographical styles being specifically designed to catch the eye of the new, fast-paced, modern marketplace. Beardsley admired Whistler more than any other living artist. When he was still a clerk at the Guardian Fire and Life Insurance Company, he once spent his entire salary of fifteen pounds on Whistler's minor 1859 "Thames Set" etching (Scotson-Clark, "AB" 13; Weintraub, *AB* 26). In August 1891 Beardsley praised Whistler's *Miss Alexander* as "a truly glorious, indescrib-

able, mysterious and evasive picture" and demonstrated his homage to Whistlerian aesthetics by attempting "an exact reproduction in black and white of Whistler's *Study in Grey and Green*" (*Letters* 25).

Along with Rossetti, Whistler had been a leader in introducing Utamaro and other (primarily ukiyo-e) Japanese influences into England, following upon Commodore Matthew Perry's opening of Japan to the West in 1854, the imports of the dealer Murray Marks, and the first Western exhibition of Japanese art (the International Exhibition) organized by Sir Rutherford Alcock in 1862 (Woodring 237). Whistler's Japanese interests were no small inspiration to Beardsley. He was awed by the Japanese-influenced Peacock Room Whistler had designed and decorated in 1876 and 1877 for the Liverpool shipowner Frederick Leyland's dining room at 49 Prince's Gate—so much so that he commemorated his and sister Mabel's July 1891 visit to see it with some dozen sketches, including *Going thro' the Rooms* (Hind, *UW* 59), where a respectful, somewhat bowed young artist, hat in hand, is shown following his sister through the exhibit. Beardsley appropriated several elements from the famous room— such as stippled ornamentation, the whiplash "sting," and concentric circular arcs and scales designed in dotted lines—for use in his "japonesque" drawings (Schmutzler 74), as well as in more abstract later designs such the cover of Dowson's *Verses*. He was influenced also by Whistler's use of "negative space," large areas of white space accentuating essential, but often uncentered, images (or typeset text). Even Beardsley's "japonesque" signature was inspired by Whistler's stylized butterfly, both "signatures" involving an elimination of written words that would presumably interfere with the pictorial purity of the overall composition (Slessor 31).

Like the rival-dandy Wilde, Whistler was a virtual icon of the Café Royal, which had catered his wedding feast, reportedly eaten off packing cases at his Tite Street studio (Deghy and Waterhouse 59–60; Crawford, "Nineties" 22–23). In fact, Whistler's famous Sunday morning brunches had predated Wilde's luncheons, and, as with Wilde, Beardsley found irresistible and sought to imitate Whistler's mystique and the legends of his verbal repartee.[19] It was from studying both Wilde and Whistler that Beardsley refined what Arthur Symons called the "peculiar kind of brilliance" in his conversation, "a salt, whimsical dogmatism, equally full of convinced egoism and of imperturbable keensightedness" ("AB" 91), although the arrogant and grandiosely defensive persona Beardsley created for himself was modeled more after the "bitter Whistler" (MacFall 19, 83).

Nevertheless, like so many other Whistler disciples, Beardsley soon found himself rejected, another victim of the cantankerous expatriate's *mauvais langue*. During a May 1893 encounter at the Café de la Paix, Whistler, put off by Beardsley's odd physical appearance (and used to scorning anyone associated with Wilde), scolded Pennell (after Beardsley had retired) for his interest in the lad: "Why do you get mixed up with such things? Look at him!— he's just like his drawings—he's all hairs and peacock's plumes—hairs on his head—hairs on his fingers ends—hairs in his ears—hairs on his toes. And what shoes he wears—hairs growing out of them!" (Pennells, *Whistler* 2: 139–40). Pennell prevailed upon Whistler to allow Beardsley to join a large group of admirers, including Puvis de Chavannes and Mallarmé, the next day in the garden of Whistler's new apartment at 110 rue du Bac. A worshipful Beardsley appeared in the stylish straw boater his idol had made famous, but the irascible Whistler could

only continue his litany of "Those hairs—hairs everywhere!" and deliberately stood up Beardsley for dinner, which Beardsley took (as it was intended) as a personal insult (J. Pennell, *AB* 32–33; Pennells, *Journal* 12; Weintraub, *AB* 52). Whistler similarly made no effort to hide his dislike of *The Yellow Book*, particularly Beardsley's work in it, and found the *Salome* drawings even more offensive. When asked by the art critic Royal Cortissoz his opinion of the sensationally successful Beardsley, Whistler gave a disgusted wave of his hand, answering disdainfully, "He seems to me like one of those men who stand idle in the market place because no man hired them" (Cortissoz 16).

Beardsley's response to such treatment was, as so often the case with his father figures, oddly ambivalent. He continued to use Whistlerian elements in his drawings, and even asked Whistler to contribute to *The Savoy* (Benkovitz 138, 150), but wherever possible tried to ridicule him, either through direct caricature or by mocking some association, like Whistler's butterfly signature. One typically venomous attack is his Title page of *The Dancing Faun* (1894) by Florence Farr (Figure 3–5), which caricatures Whistler's effeminate dandyism, even representing him as a grotesque animal. Farr's novel had nothing whatever to do with Whistler, but Beardsley showcases the dandified artist—readily identifiable by his distinctive hair, monocle, and black-bowed patent shoes—in a rather Whistlerian modern design. Invoking the novel's title ironically, Beardsley transforms Whistler into a lounging satyr, which is presumably appropriate to what Beardsley considered to be the expatriate's uncontrollably monstrous personality. Beardsley was even more specific in what he called his "very malicious" *Caricature of Whistler* (Figure 3–6), which he claimed he and Mabel hung in mockery on their 1894 Christmas tree (*Letters* 230). Beardsley here cunningly augments the content stylistically, emphasizing Whistler's presumably effete eccentricity by metonymically skewing the balance of the picture itself: he places virtually the entire figured portion in the upper sixty percent of the space (the main figure concentrated in the upper right-hand corner), leaving the lower forty percent empty—an appropriately Japanese-Whistlerian perspective here carried to an extreme. The drawing cleverly ridicules its subject by playing on other in-jokes as well. Besides introducing the butterfly signature and the Japanese effects of which Whistler was so fond, Beardsley added to Whistler's lapel the sunflower associated with Oscar Wilde, whom Whistler had come to detest. He also places on Whistler's expanded hair a straw boater, "hairs" and the boater being two elements Whistler found objectionable and ridiculous on his young disciple but now amusingly turned against himself. Furthermore, Beardsley cruelly positions Whistler on a garden loveseat of the frail, Japanese-influenced, "Aesthetic" type designed by Edward William Godwin (Reade, *AB* n. 336), who was an outspoken champion of Whistler's work but whose former student and wife, "Trixie," Whistler had taken as his mistress and then as his second wife.[20] Beardsley's need to satirize Whistler continued unabated even two years after Whistler's initial snubs of him, when in the summer of 1895 Beardsley and Will Rothenstein collaborated on a satirical dialogue that Beardsley used as a vehicle for denigrating "severe attacks of Whistlerian tremens" (Rothenstein Papers).

So intense was Beardsley's fixation on Whistler that he even struck at him through his beloved wife. Beatrix Godwin Whistler is the subject of perhaps Beardsley's favorite caricature, unflatteringly titled *The Fat Woman*, following the lead of detractors who considered the

3-5 Title page of *The Dancing Faun* (1894) by Florence Farr. (E.452-1899 [neg. no. FF136], Victoria and Albert Museum, London)

3-6 *Caricature of Whistler.* (Rosenwald Collection, National Gallery of Art, Washington, D.C.)

corpulent "Trixie" annoyingly bossy and referred to her maliciously as "the fat thing" (McMullen 238). Hoping for maximum effect, Beardsley intended the drawing to appear in the debut issue of *The Yellow Book*, but publisher Lane refused, being too prudent a businessman to risk having the master's notoriously effective malevolence endanger his new magazine. Beardsley's unusually strenuous and melodramatic March 1894 appeal to save the picture—accompanied by a drawing of a tearful Beardsley contemplating a gallows noose (*Letters* 224–25; *Miscellany* 33)—suggests, for all its comic touches, the emotional stake he invested in seeing the piece appear:

> I shall most assuredly commit suicide if the *Fat Woman* does not appear in No. 1 of *The Yellow Book*.
>
> I have shown it to all sorts and conditions of men—and women. All agree that it is one of my very best efforts and extremely witty. Really I am sure you have nothing to fear. I shouldn't press the matter a second if I thought it would give offence. The block is such a capital one too, and looks so distinguished. The picture shall be called *A Study in Major Lines*.
>
> It cannot possibly hurt anybody's sensibilities. Do say yes.
>
> I shall hold demonstrations in Trafalgar Square if you don't and brandish a banner bearing the device "England expects every publisher to do his duty."
>
> Now don't drive me into the depths of despair. Really I am quite serious.
>
> (*Letters* 65–66)

His disclaimers aside, Beardsley clearly did intend offense, as is obvious from his original title—"A Study in Major Lines"—a nasty parody of Whistler's well-known method of titling his own pictures, as well as a catty allusion to Mrs. Whistler's ample dimensions.[21] When Lane proved adamant, Beardsley gave the drawing to Rothenstein (who at the time shared a work-room in Pimlico with Beardsley), but his nervous friend returned the drawing, urging Beardsley to destroy it. Instead Beardsley placed it as soon as he could with Jerome K. Jerome, and it appeared in the 12 May 1894 issue of *To-Day* (Reade, *AB* n. 325). When Whistler saw the picture, he was incensed, to Beardsley's immense delight.

We can see why Whistler was insulted. Kenneth Clark has called *The Fat Woman* (Figure 3–7) "one of Beardsley's most masterly" caricatures (96), and Simon Wilson has hailed it as "one of Beardsley's greatest drawings of any period of his career" (*AB* 21). Making a rather deep pun on her name, Beardsley depicts "Trixie" Whistler as a huge demimondaine, sitting at a table intended to suggest the Café Royal, not only the favorite restaurant of Whistler and many other artists but a legendary haunt of women of the night looking for "tricks." Her large block of hair supports a wildly exotic hat, and she surveys the scene with domineering aplomb (characterizations that, by the way, also mocked the effeminate, vain, and arrogant Whistler himself). Beardsley further accents the woman's dominating aura by the pitch-black back-ground that recedes from her imposing white form and the table she rules, the massive expanse of her shoulders and bust, the animalistic construction of her hands and arms, and, as Fletcher has noted, the cruel and complacent set of her mouth, the cool and authoritative nature of

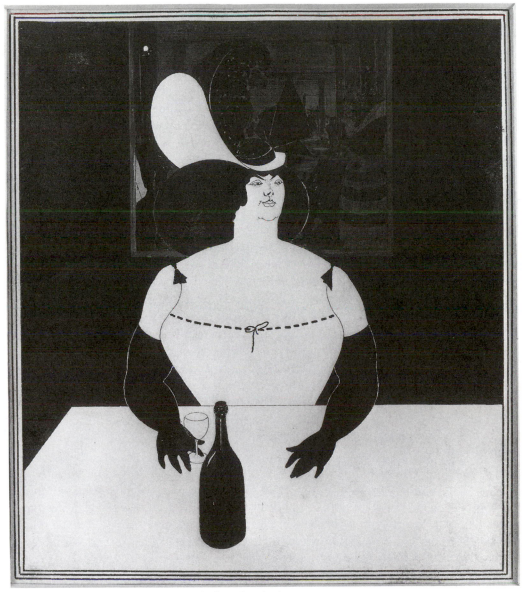

3-7 *The Fat Woman*. (N04609, Tate Gallery, London)

her gaze (or glare), and the fact that her "large index finger rests on the empty glass in front of her, a mute command to a waiter or perhaps a client to fill it" (AB 107).

However, subtle details of the picture work to make Mrs. Whistler's regal air "an absurd overconfidence in the authority of her charms" (Fletcher, *AB* 107). The tiny delicate bow that sits precariously on her dress is comically dwarfed by her huge bosom, as are the little

strips of black cloth by her mammoth shoulders. Her far-off gaze seems oblivious to the fact that a black bottle encroaches rather phallically upon her white frame and that, moreover, the hair against her face, which in one sense enhances her dominance, also simultaneously undercuts it, forming as it does the profile of yet another of Beardsley's leering grotesques (Fisher 399–400). Finally, and perhaps most cunningly, although Mrs. Whistler's authority seems metonymically reinforced behind her by what appears to be a river scene resembling her husband's Old Battersea Bridge painting, that too is an illusion. The reflected tuxedo in the lower left-hand corner of this presumed "painting" reveals Beardsley's clever mimicry of the familiar Pre-Raphaelite trick of turning windows into mirrors: by turning a painting into one he is raising the question whether Whistler's masterpiece is merely the "impression" of a saloon or, as Ruskin claimed, indecipherable blobs of paint that could "reflect" almost anything the viewer wished to make of them.

Beardsley's continuing swipes at Whistler only mark how great was the psychological hold this father figure had on him. It became especially clear one evening in 1896 when Beardsley unexpectedly ran into Whistler at Pennell's, where he had gone to get an opinion on the *Rape of the Lock* drawings. Ignoring the stern dandy, Beardsley handed Pennell one drawing at a time, which Pennell then passed on to Whistler, who looked at them first with indifference and then with ever-increasing interest. After seeing all the illustrations, Whistler peered at Beardsley and said slowly, "Aubrey, you know I never thought much of you, but I have made a very great mistake—you are a very great artist," whereupon Beardsley burst into tears (J. Pennell, *Adventures* 221; Pennells, *Whistler* 2: 140).[22] Nor was this famous incident the only occasion on which Beardsley reacted emotionally upon receiving praise from respected artists, especially those he feared might reject him. "Tears came into his eyes" when he learned that Lord Leighton had rebuffed his rival Phil May's questioning of Beardsley's artistic credentials, asserting before a hostile audience that Beardsley was "one of the supreme masters of line" (MacFall, *AB* 69).

So solicitous was Beardsley of approval from respected artists and writers that when Henry Davray reported, in passing, a small word of encouragement from Mallarmé (who was coincidentally a frequent visitor of Whistler's), Beardsley quickly offered to send Mallarmé a complimentary "large-paper copy" of his *Book of Fifty Drawings*, adding hesitantly, "if you think he would care for it" (*Letters* 348). Indeed, if Fletcher's judgment is correct and Beardsley's "embroideries" of *The Rape of the Lock* are all-too-faithful capitulations to Pope (*AB* [ii]), then it would be but one more example of Beardsley's inclination to accede to authenticating authority figures.

Perfection and Control

One way to try to forestall rejection by the "father" (for an artist particularly) is to try to be as flawless as possible, the perfecting of aesthetic illusion having been historically a key strategy "to reëstablish the control which is threatened by dammed-up instinctual demands" (Kris 45–46). Symons thought that all of Beardsley's art, if most obviously his literary work, demon-

strated an "infinite capacity for taking pains," more willed intellectual mimicry than emotional inspiration. It was a compulsiveness that ultimately produced a "thing done to order, to one's own order, and done without a flaw in the process"—a function, indeed, of the fact that "he was terribly anxious to excel" ("AB" 89–90; *AAB* 17–18). Whatever reservations critics may have had about Beardsley's work, they marveled at his "extraordinary technical perfection . . . the purely executive calligraphic qualities of his pen work . . . the accuracy with which he carries out his intention, does exactly what he proposed to do, measures his technical efficiency" (MacColl, "AB" 24).

As Brian Reade has shown, Beardsley's compulsive perfectionism was reflected even in his rather unusual method and materials. Technically, he drew more like a calligrapher than an artist—holding the pen not loosely and toward the middle or far end of the shaft, as art schools instructed, but with tight wrist and rigidly fixed fingers positioned close to the nib ("Beardsley Re-Mounted" 106). To maximize control, Beardsley drew, somewhat eccentrically, mostly on Whatman papers (or occasionally on cartridge drawing paper or writing stationery), which had a slight roughness of surface and was more absorbent than the smoother, sturdier, and photographically "clearer," chalky bristol board that draftsmen and photographic line-block makers recommended (103–7). This mania for control also dictated Beardsley's choice of drawing implements: initially he used tiny hairline nibs or "etching pens"; then, beginning in 1894, the popular and versatile Gillott No. 1000 pen; and finally, the famous special pen he had custom-made for himself, with its gold nib, gold fitting, and black wood handle. Indeed, Reade suggests that Beardsley may have given up the "etching pen" for more precise instruments mostly in response to Charles G. Harper's criticism of his "bad draughtsmanship," which included tacit advice for gaining better control, expressed in *Drawing for Reproduction* (1894) (Reade 117–19).

But the most unusual manifestation of Beardsley's perfectionism was his method of production, which seemed designed (in yet another self-contradiction) to both reduce the uncertainty between idea and execution and yet maximize the "gamble." He worked on a single sheet of paper, without separate sketches or studies, creating the picture in four distinct stages. First, he sketched "vague pencil scrawls and rough lines to indicate the general rhythm and composition and balance." Second, he drew "with firmer pencil lines the main design." Third, with meticulous concentration and "astonishing certainty," he executed the final pen lines and masses in India ink directly over the earlier penciled lines. Last, he erased the unwanted penciled remnants or obliterated them in black masses (W. Rothenstein, *Memories* 1: 135; MacFall, *AB* 30). Amazingly, Beardsley often inked the lines of his "frame" *first* (its restraining force sometimes accentuated by a double- or triple-edged border), even before he drew the picture itself—all of this despite the dangers of smudging and the artificial limitations on space that such a practice enforced (J. Pennell, *AB* 41; Reade n. 300; Hofstätter xviii).

Paradoxically, such a method demanded extraordinary control yet also surrendered to a kind of gambling "inspiration."[23] On the one hand, it seemed to show "no cant about inspiration" (MacFall, *AB* 29) or even a "great contempt for . . . the plenary inspiration of first thoughts" (Symons, "AB" 92), suggesting in the preliminary penciling a tacit insecurity about being able (inspired or not) to achieve "perfection" the first time. Beardsley's drawings became

disciplined palimpsests, a final bold ink stroke incorporating the "original" penciled inspirations on a single, layered, "original" surface, even at the risk that the numerous embroiled pencilings might cause him to lose or muddle his idea for the final contour. Yet, on the other hand, ironically, in the decisive execution of the drawing, Beardsley gave himself over irreversibly to the "caprice of the moment," demonstrating a Romantic faith in the unerring correctness of that other, more delicate point of origin, the momentary inspiration of each permanent and irrevocable contact of ink with surface. Even the way he sometimes inked his final lines seems both compulsive and risky: he told Yeats that he would drop a large "blot" of ink on the site of what was to be a black mass, then swirl it around and "shove it about till something comes," drawing lines "out from there, as chance had plotted the figure in the bud" (Yeats, *Letters* 860; Hofstätter xiv). Beardsley's technical approach to his art was a bold attempt to capture and sum up in a single "gambling" stroke both the original moments of conception and his final instantaneous inspiration: "[T]he technique he employed, with all its risks, . . . enabled him to preserve the fruits of concentration or chance, the instruction of his Muse, which might otherwise have vanished under his untrained hand in the course of transference, by copying or even tracing, on to a fresh surface" (Ironside 212).

Just as significant, perhaps, Beardsley's meticulous method signals his anxiety that anything less than painstaking and perfectionistic control—even to the point of working and reworking the same surface—might result in irredeemable loss of the artistic idea. Mabel recalled that in order to achieve "infallibility and assurance" Beardsley "brooded over a sketch for days . . . and then he worked days and nights with a passionate energy in order to bring into being his imaginative vision with the highest precision" (quoted in Gallatin 12–13). Indeed, it is an indication of Beardsley's perfectionism that once when one of his original drawings was sent to New York to be reproduced, an official of *The Century Magazine* tossed it into the waste basket, thinking it a finished printed reproduction (J. Pennell, *AB* 23). Beardsley was equally obsessive about his written work. Even when on holiday, he was said to be "for ever jotting down notes" in his ever-present, gilt-hinged, morocco-leather Louis XIV–style portfolio (MacFall, *AB* 82). MacFall reported how by "dogged toil" and "infinite travail" an agonizing Beardsley "chiselled and polished and chiselled" his poetry, piecing "the overpolished sentences and phrases together like a puzzle, making them fit where best they can" (*AB* 82).

Ironically, Beardsley's workmanlike assiduity and painstaking execution balanced, or at least mitigated against, the destructive, revolutionary aspects of his "marginalizing" pictures. While much of Beardsley's art has the semblance of revolutionary free play, the discipline of his well-crafted style is implicitly and decidedly logocentric—a rather bourgeois, and certainly classical, attempt to reduce elegance to law, to a "respectable" economy of constituent elements, with no "waste." In a technical sense at least, what Kenneth Clark calls Beardsley's "extraordinary . . . simplification," leaving out "everything which doesn't contribute to his effect" (24), is but a variation of the traditional Victorian emphasis on controlled, efficient, utilitarian performance. We recall that Beardsley's art-for-art's-sake ornamentation almost always reinforces the thematic content of his pictures, thereby in one sense actually *limiting* viewer "play." Far from overturning Victorian sexual obsessions, for instance, Beardsley's overdetermined drawings only confirm the reductionist view that *everything* is sexual. His fore-

grounding of defamiliarizing style disguises the fact that his satirical "narratives" are actually reinforcing much of the ruling cultural order—narrative itself being a particularly powerful means of "affirming the coherence of the text and binding the reader or viewer to it in a relationship of pleasurable dependence" (K. Silverman 245).

For that matter, Beardsley's tacit desire to incorporate virtually everything—concept, sketches, revisions—into one ultimately all-encompassing, perfectionistic drawing, without meaningful loss, was positivistic in a thoroughly bourgeois Victorian way. In one sense it was but the formalistic equivalent of his urge to absorb and move restlessly through numerous fatherly influences. Each change in style became a dialectical incorporation and supersession of previous models, another means of gathering the Whole, of omnivorous perfectionism. It was just this implicit need to recuperate loss and return to some mythical wholeness that Brigid Brophy identifies when she cites, as an example of his Freudian repetition-compulsion, Beardsley's repeated revisions in *The Story of Venus and Tannhäuser* and his practice of tracing and retracing "the details of images to get them exactly correct" (*Black* 50).[24]

Whatever we may wish to label it, Beardsley's compulsive perfectionism and need for control seemed to recognize few boundaries, extending even beyond the execution of his drawings to the supervision of their reproduction. He routinely gave unusually detailed instructions regarding the making of plates and insisted on seeing the proofs of his work before publication (see *Letters* 309, 310, 413, 417, 418, 426, 427). He often expressed an almost paranoid fear that "my masterpieces are getting lost or spoilt in the post" or would be otherwise marred before their plating (422). On several occasions, even when dealing with an experienced firm familiar with his work, he rushed strident letters to Smithers, labeled "Urgent and Pressing," directing him to "beg [the plate setters] *not* to *rub* or *touch* the drawing" (319, 420). Beardsley sometimes went out of his way to specify what kind of paper and which printer he wished Smithers to use in reproducing his drawings. Nor was his control fixation calmed by good past experience. He expressed delight with Boussod Valadon's reproduction in photogravure of his frontispiece for *Mademoiselle de Maupin*, even vowing that Valadon should henceforth do all his work, only at other times to fear using the French printer since there was "no one near to see after him" (*Letters* 279, 381; MacFall, *AB* 95).

Beardsley's perfectionistic obsessiveness showed itself also in his unceasing (if often unsuccessful) efforts to retrieve and destroy early work that he felt was inadequate. Ross reported that not only was Beardsley loath to show an unfinished picture but he carefully destroyed any pictures with which he was not thoroughly satisfied. He even tried to destroy what he considered immature works bought by or given to friends—such as the aforementioned *Self-Portrait* (Figure 1–12), which Beardsley reputedly "strained every resource to recover" from Ross—offering to substitute in their place "more mature and approved specimen[s] of his art, or the *édition de luxe* of some book he had illustrated" (R. Ross 22–23; MacFall, *AB* 13, 93). Beardsley was so concerned about "bad" works he had failed to destroy that he made Smithers swear "a solemn oath and covenant" that Smithers would never, if he could prevent it, allow certain drawings to be published—particularly anything from Beardsley's boyhood *Scrap Book*, then belonging to Ross—a promise Ross eventually persuaded Smithers to break after Beardsley's death (MacFall, *AB* 93).

The late-nineteenth-century tide of confessional writing, perhaps evinced most obviously

in the increasingly popular genre of autobiography, encouraged greater exposure of the private and psychological elements of human character. While Beardsley seemed ever eager to exploit the cult of personality, however, he paradoxically exercised more than average British control in his personal life. Pennell reported that the ostensibly urbane Beardsley was shocked and embarrassed at even a routine and amenable crossing of personal boundaries, such as "when he had to undergo getting properly kissed" by the female concierge of one of the noted way stations for artists in Paris, the Hôtel de Portugal et de l'Univers (AB 26). Often relying on a role he wished to project, or one he felt was expected of him, Beardsley deflected personal intimacy wherever possible, taking pains never to reveal himself fully: "All the time the personality of Beardsley was hidden from the public, and many wondered what the artist was like. But they could never reach him. Except to his nearest friends his door was always closed" (Smith 16). As it happened, even his nearest friends didn't fare much better, finding him to be, in Beerbohm's words, "always a preposterous mystery" ("Ex-Cathedra" 31). Very few of the scores of letters and notes Beardsley wrote in his short lifetime are at all intimate, even those he wrote to his sister, who was the closest thing to his confidante (Benkovitz 51, 105). Symons pointed out that for all Beardsley's varied interests and social contacts, his obsession with control made him "essentially very lonely":

> Many people were devoted to him, but he had, I think, scarcely a friend in the fullest sense of the word; and I doubt if there were more than one or two people for whom he felt any real affection. . . . How far he had deliberately acquired command over his nerves and his emotions, as he deliberately acquired command over his brain and hand, I do not know. But there it certainly was, one of the bewildering characteristics of so contradictory a temperament. ("AB" 92)

As liberal and disrespectful of limits as Beardsley's pictures seem, his personal habits were strikingly conservative, favoring rigid discipline and control. In large measure he sought to make most of his interactions with people, like his famous "accidental" encounter with Burne-Jones, into real-life equivalents of his meticulous drawings—that is, carefully planned and compulsively controlled events.

In this regard Beardsley took particular pains to ensure, whenever he could, that his famous press interviews were as prepackaged as possible. Arthur H. Lawrence's "Mr. Aubrey Beardsley and His Work," which appeared in the 11 March 1897 issue of The Idler, purports to be a journalist's observational narrative, interspersed with Beardsley's responses to the reporter's questions. But according to Beardsley's letters (Letters 229, 234), the overwhelming majority of the text was written (almost three months before) by Beardsley himself—a fact that may account for its occasional striking resemblance to Wilde's Socratic dialogues "The Decay of Lying" and "The Critic as Artist," complete with mythmaking allusions to the dandiacal Beardsley's wealthy life-style, connoisseur tastes, and "[passion] for fine raiment" (A. Lawrence 190).

Indeed, Beardsley even sought to control (or at least fictionally modify) the passing of time itself. After his career took off, he began systematically lying about his age, slyly setting

forward each year the date of his birth, not only to retain and accentuate even further his status as a prodigy but also, in effect, to retain, control, and even increase symbolically his "allotment" of time (Fletcher, "Study" 27). In a biographical sketch for the 1895 *Hazell's Annual*, for example, he wrote that he was born in 1873, not 1872 (*Letters* 76), a prevarication he also passed on in a February 1895 interview with *The Boston Evening Transcript* (Smith 16) and an August 1896 interview with *Leslie's Weekly* (90). In his March 1897 interview with *The Idler*, he reported himself as being twenty-three years old, a statement he could have also made over eighteen months earlier (A. Lawrence 189). Beardsley seemed to express his general approach on this matter in a letter to Smithers (11 September 1896) concerning Aymer Vallance's iconography to appear in *Fifty Drawings*: "Don't let Vallance give the public the idea that I am forty-five and have been working for fifteen years; but give people the impression that I am two and have been working for three weeks" (*Letters* 162). In this respect Beardsley's elegant Louis XIV portfolio was not only an emblem of traditional refinement and authority; it was also a vehicle for control. As a talisman that he "opened on impulse to set down penciled jottings of ideas and impressions" (Weintraub, *AB* 143), his portfolio ensured that no important observation would be lost, no opportunity missed—a not unnatural concern for one who sensed he would die young.

So great was Beardsley's mania for control (and the basic insecurity underlying it) that he continued to behave as if he were in serious financial trouble at times when there was no longer any crisis. After his dismissal from *The Yellow Book*, a panicked Beardsley traveled overnight from Paris to Raffalovich's door in order to ask for his financial help, which Raffalovich gave generously (Benkovitz 128).[25] By late 1896 or early 1897 Raffalovich had placed Beardsley on a regular allowance of one hundred pounds per quarter, and Smithers had given him a retainer contract for twenty-five pounds per week. Beardsley himself wrote Raffalovich in 1896 and Mabel in 1897 that money was no longer a pressing concern (*Letters* 343, 388). Despite this significant assistance, however, Beardsley kept reminding Raffalovich and especially Smithers of his presumed need for money, even when he was actually experiencing relatively little financial inconvenience and even when the promised funds (and sometimes supplementary gifts) were in fact being provided (*Letters* 174, 202, 204, 208, 250, 289, 343, 347, 349, 358, 370, 372, 375–76, 393, 416). He publicized to Smithers—and made a running joke of the fact—that he had left Paris without paying his bill at the Hôtel Saint Romain (147–48, 300, 310). He subsequently asked Smithers to pose as his solicitor, in order to persuade his tailor Doré to accept deferred payments on his account (175, 279, 284). Beardsley lamented that he was being pursued by creditors in Bournemouth but hoped "no one will be so hard as to expect more than 1d in the pound from me" (255). In October 1897 he asked Smithers to sell almost "all the books of mine you have," writing a few days later in desperation: "I am utterly cast down and wretched. I have asked my sister to come and see you and have a talk with you. I must leave Paris. Heaven only knows how things are to be managed" (380, 382). And again, in February 1898, he asked Smithers to sell much of his library "and put the results of sale to the credit of my account with you" (430, 432).

Given his family's history of financial instability, Beardsley, not surprisingly, was inclined to make money the basis of his emotional security; and emotionally depleted and under the

strain of approaching death, he may well have felt himself in dire financial straits. But, in fact, he was not. For all his pretense to the popular press of maintaining a life of stylish decadence, Beardsley and his mother lived modestly and frugally, and, unlike many of the artist's colleagues, were generally able to pay their bills. Moreover, it appears that despite all his pleas of insolvency and the expense of his illness, Beardsley had been secretly hoarding a not inconsiderable portion of the money he had received. At his death his estate was valued at a little over one thousand pounds (£836. 17. 10 net) (Easton 102). We cannot assume that Beardsley was simply trying to make provisions for his mother in the event of his death, because in his will he left her nothing (Reading MS. 160/3/1). Despite being intermittently an invalid dependent on his mother, Beardsley maintained at least as much secretive control over his financial affairs as he did over the rest of his personal life. He controlled the family finances himself, doling out money to his mother only as necessary. Indeed, he shared with her very little about any aspect of his personal life—artistic, personal, or economic.[26]

The obsessive concern with control that Beardsley exhibited in his work and his life may have been in one sense, especially given his art's emphasis on the grotesque, a personal manifestation of the fin de siècle's general fear of the irrational, as evidenced in the theories of such thinkers as Bergson, Durkheim, and Freud—the fear of losing mastery, of being swallowed by illogical meaninglessness, of being reduced to the animalistic and monstrous. The Decadents' interest in style and in an aesthetic sensibility that could mold life itself was, at least in part, an attempt to prove that everything was not "an enigma" and that they were not mere "playthings of the inexplicable" (Stutfield 835). Beardsley abhorred "the vague, the blurred, all that is mysterious" (Gray, "AB" 126); and his preoccupation with developing an exacting and even dominating style reflects the desire for some mastering and authenticating authority, "a presence in him of the urge to define, and of what arises from this urge, coherence . . . by drawing lines which give the impression at normal focal length that they are 'perfect'" (Reade, "AB" 12).

Testifying to Beardsley's obsession with control, Reade hypothesizes,

> I suppose being a consumptive his mind worked at rather a feverish pitch. . . . And he was able to put it down very clearly, and without a great deal of preliminary sketching. . . . Well, I don't see how you can do that unless you have great powers of concentration—a very strong will, and a command of your hand to such a degree that you can make it do exactly what you want—a fluent outline, there's no spontaneity in his touch at all, it's absolutely controlled all the time. (quoted in J. Gilbert, BBC transcript 9)

Indeed, Reade argues that Beardsley's stylistic shift after 1896 (in such projects as *Mademoiselle de Maupin* and *Volpone*)—away from his customary black-and-white method to a multidimensional, full-tonal technique involving diluted ink wash and necessitating photogravure reproduction—signaled a psychological yearning for "the substantial qualities of objects and bodies," the "stability, chiaroscuro, solidity" that reflected his "searching for something, some other quality beyond himself" ("Beardsley Re-Mounted" 127). Enervated and confused as death

approached, Beardsley "found authority in the nearly absolute control imposed on the line-engraver . . . as in the seventeenth century" (129, 127)—a kind of a graphic-arts parallel of his eventual conversion to the Roman Catholic Church. John Selwyn Gilbert agrees, observing that "as Beardsley grew weaker, his technique became more demanding" ("AB" 11), his last *Volpone* designs dictating perhaps his most exacting requirements of style. In fact, in Beardsley's last works the lines were drawn to such firm "mechanical severity" that MacFall marveled, "[H]is hand's skill reveals no slightest hesitations nor weaknesses from his body's sorry state" (AB 101–102).

Beardsley's extraordinary compulsive control is perhaps nowhere more clearly evident than in *Ali Baba in the Wood* (Figure 3–8), made in July 1896 at a time when his doctor had told him that his left lung was collapsing altogether and that the right was endangered (*Letters* 143). Employing what Reade calls an amazing attention to technical detail, Beardsley conveys the denseness of the wooded thicket by means of close-laid lines and white dots of varying sizes, spaced at calculated distances on the pitch-blackened background, white being "left in reserve, not applied on the black background" (AB n. 459). It was indicative of his mania for control that he almost invariably chose to convey a sense of texture *artificially*—meticulously drawing innumerable configurations of lines, dots, or other motives until they accumulated to form the desired effect, rather than employing frottage or utilizing one or another of the special textured drawing papers then newly in fashion (Ashwin 366–67). It was as if extreme rigor of style and technique became for Beardsley a means of managing the "monsters" of his emotional turmoil. Penrhyn Stanlaws rationalized that his "slow, certain, steady line" was "free from that nervousness which characterized the man" (212). MacFall even pondered,

> There is something uncanny in the aloofness of Beardsley's art from his life and soul. His art gives no slightest trace of spiritual upheaval. It is almost incredible that a man, if he were really going through an emotional spiritual upheaval or ecstasy [physically dying, yet finding new life in Catholicism], could have been drawing the designs for *Mademoiselle de Maupin*, or indeed steeping in that novel at all, or drawing the *Arbuscula*. (AB 97)

Although MacFall is surely wrong in thinking Beardsley's art "gives no slightest trace" of the spiritual tensions in his life, it seems evident that Beardsley did use his art to try to master his personal pain, or at least distract himself from it.

Yeats interpreted Beardsley's lament that "beauty is so difficult" as another confirmation that artistic beauty is a stylistic means of imposing order, compensating for and reflective of the absence of inner peace in life (*Autobiography* 223). Yeats concluded, as a result, that the increasing tensions in Beardsley's life produced an ever more domineering stylistic rigor: "[A]s the popular rage increased and his own disease increased, he became more and more violent in his satire, or created out of a spirit of mockery a form of beauty where his powerful logical intellect eliminated every outline that suggested meditation or even satisfied passion" (223). In this view, Beardsley's aggressive iconoclasm becomes a psychological defense against not only philistine hypocrisy but also metaphysical meaninglessness. Indeed, so struck was Symons

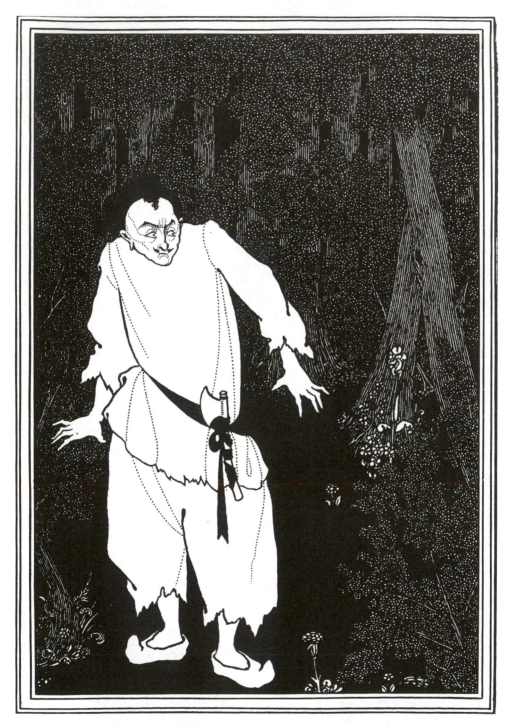

3-8 *Ali Baba in the Wood.* (1986.665, Scofield Thayer Collection, Courtesy of The Fogg Art Museum, Harvard University Art Museums, Cambridge, Mass.)

by Beardsley's compulsively controlled "dogmatism," his "coldly impartial" approach, which was "emotional only . . . in the abstract, for ideas, for lines" and which "hated the outward and visible signs of an inward yeastiness and incoherency," that he proclaimed, rather remarkably: "Beardsley did not believe in his own enchantments, was never haunted by his own terrors, and, in his queer sympathy and familiarity with evil, had none of the ardors of a lost soul" ("AB" 92; *AAB* 19).

Such overstatement is perhaps understandable since Beardsley encoded a certain structural defensiveness into even his rhetoric. Although his pictures often deal with highly charged sexual content, they are hardly ever erotic in the classic sense. Customary erotic passion is encased or defused by Beardsley's distancing "magical technique," by which, according to Martin Birnbaum, he can transform the "most repulsive ugliness into a strange, forbidding, fascinating beauty" ("AB" 7). Even when Beardsley introduces into his drawings a surrogate for himself, the surrogate's position, as Fletcher notes, is generally that of a voyeur, the detached spectator viewing life's otherwise dangerous drama safely "from his theater box":

> Images such as the foetus, the dwarf, the hermaphrodite; monsters such as satyr and satyra; effeminized men; aggressive women; Pierrots; the toilette scene, always from the viewpoint of the voyeur; these stress isolation, exclusion, passivity, and much criticism relates them to Beardsley's sense of his own exclusion from life's feast. . . . Beardsley seems to regard his isolation as a privilege rather than a curse. . . . His is less an expressive than a rhetorical art. And if music was one of Beardsley's compulsions, so that his lines, his blacks, and whites are "composed," set against one another, disposed like chords, then so far as the actual presentation of his work goes, theatre furnishes the appropriate metaphor. ("Grammar of Monsters" 145–46)

Beardsley was in fact very *topos* oriented in both life and art, reflecting the need to create a secure "place" or to defend adequately against the possibility of (once more) losing his "place." When he could, he preferred to draw always in the same workplace and under the same conditions—in his tapestry-darkened rooms, by candlelight. Until his health made staying in London impossible, Beardsley imagined himself "unable to draw anywhere but in London," the "only place where you can live, or work (which comes to the same thing)" (Symons, "AB" 88; *Letters* 73). Certain petulant laments notwithstanding, he loved London "above all the world," and even when he was forced to give up his home there, "he carried his spiritual home with him—clung to a few beloved pieces of Chippendale furniture and . . . the engravings . . . the two old Empire ormolu candlesticks" and other icons of his roots (MacFall, *AB* 86). Throughout his life Beardsley manifested an almost compulsive predisposition to return again and again to the same places he had lived in or visited before. It was as if he felt that by returning to familiar points of origin, he could not only affirm his identity but also control his destiny in another sense—"by going back in terms of place he could go back in time and thereby prolong his life" (Brophy, *AB* 69).

Beardsley's art is probably as sensitive to and as dependent on the manipulation of shapes and spaces as the work of any previous artist, as suggested by its recurring Rococo elements

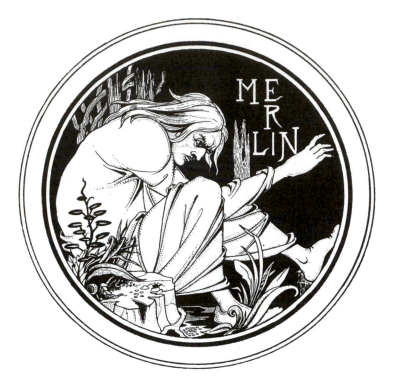

MERLIN

3-9 *Merlin* from *Le Morte Darthur* (for the roundel on the verso of the contents page). (Rosenwald Collection, Library of Congress, Washington, D.C.)

and its persistent themes of imprisonment, of suffocating or being otherwise trapped in impacted spaces. Perhaps because the drawing captured the idea of an imprisoned existence and because he may have identified with its victimized master-magician, Beardsley always had a peculiar affection for his *Merlin* from *Le Morte Darthur* (Figure 3–9), which he gave a frame composed of no fewer than five concentric circles and which (bewildering some critics) he chose to highlight in his prized 1897 collection *Fifty Drawings*. Enclosing a pitch-black background, the circular frame constricts a haggard Merlin (his name in gothic script) into an almost fetal position, emblematic of his helplessness.

A variation on this theme appears in a design for the heading of chapter 3, book 1 (page 3) in *Le Morte Darthur* (Figure 3–10). A kneeling and scowling figure, ironically reaching for a bloom, is entangled by the foliage in the foreground, the ominous sense of imprisonment being accentuated by a trio of black trees, with highlights resembling skeletal bones, and by a pair of swordlike briars blocking the figure's access to the unusually narrow doorway and prospect in the background. In a typically ironic touch, Beardsley designs the background wall ambiguously, so that at first glance it might be mistaken for the sky and its cracks for foliage or clouds, providing an illusory sense of freedom that is ultimately foreclosed. Beardsley's Frontispiece to *The Pierrot of the Minute* (1897) by Ernest Dowson (Figure 3–11) conveys the feeling of imprisoning hopelessness more subtly. The garden—with the trellis, lilies, stylized

roses, tall trees, and Eros on a pedestal—is presumably the open and majestically authoritative garden of the Palace of Versailles, but in fact it is arranged more like the static, enclosed pastorals of Beardsley's idol Watteau (see *Letters* 89, 211, 232, 244). The trellis is positioned as an incarcerating wall, and Pierrot's helpless posture and dazed expression is reminiscent of one of Watteau's doomed figures (Reade, *AB* n. 477). The thick foliage provides Pierrot no exit and partially obscures Cupid, who cocks no arrow of love.

The more Beardsley's career advanced (and the closer he grew to death), the more his drawings seem to become compulsively "busy" and cramped with proliferating details; in most of the illustrations for *The Rape of the Lock, Under the Hill,* and *Volpone* very little unfilled white space remains. The viewer is led almost invariably to the same sensation Ralph Steadman reported upon scrutinizing *The Abbé* for *Under the Hill* (Figure 3–12): "[T]he more one looks at it the more one is drawn into it and the more one feels suffocated" (quoted in J. Gilbert,

3-10 Design for the heading of chapter 3, book 1 (page 3) in *Le Morte Darthur*. (899/OD13, Art Gallery of Western Australia, Perth, Australia)

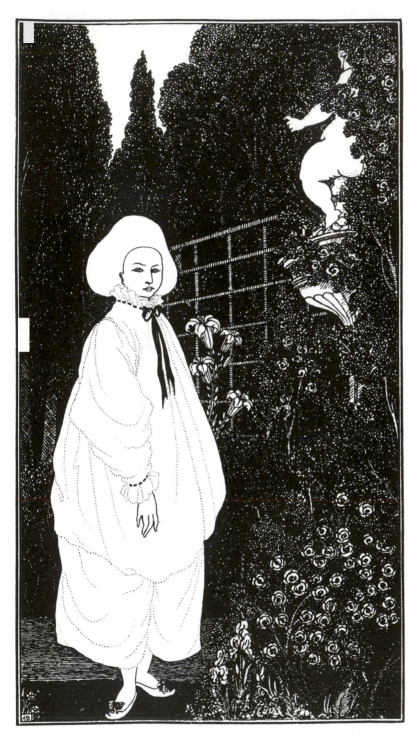

3-11 Frontispiece to *The Pierrot of the Minute* (1897) by Ernest Dowson. (Rosenwald Collection, Library of Congress, Washington, D.C.)

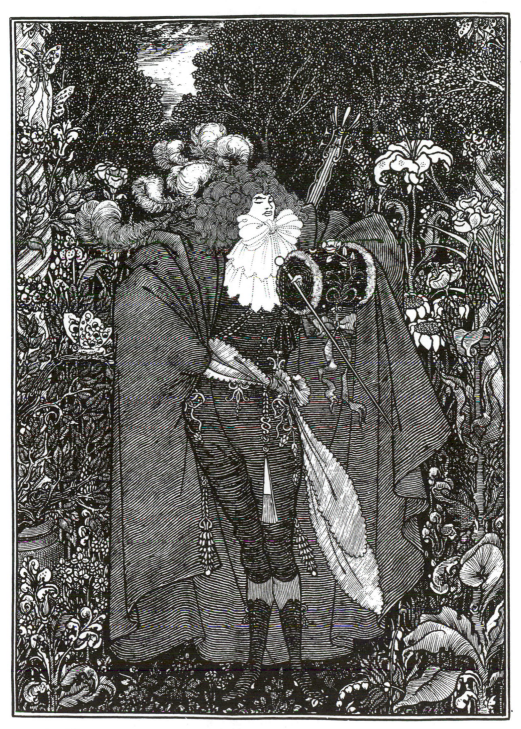

3-12 *The Abbé* for *Under the Hill.* (E.305-1972 [neg. no. HD748], Victoria and Albert Museum, London)

"AB" 10). At the least, the frenetic, "overfilled" spaces in many of Beardsley's later drawings reflect once again his obsession with control. It was appropriate that Beardsley described his drawings for *The Rape of the Lock* as having "embroidered" the text, because, as Robert Halsband notes, "except for carefully balanced patches of white every bit of surface is textured like hand embroidery of various sorts, from faintly visible, delicate stippling of dots to heavy, almost solid blacks" (109). Indeed, Beardsley had the *Rape* drawings reproduced at eighty percent of their actual size, thus enabling him, first, to cram even more detail into the drawing than might otherwise be possible, and then minimize still further the sense of "unfilled" space. Ernst Kris has observed that *horror vacui* is a typical characteristic of the drawings of schizophrenic personalities (107)—that is, those who tend, like Beardsley, to oscillate among alternative realities or alternative approaches to reality. His relentless desire to fill (even overfill) vacant space ironically highlights one of the Janus-faced impulses in his art—a desire to fill and presumably redeem the "emptiness" that simultaneously signifies the smothering imprisonment he felt.

Art as Rescue

Symons argued for Beardsley's greatness on the basis that his pictures revealed "a sort of abstract spiritual corruption . . . in beautiful form; sin transfigured by beauty"; Beardsley's was quite literally a redemptive art "in which evil purifies itself by its own intensity, and by the beauty which transfigures it" ("AB" 99). It was this same logic that allowed Gray to make the astonishing claim that "all that [Beardsley] was, all that he did, was good" ("AB" 126), and that permitted Julius Meier-Graefe to conclude that Beardsley's art was healthy because it "made a formula of morbidity," generating "a deliberate, scientifically exact representation that achieved the desired effect" (2: 258)—what Reade calls Beardsley's "compulsion . . . to convert excruciation into a kind of macabre comedy, by way of stylization" (*AB* n. 261). Like many of his nineties colleagues, Beardsley wagered that the rigidly stylized and purified realm of Art could ultimately redeem the evil and morbid world it addressed, setting itself against that compromised lower world as an enduring source of meaning and value. Their emphasis on iconoclastic modernity notwithstanding, the almost puritanical devotees of the Decadent Religion of Art were, as J. E. Chamberlin has described,

> mysteriously united in a high-minded purpose too pure and ideal (and too easily distorted) to set down in words. They had a sacred mission, they had their "scarlet sins," and they posed as an ennervated [sic] and ennervating [sic] lot, determined in their ennervation [sic] to subvert the virtues of industry and thrift which the age espoused, and to keep art away from utilitarian and moral ambitions. . . . Decorative and other similarly abstract forms of art were in a way a defence of this sort against the perversions of representative art; just as symbolism, with its isolation of the elements of a numinous reality, was (in Arthur Symons' view) a defence against materialism. ("Decadence" 602, 598)

Beardsley's "abstract" and "decorative" drawings, so esoterically sinful and mysteriously oriental, were perfect embodiments of the nineties' elitist Religion of Art, substituting (in a most Decadent revision of Platonic idealism) the arcane spirituality of "groundless earth," "floating figures," and "reckless lack of perspective" (MacFall, *AB* 50) for the "objective" realism that Victorians used to reinforce materialistic notions of truth and power.

Undoubtedly, part of Beardsley's attraction to Japanese art was the way it manipulated frozen forms and space to achieve a sense of timeless order and logic—the Absolute—in opposition to the kinetic flux of historical change.[27] Devaluing such bourgeois seats of superior authority as the author's text, the material "real" world, and conventional morality, Beardsley's art, like much of Decadent art, ventured to create an independently sovereign imaginative world, to provide metaphysical meaning and value through beauty of line, pattern, design, and highly stylized representation. Beardsley's bold, black lines conveyed a triumph of inherent form, intrinsic order, and (perhaps above all) mastering control—as powerful as, and seemingly more secure than, Impressionism's fleeting dabs of color. Yeats marveled that Beardsley focused so greatly on "patterns and rhythms of line" that sometimes "the images of human life have faded almost perfectly" into pure form (*Uncollected Prose* 2: 134). Pennell was similarly awed by Beardsley's perfect execution (*Studio* 14); and Philip Gilbert Hamerton exalted his "extreme economy of means . . . the perfection of discipline, of self-control, and of thoughtful deliberation at the very moment of invention" (187). The attempt to detach language or images from syntactically compromised conventional realism—in order to focus, instead, on "pure" sound, decorative line, momentary sensation, and symbolic meaning—was in itself only another bourgeois conception of superior authority. It had, however, the virtue of being without what the Decadents took to be the more onerous slavish "realism," political conformity, and pervertible moralism of conventional society.

Like any group of elitists, Beardsley and his fellow Decadents were affirming their independence from bourgeois compromise not in order to repudiate transcendent authority but precisely in order to affirm as that authority their own version of truth—Art's "holy writ of beauty." Far from rejecting the spiritual foundations of conventional religion, the Decadence, in its worship of order and artistic control, sought merely to refurbish them, establishing a new priesthood with new tools but following virtually the same traditionalist principles and logic. As Roger Fry noted, even as the "Fra Angelico of Satanism," Beardsley has "all the stigmata of the religious artist—the love of pure decoration, the patient elaboration and enrichment of surface, the predilection for flat tones and precision of contour, the want of the sense of mass and relief, the extravagant richness of invention" (236). Like other nineties Decadents, Beardsley had come to fashion himself as Art's "priest." Indeed, we recall that he not only invariably carried the relics and sacred trappings of his office around with him (his drawings and the draft of his novel in his gilt-hinged portfolio); he also worked at a "priest's desk" in a room wholly darkened by heavy tapestries except for the lit altar candles of two Empire ormolu candlesticks (Stanlaws 212; Mix 50–51).

Henry Melancthon Strong said that for all Beardsley's "lack of reverence for serious subjects, his schoolboy candour and fondness for shocking the feelings of others," history would ultimately attribute his unprecedented success to "his marvellous power of seeing and repro-

ducing the *essential*" (90). Like the Decadence generally, as much as Beardsley's bizarre and "ugly" art seemed designed to shock and titillate, it was utterly conventional, even bourgeois, in its romantic allegiance to the age-old principles of artistically achieved unity and wholeness, and even hierarchical "morality." In the nineties Art was still held to embody a sanctifying transcendental idea or essence, mirroring a pattern of reality that was at some level balanced, ordered, understandable, and universally significant. Even decorative art, claimed Wilde, "develops in the soul" a fundamental and implicitly hierarchical "sense of form" (*Intentions* 206–7). For Beardsley certainly, decorative art's aesthetic concern with creating a pleasing and fitting effect—and even a striking affect—implied a *standard* of conduct, a pattern of significance, the establishing of an appropriate (more or less harmonious) correspondence to a tacit imperative. Beardsley's art implies a rather aristocratic disdain for "lower" behavior by the very way it stylistically isolates, and sequesters within pristine sharp lines and cunningly elegant designs, such sullying elements as lust, vulgarity, and hypocrisy. Symons asserted that Beardsley was "content to follow the caprice of the moment" because he had already established for himself, "very precisely indeed," a "line of beauty" that was simultaneously formal and "moral":

> In those drawings of Beardsley which are grotesque rather than beautiful, in which lines begin to grow deformed, the pattern, in which now all the beauty takes refuge, is itself a moral judgment. . . . Need we go further to show how much more than Gautier's meaning lies in the old paradox of *Mademoiselle de Maupin*, that "perfection of line is virtue"? That line which rounds the deformity of the cloven-footed sin, the line itself, is at once the revelation and the condemnation of vice, for it is part of that artistic logic which is morality. . . .
>
> And after all, the secret of Beardsley is there: in the line itself rather than in anything, intellectually realised, which the line is intended to express. With Beardsley everything is a question of form. . . . Working, as the decorative artist must work, in symbols almost as arbitrary, almost as fixed, as the squares of a chess-board, he swept together into his pattern all the incongruous things in the world, weaving them into congruity by his pattern. ("AB" 100–102, 104)

Thus "artistic logic" of line becomes itself a "moral judgment," condemning vice as it reveals it, bending deformity "into congruity by his pattern."

In the nineteenth century, since Darwin and Schopenhauer at least, the human appetite for beauty had come to be feared as surreptitiously anarchic and animalistic. For all the lascivious trappings of his pictures, however, Beardsley represented "the triumph of an aristocratic, classically oriented aesthetic taste . . . a conventionally unified poetics as an expression of the coherent moral sense" (Michelson 3, 6). It was to this underlying sense of hierarchy and coherence that Kenneth Clark was alluding when he said Beardsley "was above all an architectural artist" (9). We should remember that despite his iconoclasm, Beardsley grew up in a family that not only believed strongly in personal morality but whose politics were distinctly Tory (E. Beardsley, "Recollections" 5). Following his mother's lead, Beardsley was himself eager to claim that he descended from Tory heroes: "Beardsley used to say he was a

connection of the famous Pitt family, and I well remember his delight when he came across a print of Blades' 'Descent of Pitt into Hell.' He looked upon it as a family portrait" (Scotson-Clark, "AB" 13). Like his hero Balzac (a royalist, after all), Beardsley attacked the bourgeoisie for, in effect, betraying bourgeois ideals—or, rather, the aristocratic standards to which the bourgeoisie aspired.

John R. Reed has remarked that "Decadent style is intellectual order disguised as rebellion" (*Style* 241). Certainly the paradox applies to Beardsley. He acknowledged that even his most scandalous drawings were "extremely fantastic in conception but perfectly severe in execution" (*Letters* 34). For all their innovations, pornographic overtones, and revolutionary rhetoric, Beardsley's pictures reflect, like the art of the Decadence generally, a strong editorial and teleological control, creating a "rhythm of intersecting images which articulate causes . . . forcing us to concentrate on the imagistic connections" and their implications (Michelson 153). For Beardsley Art's reassurance of order and control is precisely what permits a "safe" investigation of life's depraved and chaotic realities—the stylistic chastening of evil and depravity through artistic technique making it possible to avoid moral degradation without having to resort to the demeaning bromides of mindless bourgeois probity. Beardsley's highly stylized pictures were thought to have depicted the essence of evil without being corrupted by it: "The cold purity of their perfection seems to ban the emotion they arouse" (Walker, *Best* 9). Osbert Burdett marveled that Beardsley was able to show how "to men without convictions the passions become identified with sin," while at the same time evincing no "concession to idealism but the beauty of his line." His drawings "confine themselves to the abyss with nothing, except the saving beauty of their line, to remind us of the height from which it falls" (8–9, 118).

We can see how Beardsley exposes evil while simultaneously trying to seal it in stylized elegance in *The Climax* for *Salome* (Figure 3–13). In *The Climax*, we have virtually the identical horrific idea as appeared in Beardsley's earlier *J'ai Baisé Ta Bouche Iokanaan* (see Figure 2–8): an eerily suspended, sensuous-lipped Salome holds and peers at the decapitated head of Iokanaan. There is also a similar manipulation of design. The counterbalancing curves of Salome's wild hair, and the way the upward curve of the line dividing the black/white background is offset by the complementary line of Salome's back and "the contrary swoop of her dangling robe," reinforce the fact that she is "suspended forever agonizingly close to a fulfillment she can never know" (Reed, *Style* 165). Furthermore, by situating the figure at the top of the drawing Beardsley accentuates the long line of blood that ironically connects (flowing down from, or rising up to) the severed head and the lilies that seem to feed on the blood.

However, the increased width of *The Climax* mitigates this latter effect considerably, as well as easing the feeling of claustrophobia that is so strong in the earlier picture. In fact Beardsley alleviates the sense of hothouse suffocation in the later drawing—and differentiates it most markedly from the earlier one—by abandoning several details and, especially, by eliminating the profusion of hairline flourishes. As a result, the later drawing is much simpler, cleaner, starker, smoother, and firmer of line. Such pruning lends more elegance to, and concentrates more sharply our attention on, Salome's confrontation with Iokanaan's decapitated head. It even makes more obvious, for example, the fact that the sexualized lilies below

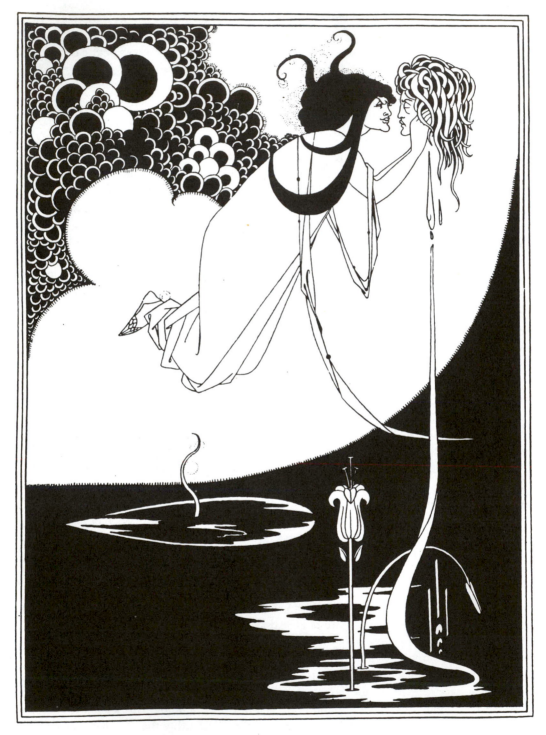

3-13 *The Climax* for *Salome*. (Private Collection)

Salome are either erect (with accentuated stamens and petals approximating female labia) or wriggling phallically upward, and that the upper part of the broken spike of Iokanaan's blood is shaped to suggest a penis, reinforcing the castration theme as well as Beardsley's pun on the scene being a female sexual "climax" (see Reed, *Style* 165; Dellamora 253; E. Gilbert 158).[28]

But the removal of complicating details also paradoxically lessens somewhat the sense of teeming, unleashed evil the former drawing conveys. By removing the lines that indicate wrinkles (or decadent puffiness) from Salome's face, trimming half a dozen of the tentacles from her hair, and excising the poisonous flowers and other hothouse details attending her, Beardsley has made Salome less grotesque and, in the process, slightly less frightening. Karl Beckson suggests that even Iokanaan's "curiously white" blood stylistically mitigates otherwise disturbing elements: "Beardsley's horror at his own blood is here neutralized and transfigured into an aesthetic design" ("Artist" 215). The purging of complicating details also softens the picture in another sense: it makes slightly more apparent certain droll Beardsleyan ironies, such as chaste lilies feeding on the blood of murder, or lustful Salome being transported in the manner of angels. Clarifying such ironies assuages the sense of unrelenting corruption and so necessarily reduces somewhat the Gothic voltage of the picture. While it is still extremely powerful, the scene in *The Climax* is nevertheless calmer and more abstract, even if more "beautiful," than its earlier counterpart, the evil more contained within a distanced elegance. As Clark maintains (overstating the case somewhat), "what is gained in clarity is lost in intensity. [The scene] no longer makes one's flesh creep. The ferocious head of Salome has become almost compassionate, and St. John has ceased to be an object of desire" (70).

Beardsley's penchant for using art as a means of deflecting life's horror is evident once again in his impish cul-de-lampe *The Burial of Salome* for *Salome* (Figure 3–14). Wilde's grim and somber treatment of Salome's death—having her crushed by the shields of Herod's soldiers immediately preceding the final curtain—differs radically from Beardsley's playful (and distancing) aestheticization. Clearly a parody of entombment, Beardsley's drawing is likely based on Girodet's *Funeral of Atala* (1808), which depicts Chateaubriand's heroine being buried by two men in a cave (Shewan 136). In Beardsley's wry variation a Pierrot and a satyr—his heroine's appropriate attendants—delicately inter an erotically nude and atypically beautiful Salome, who is in no way marked by her gruesome execution, which is itself not even suggested. Indeed Beardsley's stylized rendering almost suggests that Salome is not dead but only sleeping (even dreaming) in Decadent refinement. Her "tomb" is not a coffin or even Girodet's cave (with all its problematic sexual connotations), but a face-powder box (another emblem of "distance" or masked reality), adorned by Beardsley's customary rose-gems and by the punning label "FIN" (meaning not only "end" but also "high-class," "top-quality," or "shrewdly witty")—an egotistic reference to either Salome or Beardsley himself. Any connotation of violence or evil is either stylishly aestheticized or diffused (and defused) in typical Beardsleyan sexual humor. Pierrot's farcical hair/wig softens his cat's eyes and the fact that his face seems buried in Salome's highly sexualized egg-hair. Moreover, the giant powder puff, which dominates the lower right of the drawing, covers the presumably animalistic lower quarters of the boyish grotesque satyr and even disguises the fact that Salome's foot is lodged in the satyr's pubes-covered groin.

Affirming the view that Beardsley's defensive use of style only increased with time,

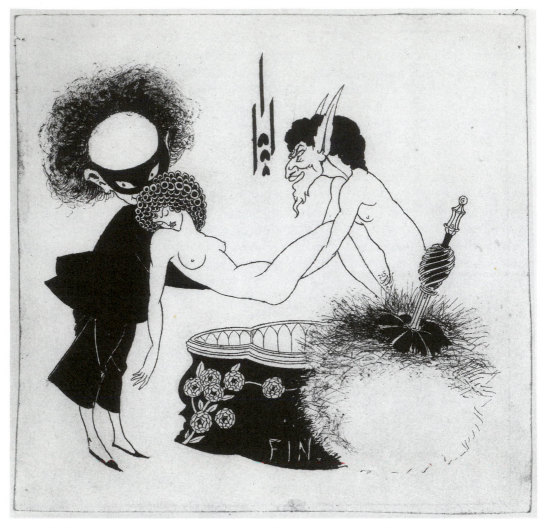

3-14 *The Burial of Salome*, cul-de-lampe for *Salome*. (1943.642, Grenville L. Winthrop Bequest, Courtesy of The Fogg Art Museum, Harvard University Art Museums, Cambridge, Mass.)

MacFall argued that after his dismissal from *The Yellow Book*, a "drifting, rudderless" Beardsley came to master the "austere artistry" of Greek painters, who were able to express "erotic moods by the rhythmic use of line and mass" (AB 55). Beardsley's new classical discipline is most notable, MacFall suggests, in the proposed frontispiece for *The Story of Venus and Tannhäuser*, the "astounding" *Venus Between Terminal Gods* (Figure 3–15), whose "mastery of arrangement and rhythm creates an orchestration, unhesitating, pure, and of haunting melody" (AB 72, 74–75). The profuse, teeming foliage that proliferates wildly behind the fierce terms is neutralized into stylized static symmetry, seeming but a pastoral, decorative frame for the demurely

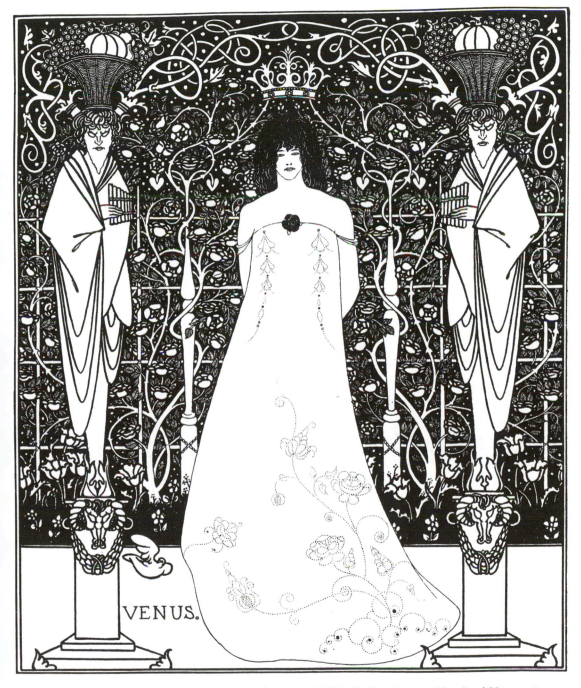

VENUS.

3-15 *Venus Between Terminal Gods.* (P.225 [neg. no. 58P/5313], The Trustees, The Cecil Higgins Art Gallery, Bedford, Eng.)

posed, placid, idealized, yet deceptively erotic Venus. (Her shape and the decoration on her gown are sexually suggestive.) The neutralized foliage even molds an elegant coronet for her. On the head of each term is a basket filled with fruit, which transforms them into harmless atalantes, while the intimation of horns given by the "riot of coiling branches" suggests a rather sexual cornucopia, connecting organically with a "galaxy of roses" but safely constrained (Fletcher, AB 251).

Part of the traditional vitality of Rococo ornamentation has always been the fact that, as is subtly the case in this picture, one side of the piece never exactly repeats the design of the opposite side, giving us equivalence rather than restatement, the variety of naturalistic detail being "so spirited that without the symmetry of the substructure it would look confused" (Sypher 27). But while Beardsley's baroque designs embody the ambiguity, the residual inequality, of rococo "free play," they nevertheless ground themselves fiercely in a virtually classical symmetry. In *Venus Between Terminal Gods* Beardsley achieved what is, in effect, stylistic equipoise, tempering baroque transience and eccentricity with classical stiffness and independent order. The Baroque characteristically emphasized (unbalanced) one side of the design, but Beardsley gives us variation without favoring one side over the other. While the details of the terms and vegetation on each half of the picture are different, neither half draws our interest more than the other; and while Venus's gown drapes to the viewer's right, Beardsley offsets that flow by having the gown hide slightly more of the left-hand trellis and by positioning a dove at the lower left. Furthermore, where the Baroque customarily "abolishes the uniform independence of the parts in favour of a more unified total motive" (Wölfflin 159), Beardsley's picture "classically" affords each varied part its own center of interest, even as those parts blend to give a sense of some indissoluble whole.

Edmund Wilson observed that in the erotic novella *The Story of Venus and Tannhäuser* Beardsley was similarly able to invest sexuality with an artificiality that rendered it "quite natural and harmless," in effect transforming a threatening, potentially guilt-evoking world into an aestheticized pornotopia (E. Wilson 71; see also Gardner 7–13). It may have been more a defense than mere coincidence that, especially after the scandalizing eroticism of the *Salome* illustrations, the shock of the Wilde debacle, and the increasing certainty of an early death, Beardsley brought to his *Savoy* phase an increasing interest in the "heavy style" of the Italian Renaissance (and Mantegna in particular). It was a style that gravitated "toward the severest kind of Renaissance classicism," in which figures are centralized, designs carry a somewhat monumental quality, and "the Beardsley woman remain[s] sensual but destructive no longer" (Fletcher, AB [iv]; J. Gilbert, "AB" 11; Lucie-Smith, "AB" 12).

It was surely, in part, this increased craving for classical order and hierarchical standards—what John Rothenstein took to be "a deeper seriousness and a greater dignity" in the later, more ascetic part of his career (*Pot* 171–73)—that led Beardsley to insist to Smithers that *The Peacock*, their proposed successor to *The Savoy*, "must be edited with a savage strictness . . . [must] attack *untiringly and unflinchingly* the Burne-Jones and Morrisian medieval business, and set up a wholesome seventeenth and eighteenth-century standard of what picture making should be" (*Letters* 413). In Beardsley's revisionist concern for classical restraint, presumably in contrast to medieval and decadent excesses, he even suggested changing the title of the

new magazine from *The Peacock* to *Books and Pictures* (414). While wholesomeness was not Beardsley's primary concern, in a deeper sense Art had always been for the Decadents "whole"-some in its redemptive, logocentric character, its ability to protect metaphysical unity against life's destructive and fragmenting forces. Wilde once said that we must go to art for everything, "because Art does not hurt us" ("Critic as Artist," *Intentions* 174), and it was surely as much out of prudence as wit that Beardsley replied to a friend who asked him whether he ever saw visions: "No. I do not allow myself to see them except on paper" (Symons, "AB" 92–93).

Beardsley's belief in the sanctity of Art grew from roots as paradoxical as those feeding the rest of his temperament. While he held Neoclassical tastes and set for himself painstakingly meticulous methods, he nonetheless still shared (the disclaimers of MacFall and others notwithstanding) the Romantic presumption that true art was a self-expressive act of genius, an inspirational expression of sanctified truth, rather than the product of technical craft, of scientific schooling. Such a presumption was hardly discouraged by the fact that as a boy Beardsley was something of a musical prodigy. Certainly when A. W. King once questioned Beardsley about the meaning of the lad's scampishly indecipherable copy of sheet music, Beardsley responded typically, "It doesn't matter what lines the dots are on if you're a *real musician*" (Scotson-Clark, "AB" 2). But Beardsley's assumptions about the inspirational genius of the artist were surely fostered also by the way his own artistic career evolved. Although at fifteen he reportedly devoured Robertson's famous handbook on pen drawing, he was notably uncongenial toward traditional craftsmanlike art instruction.[29] Indeed, it is possible that at least some of Beardsley's notorious tendency to act "like a naughty child . . . if one attempted to interfere with certain expressions of his work" (Lane, "Notes" 1) may have grown as much from an idealistic privileging of artistic self-expression as from childish petulance.

The Romantic myth of inspirational genius shares the same logic as the myth of another version of "original" authority, the myth of prelapsarian innocence, which Beardsley evoked in such pictures as the design for the heading of chapter 5, book 2 (page 31) in *Le Morte Darthur* (Figure 3–16). Here a central apple tree visually separates a pair of nude figures in the background—the left one clearly male, the other rendered mischievously androgynous. They would seem to represent Adam and Eve, given the fruit-bearing tree, the pride-signifying peacock at Eve's side, and the fact that they are sequestered in an enclosed garden. More significantly, the dominating apple tree separates the garden (reinforced perhaps by the briars at the left) from an aging and disillusioned figure reclining in the foreground, a figure who is apparently suffering from his (or her) own exile from paradise. Beardsley implies, by the figure's Medusan hair, the hiked-up gown, and the copy of Boccaccio lying at his/her side, that this medieval Maloryan figure has lost Eden by falling prey to the dissolute "progressive" ideas of the rakish Italian author. That Beardsley makes the apple tree appear to rise phallically from the reclining figure's thighs reinforces the idea that decadent sexuality and prideful narcissism brought the ruin of Arthur's Camelot (Kooistra 65).

From the perspective of the "Romantic '90s," and consistent with the decade's Pre-Raphaelite and Aestheticist roots, perhaps the most notable reason for the loss of original innocence and harmony was the culture's acceptance of philistine bourgeois notions of "progress," its corruption by middle-class vulgarity and modern industrial greed. We find such mor-

alistic "urban pastoral" concepts at the heart of Beardsley's ironic endpaper designs for the "Pierrot's Library." In the design for front endpapers of volumes in *Pierrot's Library* (Figure 3–17), two Pierrots rusticate in a nostalgic pastoral setting—the standing one appearing as a boyish troubadour, the seated one having literary tastes (or, in typical Beardsleyan equivocality, perhaps disdaining them, as his books lie unopened). The scene is made slightly, but perceptively, discordant and melancholic by the black grass, fecund vegetation, migrating birds, familiar breast/eye tree knobs, grotesque shapes in the trees' foliage, and the seated Pierrot's bored and supercilious expression. Beardsley made the death of pastoral innocence more obvious in the design for back endpapers of volumes in *Pierrot's Library* (Figure 3–18), where the freely scattered trees have been replaced by a telephone pole laden with connecting wires and a fence that divides the two Pierrots from the open landscape and the distant church steeple. The lead Pierrot has now donned the trousers of a hobo and exchanged his books for the stick

3-16 Design for heading of chapter 5, book 2 (page 31) in *Le Morte Darthur*. (Rosenwald Collection, Library of Congress, Washington, D.C.)

3-17 Design for front endpapers of volumes in *Pierrot's Library*. (Drawing no. 56, Albert Eugene Gallatin Collection, Princeton University Library, Princeton, N.J. Also E448-1899 [neg. no. HD712], Victoria and Albert Museum, London)

3-18 Design for back endpapers of volumes in *Pierrot's Library*. (Drawing no. 57, Albert Eugene Gallatin Collection, Princeton University Library, Princeton, N.J. Also E.449-1899 [neg. no. HD713], Victoria and Albert Museum, London)

and kerchief-bag of an insecure vagabond; and the trailing Pierrot, slumping slightly and hands thrust into his pockets, seems to be looking about with a certain nervous and aimless anxiety. We still have the overripe vegetation and the migrating birds, but here two of the birds have been separated from the flock, each flying alone, perhaps metaphoric of the two Pierrots. Indeed the sense of foreclosure and doom is accentuated by the fact that the end of the lead Pierrot's walking stick resembles a bone and the Pierrots' path leads past a tombstone, a clear sign of the travelers' (and the artist's) imminent destiny.

Havelock Ellis recognized the Decadents' infatuation with paradox to be fundamentally a fascination with "the mysteries of style," and certainly Beardsley often seems to approach human problems as if they were stylistic problems. While as playful as always, Beardsley's wit takes a somber turn in these designs, employing ironic juxtapositions to attack the bourgeoisie's betrayal of its pastoral ideals and to disclose the loss of what was an implicitly better world. Just as implicitly, however, the elegance of Beardsley's drawing suggests that the loss is in some measure redeemable by the workings of artistic refinement. It is a Romantic presumption similar to the one that underlies Beardsley's placement of blots of ink along his mass-reproduced lines—a nostalgic recalling of the reproductive effect of wormholes in woodcuts (e.g., Figures 2–14 and 2–23). That is, he evokes stylistically the authority of an ancient, preindustrial age, thus mitigating to some small degree the overpowering force of the drawings' dislocating content. While the fallen world may not always heed the lessons of artistic style, Beardsley proceeds as if Art's playful manipulations and subtle jokes are the most significant means of trying to recuperate loss. It is, in the end, but another fin-de-siècle desire to gather the whole, to "have it all," which—whether it manifested itself as a desire for more than one mentor, or style, or nationality, or gender—was finally an edenic desire to *be* all, perhaps ultimately to have more than one life. That Beardsley took to carrying around with him almost everywhere his autobiographical fantasy *The Story of Venus and Tannhäuser* (whose protagonist was originally named "Abbé Aubrey"), and that for all his numerous revisions he could never bring himself to finish it, may reflect less the artist's difficulty with the story than his unconscious need to keep open his ebbing life's own potentiality.

Final Rescues and Continuing Contradictions

R. K. R. Thornton has defined the "Decadent Dilemma" as treating "obviously Decadent themes . . . while longing for religious acceptability" (49), the Decadent artist viewing sin less as a "new territory to explore" than "a means of enshrining the guilt of his age" (173). Indeed, for all its protestations against bourgeois morality, the Decadence (not least in its Religion of Art) focused persistently on the need for redemption. Contemporaries often claimed that "morality" was irrelevant to Beardsley because "the pure singing beauty of line was all he cared for" (Preston 430); but it is hardly insignificant that in both *The Rape of the Lock* and *Volpone*, Beardsley chose to treat rather traditional *vanitas* themes, specifically depicting his principals' worshiping at false altars, highlighting a pursuit of worldly rather than spiritual ends (Brophy, *Black* 18; Thornton 174).

Yeats thought Beardsley was able to effect "the exhaustion of sin in [the artistic] act," and so through his "virginity of the intellect" was able to "take upon himself not the consequences, but the knowledge of sin" (Yeats, *Letters* 575; *Autobiography* 221). To the contrary, however, notwithstanding Beardsley's attempts at intellectual control and his dandiacal pretense of moral indifference, he continually characterized himself and his work in distinctly moralistic terms, as if in real danger of suffering the consequences as well as the knowledge of sin. He labeled his iconoclastic work "indecent," referred to his life as an "ignoble existence," and routinely hinted that worsening turns in his illness might be in some degree a "punishment" for sin (see *Letters* 43, 265, 171, 396). When at a dinner for *Savoy* contributors he overheard the reading of a letter from "A.E." (George Russell) vehemently denouncing *The Savoy* as the "Organ of the Incubi and the Succubi," Beardsley pulled Yeats aside and confessed solemnly, "You will be surprised at what I am going to say to you. I agree with your friend. I have always been haunted by the spiritual life. When I was a child, I saw a bleeding Christ over the mantelpiece." Then he added, "But after all I think there is a kind of morality in doing one's work when one wants to do other things far more" (Yeats, *Memoirs* 91; *Autobiography* 219–20). Beardsley confessed the same guilt and concern with "the strange ways by which the soul might have come and must certainly go" when he related to Symons a haunting "dream or vision which he had had when a child, waking up at night in the moonlight and seeing a great crucifix, with a bleeding Christ, falling off the wall, where certainly there was not, and had never been, any crucifix" ("AB" 90).

Despite his devotion to the Decadent Religion of Art, Beardsley may never have been entirely convinced that it was a sufficient substitute for that other more conventional faith or, for that matter, that the artistic life and the life of religious faith were not fundamentally at odds. Writing to John Gray about priests who were also painters, he pondered, "But what a stumbling-block such pious men must find in the practice of their art" (*Letters* 246). When Raffalovich's butler Joseph Tobler converted to Catholicism in February 1897, Beardsley confessed himself "most envious" of a young man "whose conduct of life puts no barriers in his way to the particular acceptance of what he believes in" (249). Trying to explain to Raffalovich his own vacillation regarding conversion, Beardsley cited Blaise Pascal as one who "understood that, to become a Christian, the man of letters must sacrifice his gifts, just as Magdalen must sacrifice her beauty" (249). Kenneth Clark argues that Beardsley's later "eighteenth-century" work, while technically extraordinary, exhibited such a sacrifice, "a loss of intensity" from his earlier work: "It is as if he had been deserted by the powers of evil which had been his inspiration" (38–39). (Or it may have been that Beardsley subconsciously backed off from the "horror" of those powers, seeking to fill his *Volpone* drawings with details and full-tonal ink washes, in contrast to the emptiness and sterility of his earlier black-and-white visions.)

As suggested by his admiration for Pascal and the fact that he kept a portrait of Racine prominently displayed in his rooms, Beardsley's view of religious salvation was a distinctly Jansenist one; in many respects, for him salvation "could only mean repentance and mutilation" (Lavers 251). Rothenstein reported that in the last year of his life Beardsley "was filled with remorse at having been persuaded to supply Smithers with so many erotic drawings; he told me so when I last saw him in Paris, and how anxious he was that none of these should

survive" (*Memories* 1: 245; see also 1: 317–18). Accordingly, in his famous, hastily scrawled "deathbed" letter (postmarked 7 March 1898)—in imitation of his idol and fellow consumptive Watteau's similar letter (Gallatin 6)—Beardsley implored Smithers "in my death agony" to "destroy *all* copies of *Lysistrata* & bad drawings. . . . By all that is holy *all* obscene drawings" (*Letters* 439).

Given his tendency to associate illness with guilt, it seems hardly surprising that, despite his ostensible iconoclasm, Beardsley followed the path of "Watteau his master" (Gray, *Letters* viii) and ultimately sought cleansing sanctuary with the Roman Catholic Church. This was in a sense his last surrogate parent—the Church of the "pure" Virgin, the all-consuming "mother" Church, which was ruled by ostensibly benevolent, officially asexual "fathers." It is generally conceded that the serenity Beardsley experienced in his last days was a direct result of his conversion to Catholicism, finding there the higher authority for which he had been implicitly searching for most of his life. Beardsley's moving conversion has been cited as the reason for John Gray's decision to take priestly orders (McCormack 170, 173, 180). Shortly following his conversion, confessing "the knowledge of my own unworthiness," Beardsley wrote to Gray, "It is such a rest to be folded after all my wandering" (*Letters* 291, 293). He told Father David Bearne, S.J., who received him into the Church, that he knew "he needed the staying principle of authority and above all the sure grace of the Sacraments, and these, he felt he could not find outside the Catholic Church" (Blunt 647; see also *Letters* 288–95).

Since for many nineties artists conversion to the true "aesthetic" church was but a logical step in the Decadent Religion of Art, another manifestation of the aesthetic life, the move was certainly no radical reversal on Beardsley's part. Confirming what Henry Harland saw as his colleague's essentially religious temperament ("AB" 438), Ross testified that despite his superficial flippancy in conversation, Beardsley was "always strict in his religious observances" (R. Ross 26; Blunt 647). He had always been fascinated with church history and ecclesiastical rituals and had immersed himself while in Pimlico in the Catholic-minded community of the parson Alfred Gurney (who acquired several of the artist's works), the two routinely enjoying sumptuous lunches (Easton 165).[30] Jacques-Emile Blanche remembered that while they were in Dieppe Beardsley "knew certain of the pages of the learned abbot Denis Guibert by heart, descriptions of processions, of festivals, of Mysteries performed at the Church of St. Jacques, which all delighted him" (*Portraits* 91–92). In the final years of his life Beardsley frequently sought spiritual consolation from Faber's *Heavenly Promises*, Saint Alphonse Marie dei Liquori's treatise on the Blessed Sacrament, and even a tortuous, double-columned, three-thousand-page set of collected sermons of Louis Bourdaloue; moreover, he read avidly about the lives of such canonized saints as Aloysius, John Berchmans, Francis Borgia, and Stanislaus Kotska in the Jesuit Pedro de Ribadaneyra's *Flos Sanctorum* (1592) and in other volumes he received from Raffalovich and parish priests, the three-volume autobiography of Saint Theresa being one of his most cherished books (*Letters* 233, 276, 280, 301, 304, 437–38; Easton 115, 162). Indeed, when Beardsley instructed Smithers to dispose of his library in October 1897, he was willing to let everything go except his four-volume Wagner, his Saint Theresa, his Ribadaneyra, and Raffalovich's gift of John Gray's spiritual poems (*Letters* 380). Symons may well have been right in observing about the "very spiritual" Beardsley: "It is because he is supremely

conscious of virtue that vice has power to lay hold upon him" (Yeats, *Autobiography* 216; Symons, "AB" 177, 179).

It is, of course, a Christian commonplace that human beings are fated to be houses divided against themselves, and Yeats among many others found Beardsley to be so torn: "I think that his conversion to Catholicism was sincere, but that so much of impulse as could exhaust itself in prayer and ceremony, in formal action and desire, found itself mocked by the antithetical image" (*Autobiography* 223). Again and again in Beardsley's work, the scatological and blasphemous appear side by side with "all the stigmata of the religious artist" (Fry 236), not least in his erotico-religious parody *The Story of Venus and Tannhäuser*, where, as Geoffrey Galt Harpham has shown, sin and penitence, passion and religious ritual, hedonistic style and penitential plot pull in unreconciled tension until the book can only be abandoned without resolution ("VT" 24–30). Despite Pennell's claim that Beardsley weaves "an harmonious whole, joining extremes and reconciling what might be oppositions" (*Studio* 18), the "oppositions" are never truly reconciled in his drawings.

If so often the fin-de-siècle avant-garde seemed representative of the very culture it opposed, it only reinforces Roland Barthes's observation that paradox and antithesis are the most theological and conservatively ideological of tropes (see *S/Z* 156, 181–82). The customary dialectical oppositions of the Decadence ultimately did not neutralize Victorian bourgeois culture's basic hierarchical and logocentric assumptions; rather, it only reinforced them by emphasizing the culture's departures from those cherished assumptions. Unlike much of post-Einsteinian abstract art, which rhetorically and stylistically both reversed and displaced many classical assumptions, Beardsley's antithetical and paradoxical pictures relied ultimately on traditional formal principles of harmony, balance, and narrative unity, as well as on such traditional philosophical premises as representational truth, thematic transparency, and sequential logic. Beardsley's art does not seek to eliminate oppositions so much as it utilizes paradox and irony as structuring principles, its "violations" implying the existence of transcendental value and the authority of a preexisting cultural order, even as it throws that value and authority into question.

In the end Beardsley's need for authority was no more able to dominate his urge to outrage than his urge to outrage was able to supersede his need for authority. We recall that the elegant sample illustration *The Achieving of the Sangreal* (Figure 3–19), which became the frontispiece for volume 2 of *Le Morte Darthur*, was the basis on which Dent commissioned Beardsley to produce a Morrisian "replica." But ironically, even here we find that the metaphysical foundations of the picture's world ultimately dissolve under stylistic mixed signals. Compositional balance, meticulous detail, and stylized elegance make the drawing's immediate impression one of devotional peace and resolution. Yet spliced into the drawing are dozens of grotesque Gothic elements that finally unhinge the sense of univocal harmony. Percivale and Galahad are depicted in postures of adoration before a beautiful angel, who holds the flame-licked chalice. But the reptilian armor—menacing knee guards sticking out like dragon's wings—belies peaceful devotion, as does the highly ambiguous gloomy visage of the standing knight. Moreover, the angel is herself an ambiguous figure, bathed in a halo yet sprouting Gothic

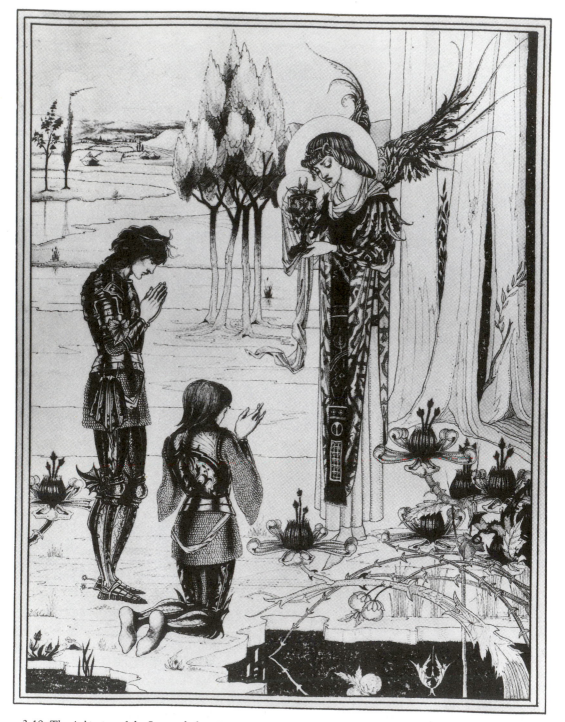

3-19 *The Achieving of the Sangreal*, frontispiece to volume 2 of *Le Morte Darthur*. (Private Collection)

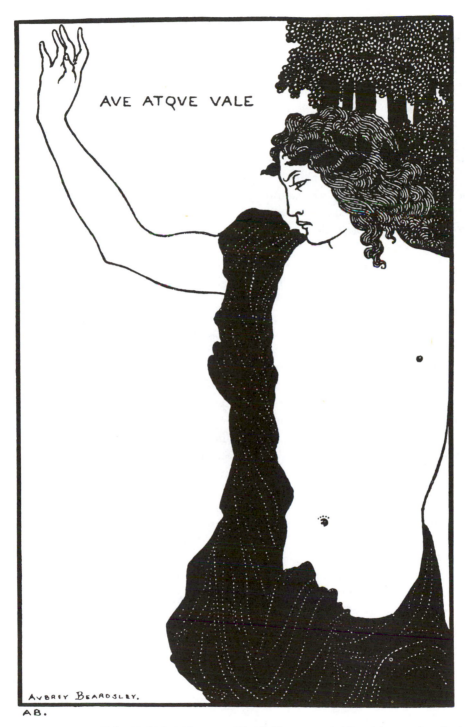

AVE ATQVE VALE

3-20 *Ave Atque Vale*. (G.28 B.26 [neg. no. FF140], Victoria and Albert Museum, London)

feathers from sinister black wings. Nor do the fierce briars and mutant hothouse vegetation connote harmony; indeed, the bizarre lower landscape encroaches on the devotional figures as if to mock and expose as fallacious their classical serenity.

While Beardsley's stylistic legerdemain suggested that Art's elegance can mitigate metaphysical loss, even recuperate it, his ironic grotesque angels, voyeuristic tree knobs, and emblematic tombstones raised the possibility that Art serves only to soften and deaden our experience of that loss and is thus itself only another false god. Even the picture often cited as Beardsley's most riveting and most stylistically effective mastery of pure design, the elegant *Ave Atque Vale* (Figure 3–20), turns out upon closer inspection to encode its own deceptive, self-mocking rebuke. The picture, whose title means "Hail and Farewell," illustrates "Carmen CI" [Song 101] by Catullus (who like Beardsley died young of tuberculosis) and shows a noble Roman youth mourning and bidding farewell to his dead friend. Beardsley made the picture (along with a moving translation of the poem) shortly before he left England for the last time, and it has generally been acknowledged as a self-reflexive statement on his own approaching death. That assumption gains strength from the effect of the highly unusual double signature, Beardsley's full name inside the frame (immediately above his initials outside it) seeming in this context to be a label identifying the figure itself. Reade praises the way Beardsley uses minimal detail and exquisite balance to convey the "arrested movement" and broad-chested solidity of the youth's torso, "making the most of black against white" (AB n. 441). Beerbohm declared that "nothing could be more dramatic, more moving and simple" than Beardsley's drawing, that it proved that as he grew older "he became gradually more 'human,' less curious of horrible things" ("AB" 545). The drawing surely does provide conventionally nostalgic human poignancy, but in fact it also subverts it, inscribing Beardsley's own iconoclastic stamp on the "authoritative" scene and in a manner neither simple nor obviously dramatic. It is a stunning tribute to Beardsley's seamless stylistic cunning that, like almost every other viewer until Heyd (201), even the sly Beerbohm failed to notice that Beardsley combined the Roman's navel with the lower portion of his tunic to form an irreverent version of Beardsley's own famous profile, in effect parodying the mourner's more solemn one.

Meier-Graefe said that "Beardsley's wit was always directed against itself" (2: 319), and we see that here, once again, Beardsley vitiates authoritative metaphysical closure, even as he gives every appearance of providing it. In laughing off everything, itself included, Beardsley's art also calls everything into question, including its own impure "pure" images. Even as he strives to posit authenticating univocal values, we find that the puckish iconoclast cannot ultimately avoid hoisting himself on his own petard. So it is that, again and again, Beardsley's art oscillates incessantly between subversion and reverence, between the urge to outrage and the affirmation of authority, carving out its meaning only in that intensified paradox.

chapter 4

The Rhetoric of the Grotesque: Monstrous Emblems

A poet writes always of his personal life, in his finest work out of its tragedy, whatever it be, remorse, lost love, or mere loneliness; he never speaks directly as to someone at the breakfast table, there is always a phantasmagoria.

—W. B. Yeats, "A General Introduction for My Work," *EI* 509

I have one aim—the grotesque. If I am not grotesque I am nothing.

—Beardsley to *The Idler*, March 1897

THE grotesque is, as Osbert Burdett noted, "the invention of a form that does not exist in nature" (113). It is an artificial, human-animal hybrid that has been used throughout history and in virtually all parts of the world, in both horrific and benign forms, to symbolize the desire to avert the powers of evil and channel the forces of good (Sheridan and Ross 21). It also became Beardsley's favorite vehicle for representing not only the disparate impulses of his own personality, but also what he took to be the paradoxical nature of life itself. But whereas the satyrs of classical art worked to invoke a moral lesson, and the gargoyles and other grotesques of medieval art served as an equally moralistic reminder that death was "the universal leveller in a rigidly hierarchical society" (Lucie-Smith, *Caricature* 28–31), Beardsley's grotesques give no such reassurance of transcendental verities. In fact, set within his formalistically elegant (if perversely parodic) styles, they function as especially effective emblems of a world locked in paradox.

The fact that Beardsley was fascinated with the grotesque from early childhood and grew up identifying himself with it, as in his ghoulish 1892 *Self-Portrait* (see Figure 1–12), may have been a rather logical consequence in one whose physical appearance and personal demeanor were so often belittled. Wilde's remark that Beardsley had "a face like a silver hatchet" (Pearson 230) was only one of many unkind references to Beardsley's striking profile, captured in

161

4-1 The "Gargoyle" Photograph of Beardsley by Frederick Evans. (P115, by courtesy of the National Portrait Gallery, London)

Frederick Evans's famous photograph for which Beardsley was said to have posed as "a gargoyle" (Small 27) (Figure 4–1).[1] But whatever the reasons, Beardsley made the grotesque the essence of his art, what has been called "the most brilliant example of the last stage of the European grotesque" (Kuryluk 7). Joseph Pennell saw Beardsley's pictures as ever tending toward "some new grotesque, some strange conceit which haunted us" ("Appreciation" 3), a world that Ian Fletcher has described as a catalogue of bizarre mutants:

> Nature in borders and chapter headings erupts with a self-circuiting energy that spats in monsters: hermaphrodites, satyresses with cleft feet and legs that are scaled like those of locusts and mantises. . . . The human constantly melts into the animal . . . human skin has scurfed into the scales of reptiles and insects. . . . Nature in the world of these drawings is a font of copiousness and frustration, and what is unsatisfied constantly transforms itself into monstrous modes as in the hermaphrodites, gynanders, and other creatures of dubious gender. (*AB* 53)

Indeed, so central was the strange and monstrous in Beardsley's sensibilities that he once asserted in an interview with *The Idler*, "I have one aim—the grotesque. If I am not grotesque I am nothing" (A. Lawrence 198).

Grotesque Reality

From at least the Middle Ages, when playful Greek and Roman satyrs began to be invoked as figures that could bring *either* good *or* evil (Lucie-Smith, *Caricature* 31), the grotesque has served as a force of indeterminacy. Although it confirms death as the universal leveler, such universality only reminds us of the fragility of our supposedly transcendental distinctions. For Beardsley, too, the grotesque represented a certain fundamental metaphysical dislocation, the kind of ambiguity and undecidable self-contradiction that he felt in his own life, in his urge to outrage and his craving for authority, and saw in the fin de siècle generally.

The rhetoric of the grotesque is, of course, the rhetoric of shock. Grotesques are alienating, estranging in a fundamental way. Moreover, alienation being originally a religious concept—the guilt of being deprived of the presence of God (N. Frye 23–24)—conventional society has had a particular stake in shunning forms that seem, like the grotesque, to blur the clear demarcations between evil and the divine. During the Age of Reason, the grotesque, so much at variance with classical conventions, had been condemned as degenerate, a "perversion of truth," the substitution of "extravagance, fantasy, individual taste" in place of an "essential" type or "natural condition of organization" (Clayborough 6). In the nineteenth century, however, after the Romantic revolution, it came to connote artistic freedom and the overthrow of cramping convention, even a more accurate depiction of objective reality (13).[2]

That the grotesque came to be defined by the norms and values it threw into question is only fitting in light of its ironic etymological origins. The terms *la grottesca*, *grottesco*, and *grottesche* derive from *grotta* ("cave") and were coined in Renaissance Italy to designate a certain eccentric ornamental style (of such Roman fresco painters as Fabullus) that came to light when the ruins of Roman villas and baths were excavated and were mistakenly believed to represent underground "artificial grottos" dug in antiquity for Diana and the nymphs (Kayser 19; Harpham *Grotesque* 27; Kuryluk 11–12). Moreover, the Latin form of *grotta* is *crupta* ("crypt"), derived from the Greek for "vault" and one of whose cognates is "to hide," thus implying that the grotesque reveals the underground, the secret, the "buried," which "teases us with intimations of 'deep' or 'profound' meanings" (Harpham, *Grotesque* 27, 43). So the term *grottesco* came to mean not only something playful and carelessly fantastic but also something ominous and sinister, the discovery of a totally different "underground" world in which the realms of the animate and the inanimate are no longer separate and the "normal" laws of symmetry and proportion are no longer valid, the highly volatile "unmediated presence of mythic or primitive elements *in* a nonmythic or modern context" (Kayser 21; Harpham, *Grotesque* 51).

In the nineteenth century John Ruskin, although he was unwilling to risk defining the grotesque as an objective element in nature itself (as opposed to a subjective quality psychologically attributed to it), nevertheless led the way in acknowledging the "true" grotesque as

something that provided a "deep insight into nature." He even stated, "There is no test of greatness in periods, nations, or men, more sure than the development . . . of a noble grotesque" (*Stones* 187). Foreshadowing psychoanalytic explanations of the unconscious imagination, Ruskin characterized the grotesque as reflecting a religious sensibility particularly sensitive to the metaphysical confusion evil provokes—a manifestation of the "irregular and accidental contemplation of terrible things, or evil in general," the "confusion of the imagination by the presence of truths which it cannot wholly grasp" (*Modern Painters* 130, 131; see also Steig 254–55). The "wild" quality of an artist's grotesque works reveals an imagination that is "like bad children, and likes to play with fire" and exhibits how "the dreadfulness of the universe around him weighs upon his heart." Fearing ultimate estrangement from God, the artist's "ungovernable" imaginative vision, far from being a rejection of nature, is only his/her "broken mirror" of it, still "noble" in its implicit expression of "ruling and Divine power":

> And the fallen human soul, at its best, must be as a diminishing glass, and that a broken one, to the mighty truths of the universe round it; and the wider the scope of its glance, and the vaster the truths into which it obtains an insight, the more fantastic their distortion is likely to be, as the winds and vapours trouble the field of the telescope most when it reaches farthest. (*Stones* 169, 178, 181)

In fact, for Ruskin, since fallen humans are unable to contemplate in "true light" the sublime character of "grotesque" elements, the more exalted the reality, the more grotesque our image of it is likely to appear (178).

Such analysts as Victor Hugo and Charles Baudelaire, while agreeing with many of Ruskin's insights, did not share his qualms about defining the grotesque as an "objective" reality. For Hugo Christianity's emphasis on the dual nature of humanity had only made humans more aware of the basic antithetical structure of the world itself, its foundation on polarities that might naturally take on a grotesque aspect (8–9). Not merely the human personality but the very nature of the world is grotesque, in the sense that we can at any point and without provocation be the targets of malicious forces, the most familiar elements of everyday life suddenly becoming strange and evil. Therefore, in Hugo's view, if art was to reflect the whole of life, it necessarily had to join the lofty sublime with the infernal grotesque (11–13, 16–17, 21, 23). For Baudelaire, too, the grotesque imitates chaotic and unorganizable elements pre-existing in nature, although representing not so much a "dark" portion as the paradoxical and inextricable intermixing of elements, a deforming reformation intrinsic to all true art and reflecting in this case the fated death and decomposition of all human enterprise (*SW* 151–52; *CE* 383–85).

As the varying views of Ruskin, Hugo, and Baudelaire suggest, the "deep insight into nature" provided by the grotesque is unsettlingly ambiguous. Ominously, it gives the latent promise of meaning within an ostensibly meaningless form, thus engendering a basic, uncanny, often paradoxical, hermeneutic dislocation. Paradox, because it violates conventional order, can, as Geoffrey Galt Harpham has explained, "penetrate to new and unexpected realms of experience," expanding and enriching us with insights we feel to be deep and profound. Yet,

on the other hand, "while we are in the paradox, before we have either dismissed it as meaningless or broken through to that wordless knowledge (which the namelessness of the grotesque image parodies), we are ourselves in 'para,' on the margin itself," trapped in an "intertextual 'interval,' " awaiting resolution and comprehension (*Grotesque* 20, 38). The grotesque is a true paradox. It is both a fiction of autonomous artistic vision, operating by laws peculiar to itself, and a reflection of laws and contradictions in the world—paradoxically both "pure" and impure, autonomous and dependent, fictional image and mimetic mirror—in effect, incarnating the same contradictions that are central to art itself (see 177–78).

Among the many aesthetic assumptions Beardsley shared with Ruskin, Hugo, and particularly Baudelaire were not only the modern privileging of eccentricity, transitory beauty, and stray souls who "will eternally escape from the rules," but also the belief that "beauty always has an element of strangeness," specifically "the horrible" (Baudelaire, *SW* 118–19; *AR* 238–39, 172; *CE* 287, 199, 224).[3] In a vignette on page 55 of *Bon-Mots* (1893) by Sydney Smith and R. Brinsley Sheridan (1893) (Figure 4–2), the "strangeness" of Beardsley's grotesque figures (and configurations) incarnates what is, in effect, a "horrible" erosion of normal metaphysical distinctions. Just as the medieval jester served to reduce airy ritual to laughable materiality, collapsing presumably fixed and weighty hierarchical distinctions into uniform frivolity, so Beardsley's clown-grotesques conflate the real and the surreal, dissolving meaning into absurdity. Here the clown figure on the left, disheveled and perhaps aged before its time, has its gaze fixed on an exotic bird, which it is introducing (or offering) to a grotesque puppet head

4-2 Vignette on page 55 of *Bon-Mots* (1893) by Sydney Smith and R. Brinsley Sheridan. (Private Collection)

of a clown—itself protruding from an even larger, maliciously visaged, equally disheveled and truncated, grotesque clown-puppet, whose ripped clothing exposes a black void that seems to define its being. The limits of the drawing's joke have become almost impossible to define. Is it that the left-hand clown is too engrossed (or too self-deceived) to see that it is introducing the bird to a mere puppet head? Or that the puppet head is held by only another puppet? Can we in fact be sure that the bird itself is alive and not stuffed? Or is the joke that the exotic, overly refined bird, even if "alive," is really little more than another puppet? But then, cannot the same be said for the left-hand clown, that it is little more than life's puppet (its face does in fact resemble that of the right-hand clown), that the joke really rebounds on it, that we are seeing the meeting of multiple mirror images, pet to pet, pet to puppet, puppet to puppet, and so forth? Or is the joke that they *recognize* this truth, but they are nevertheless compelled to play out the game? Or that even though *they* recognize it, *we* do not, and thus do not understand that *we* are puppets looking at puppets looking at puppets? And on and on. The boundary lines between fake and real, artificial and natural, frivolous and serious, are so confused that there is no way to stop the meaning from sliding almost endlessly. It thus becomes increasingly clear why such commentators as Theodore Wratislaw characterized Beardsley's delving into "the abnormal and grotesque" as "push[ing] his work to the extreme limits of insanity and unhealthiness" (101, 100).

Early analysts found "the very essence of the grotesque to lie in its complete detachment from reality" (Kayser 30–31), a characterization that in effect sought to sequester the grotesque from what was presumably the saner, central reality of life. For that matter, in art the "nonsensical" grotesque has traditionally occupied a marginal position similar in many respects to that accorded to ostensibly nonsignifying, "unreadable" ornamentation. In fact, "grotesque . . . ornamentation" is one of the definitions the *Oxford English Dictionary* gives for one of Beardsley's favorite styles, the Baroque (678). Often relegated to the presumably "marginal" sides or corners of the picture, his grotesque elements nonetheless disorient the viewer's focus and, in fact, become "central" signifying tropes, even if the viewer cannot entirely interpret what is seen. In this sense the grotesque destabilizes the entire structure of meaning in the picture, causing it to oscillate across traditional artistic "boundary lines."[4]

In *The Toilet of Helen* for *Under the Hill* (Figure 4–3), Beardsley's grotesque elements contribute to a virtual explosion of visual confusion and metaphysical contradiction that belies the calm expression of Helen/Venus. Despite her restrained and sophisticated bearing, and the refined undergarments of high culture she wears, the serene Helen/Venus is known to be a sexual animal. The fact is accentuated by her exposed breasts, spread legs, downward gaze toward a hand mirror positioned as if she were she masturbating, and, not least, her pointed left foot juxtaposed to the cloven-hoofed leg of her grotesque dressing table, with its multiple-breast and animal-head ornamentation. The inclination of her foot (along with the curvature of the table leg) gives a sense of kinetic energy, suggesting that she is standing upright and stepping forward. But this appearance is an illusion: she is seated, as is indicated by the fact that part of her right leg, though barely visible, is clearly extended under the table. Moreover, although the features of the nongrotesque figures are drawn in proportion, Helen appears to be disproportionately long-waisted, and her left hand, holding her mirror, is not only consid-

4-3 *The Toilet of Helen* for *Under the Hill*. (Published in *The Savoy*, no. 1 [January 1896]: 161)

erably larger than is warranted by the rest of her body but is positioned at an angle and in a place that is anatomically improbable, unless her upper arm is extraordinarily long. In these ways she is made to seem more closely akin to the grotesque "monsters" in the picture than to her dainty ladies-in-waiting.

Furthermore, as Max Beerbohm suggested when he said the picture "cries aloud for some blank spaces that would . . . distinguish the many figures" ("Ex Cathedra" 34), it is not easy to determine immediately what detail belongs to which furnishing, or even where the furnishings stop and some piece of clothing begins. Often the details of the one seem to be embellishments of the other, the distinctions between them blurring. For example, it is unclear whether the element appearing in front of Helen's face is a candelabrum attached to the dressing table, or a chandelier, or something else, for that matter. The candelabrum effect is reinforced by the long vertical white forms extending upward, but these "candles" are superimposed on, so as to blur into, the similar vertical lines on the dressing screen. The dressing screen itself is positioned in such a way that it is difficult to tell whether it is "folded" forwards or backwards. At first glance it is not apparent that it is a screen, rather than part of the wall. The floral, or bulb, trim—another confusion of endings and beginnings—on the "candelabrum" hangs down and curls around another object until the trim also adorns the dressing table. But then it is not clear whether part of that trim is actually the hem of the gown that appears to be hanging across the dressing-table mirror. Moreover, the same floral-bulb trim *does* constitute part of the hem of Helen's petticoat, which as it extends under the table seems but an extension of the other long strand of trim. In yet other examples of misdirection, the grotesque under the table has his head turned away from Helen's subtly spread legs, but he seems nevertheless to be holding a hook to lift her petticoat. Helen's ladies-in-waiting are given the faces of dolls or innocent children, yet they appear to be focusing on the buttocks of the masked attendant in front of them. And the jaded mustachioed dandy in the upper right, though presumably attending on Helen (holding what may be Helen's crown), peers down with an ambiguously sinister stare at the brawling dwarfs at the bottom of the picture. Cosmé, the attendant grooming Helen's hair, embodies another paradox. In Beardsley's story Cosmé is mysteriously indeterminate in both age and gender; ostensibly male, the "antique old thing" is designedly youthful and androgynous, manifesting "a girlish giggle under his black satin mask" (*UH* 1: 163; *VT* 20). In the drawing the masking extends the paradox: Cosmé seems to be covered—face as well as body (except for his hand, his severe cat's eyes, and the trim around his hip)—by dark textured material; yet he/she/it wears the black mask, hiding what is apparently already hidden.

The most striking dislocations are provided by the more obviously grotesque figures. Beardsley formalistically associates these figures with Helen by (in addition to the elements already mentioned) the fact that the "flowers" on her hem also appear on the hat of the obese Mrs. Marsuple/Priapusa, the manicure and *fardeuse* of Beardsley's story, seated at the far right, and on the mammoth, incongruously meticulous and elaborated headdress/wig of the fighting dwarf in the lower right. The irony of the goddess of beauty and erotic love being surrounded by such deformed creatures is obvious. But the fact that the beauty and elegance of Helen and her doll-like female companions in the upper part of the picture are compositionally framed

and "grounded" by hideous grotesques at the left, right, and lower parts of the picture seriously undercuts that beauty and elegance and threatens any univocal reading of it. After all, Beardsley has the music that presumably accompanies the action provided by a hunchback; and the illusions and masks surrounding the sophisticated goddess and the attendant coiffing her hair are counterpointed in jarring fashion by the misshapen dwarfs in the lower right, who demonstrate more brutal coiffing and brawl with unvarnished violence. Compositionally and metaphysically, the picture's meaning oscillates between disparate poles, sliding chromatically, undecidably, through many possible alignments, both humorous and horrifying.

In the end Beardsley's grotesques are merely the most extreme manifestations of a Decadent style that John R. Reed describes as "a highly self-conscious dissolution of established form," "founded on inevitable frustration" and "never fully resolved except through negation" (*Style* 11). Like the monsters of Rabelais, Bosch, and Dürer, Beardsley's shockingly "deformed" figures, more than just satirizing homogenized Victorian smugness, become an uncanny expression of the seminal tensions underlying civilization's established formulas. By design, rational form gives conventional closure and precision to existence, excluding the "irrelevant" in the service of some focused meaning. But the "deformed" contours of the grotesque, like the phantasms of our dreams, defy closure and work toward inclusive, ever-blurring heterogeneity. The grotesque presents itself as a fundamentally ambiguous and ambivalent phenomenon, without rational form, an inexorably ominous object occupying multiple taxonomic categories or falling between categories. It "violates" essential boundaries, improperly fusing properly disparate things, giving the sense that "something is illegitimately *in* something else" (Harpham, *Grotesque* 11). It is, in short, an utterly alien and anomalous monster, the incredible, the unspeakable.

Beardsley's *Cave of Spleen* for *The Rape of the Lock* (Figure 4–4) presents us with just such taxonomically self-contradictory, phantasmagoric creatures—the kind that induced Wilde to characterize Beardsley's fantastic art as having "the charm of the unreal" (Wilde, *Letters* 410). This overstuffed drawing, filled with ambiguous arabesque details, illustrates Pope's fanciful description (early in Canto IV of the poem) of the gloomy and dismal domain of the Goddess of Spleen, where Umbriel, the "dusky melancholy Spright" of ill temper with "a Branch of healing *Spleenwort* in his hand," seeks out further fuel for Belinda's wrath (*RL*, canto 4, lines 16, 18, 13, 56). The goddess herself, reclining at the far center right in the drawing, appears to have fairly normal features, save for the disproportionately tiny hat perched atop her voluminous coiffure. The rest of the drawing, however, is crammed with decidedly grotesque figures and shapes, depicting Pope's "Strange Phantoms," "glaring Fiends," and "Bodies chang'd to various Forms by *Spleen*" (canto 4, lines 40, 43, 48). In fact, the Goddess's normality is deceptive: playing on the poem's obsession with hair, Beardsley constructs her gown so as to suggest flowing, thick tresses. Indeed, the cave is made into "a grotto of hair," several other figures being "*dressed* in hair" and even the backdrop of the drawing—with "its narrow, vertical lines topped by heavy loops"—being textured like hair (Halsband 103).

The picture's grotesque flavor proliferates most obviously in the figures themselves. At the goddess's right, clutching a prayer book, stands "*ill-nature* like an *ancient Maid*" (*RL*, canto 4, line 27), on either side of whom are two elaborately coiffed, seemingly unremarkable heads,

4-4 *The Cave of Spleen* for *The Rape of the Lock*. (27.61 [neg. no. 27B10.5], Bigelow Collection, Museum of Fine Arts, Boston)

except that upon closer examination they appear to be suspended bodiless. At the right of the glowering "ancient Maid" is the sickly figure of Pope himself. Beardsley takes the pose from the well-known portrait by Godfrey Kneller (Halsband 106), but he gives his Pope an emaciated face attached to a misshapen body almost camouflaged by the plethora of surrounding exotica, including a stylized embryo that seems to rest mockingly on his swollen stomach. Below the Pope figure, between Umbriel and the Goddess of Spleen, are two other dwarfish creatures, who are in a sense also incredible mutants. The veiled nude, Affectation, has the face and tiny stature of a small doll-like child, but her head is disproportionately huge and her bare breasts are those of an adult woman. The clothed other figure, into whose neck Umbriel seems to be lodging his scepter and who is holding what could be variously interpreted as a walking stick or an opium pipe, appears to be male, although Beardsley's familiar breast-pustules sprout on his chin. Even his status as a human seems compromised by the fact that his face has the look of a sculpted mask, from which spin out numerous curling ornaments. Not surprisingly, we find that Umbriel, who stands at the left across from the goddess, is himself sexually ambiguous—ostensibly male but having a shapely torso and facial features similar to those Beardsley gives to the females in the drawing. Umbriel's androgynous character is accentuated by his spavined legs and his exotic, effeminate clothing.

At the bottom of the drawing we find perhaps the most bizarre and disorienting grotesques. In the lower left corner are illustrated two of the Cave of Spleen's astonished men who "prove with Child, as pow'rful Fancy works" (*RL*, canto 4, line 53), an embryo being placed in the distended abdomen of one and in the thigh of the other. But as perverse as this might be—a clear case of "something illegitimately *in* something else"—Beardsley defies the laws of nature in an even more fundamental way by having these figures appear as hybrid conflations of persons and crockery, resembling bottles and vases as much as people. They are hardly dissimilar from the next two figures, which illustrate Pope's lines "Here living *Teapots* stand, one Arm held out, / One bent; the Handle this, and that the Spout: / A Pipkin there like *Homer's Tripod* walks" (canto 4, lines 49–51). In the lower right corner we have yet another hybrid grotesque, an elegant conflation of bird and woman (without model in Pope's poem) who shades a man trapped in a jar and a uniformed scamp. The scamp is leaning forward as if, like many of Beardsley's other dwarfs, to implicate the viewer in the drawing's absurdities. As Milly Heyd has noted, the embryos trapped in mutant bodies are analogues to the picture's other figures imprisoned in various vessels, such as the silhouetted figure inside a gazebolike cage (64). Here as elsewhere in Beardsley's work, spatial constriction becomes a metaphor for general metaphysical suffocation and disorientation.

It was part of the threat of the fin de siècle that paradoxically frank ambiguity often stood as an implicit "acknowledgement of the essential ambivalence of truth and experience, of life itself" (Shattuck 37). In this vein many of Beardsley's drawings contradict the logical impossibility of merging mutually exclusive categories. Male and female, old and young, plant and animal, even animate and inanimate, routinely combine in one or another body. His symbols, as Heyd puts it, "are hybrid formations containing substances drawn from heterogeneous realms," a "mixed and multiple nature" and inherently ambivalent (203, 204). Far from having a world of solid ontological demarcations, we find that every form is potentially continuous

with every other, a world of perpetual contradiction, metamorphosis, and ambiguity. It is no accident that in *The Story of Venus and Tannhäuser* each chapter, while centering on one elaborate scene, unravels in a plethora of static heterogeneous details, disrupting any narrative line with lingering, inconclusive pornographic routines (see Fletcher, "Verse and Prose" 233–38).

Like the grotesque generally, while Beardsley's distorted creatures are a part of the mutable, historical world, they also partake of the world of myth, where gods (sometimes assuming hybrid forms) are often, like the Roman Janus, of a dual nature, marrying the "beneficent and maleficent," being simultaneously "most gentle" and "most terrible," erasing the differences between good and bad (Girard 251). It is as if to confirm the mythic truth that order can only come as a by-product of chaos, from saviors who are also (literally or figuratively) monsters (see Leach 11). As a consequence, for all its horrors, the grotesque is not tragic, which would necessitate a comprehensible moral order where life and death are tied to individual culpability, but rather mythically comic, life and death being but metamorphosing phases in a cosmic process that renders absurd the pretensions of individual action.[5] Within the individually incomprehensible, inexplicable, impersonal world of the grotesque, we actually come to fear death less than we fear life—a life of meaningless absurdity—a fear "increased by the awareness of the vanity of life and the aimlessness not only of man's actions but also of his suffering" (Kayser 185–86, 91; see also Bakhtin, *Rabelais* 50).

On the other hand, however much the grotesque may be mythic, its intractable confusion of types and what Baudelaire called its utter unorganizability, its exuberant "inexhaustible abundance" (*SW* 234; *CE* 434), ultimately resists incorporation into any rational whole, even mythic or cyclical "resolution." While myth seeks to integrate experience into coherent universal principles and protests "against the idea that anything can be meaningless" (Levi-Strauss 22), the grotesque, isolated by its eccentric deformed singularity, rejects any such unifying higher reality. In its collapsing paradoxes, its capacity to be two things at once, it "foregrounds the mysteries of the processes of making and un-making meaning," installing a meaningless vacuum (Harpham, *Grotesque* 40–41). Having its origins in depictions of beasts on the caves of antiquity and in the ancient artist's iconoclastic efforts to probe "lower" subjects, the grotesque occupies an ambivalent space between history and myth, culture and nature, order and anarchy, throwing into question any pretense of logical necessity, or, for that matter, any univocal and unconditional meaning. Like the Christian grotesques on medieval churches, which were frequently icons of suppressed pagan deities, even a composite of good and evil spirits (Sheridan and Ross 7–8, 12–21), Beardsley's grotesques are truly the incarnation of paradox, the visual assertion of both terms of a contradiction simultaneously.

Ruskin, in *Stones of Venice*, was one of the first to treat the grotesque seriously as this type of fundamentally paradoxical and self-contradictory phenomenon. For Ruskin, although the grotesque's overall unity and expansive profundity reflect the divine, its basic dualistic pattern disdains balance and ever divides into the moral extremes of true and false, noble and ignoble (*Stones* 170). Like the uncanny, which is both comic and disturbing, the grotesque produces in the viewer an emotional civil war of attraction and repulsion. It is both "sportive" and "terrible," combining "ludicrous" and "fearful" elements and evoking in the viewer a

violent clash of opposite feelings (*Stones* 151–63). On the one hand, its horrible and monstrous elements evoke fear, horror, dread, disgust, as embodying a distortion or ugliness almost beyond human limits. On the other hand, those same preposterous deformations move us to laughter. Despite (or because of) resemblances between the distorted, inhuman qualities of the grotesque figure and our own human qualities, we respond to it with horror and anxiety as fundamentally strange and alien. Indeed, the grotesque is, in some respects, the most dangerous alien Other, precisely because of its perceived kinship, its closeness, to us. Yet the very fact that its horrific qualities obviously disqualify it as human also allows us to think of it as unthreatening, something sequestered from our own reality.

Beardsley's use of the grotesque as a vehicle for social satire shares the vision of Baudelaire, who saw grotesque dualism at the heart of laughter itself. In Baudelaire's view laughter, particularly as reflected in "convulsion," is a logical, "axiomatic and primitive" extension of the grotesque, that expression of human pride's idea of superiority over alien nature. Like the grotesque, laughter is a defense against anxiety: "He who laughs is powerful, strong and superior" (Kris 232). It represents aggression and seduction simultaneously. Laughter seeks to ridicule or "bite," as Baudelaire would say (*SW* 145; *CE* 376–77), even as it suborns others to join in, because "human laughter is intimately connected with the accident of an ancient fall, of a physical and moral degradation" (*SW* 141–43). Unlike joy, laughter is the "necessary product" of a fallen dual and contradictory nature, "at one and the same time a sign of infinite greatness and of infinite wretchedness, infinite wretchedness in relation to the absolute being" (*SW* 145–52; *CE* 376–85).

Hugo also treated the duality of the grotesque as a property of nature and saw the darkness of the abysmal grotesque as the reverse of the purer, grander sublime (11–15). For Hugo, as for Ruskin and Baudelaire, the grotesque's vexing contradictions provide no comforting reconciliation but, rather, open an abyss under what we thought was firm ground (15–23). "True" but without comprehensible reference or direction, the wild and supernatural world of the grotesque is a radically alienating world, estranged from human life by virtue of its essential absurdity as much as its horror, by the way it "contradicts the very laws which rule our familiar world" (Kayser 31). In the end it combines two divergent and seemingly irreconcilable realities—the fearful and the humorous—meaning left to slide back and forth between them. In fact, for all Ruskin's efforts to extol the "nobility" of the grotesque in church architecture, it was precisely its semiotic ambivalence—its plethora of possible meanings, in contrast to the divine, univocal architectonics of the cathedral itself—that continued to disturb him (see *Stones* 151–78).

In an attempt to escape being scissored "between incompatible reactions—laughter on the one hand and horror or disgust on the other"—it is natural to want to resolve the issue to one extreme or the other, in effect employing our defense mechanisms to try to reestablish stability in the face of such disorienting circumstances. If we find the grotesque more horrifying than funny, we become indignant and regard such frivolity as an outrage to our moral sensibilities. Alternately, if we find the grotesque more funny than horrifying, we tend to laugh it off, treating it as a joke (Thomson 2–3). However, part of our delight in seeing taboos flouted, having our inhibitions momentarily released, or catching some "sick" joke, is a sadistic pleasure

in the horrifying, the cruel, the disgusting (54, 56). Baudelaire argued, after all, that the laughter of "superiority" is "profoundly human" precisely because it is pridefully satanic (*SW* 148; *CE* 379). Routinely filled with nostalgic bitterness, such laughter frequently comes to mirror the mocking, cynical, and ultimately satanic characteristics of the horrifying grotesque. As a consequence, the wise man laughs "only with fear and trembling," his laugh being implicitly a shudder (*SW* 141–43; *CE* 371). Kant thought that laughter presupposes something absurd, "the sudden transformation of a tense expectation into nothing" (*Kritik* 409–10); and typically, the laughter that turns terrifying monsters into objects of mirth ultimately descends to the chillier regions of sarcasm and irony, exposing the secret, "somber, tragic aspect," "a terrible vacuum, a nothingness" underlying it (Bakhtin, *Rabelais* 38–40). Rationally uncontrollable, the grotesque is, like tragicomedy, an "impossible" mixture of the horrible and the farcical, a commingling to which we cannot ultimately reconcile ourselves.

D. S. MacColl's claim that Beardsley turned to the grotesque necessarily, because he "had no sure hold on the forms of life" ("AB" 419) seems only to confirm how integral the grotesque was to Beardsley's peculiarly modernist vision. Being, like Blake, a visionary and appealing to "expression" rather than mimetic experience, Beardsley crafted not just images but conceptual analogues; he summed up "delightful manias" and "twisted human forms . . . into fantastic peculiar shapes" (R. Ross, *AB* 53, 55; see also Bazarov 35). Moreover, especially in light of Ruskin's, Baudelaire's, and Hugo's views on the grotesque, Beardsley thought what the grotesque expressed was a perversion as moral as it was metaphysical—a corrupted "antithesis of the old ideal: the soul in the stage not of innocence, but of experience, weary in the pursuit of a now exhausted conception" (Burdett 113, 114–15). Whether Beardsley took the grotesque to be a reflection of objective elements in nature—"the striking essence of human beings" (MacColl, "AB" 29)—or a metaphor of our psychological reactions, his obsession with it seemed clearly based on a belief that it captured some fundamental moral and metaphysical reality. He insistently maintained, despite all appearances to the contrary, that his bizarre, misshapen figures were "life itself," showing "life as it really is": "I see everything in a grotesque way. When I go to the theatre, for example, things shape themselves before my eyes just as I draw them. . . . They all seem weird and strange to me. Things have always impressed me in this way" (Smith 16; *To-Day* 29; *Leslie's Weekly* 90).[6] Beardsley even maintained that the phantasmagoric prose and pictures of his *Story of Venus and Tannhäuser* treated "the German legends in a realistic manner" (*Leslie's Weekly* 90).

In some sense the assumptions underlying Beardsley's world are not so different from those of Ovid's *Metamorphoses*, where grotesque change reflects a kind of moral justice, even as it is alienating and dehumanizing. As Hillis Miller remarks,

> Ovid's stories show that you always get some form of what you want, but you get it in ways that reveal what is illicit or grotesque in what you want. On the other hand, the *Metamorphoses* suggests that the account is never fully paid off by any materialization of desire, however apparently decisive or conclusive, however exactly the punishment fits the crime. . . . A metamorphosis is not exile from the human community, such as Ovid himself was to suffer, and it is not the ultimate separation of

death. It is halfway between the two, neither death nor life. The one who has been transformed remains as a memorial example still present within the human community—in the form of a tree, a fountain, a bullock, a flower. The halfway state of the victim of a metamorphosis is a sign that his or her fault has not been completely punished or expiated. (1–2)

If, as contemporaries argued, Beardsley had an "obsession with the monstrous and grotesque" (Wratislaw 101) and his work represented for most viewers "the apotheosis of the ugly" (*Leslie's Weekly* 90), it was at least in part because the grotesque was for him emblematic of an unregenerate moral and metaphysical perversity in life. Far more than classical mythology, Christian doctrine (in which Beardsley was steeped) had traditionally shown good to be something central, symmetrical, blended, and ideally beautiful while depicting evil as marginal, askewed, singular, and monstrously ugly. The grotesque came to represent the material expression of a destruction of order, the manifested result of sin's warfare with and corruption of the soul, which was tradition's organizing spiritual source of structure and order, the form that "doth the body make." If Beardsley felt compelled to "gloat upon ugliness and add to it; and when it is not there, he must create it" (Armour 9), it was because, as he told one interviewer, "I find that most people are ugly" (Smith 16).

In producing "some of the most dreadful faces in all art" (Hammerton 187) Beardsley uses the grotesque as an emblem of the moral perversity of modern life, the material manifestation of sin's destruction of order. In his landmark obituary essay, Arthur Symons pairs Beardsley with Baudelaire and cites Beardsley's grotesques as emblematizing the soul's "spiritual corruption," sin that is always

> conscious of itself, of its inability to escape itself, and showing in its ugliness the law it has broken. . . . In those drawings of Beardsley which are grotesque rather than beautiful, in which lines begin to grow deformed, the pattern, in which now all the beauty takes refuge, is itself a moral judgment. . . . The leering dwarfs, the "monkeys," by which the mystics symbolised the earthlier vices; these immense bodies swollen with the lees of pleasure, and those cloaked and masked desires shuddering in gardens and smiling ambiguously at interminable toilets; are part of a symbolism which loses nothing by lack of emphasis. And the peculiar efficacy of this satire is that it is so much the satire of desire returning upon itself, the mockery of desire enjoyed, the mockery of desire denied. ("AB" 99, 100–102)

In a world where disorder and isolation had eroded all humanistic kinship, Beardsley's physically deformed and haggard figures struck viewers as a "complete realisation of the essentials of evil," the "heights and depths of depravity" (Strong 90). In contrast to the order the classical soul reflects, the monstrous fin-de-siècle soul recalls the degenerate atavism that late Victorians were inclined to see everywhere at the end of the century: "Mr. Beardsley's figures are not men and women: they are but monkeys aping humanity" (Smith 16). Beardsley plays, in part, on just this resonance in *The Murders in the Rue Morgue* (Figure 4–5), where he makes

4-5 *The Murders in the Rue Morgue.* (Private Collection)

the criminal ape "a degenerate aesthete," having "human feet with long prehensile toes, nails manicured to a point, and a large earring" (Fletcher, *AB* 138). Both Yeats and Vincent O'Sullivan defined as Beardsley's "noble courage" his commitment to revealing a "sense of sin," his having what Lewis Hind called "a strange, age-long, intuitive knowledge of things hidden and evil" (Yeats, *Memoirs* 92; O'Sullivan, "Literature" 49; Hind, *UW* xxii). It is in

this distinctly moral sense that he became for Symons "the satirist of an age without convictions" ("AB" 101) and for Yeats "the first satirist of the soul English art has produced" (*Memoirs* 92).

Irony, even the irony of paradox, depends for its effectiveness on the ultimate "resolvability, intellectually, of a relationship (appearance/reality, truth/untruth, etc.)"; but the grotesque incarnates the essential "unresolvability of incompatibles" (Thomson 50). Taking full advantage of this elusiveness, Beardsley creates in his drawings a world of unsettling equivocality. Far from creating harmonies, his grotesque images overstrain the medium, introducing ever more violent, and unresolvable, thematic possibilities—a world whose very defining characteristic is grotesque self-contradiction. As such, it is a world without rest, without "place," where no value can be safely set lest it be inverted, "perverted," where the very existence of any such value is thrown into question. And it is a world where even perversion is not a viable category, because it is impossible to pervert in a world where one cannot establish a univocal value.

Fetuses and Old Men

William Gaunt stated that in Beardsley's drawings there was "something so hybrid as to be monstrous" (138); and certainly Beardsley very often makes his grotesques "monstrous" precisely by conflating normally separate, even mutually exclusive, ontological types. One of his most fascinating and ubiquitous hybrid monsters is the figure of the fetus–old man. Beardsley's works, especially in 1893, suggest a virtual obsession with fetus/embryo figures, one that may have gained impetus from his boyhood scrutiny of his grandfather's medical books, particularly such engravings as Wilhelm His published in volume 2 of his 1885 *Anatomie Menschlicher Embryonen* (Easton 179–90). Heyd argues that Beardsley's fetuses were, among other things, emblems for his creative impulse, or more specifically, his sublimated "desire for procreation" (65, 60). But as we have seen in such pictures as *The Cave of Spleen*, these figures tend to deny rather than affirm life, being melded paradoxically to images of decrepit old age and suggesting a world not of new beginnings but of imprisonment, foreclosed possibilities, and a general exclusion from any full life.

For that matter, Beardsley depicts sexual relationships as being almost universally barren. Feeling revulsion at the very thought of new life, "the sick man's hatred of recurrence" (Stanford, *Erotic* 28), he held no romantic ideas about procreation and childbirth; on the contrary, he frequently made children victims of evil or deprecated them, as he did in referring to *Choosing the New Hat* (front cover of *The Savoy*, no. 2 [April 1896]) (Reade, *AB* 427): "The little creature handing hats is *not* an infant but an unstrangled abortion" (*Letters* 120). A more obvious "abortion" appears in a vignette on page 26 of *Bon-Mots* (1893) by Sydney Smith and R. Brinsley Sheridan (Figure 4–6), pointing accusingly back at a hideously grotesque creature of typically indeterminate gender, an abortionist's suitably phallic instrument lodged in the pocket of its fur-lined cloak. In the confrontation between the abortionist and a worn, world-weary client-mother, dressed in clown's garb (Reade, *AB* n. 172), it is unclear whether

the abortionist is handing the fetus to the mother or she is handing it to the abortionist—a typical Beardsleyan ambiguity that, in effect, subsumes the implicit moral questions of the drawing in the twisted physiognomy of the characters. Indeed, the grotesque elements work to erase and render meaningless any identifiable distinction between the guilty and the innocent. The clown-mother's gnarled, long-nailed hand mirrors to a significant degree the equally grotesque hand of the abortionist, just as the lines of her hair mirror those of the abortionist's cloak. Dressing the mother as a clown may well have been symbolic in itself, suggesting that in such a grotesque world all procreators are fools.

The dangers of abortion aside, death (the mother's as much as the child's) was an all-too-frequent consequence of Victorian childbirth, and the anxiety- (and possibly guilt-) provoking circumstances of Beardsley's own birth—his mother contracted puerperal fever at the time of his delivery—may have contributed something to his tendency to conceive foetuses as "abortions" or threatening monstrosities. Far from using his fetus figure to illustrate a loving bond between mother and infant, Beardsley typically makes it a tool of "devilish irony," a "hideous monster" that Symons saw as the very symbol of Beardsley's "evil genius" ("Aspects" 131). For example, the "adoration of the child" pregnancy fantasy in *Dreams* for *Lucian's True History* (Figure 4–7), which is not in Lucian's text, is a Beardsleyan spoof of the Christian Nativity (Heyd 62–63). Under the outstretched wings of a giant bat and attended by a plethora of nightmarish, hybridized grotesques (some of them naked hermaphrodites), we have not a

4-6 Vignette on page 26 of *Bon-Mots* (1893) by Sydney Smith and R. Brinsley Sheridan. (E.314-1972 [neg. no. HD725], Victoria and Albert Museum, London)

4-7 *Dreams* for *Lucian's True History*. (1986.666, Scofield Thayer Collection, Courtesy of The Fogg Art Museum, Harvard University Art Museums, Cambridge, Mass.)

4-8 *Incipit Vita Nova.* (G.28 B.30 [neg. no. FF144], Victoria and Albert Museum, London)

serene Madonna but a life-worn temptress with snakelike, Medusan hair and scaly limbs. She presents to Lucian not a divine child but a repulsive, newtlike fetus whose hand is a claw. The god-child has become an aborted embryo, not sheltered but exposed (and perhaps given up) by its mother to monstrous demons or haggard sojourners—a demonstration that in a grotesquely paradoxical world all idealistic dreams are really nightmares.

In the striking *Incipit Vita Nova* [Here Begins the New Life] (Figure 4–8), which MacColl called one of Beardsley's strongest and perhaps most cynical designs ("AB" 419), is presented an even more mischievous parody of the Madonna and Child icon. Rendering the picture's title with farcically ironic literalness, Beardsley draws a particularly dour, balefully sinister, hydrocephalic (and presumably recently aborted) fetus, attended by numerous sperm and egg shapes. The fetus is reading an opened book, propped against the bosom of what Fletcher calls "a formidable female . . . acting as a species of fleshy lectern" ("Grammar" 144; *AB* 25). The

book's inscription, "Incipit Vita Nova," refers to Dante's *Vita Nuova*, his paean to ideal love mediated through young Beatrice Portinari, from whom he dated the origins of his new imaginative life. It is obvious, however, that the love to which the disgruntled fetus is being introduced is hardly ideal—or even "natural," for that matter. The sensual mother/lover, of the type often painted by Dante Gabriel Rossetti (who was fascinated with namesake Dante and the *Vita Nuova*), is regarding the fetus with a suggestive, heavy-lidded gaze apparently quite different from either Neo-Platonic or maternal tenderness. Beardsley further underscores the decadent perversity by having the precocious, grotesque fetus learn about its new life (and perhaps the origins of life) "artificially," from a book.

Part of the basic ambivalent instability of the grotesque is that it incarnates in the same body diametrically opposite yet simultaneous "poles of becoming: that which is receding and dying, and that which is being born" (Bakhtin, *Rabelais* 24–26, 52). It was a condition all too real to Beardsley, whose hybrid fetus–old man is probably, as Brigid Brophy argues, a self-portrait of his own consumptive existence, embodying in a single figure both life's earliest human form and, with the wizened looks Beardsley gave it, the death he knew was all too imminent (*AB* 55). Having come into the world abnormally early (like Beardsley's career), the fetus is a prodigy, representing through its precocious actions, huge head, and jutting frontal lobe the unusually rapid evolution of embryonic growth; yet it also symbolizes a basic lack of maturation, its feeble, undeveloped (and possibly aborted) body being ultimately unviable outside the womb (Brophy, *Black* 66). Conversely, its "old-man" aspect suggests that it has already consumed its life (as Beardsley's tuberculosis would prematurely consume his), death having been embedded in its body from the outset, claiming it even before it can be born into normal human life (Heyd 58–59). The hybrid figure's estrangement from the human world is signaled even more forcefully by its vaguely atavistic form, especially the large, unlidded fish or reptile eyes placed on the sides of its extravagantly bulging head (Fletcher, "Grammar" 146).

In a vignette on page 88 of *Bon-Mots* (1893) by Sydney Smith and R. Brinsley Sheridan (Figure 4–9) the figure of the fetus–old man (with Beardsley's "japonesque mark" signature affixed self-referentially to its head) is in the shape of a prawn, whose tail curls back into its mouth as if emblematizing the circularity of life. Out of the figure's truncated, sheared-off head arise a Whistlerian butterfly (the customary iconographic emblem of the soul now being made distinctly decadent) and a skeleton waving the familiar Aesthetic peacock or ostrich feather, which had become for Victorians "almost synonymous with funerals" (Morley 21). The juxtaposition of embryo and skeleton underscores Beardsley's grim conception of the paradoxical link between creation and death, a theme he may have adapted from Odilon Redon's work, particularly the lithographs of *Les Origines* (1883) and the illustrations to Flaubert's *Tentation de Saint Antoine* (1886) (Heyd 55–56, 58).[7] D. H. Lawrence posited as a "law of organic life" that death ensues upon any "actual mixing and confusion" of our intrinsically isolate identities (66); and in that vein Beardsley's figure of the hybrid fetus–old man, in whom beginnings and endings meet paradoxically in the identical physical form, is surely an emblem not of life's hope but of a self-reflexive prison of death. As with the fin-de-siècle revival of the Gothic monster, so Beardsley's fetus–old-man monster incarnates an intense consciousness of time

4-9 Vignette on page 88 of *Bon-Mots* (1893) by Sydney Smith and R. Brinsley Sheridan.

and fear of change, particularly those dreaded changes that mark decay, death, and the basic disintegration of values. It was, like his notorious baroque flourishes, a kind of cultural metaphor for both the "perverse" Victorian age and his beloved eighteenth century, which to him "seemed at once young and yet prematurely old, thus 'Decadent'" (Dowling, "Aesthetes" 372).

An ontological paradox, Beardsley's fetus–old man is, as Beardsley felt himself to be, fundamentally out of place. In fact, it can have no proper place, being at best a freakish curiosity on display, as in the first (uncensored) version of a design for *St. Paul's*, vol. 1, no. 1 (March 1894) (Figure 4–10). Although Beardsley impishly "seats" the alluring "japonesque" woman atop his famous salacious signature, the Beardsley-surrogate fetus is clearly precluded from physical contact with her by the enclosing glass dome, the wide-eyed voyeur himself having been sequestered (like the tubercular invalid) and even turned into the object of the gaze. It is a vexation of desire Beardsley emphasizes by positioning the fetus's accentuated eye and outstretched hand behind the restricting glass but directly opposite the woman's jutting

bare breast. Beardsley's figure of the fetus–old man becomes a true alien, a "monster," which according to the *Oxford English Dictionary* means paradoxically *both* an "unnatural" person or thing "of inhuman and horrible cruelty or wickedness" *and* "a prodigy, a marvel" (630–31). In a vignette on page 192 of *Bon-Mots* (1893) by Sydney Smith and R. Brinsley Sheridan (Figure 4–11) Beardsley makes his fetus–old man a virtual emblem of "inhuman . . . wickedness." Glaring with the furrowed brow of cerebral intensity, the misshapen hybrid perches on a chaise, attached to which is a Decadent peacock feather. The fetus's snakelike tongue and

4-10 Design for *St. Paul's*, vol. 1, no. 1 (March 1894). (23.628, Graphische Sammlung Albertina, Vienna)

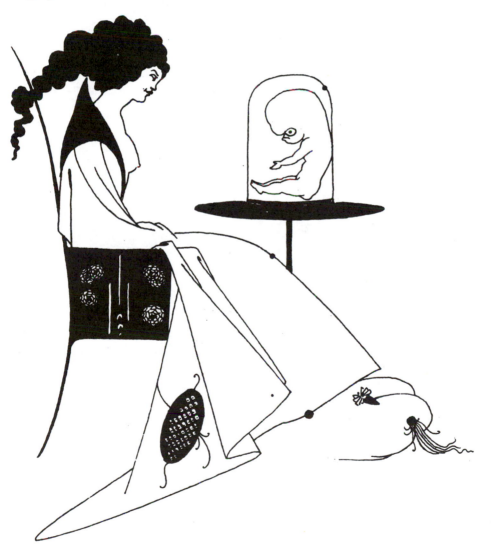

clawed hand reach ominously toward a lily, the symbolic flower of purity, whose stalk it grips with its satyr's hooves. In *Birth from the Calf of the Leg* for *Lucian's True History* (not used) (Figure 4–12) a fetus is being pulled from the leg of a man by the gnarled hands of a midwife. Beardsley makes grotesque both these hands and the toes and leg of the mother-father, blurring taxonomic categories by mischievously giving the incision in the leg the appearance of female sex organs (Heyd 62). The decadence of the precocious, scowling infant is highlighted by the petals detaching from the flowers at the lower right and especially by the telltale Godwin dressing table in front of the mother-father. As an alien Other, this ferocious fetus is as dangerous as it is "unnatural," a sense Beardsley reinforces by juxtaposing its head with the operating knife and by pointing the dressing-table scissors in the direction of the mother-father's hidden genitals, suggesting that this "monstrous" birth may, in fact, constitute a castration.

Increasingly after the early stages of his career, Beardsley shifted the role of the "miscarried," deformed freak from his fetus–old man to varied malignant infants and dwarfs (Fletcher, "Grammar" 147; Heyd 69).[8] His grotesque dwarfish infants still combine the physical attributes of both children and adults, and they continue to encompass the equally "savage" states of

4-11 Vignette on page 192 of *Bons-Mots* (1893) by Sydney Smith and R. Brinsley Sheridan. (Private Collection)

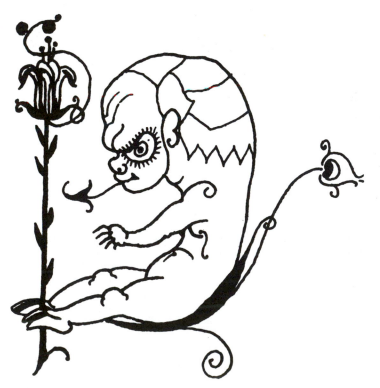

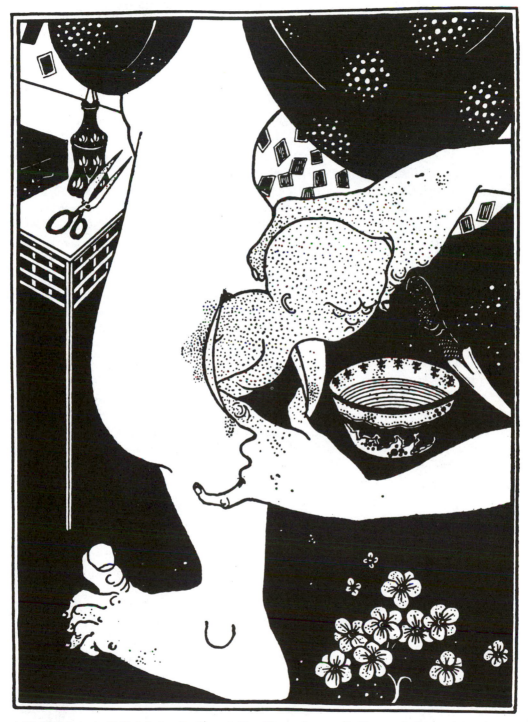

4-12 *Birth from the Calf of the Leg* for Lucian's *True History* (not used). (Private Collection)

embryonic unviability and geriatric decadence. Beardsley even suggests that his diminutive grotesques might be less "aborted" humans than animalistically devolved human mutations—a suggestion in line with dwarfs' legendary status as seducers and general purveyors of carnal desire (having unusually large sexual organs in proportion to their overall size). Beardsley's hermeneutic shift from "child" to "animal" was in one sense a smaller step than it may now seem. Victorian evolutionary physiology, anthropology, and psychology had spawned deep pessimism and anxiety about the potential of the human condition. Late Victorians had come to believe, through the works of Darwin and the antiquarian James George Frazer, among numerous others, that human moral character paralleled the evolutionary process of physical biology from lower to higher forms of life, that "social life passed through stages similar to those through which the embryo passed" (Siegel 201–2; see also Russett 47–77, 86–88). Under this psycho-physical analogical model, just as each successive stage of development represented a progressive advance over the relative savagery of previous stages, so, too, each stage carried within it traces of those savage origins to which we could revert if our development were arrested—a view that dissolved the clear distinction between civilization and savagery. Individual humans were understood to be not so much members of a separate, "higher" species as precariously situated evolutionary experiments, people who could easily plunge back into "the bestial abyss" as the result of a single hereditary flaw, physical or psychological (see Russett 194–206). Inasmuch as the life history of each person was thought to repeat the past history of the race, Victorians conceived the child to be the emblem of arrested adult development, bearing "the same relation to the savage as the adult does to civilization" (Siegel 202). Thus, part of the shocking character of Beardsley's grotesque fetuses and dwarfish infants was that they served as incarnations of the fin-de-siècle fear of decaying into primordial savagery and metaphysical dislocation.

Perhaps nowhere is this threat more blatantly manifest than in *The Kiss of Judas* (Figure 4–13), from *The Pall Mall Magazine* (July 1893). The drawing, which may have been based in part on Puvis de Chavannes's famous *Pauvre Pêcheur* painting (Clark 74), illustrates the accompanying story "The Kiss of Judas" by "X.L." (the American Julian Osgood Field, a satanist and friend of Algernon Swinburne's).[9] The story relates "a Moldavian legend . . . that children of Judas, lineal descendants of the arch traitor, are prowling about the world seeking to do harm, and that they kill you with a kiss" (X.L. 350). Beardsley thought the legend "awfully striking" (*Letters* 48) and was delighted to give it some intriguing embellishments that do not appear in the text, including a provocative infant–aged dwarf, the model for which may have been drawn from the British Museum's collection of sarcophagi (Kuryluk 265). In the story the offspring of Judas wander the earth as changeling vampires assuming various shapes (X.L. 350), one of the most fascinating resembling "a Madonna from a canvas" (364). Beardsley goes out of his way to have the pose of his "Madonna"—appearing to be more a lover than a mother—replicate that of the woman in *La Pia de' Tolomei* (Figure 4–14) by Dante-Gabriel Rossetti. But while Rossetti's woman hangs her head in sorrow and fatigue over her imprisonment by her husband, Beardsley makes the fate of his woman far more grotesquely ambiguous. For one thing he reverses her role: in the story she is the vampire who bestows the Judas-kiss of death, but in the drawing she becomes the victim of a grotesque infant-dwarf, whose

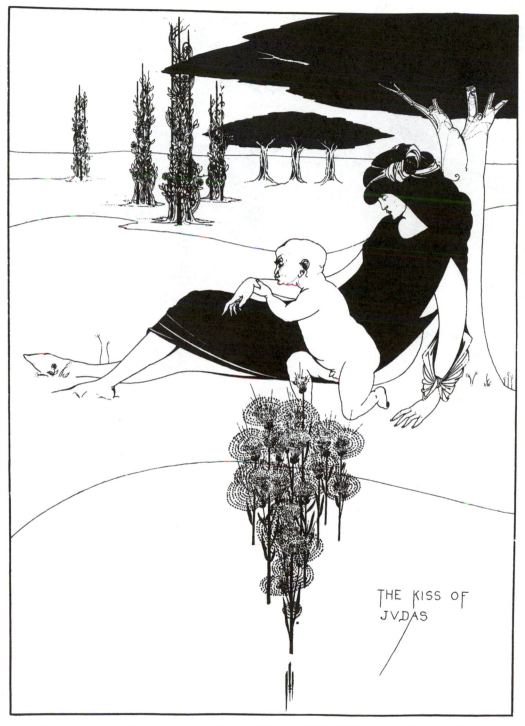

THE KISS OF
JVDAS

4-13 *The Kiss of Judas*. (Published in *The Pall Mall Magazine* [July 1893]. Private Collection)

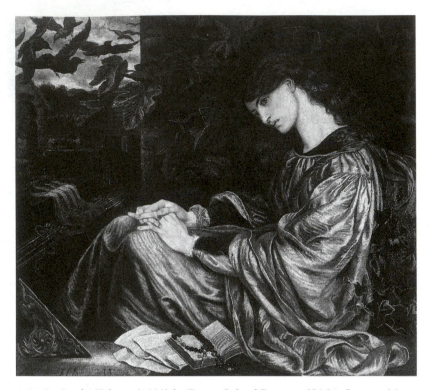

4-14 *La Pia de' Tolomei* (1880) by Dante Gabriel Rossetti. (56.31, Spencer Museum of Art, University of Kansas, Lawrence, Kan.)

exposed genitals and gnarled, prematurely aged head only heighten the drawing's macabre effect, once again collapsing beginnings and endings, confusing our normal codes of nurturing and abuse. A highly stylized disorientation pervades the scene: exotic vertical espaliers intersect trees whose foliage blends into modernistic black voids and seems to swallow the limbs, even as the foliage-voids form an ominous canopy for the two central figures (and the kiss). The limbs of the background trees and espaliers appear interlaced with this blackness, and the limbs of the tree against which the woman leans contain odd, sketchily delineated forms, as if the kiss is corrosively exposing their skeletal infrastructure or, conversely, generating in them strange gestating figures, reinforcing the perversion of the Madonna and Child motif. Beardsley draws the black shapes of the hair and dress of the woman in order to run roughly parallel to the horizontal canopy leaves and reinforce the sense of doom.

Accentuating the provocative and unsettling equivocality, Beardsley even designs the drawing so that his viewers can never clearly decipher the precise nature of the central evil. We cannot be certain whether the dwarfish infant is only in the process of kissing the (drugged? spellbound?) woman, raising her hand to his lips in perverse imitation of the continental custom, or whether he has already kissed (and presumably killed) her and is thus lowering her

limp wrist again, or perhaps merely gently guiding it in a depraved gesture of ironic benevolence. It is ironic, too, perhaps, that Beardsley depicts the Judas flowers in the foreground as rising out of his own stylized japonesque signature. The self-consciously precocious artist may well have felt that, like his fetus–old man, the aged infant-dwarf represented his own unseemly role as a terrorizing enfant terrible (and, coincidentally, constant burden and source of ill health for his mother). He was certainly acutely aware that his own youth would be foreshortened (and thus betrayed) by death, and perhaps even that he suffered from his own personal "mark of Cain"—tuberculosis—by which "contact with himself, especially through the mouth, meant death" (Heyd 73). Whatever Beardsley's autobiographical associations, what the monstrous infant-dwarf certainly did do for Beardsley's Victorian audience was to invert in grotesque fashion any comforting association of babes with innocence, joy, and hope, and remind them once again of the precarious fragility of civilization and even all human meaning.

Clowns, Harlequins, and Pierrots

That Beardsley used the grotesque to signal a fundamental confusion and disorientation of values is further evident in the frequent joining of fetuses, infants, or dwarfs with "quite mad and a little indecent" trickster clowns, harlequins, or Pierrots—"strange hermaphroditic creatures wandering about in Pierrot costumes or modern dress" (*Letters* 43). Both dwarfs and clowns have been linked traditionally to the grotesque: their perverse jokes, verbal bravura, twisted grimaces, obnoxious gestures, and outbreaks of hilarity have been read as a defense against the melancholy, depression, and death that seem to haunt them. In Roman times dwarfs were so highly esteemed as entertainers and jesters that "slave children were often deliberately maimed at birth in order to increase their value" (Lucie-Smith, *Caricature* 22). Certainly in nineteenth-century England dwarfs were a standard attraction at London exhibitions (Altick 255–60, 266–67). Beardsley's strange hermaphroditic clowns and Pierrots are, like most of his grotesques, ambiguous and paradoxical figures—androgynous, aged yet infantile, sickly and exhausted yet nervously alert, often dressed in a loose white costume that could be either a sexually portentous nightgown or a baby's dress—and as such, they serve as yet another set of his "marginal" and seminally discordant characters.

That Pierrot and other *zanni* figures should have become such obsessive tropes for Beardsley seems almost inevitable, given his love of "masks" and the fin de siècle's fascination with Pierrot as an emblem for the age.[10] Indeed, as a youth Beardsley was captivated by Michel Carré's *L'Enfant prodigue* (in which both M. and Mme Pierrot weep over their wayward son!), which he went to see repeatedly at Mrs. Nye Chart's Brighton Theatre (Cochran, "AB" 104; MacFall, *AB* 6). In fact, no other single type of figure appears more often or in more different forms and guises in Beardsley's art, nor was there any other figure with which he identified himself more frequently. Referring to a pictures-and-poems project for the journal *Pick-me-up*, Beardsley once wrote to Robert Ross that he was especially eager to have produced "a prologue to be spoken by Pierrot (myself)" (*Letters* 51).

But Beardsley's is a particularly equivocal Pierrot. Even when illustrating a text that

exploited Pierrot as a lover of the ideal, his Pierrots typically resist romantic idealism or melancholic languor, seeming more solipsistic than devoted, more cynical than disillusioned, more impish than lovelorn. The *zanni* in Beardsley's drawings have typical fin-de-siècle characteristics, but under Beardsley's hand they become more grotesque—more distorted by life's paradoxes—as Symons suggested when he described the "Pierrot gamin" he claimed Beardsley to be:

> Pierrot is passionate; but he does not believe in great passions. He feels himself to be sickening with a fever, or else perilously convalescent; for love is a disease. . . . [I]t is hard to distinguish, under the chalk, if the grimace which twists his mouth awry is more laughter or mockery. He knows that he is condemned to be always in public, that emotion would be supremely out of keeping with his costume, that he must remember to be fantastic if he would not be merely ridiculous. And so he becomes exquisitely false, dreading above all things that "one touch of nature" which would ruffle his disguise, and leave him defenceless. Simplicity, in him, being the most laughable thing in the world, he becomes learned, perverse, intellectualising his pleasures, brutalising his intellect; his mournful contemplation of things becoming a kind of grotesque joy, which he expresses in the only symbols at his command. ("AB" 97)

It is no accident that Beardsley has the paintings on the walls of his fictional Venusburg contain "terrible little pierrots" (*UH* 2: 192; *VT* 35). His Pierrots reside in a paradoxical world. Faces twisting undecidably between laughter and mockery, they are both comic and tragic, are silent and yet speak, passionately passionless, sliding grotesquely across several normally contradictory categories of meaning. In a vignette on page 168 of *Bon-Mots* (1894) by Samuel Foote and Theodore Hook (Figure 4–15) the Pierrot figure of indeterminate gender—ostensibly a traditional male Pierrot, it effeminately holds out its tunic as if curtseying—makes what seems to be a polite gesture that is contradicted by its grotesquely malignant sneer. In another vignette on page 138 of *Bon-Mots* (1893) by Charles Lamb and Douglas Jerrold (Figure 4–16) the clown is of distinctly clearer gender, but it is hardly less grotesque, nor does its black mask and cape suggest that it is any less dangerous.

That Beardsley's Pierrot figures seem to metamorphize across definitional boundary lines only parallels the transformations Pierrot underwent in the nineteenth century. At the famous Paris Théâtre des Funambules in the early nineteenth century Jean-Gaspard (Baptiste) Deburau converted Pierrot from its previous incarnations as the naïve scapegoat Pedrolino or the gross buffoon Gilles into a sophisticated and self-controlled stoic who at times united intelligence with a sinister malice. Deburau's son Charles portrayed the figure as a paranoid and alienated hermaphrodite or devil. Paul Legrand gave Pierrot the elements of tearful pathos and macabre mystery that so impressed Théophile Gautier. Finally, Adolphe Willette (habitué of the Moulin Rouge and Chat Noir cabarets) turned the figure into a mournful bohemian artist, thwarted idealist, rejected lover, neurasthenic pariah, and childlike rake (Welsford 309–11; Storey 94–127; Chamberlin, *Ripe* 182). In the course of the century, the figures of Pierrot,

4-15 Vignette on page 168 of *Bon-Mots* (1894) by Samuel Foote and Theodore Hook. (Private Collection)

Clown, and Harlequin sometimes split into antagonist doubles of each other, or their characteristics would blur almost indistinguishably.

The bumpkin Clown, popularized most notably by Joseph Grimaldi, had extravagantly "garish clothes and an absurdly distorted countenance" that caricatured the dandy and marked Clown as "fantastic" and sometimes cruel (Welsford 314; Storey 90, 104). Equally a part of Beardsley's Pierrots was the figure that often frustrated and humiliated Clown, the amoral and impudently gay Harlequin. A trickster whose most distinguishing characteristic was traditionally a "complete absence of the moral sense" (Welsford 303), Harlequin originally appeared in medieval legend as an aerial specter or demon. He changed into a comic devil in later religious drama, and finally became in the eighteenth-century Italian *commedia dell'arte* "an odd hybrid creature, in part a devil created by popular fancy, in part a wandering mountebank from Italy" (291–93). A chameleon, it occasionally taunted Pierrot in the symbolic form of a

4-16 Vignette on page 138 of *Bon-Mots* (1893) by Charles Lamb and Douglas Jerrold. (Private Collection)

black cat (Welsford 311), an association Beardsley made in such drawings as *Pierrot and cat* from *St. Paul's* (20 July 1895) (Figure 4–17).

Like other "seers" that partake of the divine (Tiresias, for example), Harlequin was a particularly unclassifiable figure, sometimes characterized as a hermaphrodite, even on occasion wearing Hermes's cap, leading Salomé's followers, and brandishing a caduceus that opened up the world of the dead (Zolla 91). More a natural force than a person, the slippery, masked Harlequin was diabolical but also very human, sometimes sentimental, highly skilled in soliloquy and witty pantomime, a resilient and gossipy free spirit (Welsford 295–97). He was never trapped by the limitations of any one historical situation—Bakhtin notes that Harlequin never died in any of the Italian or Italianized French comedies (*DI* 36)—but remained inexhaustible, ever mirroring back to us the cruel, ultimately unbridgeable discrepancy between our current reality and our unrealized potential.

As he did with so many of his icons, Beardsley ended up conflating the overlapping characteristics of the Clown-Harlequin-Pierrot traditions, particularly the *commedia dell'arte* and Decadent traditions, into paradoxically overdetermined figures—male/female, good/evil, nature/culture, fool/sage, dreamer/cynic, truth teller/trickster—that become grotesque in the process. Like his fetus–old-man characters, the Clown-Harlequin-Pierrots are dark and alien "others" who cannot be understood directly but only as highly mediated metaphors. For instance, Beardsley certainly exploited the fact that, as Jacques Callot's illustrations showed, the actors' masks of the *commedia dell'arte* "were intended to add animal qualities to the human body"—excessively long, beaklike noses, appropriately sharpened chins, batlike protuberances, and cock's feathers—and thus accentuate the grotesque character of the society they critiqued (see Kayser 39). Existing in a metamorphizing netherworld unrestrained by normal human rules, Beardsley's own ambiguous, motley figures similarly lay bare conventionality, exposing

4-17 *Pierrot and cat* from *St. Paul's* (20 July 1895). (E.538-1899 [neg. no. FF138], Victoria and Albert Museum, London)

what is false, vulgar, and stereotyped in ordinary social discourse. In their struggle against conventional limitations, they assert, in the words of Bakhtin, "the right to confuse, to tease, to hyperbolize life; the right to parody others . . . , the right to act life as a comedy and to treat others as actors, the right to rip off masks" (*DI* 163).

But if Beardsley exploited the absurdist-Clown and the trickster-Harlequin sides of Pierrot, he also emphasized its equally traditional role as a scapegoat and martyr, quite often the victim of conspiracy. A common metaphor of Pierrot's martyrdom that particularly appealed to Beardsley was sickness, both physical and spiritual. Indeed, by the fin de siècle Pierrot had become a virtual emblem of disease, most specifically the disease of love, the figure's all-white appearance connoting illness as well as detachment from reality. The moody Beardsley was well known for identifying himself with the melancholy Pierrot-Gilles of his fellow consumptive-invalid Watteau, and even more directly with the similarly impassioned and ill-fated Keats, to whom he self-consciously came to pay tribute when a bust of the poet was unveiled in Hampstead in the summer of 1894 (MacFall, *AB* 17). But while in Watteau the illness of the white, vaguely consumptive Pierrot suggested a kind of purifying refinement, such illness was more frequently read by the 1890s as a form of decadence, if not contagious insanity. The disease-tainted Pierrot thus became both a victim and a corruptor, both innocent clown and threatening specter—a sinister association in no way diminished by Beardsley's black-masked Pierrots.

In the fin de siècle "decadent" art was routinely associated with illness; however, as Susan Sontag has discussed, even from ancient times disease has carried the additional moral connotation of "an instrument of divine wrath" (Sontag, *Illness* 39). Like sexual passion and other "evils" that bourgeois society feels are mysteriously uncontrollable and must be hidden, such mysterious diseases as tuberculosis were felt to be a violation of appropriate limits. They were morally as well as literally contagious—hence the need to isolate the sufferers in sanatoriums, the same term given to insane asylums. By the nineteenth century tuberculosis in particular— etymologically, a morbid swelling or incursion (from the Latin *tuberculum*)—was considered a taint, a bodily expression of the failure of moral will, a disease of the lungs being "metaphorically a disease of the soul" (10, 18). The disease was thought to select those of a certain character type—usually someone "both passionate and repressed," having intense hidden desires or being given to passionate extremes—that is, someone incarnating a lack of moral balance (38–39, 43–46, 11). A person afflicted with tuberculosis, or "consumption," was literally consumed inwardly with a fever that leads inevitably to the wasting away of the body— in effect, an acceleration of life that intensifies even as it squanders life's moments (14, 20-21). Being a disease of repression as well as passion, its paradoxical symptoms were thought to be cunningly deceptive and seductive—rosy cheeks that seem a sign of health but come from fever, spasmodic hyperactivity that all too often only signals approaching death (13).

It was hardly surprising, therefore, that friends and critics alike tended to see the grotesque character of Beardsley's pictures as a function of his disease. The *Times* obituary ascribed "the morbid quality of his imagination" to lung disease (18 March 1898: 10). Walter Crane claimed that "the morbid elements" in Beardsley's art, which "ultimately seemed to gain the ascendancy, overshadowing his sense of beauty, and inducing him to spend his skill upon loathly

or corrupt forms and subjects," were a function of his failing physical health that "finally overcame him" (*Reminiscences* 416). Yeats, too, believed that Beardsley's "disease presented continuously before his mind, as one of its symptoms, lascivious images" that he was compelled to draw "in their horror, their fascination" (*Memoirs* 92). Even more recently, Brophy follows the same logic, conceiving Beardsley as basically "a lyrical artist" who was pounded into an ironist by the pressures of his fatal disease (*Black* 11).

Beardsley himself makes the connection between illness and guilt in *The Death of Pierrot* (Figure 4–18). Alluding to what he knew would be his own early death, Beardsley shows his diseased surrogate, a death-masked Pierrot, about to be carried away surreptitiously—as the accompanying text tells us, "whither we know not"—by scheming, tiptoeing *commedia dell'arte* characters (Columbina, Arlecchino, il Dottore, and Pantaleone) of traditionally dubious morality. Beardsley accentuates the intimation of sly criminality, decay, and impending misrule by the carelessly chair-draped costume, the detached fringe on the bed canopy, the cord that dangles spiderlike above the skull of Pierrot, the poignantly empty slippers, the hushing gestures of Columbina and Arlecchino, and, not least, the menacing Doctor, who glares at Pierrot and brandishes a swordlike instrument. For that matter, Beardsley's customary hidden salaciousness carries a particularly discomforting overtone: the covert juxtaposition of Columbina's voluminous skirts against Pierrot's chair-draped hat once again creates Beardsley's "familiar theater of penis and testicles" (Fletcher, *AB* 119), but this gargantuan phallus presses ominously on a sagging, empty gown.[11]

In *The Mask of the Red Death* for *The Works of Edgar Allan Poe* (Figure 4–19), traceable to *La Troupe Italienne* by Watteau (Heyd 44), the image of the Plague or Red Death that the carnival revelers confront, is not Poe's masked skeleton but Beardsley's autobiographical version of it—an unusually tall (and presumably thin), frowning Pierrot, dressed in what hints to be a shroud. Such an interpretation, in no way supported by Poe's story, once again links Beardsley's favorite surrogate to disease. As if reinforcing Pierrot-Death's status as anathema, Beardsley isolates the figure almost off the page to the far left, from which "marginal" position it confronts and threatens the other characters, most of whom are given at least one distinctly grotesque feature. Ironically these "threatened" characters are themselves Clown-Harlequin-Pierrot variants, who here appear in many respects more ominous than the Red Death. In the center, resting on a dandy's walking stick, is an imposing, horned femme fatale, whose bare breasts offset an exotic pantalooned costume, including equivocal winged heads—which paradoxically could be either cherubs or demons—hanging like trophies at her waist. At the far right is another figure in carnival dress, whose arm position, woeful look, and back-to-the-audience stance suggest that he may have been interrupted in the middle of a lascivious act. The other two figures are literally Clown-Pierrots, but instead of appearing as "victims" of the Red Death, they seem rather to mirror back its malice. The one nearest the Red Death is an ostentatiously effeminate fop who, sconced safely beside the horned woman poses and glares confrontationally, a hornlike protuberance on its skull. The other clown figure seems to cower behind the horned woman, but in most respects is hardly less "evil": it is dressed entirely in black, wears a black mask, and has Beardsley's familiar wild rose-gems as its billowing hair. None of these figures, neither the Clown-Pierrots themselves nor the carnival figures that

4-18 *The Death of Pierrot*. (Published in *The Savoy*, no. 6 [October 1896]: 33. Private Collection)

4-19 *The Mask of the Red Death* for *The Works of Edgar Allan Poe.* (Private Collection)

4-20 Vignette on page 162 of *Bon-Mots* (1893) of Sydney Smith and R. Brinsley Sheridan.

accompany them, suggests the dreamy romance or naïve innocence so often associated with Pierrot.

On the contrary, Beardsley's grotesque Clown-Harlequin-Pierrots are typically never very far from the perverse and dangerous world of the macabre. In a vignette on page 162 of *Bon-Mots* (1893) by Sydney Smith and R. Brinsley Sheridan (Figure 4–20), for example, a chuckling Clown-Pierrot, sporting a Decadent peacock feather, attends a turbaned, grotesquely wrinkled Clown figure, who wears Beardsley's "japonesque" signature and who scowls down maliciously at a tiny, naked, blindfolded infant whom he holds in his outstretched hand, along with, ironically, a string of rosary beads. Out of envy or merely disgust, the aged grotesque scorns the pious "blind" infant, who has its entire life ahead but cannot see how horrific that life may become. Hardly less disconcerting is the scene in another vignette on page 139 of *Bon-Mots* (1893) by Sydney Smith and R. Brinsley Sheridan (Figure 4–21), which implicitly mocks Love. A grotesque Clown-Harlequin (with hairy feet and legs of distinctly different sizes) sneeringly sticks out its tongue as he gives a showman's gesture, inviting us to view a blindfolded baby Cupid perched on a huge clawed and scarred hand not dissimilar to Clown-Harlequin's own. Suspended between the mocking Harlequin and Cupid (and pinned to earth under Harlequin's misshapen feet) is a balloon head, wearing a tiny clown hat and bearing a grief-stricken visage very much like that of the Mother-Pierrot who was presumably ill served by love in an earlier vignette (Figure 4–6).

Beardsley's Clown-Harlequin-Pierrots appear no less cynical about art than they are about religion or love. In what may be taken as a particularly autobiographical piece, a vignette for page 188 of *Bon-Mots* (1893) by Sydney Smith and R. Brinsley Sheridan (Figure 4–22) shows an infant on a Beardsleyan grotesque black cat, which balances precariously on yet another Decadent peacock feather. The infant is reaching to receive a dripping quill from a mocking Pierrot, who once again wears Beardsley's mark. As if the scene were not symbolically ominous enough, in the process of offering the drawing (or writing) implement to the infant, Pierrot reaches over a decadent black butterfly and behind a hairy dead tree. Here, as in the other drawings, Beardsley joins the grotesque to the figure of the trickster-clown, suggesting that life is finally only a perverse game, fundamentally subversive of the innocence and futurity of youth.

4-21 Vignette on page 139 of *Bon-Mots* (1893) by Sydney Smith and R. Brinsley Sheridan. (Private Collection)

4-22 Vignette on page 188 of *Bon-Mots* (1893) by Sydney Smith and R. Brinsley Sheridan.

As deformed, unrefined, and even "unfinished" creatures, Beardsley's dwarfs serve as a constant point of tension within a relatively homogeneous, "cultured" society. Similarly, his conflated Clown-Harlequin-Pierrots are complex, ambiguous figures that work to unhinge the very structure of accepted, unequivocal meaning. Scampish outcasts consigned to the margins of social discourse, they reveal the fragility of stable fact and the grotesque contradictions within all presumably univocal values. The masked carnival figure in the front wrapper of *The Cambridge A.B.C.*, no. 1 (8 June 1894) (Figure 4–23) is but one of the more subtle of Beardsley's disorienting "grotesques." Against an unusually decorous and elegant landscape and balustrade, he solicits the attention of the young woman with him in the garden. His owl's cap connotes that he can presumably be trusted as a wise sage, yet his mask and his gesture of whispered secrecy suggests that he has some surreptitious purpose. Although the young woman opposite seems to confront the Pierrot-Harlequin without apparent fear, pointing directly to him, Beardsley intimates formalistically that the interloper may have already upset the delicate equipoise of the scene. The unruly locks of his owl's cap are replicated to become "flames" in the ruffles of the woman's gown. Even more disorienting, Beardsley impishly designs the composition, so that the pitch-black ground of the garden and the equally black portions of the woman's dress blur indistinguishably. Indeed, the black void extending from the Pierrot-Harlequin literally encroaches on and erases the boundaries of her person. Once again social elegance and balance dissolve into "grotesque" dislocation.

Derek Stanford has observed that Beardsley's works do "nothing in particular" yet do it mysteriously, creating an odd, tension-sustaining "eternal suggestiveness" that ambivalently expresses intensity while "denying all final formulation" (*Erotic* 31). His figures ostensibly divide the world into dichotomies (or lead the reader to impose dichotomies), while they in fact blur the distinctions between such polarities—the threatening one is threatened, the

The Cambridge A.B.C.

No. 1. June 8, 1894.

Cambridge : Elijah Johnson

4-23 Front wrapper of *The Cambridge A. B. C.*, no. 1 (8 June 1894). (Private Collection)

powerful turns out to be effete, and so forth. Traditional codes of meaning are shaken, and if there is any "key," it is a pervasive semantic violence, a fundamental dis-ordering of previously normative values.

Yet, as the German scholar Thomas Cramer explains, the grotesque is not only a vehicle of disorder but also, paradoxically, a defense against that disorder: it not only involves "das durch übersteigerte Komik ausgelöste Gefühl der Angst" [the feeling of anxiety aroused by the comic being pushed to an extreme] but also represents "die durch Komik bekämpfte Angst vor dem Unerkläbaren" [the defeat of anxiety, by the comic, in the face of the inexplicable] (26). Beardsley's use of the grotesque is certainly frequently humorous, and it gives every evidence of being an attempt to shape the inexplicable—what Wolfgang Kayser describes as that manipulative game, in which the artist plays, half laughingly, half horrified, with the deep absurdities of existence in "AN ATTEMPT TO INVOKE AND SUBDUE [ZU BANNEN UND ZU BE-SCHWÖREN] THE DEMONIC ELEMENTS IN THE WORLD" (186–88). It is an aggressive, combative form of humor, conforming to what Philip Thomson speculated is that unconscious "sadistic impulse," by which out of self-defense we "react to such things with unholy glee and barbaric delight" (9, 56). Ultimately, however, Beardsley's grotesques are not a "defeat of anxiety," and certainly not comic in any classical sense, because the drawings in which his grotesques appear provide no resolution; in fact, they only increase the metaphysical confusion. They are not, strictly speaking, even satiric, because we cannot clearly separate what amuses us from what disgusts or angers us, or the right from the wrong, the true from the untrue, appearance from reality. We cannot really be "instructed" regarding things in Beardsley's pictures, at least as satire usually instructs, because the frame of reference by which we can determine such moral distinctions is always shifting, cut out from under us. Instead, what Beardsley demonstrates is the unresolvability of incompatible elements—not their separation, but their basic inseparability (see Thomson 42, 59).

Psychoanalysis has argued that "we recognize the power of death when we say a thing is ugly," and so our urge for beauty is the urge for reparation, a conquering of death and destruction. Unable to contemplate "what in our unconscious phantasy we have already done," that something good has been destroyed without remedy, we wish "to find in art evidence of the triumph of life over death" (Rickman 310-11, 313). In this sense Beardsley's alternation of grotesque mutability and stylized beauty, mutability ultimately redeemable by beauty, was his play on Freud's "Three Caskets" parable: through a process of reaction-formation the Goddess of Love replaces the Goddess of Death, who "had once been identical with her" ("Three Caskets" 72–73). Unable to tolerate the homogenized hypocrisy of Victorian convention, he shattered its complacent equipoise with his disconcerting grotesques; unable to accept the eternal paradoxes of an unrelentingly grotesque world, he recuperated it in artistic style. What we get, then, is an oddly collapsed, uncanny world, where asexual androgyny is only the obverse side of lust, where beauty is the logical extension of the grotesque, where harmony is but a mask of "the horror."

Like most Victorians, Beardsley ultimately sought—most obviously through the formal properties of his art and the Decadent Religion of Art in general—a secure, unified interpretation of meaning. Part of what his vexing grotesque images expose, however, is the uncertain,

often paradoxical, variability of truth, a truth riddled with contradictions, for that matter, a truth as dependent on the personal and societal politics of the viewer as on any inherent qualities. The grotesque was for Beardsley a practical means of liberating his art from constricting conventional influences, but it also became for him a trope that captured perfectly the evanescent mystery and unsettling perversity of slippery modern experience—a trope whose signifiers slide disconcertingly between farce and fear, "sportive" and "terrible." It is one interpretation of Wilde's remark, upon learning of Beardsley's "macabre and tragic" death, that "there were great possibilities always in the cavern of his soul" and that he "was one who added another terror to life" (Wilde, *Letters* 719).

The Beardsleyan Dandy:
Icon of Grotesque Beauty

Dandyism, which is an institution outside the law, has a rigorous code of laws that all its subjects are strictly bound by.
—Charles Baudelaire, "The Painter of Modern Life," *SW* 419

Dandies . . . are the hermaphrodites of History.
—Jules Barbey d'Aurevilly, *Dandyism* 78

DANDYISM—the implicit doctrine of Oscar Wilde, James Abbott McNeill Whistler, and much of the Decadence—was the style of life Beardsley most admired, and of all his figures, the dandy most incarnates his paradoxical iconoclastic authoritarianism. Beardsley routinely employed the "madness" of the grotesque as a kind of tongue-in-cheek visual repudiation of the smugly "sane" bourgeois world; and certainly his bizarre dandy figures, often depicted as grotesque themselves, reflect that rebuke. But they represent much more, embodying a wide spectrum of the vexing ironies of Beardsley's art. Indeed, his dandies stand as a plethora of contradictions, combining and orchestrating both the grotesque disorientations of the cultural antihero and the recuperating elegance and control of Art. The dandy becomes for Beardsley not only an emblem for his own split sensibility but an icon for his evolving "dandiacal" artistic styles—styles that, like the dandy, effected a caricature of cultural meaning.

The Provocateur Dandy

For Beardsley, as for Wilde, whose famous claim, "I was a man who stood in symbolic relations to the art and culture of my age" ("De Profundis," *Letters* 466), reflects the credo of fin-de-siècle dandyism, the great artist was an imperialistic personality. Every project became a personal vehicle for his own stylistic expression of the world. In Beardsley's *Le Morte Darthur* and

Salome projects, critics found "the irrepressible personality of the artist dominating everything" (*Studio* 184). Beardsley was judged to be the back bone of *The Yellow Book* as well (J. Pennell, AB 37). Moreover, as Hesketh Pearson said of *The Savoy*, which seemed to wane in direct proportion to its art editor's failing health, it "might just as well have been called *The Beardsley*, for he was, if not the life and soul, at least the body and death of it" (231).

As much as any pictorial artist in the late nineteenth century, Beardsley embraced Baudelaire's confrontational aesthetic, which filtered conflicts and tensions through the personality of the artist, taking it as art's avant-garde duty to conquer by effrontery, to shock more than to please. It was an aesthetic based on the "decadent" belief that artistic creation itself demands contradiction, restlessness, and dissolution, prior to a fusing recreation (see Baudelaire, SW 299; CE 274)—a belief that, for that matter, may have been part of the reason both Baudelaire and Beardsley found Richard Wagner's music so unusually compelling. Beardsley's legendary love of the abnormal, his constant playfulness, his willful subversion of dreamy Pre-Raphaelite mythology, and his identification of "artist" with a "fanciful, ingenious, elaborate, somewhat tricky way of seeing things" (Symons, "AB" 95) were all variant expressions of the Decadent cult of personality. Like many of his Decadent compatriots and like the dandyism he revered, Beardsley sought to capture the Paterian "virtue" or "quintessence of things" by identifying it with what was individual, eccentric, unique.

As an emblem of iconoclastic individualism and eccentricity, the dandy was for most bourgeois Victorians a disagreeable and disconcerting figure. As Beardsley's hero Balzac had established in such society-magazine articles as "Traité de la Vie Élégante" (published in *La Mode* in the fall of 1830), the dandy is a fomenter of class struggle. With the modern erosion of traditional class distinctions and barriers, small nuances of dress and behavior become the only significant distinctions, and the dandy gladly pits his original, eccentric values of style and elegance against the leveling "progress" of the democratic middle class (*Oeuvres Complètes* 39: 152–85; see also Moers 130–32, Williams 116–17). Where the industrial classes called for uniformity, responsibility, and energy, the elitist dandy stood for superiority, irresponsibility, and inactivity (Moers 13).

Victorian antipathy against the Regency had, in fact, made dandyism generally unfashionable in England for almost half a century. It owed its resurgence (and virtual apotheosis) in the eighties and nineties to France, specifically to Barbey d'Aurevilly's celebration of the arch-dandy Beau Brummell in *Du Dandysme et de Georges Brummell* (1845) and, even more significantly, to Baudelaire's imaginative expansion of Barbey's thesis in a number of essays, particularly "Le Peintre de la Vie Moderne" [The Painter of Modern Life] (1863), which proclaimed the dandy to be the true artist of the modern age.[1] Barbey had decreed that the principal characteristic of dandyism is "always to produce the unexpected" (33). It was a highly refined, intellectual—indeed, spiritual—achievement, treading tactfully the fine line between originality and eccentricity, as evidenced magnificently in Brummell's witty irony and impudent poise (51). Superiorly reticent and refinedly self-contained, like a work of art, Brummell defined the meaning of his life in terms of beauty instead of useful production, inverting the order of the superfluous and the necessary. As such, his very presence—as the paragon of a cosmopolitan, "intellectual sex"—constituted an implicit spiritual rebuke of the vulgar, os-

tentatious materialism of a bourgeois world (Barbey 31–34, 53–58). Oddly enough, for all the dandy's effete, "unproductive" irresponsibility, his aristocratic recalcitrance did appeal to a certain late-Victorian "nostalgia for anti-bourgeois virtues": "The decorative surface, the blind assurance, the wrongheaded (but inescapable) *rightness* of the dandy figure remained somehow attractive, even to those outraged at the thought of squandering talent, energy and money on such achievements" (Moers 14).

Building on Barbey's *Du Dandysme*, Baudelaire similarly championed the arrogant, idle, isolated, self-absorbed, financially irresponsible dandy as a figure of existential revolt. Representing "what is best in human pride . . . aggressive even in its coldness," this haughty déclassé intellectual incarnates "a new kind of aristocracy," scornfully setting up a true patrician standard "to combat and destroy triviality" in a fallen utilitarian world (*SW* 421). He is "the last flicker of heroism," a modern ideal, "human-being-as-*objet d'art*," on whom "sensitivity to the new and powerful in art confers a special distinction" (*SW* 421; Nochlin 228). In the face of the newly dominant middle classes, royalty and much of the traditional aristocracy had adapted to the times by assuming a more bourgeois style of life; but the uncompromising and impertinent dandy, refusing to be co-opted, instead espouses waste, idleness, and lavish spending, in direct contradiction to the bourgeois values of utility, work, and thrift (Williams 116). Baudelaire thought Delacroix "a complete man of genius" precisely because he could self-consciously indulge, with great joy and in violation of bourgeois concepts of thrift, "all the material vanities of dandyism" (*SW* 377; *AR* 25).

As an idler and loiterer, the Baudelairean *flâneur*-dandy manifests "the metaphysics of a *provocateur*" (Benjamin, *Baudelaire* 14), isolating himself from the common bourgeois world (even as he impertinently presumes to be the "detective" of bourgeois sins) (Baudelaire, *SW* 399–405; *AR* 61–69). Like the soldier, whose beauty "lies in" a carefree, martial air, a strange mixture of calm and boldness . . . that comes from the need to be ready to die at any moment" (*SW* 417; *AR* 85), so the modern artist-dandy lives a life of acute sensitivity to the fleeting moment, of constant gambling, in order to affirm the higher morality of beauty's discipline. In his very clothing the dandy reflects his artistic sensitivity to "the transient, the fleeting, the contingent" essence of modernity, particularly the nuances of modern dress (*SW* 403; *AR* 66–67). Never vulgar himself, the dandy may commit what society considers crimes, but such "crimes" will never stem from trivial causes; rather, they arise out of "grandeur in all follies, a driving power in every sort of excess" (*SW* 420; *AR* 87–88). Seeking "to distil the eternal from the transitory," embracing the essential duality of beauty (part transient, part eternal), the dandy incarnates beauty's paradoxical virtue, his clothed body knowing sin and corruption even as it seeks stylistically to rise above them (*SW* 402, 392–93; *AR* 65–66, 52–53).

The arrogant dandy's aestheticized, alternative lifestyle was an affront to Victorian bourgeois society as much in its method as in its philosophy. The relatively plain, meticulous, traditional black costume of Barbey's and Baudelaire's archetypal dandy, through its negation of all color, became a dramatic gesture of separation and a commonly acknowledged emblem of bourgeois culture's irreversible decline. The costume was "distinguished by its restraint. . . . [F]lamboyance was generally avoided, distinction provided by subtle little niceties

of detail or refinements noticeable mainly to other 'insiders'" (Nochlin 228; Moers 143n, 272). Ironically, in his oblique way the dandy turns out to be more authentically frugal than the bourgeois philistine; he is "most economical, most scrupulous of means," seeking "production of the supreme effect through means the least extravagant" (Beerbohm, "Dandies" 6, 2). The "aristocratic superiority of his mind" reflects a return to that basic unifying purity characteristic of all sacred things: "[P]erfection in dress consists in absolute simplicity, which is, indeed, the best way of being distinguished" (Baudelaire, *SW* 420; *AR* 89–90). Fusing his life with his art, the dandy translates every conviction or principle into unifying habit and gesture (see Moers 274). He appropriates inherently unexceptional objects and implements and, by magical (often "camp") realignment, has them carry secret meanings—meanings that express in code a form of resistance against the oppressive ruling order. Style itself becomes pregnant with signifi-cance, the "content" becoming marginal, substitutable, in a world engendered not by "essence" but by models, simulacra, where everything (and everyone) becomes a potentially clonable instrument. Meaning becomes a function of theater, roleplaying, the filtering of eroding reality through the artifice of an individual temperament. The impertinent dandy's ironic stylistic transformations go *à rebours*, "against nature," interrupting the dominant culture's process of "normalization," offending it and challenging its bogus myths of unity and cohesion.

This highly restrained art of subtle signification defined the dandy's safety as well as his power and freedom. In a capitalist culture that increasingly threatened to turn all forms of life into commodities for consumption, the dandy's emphasis on subtle, differentiating details of fashion—and the theatrical "mask"—enabled him not only to promulgate true value to knowl-edgeable insiders, but also to protect it from the despoiling philistine.[2] Certainly, as suggested by the plethora of fans, veils, and facial masks that show up constantly in his pictures, Beardsley viewed representation as essentially a representation of one or another fictional "mask." Robert Ross reported how Beardsley cultivated "an artificial manner" through which he often "supported theories for the sake of argument in the most convincing manner, leaving strangers with a totally wrong impression about himself, a deception to which he was much addicted" (30).

It is not hard to see why the "decadent" dandy was perceived as a kind of criminal by Victorian bourgeois society, given its tradition of establishing authority by equating its con-ventions with natural law. The Victorian ruling class was, after all, a capitalist society, so whatever aided the production of surplus value (capital)—speed, practicality, frugality, def-erence to authority and tradition, the privileging of wealth deriving from interest or manage-ment skills, conservative morality, large families, virility—was seen as "natural" and "good." The opposite values, those that impeded the generation of surplus value—slow and meticulous care, useless decoration, waste, avant-garde iconoclasm, the privileging of the eccentric and spontaneous, immorality, nonreproduction, androgyny—were, consequently, "unnatural" and "bad." The "unproductive" and "inconsumable" dandy, who resists reducing life to its ex-change value, was clearly judged to be unnatural and thus unhealthy. In contrast to the favored Aristotelian idea that art imitates nature, the dandy asserted that true art (including his own fashion art) must be a "sublime distortion"—or de-formation—of nature in an attempt to

reform it (see Baudelaire, *SW* 426; *AR* 97–98). Through his dexterous control and powers of discrimination the dandy establishes a morality of the artificial, which overturns the false morality of the "natural":

> [N]ature can do nothing but counsel crime Everything that is beautiful and noble is the product of reason and calculation. Crime, which the human animal took a fancy to in his mother's womb, is by origin natural. Virtue, on the other hand, is *artificial*, supernatural Fashion must therefore be thought of as a symptom of the taste for the ideal that floats on the surface in the human brain, above all the coarse, earthy and disgusting things that life according to nature accumulates, as a sublime distortion of nature, or rather as a permanent and constantly renewed effort to reform nature. (Baudelaire, *SW* 425–26; 96–98)

In fact, like Huysmans's Des Esseintes, whose aestheticism was a pathological detestation for all things primitive or unrefined—"not an escape but a perpetual violation of nature . . . to make outside or inner nature deviate from its norms and laws" (Calinescu 172)—the dandy aristocratically inverts the hierarchy (if not the logic) of the bourgeois-capitalist ideology of consumption. Linking value to the destruction of objects, the bourgeois capitalist conceives consumption as a materialistic "using up" (from the Latin root *consumere*, meaning roughly "to take away with") that generates additional profits out of the demand for more merchandise. The dandy, on the other hand, retains the value of the transitory but turns the principle upside down, transforming material consumption into the artistic affirmation of spiritual truth (from a second Latin root, *consummare*, meaning "to sum up" or "to consummate," as in the distilled essence of consommé broth) (see also Williams 6). To the dandy the stylish use (consumption) of the fashionable object reflects the "distilled essence" of the wearer, his sanctifying originality, "something essentially *sui generis*, by the grace of which he is himself and not someone else" (Baudelaire, *SW* 354; *AR* 238). Far from authenticating bourgeois consumerism, the dandy's initial and highly artificial use of the object "consummates" it, making it a symbol but also rendering it instantly obsolete. While the object's use can be aped by imitators, its "real" value dies with the dandy's original use of it, distinguishing his highly individualistic artistic consumption from the vulgar materiality of the bourgeois hordes. Indeed, instead of reducing his free will, fashion provides him the liberty of expression to "make more subtle symbols of his personality": "Every day there is not one accessory, from the butterfly that alights above his shirt-front to the jewels planted in his linen, that will not symbolize the mood that is in him or the occasion of the coming day" (Beerbohm, "Dandies" 13).

The dandy dealt with the nineteenth-century fragmentation of human value and identity by transforming dress itself into an emblem of character, ordaining the myriad of changing surfaces, appearances, and artificialities of the human spirit as the material incarnation of that spirit. Making a virtue of necessity, he parlayed the routine Victorian custom of wearing different, precisely defined costumes for different occasions (necessitating several changes of clothes in a day) into an way of reflecting essential antibourgeois values. Ironically, the dandy's "selfish concentration" becomes the least selfish (but from the bourgeois perspective, the most

profligate) of all the arts: while musicians, poets, and painters all sell their art for a price, the dandy freely "presents himself to the nation whenever he sallies from his front door. Princes and peasants alike may gaze upon his masterpieces" (Beerbohm, "Dandies" 9). It is no wonder that contemporary attacks on Decadent dandies, like Max Nordau's famous *Degeneration* (1895) or Hugh Stutfield's "Tommyrotics" article (*Blackwood's*, 1895), customarily focused less on the dandies' presumed "immorality" than on "their unnaturalness" and "unwholesomeness" (Stutfield 834).

It was no accident that Holbrook Jackson cited Beardsley, with Whistler and Wilde, as a major reason for dubbing the nineties the era of "The New Dandyism" (111). Beardsley made every effort (within his limited finances) to play the role of the dandy, dressing "with scrupulous care to be in the severest good taste and fashion" and striving to adopt the caustic wit made fashionable by Whistler's *Gentle Art of Making Enemies* (MacFall, AB 54, 11-12). When in public view he almost invariably wore gloves and carried a cane, even to the beach in Dieppe. Not infrequently his "affectations and artificialities of pose and conversation" were judged to be "almost painful" (30). He once urged Ada Leverson to come an hour early to his dinner party in order to help "scent the flowers"; upon arriving, she discovered that he was literally spraying bowls of gardenias and tuberoses with opopanax and handed her a spray of frangipani for the stephanotis. Turning his tuberculosis into a badge of aesthetic affectation, Beardsley quipped proudly to her, "Really I believe I'm so affected, even my lungs are affected" (Sitwell, *Essences* 137). Although, in fact, he was forced to live frugally and worked obsessively on his drawings, he pretended to the outside world to carry on a life of expensive tastes and effortless leisure. His interview in *The Idler*, most of which he wrote himself, pushes hard to convey the impression of aristocratic grace and opulence. The interviewer comments that Beardsley is "faultlessly dressed," perhaps his grandest passion being "for fine raiment," then goes on to note his subject's charming study and library, "with its rare copies of last century *livres à vignettes*, and various presentation copies of valuable books, and . . . numerous pictures" (A. Lawrence 190–92). In perhaps the most shameless passage, having recommended a "Château Latour of 1865," Beardsley continues his pose as a wealthy (and condescending) collector and connoisseur:

> Mr. Beardsley is not to be denied on these matters, and refuses to say anything more about himself until I have sufficiently admired a goodly collection of Chippendale furniture—two rare old settees in particular, which he assures me are almost priceless—while he rapidly goes over the titles and dates of some of his rare editions, making up a collection sufficient to cause a bibliophile's eyes to bulge with envy. (197–98)

Like Barbey d'Aurevilly and Baudelaire, Beardsley preferred Beau Brummell's understated dandyism to the more flamboyant and luxuriant version made famous by Alfred Count d'Orsay, who spanned the eras of George IV and William IV and was a powerful shaping force of fashion in the latter.[3] Particularly appealing to the semi-invalid Beardsley was Baudelaire's *observateur passionné* and *parfait flâneur*, whose detached and intensely intellectual discipline

allowed him "to be away from home and yet to feel at home anywhere; to see the world, to be at the very centre of the world" and yet remain uncontaminated by it (*SW* 399–400; 61–62). Max Beerbohm relates that while Beardsley "had that absolute power of 'living for the moment,'" he nevertheless "seemed always rather remote, rather detached from ordinary conditions, a kind of independent spectator. He enjoyed life, but he was never wholly of it" ("AB" 546). Symons associated Beardsley's commitment to "elegance and restraint; his necessity of dressing well, of showing no sign of the professional artist" with a studious admiration for Baudelaire: "It amused him to denounce everything, certainly, which Baudelaire would have denounced; and along with some mere *gaminerie*, there was a very serious and adequate theory of art at the back of all his destructive criticisms" ("AB" 92). Beardsley played on this Baudelairean disgust in his *Boston Evening Transcript* interview, establishing himself as a modern artist of iconoclastic moods, distinct from bourgeois society's staid masters:

> My present idea is to apply the decorative style to modern life, modern dress, modern costume, and to see how far it can be done in black and white . . . [T]he everyday life I see is offensive to me. I know that some people are disappointed and disgusted with my work But it's only my present mood, and I must express it. (Smith 16)

Like Baudelaire, Beardsley clearly believed that dandyism (along with controlled passion, strangeness, and modernity) was fundamental to the creation of great art. Certainly his pictures seem obsessed with arcane details of dress and toilette, prompting Julius Meier-Graefe to argue that Beardsley "put his soul into" the depiction of clothes, often "making them his exclusive theme" (2: 254). While the salacious nudity in *Cinesias Entreating Myrrhina to Coition* from *Lysistrata* (Figure 5–1) is eye-catching, the visual focus of the drawing actually seems to be on the clothing and accoutrements, not the people. At the center of the drawing is Myrrhina's flowing dressing gown, framed by her ornate hair and headpiece, her stockinged and gartered left leg, Cinesias's ruffled sleeve, and his enormous feathered headdress. In fact, in a sense, the figures themselves are defined by—or as—their stylized appendages. Myrrhina's face is mostly an accompaniment to her elaborate coiffure, its tassels paralleling those of her gown that emblematically "tease" Cinesias's penis (Zatlin, *AB* 65). Her arms jut from the gown; and her unseen right leg appears to have become absorbed as wholly a part of the trailing robe.

Symons felt that Beardsley's entire approach to art reflected the logic of the self-mythifying dandy: "Art is not sought for its own sake, but the manual craftsman perfects himself" ("AB" 95). Indeed, it was ultimately this self-reflexive, antinaturalist, dandiacal sensibility that prompted Beardsley to transform his landscapes into highly stylized tableaux, destabilizing the bourgeois concept of the "natural" by once again severely blurring the differences between nature and human fabrication. In *The Achieving of the Sangreal* from *Le Morte Darthur* (see Figure 3–19), for example, the frozen figures, the foreshortened sky, and the exotic ornamental flowers, vines, and pools all act to unhinge "naturalized" categorizations. It is Beardsley's standard ironic design, where a presumably solemn (in this case, holy) theme is undermined by ominously grotesque decorative details—the jagged mass of black water that drops like a pit beneath a seemingly fragile, crustlike bank; the "predatory" thorns, hairy blossoms, and

5-1 *Cinesias Entreating Myrrhina to Coition* from *Lysistrata*. (Private Collection)

incurling leaves in the shape of mandibles; the stiffly vertical humans contrasting with the curving horizontal elaboration of deformed plants. In the eccentric, stylized rendering of the figures and the attending foliage we are given not only a heightened awareness of fabricated "nature," which undercuts the normal separation of natural from man-made; but we also experience a blurring of the customary boundary between the natural and the human, as the time-frozen human figures take on the same highly artificial qualities as the plant life. In a reversal of Romantic agency, man is no longer a "child of nature," but nature and man both appear as man-made constructions (and not even benign ones), implicitly throwing into question not only basic ontological distinctions but also all those Victorian myths based on "natural law." Could it be that "natural law" itself is but a man-made construction, a desired fiction?

Even the horizontal lines forming part of the background of the drawing—which at first seem only to be suggesting topographical variations—become obstacles to any reading of the scene as "natural." The same lines that sometimes function merely as highlights, or to break the solid plane, elsewhere form river banks, ripples in the water, or even intimations of a dreamy immateriality—all of which belies the frozen finality of the quest that the drawing otherwise suggests: "There is no point of rest. The stiff hieratic angel's wings repeat the shapes of the foliage but are ragged and fluffed in fronds, or are they suckers?" (Fletcher, AB 38). In a final dandified stroke, Beardsley signs the drawing with what would become—this was the first drawing in which he used it—his prized "japonesque" trademark. An implicit ranking of Eastern abstraction over Western anthropomorphic naturalism, the mark also signals, in its mimicking of Beardsley's talismanic three-stemmed Empire ormolu candlesticks (as well as his more vulgar interpretations of it), the "decadence" of an artist who chose to work at night by artificial light, instead of following the natural-light conventions of traditional European art. In all its overdetermined meanings, Beardsley's personalized "japonesque mark" becomes but another ironic dandiacal element of the landscape itself, alternately reinforcing and mocking the pious subject or grotesque subversion of it, a confusing amalgamation of objective validation and subjective imposition.

Beardsley gives similar, if less elaborate, stylized dislocations of meaning in such drawings as the heading of chapter 16, book 9 (page 215) in Le Morte Darthur (Figure 5–2), where he iconoclastically reconfigures the raw natural material of sharply slanting trees and a gully to represent a worshiped pubis, and the design for the heading of chapter 33, book 7 (page 153) in Le Morte Darthur (Figure 5–3), in which a breast-encoded tree trunk divides two highly stylized confusions of culture and nature. On the right side of the latter picture, ambiguous rosegems adorn both a bush and the languid damsel's hair; and on the left, a river/looking glass reflects a clump of "metallic" trees (the stippled and shaded highlights emphasizing their artificial quality) placed against what appear to be the terraces of a stage set. In these and numerous other eccentric, mannerist reformulations—not least, his novella The Story of Venus and Tannhäuser, which substitutes a utopia of sexual frivolity and indolence for the utility-based world of bourgeois sin and guilt—Beardsley manages to call into question the nature of bourgeois ideology by, in effect, "dandifying" (as well as scandalizing) the entire landscape in a whirlpool of metaphysical irony.

Meier-Graefe claimed that "utilitarianism was never rebuked in stronger or haughtier

terms" than in Beardsley's art (2: 254). It is a claim that seems well substantiated in what is perhaps Beardsley's most famous exposition of dandiacal irony, his japonesque *Toilet of Salome* (second version) for *Salome* (Figure 5–4), which problematizes, if not inverts, bourgeois conceptions of "natural order." We recall that the original *Toilet of Salome* (see Figure 2–13) had been censored on the grounds of its too naturalistic representation of carnal desire. Typically, Beardsley here "answers" Victorian objections by denaturalizing the picture utterly while, in a sense, retaining its original onanistic fetishism. Most obviously, he destroys the picture's "natural" or "realistic" relation to the text—its illustrative utility—by transporting what he himself called this "quite irrelevant" Salome from a biblical costume and setting into a contemporary one (*Letters* 58). Moreover, far from being in any sense "natural," her dress mocks the natural, presenting an abstract design that literally abolishes Salome's previously offending arms (and voluptuous breasts), absorbs her hair into a fashionable Ascot concourse hat, and satirically subsumes vestigial white flowers (on her hair) and twigs (on her skirt) into the phosphorescent black of her modernist attire.

5-2 Heading of chapter 16, book 9 (page 215) in *Le Morte Darthur*.

5-3 Design for the heading of chapter 33, book 7 (page 153) in *Le Morte Darthur*. (Rosenwald Collection, Library of Congress, Washington, D.C.)

The accessories on the two Godwinian tables at the right offer an ironically inverse hierarchy of antinaturalist values. Symbolically, the most "natural" should rest at the crown of our vision, and here it does, in a fashion. Visually *above* all the other accessories, but in fact isolated on a separate table *behind* them, is what looks like a stunted, and apparently dead, miniature tree. At the next level below the tree, but dwarfing it, is a collection of relatively material cosmetic enhancements—a hair pin, powder and puff, a bottle of oil, a jar of cream, a pair of scissors, and so forth. These "artificial" beauty aids are reinforced metonymically by the attending Pierrot, someone "exquisitely false, dreading above all things that 'one touch of nature' which would ruffle his disguise, and leave him defenceless" (Symons, "AB" 97), who here wears a mask, daintily holds a powder puff, and has a pair of scissors in his smock. Beardsley reinforces this sense of hermetically sealed artifice by the window at the upper left, which is the scene's only access to the outdoors but whose closed modern blinds block out any possible natural light. On the next lower shelf of the dominant table, but ironically (continuing the

5-4 *The Toilet of Salome* (second version) for *Salome*. (1919-4-12-1 [neg. no. PS209796], Copyright British Museum, London)

reverse logic) presumably higher in aesthetic value, is an even less material collection of accessories designed expressly to create an unnatural, artificial atmosphere—a perfume atomizer, a box for incense, a jewelry case, a bottle of pills, and so forth. Finally, on the lowest shelf of the table, but presumably embodying the highest (Decadent) value, we find the most cerebral (least material) of mood-altering inducements—an olympiad of decadent novels: Zola's *Nana* (ironically, a naturalistically decadent text), Verlaine's Parnassian *Fêtes Galantes*, the writings of the Marquis de Sade, Abbé Prévost's *Manon Lescaut*, and Apuleius's *Golden Ass*.

What rules here is not the natural and innocent but the artificial and Decadent, not the simplicity of fact but catalysts to complicating desire. Implicitly, value asserts itself only to the degree that the natural is refined away. It was no doubt pictures such as this one that induced Holbrook Jackson to call Beardsley "the supreme example of the revolt against Nature" and to claim that his work "creates life out of cosmetics and aberrations; and Nature never appears except in the form of an abnormality" (114–15). Much has been made of his debt to the abstractions of oriental art, but where oriental artists used the abstract to simplify, Beardsley refines and abstracts in order to complicate, to evoke still deeper levels of irony (Yuanning 453).

Stylistically speaking, irony is itself a form of dandyism, taking what may be pertinent in one context and making it *impertinent* in another (Godfrey 29; see also Muecke 52). Moreover, like the urbane and "unnatural" dandy, irony seeks maximum effect by means of the most subtle effort. Its underlying premise is that the shakiness of an adversary's position is demonstrated in inverse proportion to the effort needed to topple it. By the same logic that the dandy applies to his clothing, Beardsley's ironic pictures emphasize the need to pay attention, for it is in the hidden details—minute stylistic flourishes—that value is actually defined. In a world where there are no more stable values but only differences, only endless displacements deferred by unfulfilled desire, the larger metaphysical truths—love, honor, liberty—are invariably buried under layers of masks, their ultimate meaning (and value) lying always "beyond" the immediate discourse. All that tangibly remains for the true artistic sensibility to focus on are the masks themselves. The scandalously avant-garde quality of Beardsley's images notwithstanding, his art is in large part modeled after the shock effects he saw in the work of his eighteenth-century idol Alexander Pope: "Pope has more virulence and less vehemence than any of the great satirists . . . The very sound [sic] of words scarify before the sense strikes" ("Table Talk" 82). It was with the subtle, if impertinent, profundity of the dandy that Beardsley sought to "scarify" the Victorian bourgeois order.

The Authoritarian Dandy

But as we have seen in other aspects of Beardsley's life and art, so with his dandyism, iconoclasm exists side by side with a reverence for fundamental authority. The dandy was such an attractive figure in the fin de siècle, precisely because it addressed a pressing metaphysical void. The abyss that was, for the Christian, sin, and for the bourgeois, illegality, was, for the Decadent, anything that could not be stylized, reduced to an aesthetic concept or formula (see

Hauser 186). Artistic form became the chief hedge against meaninglessness. Inasmuch as the dandy was virtually a creation of Art, more a metaphor than a person, the figure became in the nineties almost an emblem for sanctifying artifice, an icon for the Religion of Art.

As Ellen Moers has demonstrated, nineteenth-century dandyism developed in very large degree as an essentially *literary* doctrine, a promulgated pose for the intellectual in revolt. Aspiring French dandies drew most of their attitudes from such books as Edward Bulwer's *Pelham* (1828; translated in 1832), Thomas Henry Lister's *Granby* (translated in 1829), and Robert Plumer Ward's *Tremaine (ou les raffinements d'un homme blasé)* and *The Exclusives* (translated in 1830), attitudes that were eventually distilled in Barbey's and Baudelaire's famous treatises (Moers 123–24). It was not lost on Beardsley that Baudelaire made the dandy the epitome of his "pure artist" (*SW* 399; *AR* 61). Indeed, Beardsley was responsible for including in *The Yellow Book* works by Constantin Guys, whom Baudelaire proclaimed as the "painter of modern life" and whose art, though he had died in 1892, had just been exhibited at the Galerie Georges Petit in Paris (Mix 156). Barbey's and Baudelaire's apotheosis of dandyism made possible the cult status in the late nineteenth century of such figures as Robert de Montesquiou, who was hailed as the fin-de-siècle incarnation of dandyism, "the thing itself," as Brummell had been earlier. Montesquiou was the model for Des Esseintes in Huysmans's *A Rebours* (1884), the reputed "breviary of the Decadence" (Williams 126–27; Hemmings 217). He was also a friend and patron to several prominent figures—Barbey, the Goncourt brothers, Mallarmé, Huysmans, and Whistler—and one of Beardsley's greatest admirers. Montesquiou reportedly "went into transports of delight" over Beardsley's illustrations (particularly those whose subjects were Wagner and Wilde). He displayed Sickert's portrait of Beardsley in his library and wrote an article praising Beardsley's "sense of ornamentation" and his geometric lines and curves, which seem to have been "traced with a compass" (Jullian 189, 178).

One of the things Beardsley surely appreciated most about dandyism was that the dandy was not only a living incarnation of Art but, more specifically, the consummate "artist of control." If he was an iconoclastic rebel against all things common and vulgar, it was nevertheless a rebellion that conformed to highly disciplined rules. Barbey had described dandyism as less a "revolt of the individual against the established order" than a playing with conventionalities, even while respecting them, a "twofold and changing game" that "requires complete control" (33). Baudelaire similarly held that dandyism "is an institution outside the law" yet having "a rigorous code of laws that all its subjects are strictly bound by, however ardent and independent their individual characters may be" (*SW* 419; *AR* 87–88).

Moreover, for Baudelaire, the true dandy's special sensitivity, his compulsive and rigorous personal discipline, and his keenly developed capacity to discriminate and value every shade of human behavior inevitably combine aesthetics and morality. Every detail of clothing, every aspect of the Baudelairean dandy's personal taste and demeanor, carries a *moral* grace and testifies that external beauty derives from moral laws: "The word 'dandy' implies a quintessence of character and a subtle understanding of all the moral mechanisms of this world" (*SW* 391, 402–5, 417, 399; *AR* 50–51, 65–69, 85, 61). In an introduction to a collection of Pierre Dupont's poetry in 1851, Baudelaire argued that the "puerile utopia" of the *l'art pour l'art* school was sterile precisely because it sought to exclude morality; as a result of that error, "the

question was settled, and art was thereafter inseparable from morality and utility" ("Pierre Dupont," 51–53; *AR* 183–85). Art comes to be, said Baudelaire quoting Stendhal, "essentially a system of moral values made visible!" (*SW* 51; *CE* 88).

Part of the dandy's artistic morality involved another type of personal control—keeping true emotions safe from the vulgar horde, "never showing any [ordinary person] oneself." Barbey had praised Brummell's insolent "look of glacial indifference," by which he escaped the "slavery" of desire (54, 47–48). For Baudelaire, too, the dandy may suffer, but unless he wishes to dishonor himself, he can never lose control and reveal his sufferings to the world— only "keep smiling, like the Spartan under the bite of the fox" (*SW* 420; *AR* 89). Such a rigorous dandyism, as Baudelaire explained, "comes close to spirituality and to stoicism." It is, in fact, a kind of religion, in which "those who are its high priests and its victims at one and the same time" undergo, like monastic disciples, hardships that resemble "a series of gymnastic exercises suitable to strengthen the will and school the soul" (*SW* 420–21; *AR* 89–91). In this respect, secured in the inner grace of his meticulous elegance, the dandy's customary defensive air of boredom is itself a sign of not only his disgust with the common vulgarity of the bourgeois world but his aesthetic control of it, roughly equivalent to the order-preserving superiority of the priest, who, knowing God, does not need the world.

The dandy's acute attention to the most fleeting and subtle details, and his constant labor "to strengthen the will and school the soul," converge nicely with the "spiritual" philosophy of another idol of the nineties, Walter Pater. Pater's epicurean aesthete, we recall, seeks to "define, in a chill and empty atmosphere, the focus where rays, in themselves pale and impotent, unite and begin to burn," yet to do so with the ascetic "law of restraint" that purges away "all traces in them of the commonness of the world" (*Renaissance* 171–72). The art of both Baudelaire's Brummellian dandy and Pater's aesthete derived from a kind of classical discipline—"the removal of surplusage" by "a skilful economy of means, *ascêsis*," whereby style makes great art "a refuge, a sort of cloistral refuge, from a certain vulgarity in the actual world" (Pater, "Style" 16, 14).

It was altogether logical that the highly ironic Beardsley should favor the conservative, minimalist Brummellian style of dandyism over the much more flamboyant d'Orsay version, given his admiration for Baudelaire, his attraction to the Regency, and his ambivalence toward Wilde and Whistler (whose dandyism was modeled on Comte d'Orsay, not Brummell). Just as his pictures demand that the viewer pay especially close attention in order to catch significant details, so for Beardsley, as for Brummell and Baudelaire, dandyism represented an art of the most subtle signification. It is also an art of mastery: society "is always ruled by a dandy, and the more absolutely ruled the greater that dandy be" (Beerbohm, "Dandies" 4). Like the sirens in so many of Beardsley's pictures, the very imperiousness of the dandy's disinterested stare works to disconcert the person stared at, affirming the dandy's own superiority by compelling the other person to look away in embarrassed defeat. Unlike the d'Orsay-style dandy, who primarily desires enjoyment, "a relaxed way of life free equally from anxiety and boredom," the Brummell-style dandy seeks power—to establish and impose on the world the superior authority of his aesthetic sensibility and self-disciplined intellect (Moers 148). Certainly, much of what attracted Beardsley was precisely the dandy's capacity to control and even dominate his audience by his mere presence.

Beardsley's personal habits clearly reflected a classicist's preference for the dandy's pristine standards and detached control. The unusual cleanliness, formality, and "aristocracy of spirit" of Beardsley's dandyism was a conscious rebuke to undisciplined bohemianism. Possessing what Symons described as a hatred of "the outward and visible signs of an inward yeastiness and incoherency" ("AB" 92), the fastidious Beardsley was personally disgusted at what he considered the inexcusably "tasteless" and squalid life-styles of such artists as Charles Conder and Ernest Dowson: "In sight of Dowson's appearance and way of life, Beardsley lost all patience and tolerance," being "irritated . . . beyond control" when forced to dine with him (O'Sullivan, *Wilde* 115–17; see also Longaker 184–85, J. Rothenstein, *Conder* 135–36). Leonard Smithers once tried to defend the dissolute writer, saying, "But Dowson is a great poet," to which Beardsley returned sharply, "I don't care. No man is great enough to excuse behaviour like his" (O'Sullivan, *Wilde* 117). Beardsley appeared to have very little tolerance for bohemians generally. He once quipped to his sister Mabel, in reference to a luncheon, "Rachilde [the novelist Marguerite Eymery] and some long haired monsters of the Quartier were with us. They all presented me with their books (which are quite unreadable)" (*Letters* 308).

Beardsley seemed to share Baudelaire's view that evil was natural, but good was always the product of design and purpose (and therefore artificial and unnatural). Beardsley's drawings for *Ben Jonson, His Volpone: or The Foxe*, revealing his last and perhaps most radical shift in style, suggest the degree to which he believed dandiacal discipline and style could mitigate against "evil" nature. He expressed the highest admiration for Jonson's *Volpone*, calling it "undoubtedly the finest comedy in the English language outside the works of Shakespeare" (Princeton MS. 7; *Miscellany* 86, 87); and the project, which Beardsley undertook while gravely ill in the last months of his life, clearly excited and energized him. It may be that, as Ian Fletcher suggests, he was enchanted by the "notion of a man whom everyone thinks is about to die, but who is in fact a healthy, 'libidinous' creature" (*AB* 180). Beardsley wrote his sister that "I can think of nothing but *Volpone* and have set my heart on doing it finely," and he proclaimed to Smithers that *Volpone Adoring His Treasure* (Figure 5–5), originally designed as the showcase prospectus for the book, was "one of the strongest things I have ever done. I want all the drawings to be [so] full of force both in conception and treatment" (*Letters* 406, 399).

It is puzzling that the artist, who was usually not self-deceived about the relative merits of his pictures, should think so much of a drawing that shows "nothing of Beardsley's characteristic subtlety and elegance; neither wit nor understatement; no grotesquerie of atmosphere: simply a greedy man, somewhat melodramatically posed" (Fletcher, *AB* 179–80). Beardsley praised his new style as one in which he "definitely left behind . . . all . . . former methods" (*Letters* 409), and it may well be that the shift reflects "a young man's anxiety to achieve respectability by the canons of traditional art—a loss of faith in his earlier work, both in its technique and subject matter" (Fletcher, *AB* 180).[4]

It is also possible, however, that Beardsley's unusual enthusiasm for this drawing stemmed in part from his perception that he was achieving the same "savage strictness" of style about which he was writing Smithers at this same time (*Letters* 413). No doubt Beardsley's effusive critical introduction for the prospectus shows that he was impressed with the moral aspects of the play:

5-5 *Volpone Adoring His Treasure* from *Ben Jonson, His Volpone: or The Foxe*. (Drawing no. 61, Albert Eugene Gallatin Collection, Princeton University Library, Princeton, N.J.)

> The whole of Juvenal's satires are not more full of scorn and indignation than this one play, and the portraits which the Latin poet has given us of the lechers, dotards, pimps and parasites of Rome, are not drawn with a more passionate virulence than the English dramatist has displayed in the portrayal of the Venetian magnifico, his creatures and his gulls . . . Volpone is a splendid sinner and compels our admiration by the fineness and very excess of his wickedness . . . Volpone's capacity for pleasure is even greater than his capacity for crime. (Princeton MS. 7; *Miscellany* 86, 87)

But what is intriguing is that Beardsley goes on to see the "fineness" of the "splendid sinner" defined, in effect, by his instincts as a dandy, a "capacity for pleasure . . . even greater than his capacity for crime." What impresses Beardsley most is Volpone's "cunning and audaci[ous]" ability to "play a part magnificently," "developing and accenting some characteristic of his inexhaustibly rich nature" (Princeton MS. 7; *Miscellany* 87–88). The audience is not shocked by Volpone's sin precisely because "disguise, costume, and the attitude," the "blood of the mime," have mitigated the sense of wickedness (Princeton MS. 7; *Miscellany* 87–88)—that is, style has restrained, aestheticized, our experience of evil, turned it into manageable, civilized play.

Similarly, in Beardsley's drawing the scores of compulsive, perfectionistic, close-lined pen strokes that form the floor, wall, door and frame, curtains, and accessories, as well as the dozens of little baroque flourishes on Volpone's treasure and hanging name plaque, all serve to ground and stylistically "civilize" Volpone's greed. The drawing, whose subject is crime, actually reveals little of the "very excess of [Volpone's] wickedness," the "vehemence of his passion." There is nothing raw, grotesque, or potentially explosive about this evil; it is safely muted under the beauty, balance, and obsessive technical skill of the design. Heinrich Wölfflin explained how the Baroque uses a dominant diagonal to undermine the rigid horizontal and vertical tectonics of classical art, negating or at least obscuring the sharp, self-contained rectangularity of the picture space (126–27). Beardsley adored the Baroque, but frequently, as in this drawing, he appears to have reversed the process, using ostensibly Baroque principles to "freeze" the scene in rigid classical rectangularity. He frames the curling Baroque details of Volpone's treasure in a strict vertical-horizontal plane. Whereas the door frame and portal are formed from numerous right-angle lines and are perpendicular to the floor, their surfaces, comprising parallel diagonal lines, are "rectified" in a lattice work of tight crisscrossing perpendiculars, as are the surfaces of some of the treasure. The pillar at the far left seems to break the regularity in part, being formed by diagonal lines running only upper left to lower right, and the draperies are formed by slightly wavy lines in the same direction. This "imbalance" is nullified by Volpone himself, who leans forward in a line perpendicular to those of the pillar and draperies. The effect is a form of stylistic gridlock, suspending in an odd static equilibrium the implicit kinetic energy of the avaricious Volpone leaning toward his ill-gotten gains. This feeling of evil arrested, frozen with regular right-angle oppositions, is in stark contrast to the ominous volatility conveyed by the swirling, chaotic, uncontained diagonals of the grotesque figures making up the design for the front cover of *Ben Jonson, His Volpone* (Figure 5–6)—the initial unlimited evil that style will in the end contain.

5-6 Design for the front cover of *Ben Jonson his Volpone: or The Foxe.* (1986.683, Scofield Thayer Collection, Courtesy of The Fogg Art Museum, Harvard University Art Museums, Cambridge, Mass.)

We find a more amusing example of stylistic suppression in the design for the initial V on page 21 of *Ben Jonson, His Volpone* (Figure 5–7). Instead of relying heavily on dramatizing outlines and sharp-edged figures, as he had in the past, Beardsley here resorts to a softening sfumato. The fierce elephant; the overfilled, basket-shaped urn of fruit it supports; and the huge, superimposed, central initial V all give the drawing a "thick, ponderous force" (Reade *AB* n. 498). Beardsley also reinforces the sinister intensity of the elephant by means of the shadows in the left background. Most of this ostensibly threatening quality is amusingly undercut, however, by the overpowering static design, which turns the elephant's ominous ferocity into merely the disgruntled frustration of a shackled beast of burden. In droll fashion, Beardsley makes the elephant seem virtually pinned under the weight of its treasures—the elaborately ornate harness and accessories that include a stapled earring and anklets resembling imprisoning chains. Furthermore, Beardsley mounts the beast on a raised platform as though

to make it a permanent static decoration, a connotation powerfully reinforced by the initial itself, which frames and stabilizes the supported urn and is so placed as if to pin the elephant where it stands. Ernst Kris has theorized that the pleasure derived from Aristotelian catharsis is primarily one not of release but of a reestablishing of control, stylistic "aesthetic illusion" distancing and resolving the threatening potentialities that it otherwise presents (45–47, 63).

5-7 Design for the initial V on page 21 of *Ben Jonson, His Volpone: or The Foxe.* (1986.636, Grenville L. Winthrop Bequest, Courtesy of The Fogg Art Museum, Harvard University Art Museums, Cambridge, Mass.)

In this drawing, as a case in point, the potential evil that the drawing entertains has been stylistically neutralized, trapped in a dandiacal fortress of form.

The Decadent priests of the Religion of Art took the dandy's detached safety, mastery of subtle signification, presumed ideological purity, and ostensible ability to impose order through style alone as constituting both an attractive alternative mode of life (and art) and a necessary defense against the meaninglessness and decay intrinsic to common existence. If, as Baudelaire maintained, the virtues of style were the only antidote for the raw evil of life's "natural" laws, then the task became to try to turn all of life into the dandy's toilette, where nothing "raw" is ever allowed to surface. In this sense Beardsley's art does indeed reflect the "dandyishness" Beerbohm saw in it. For all its shocking iconoclasm, it is rhetorically an ultraconservative aesthetic, spinning the illusion that even if visions—or nightmares—do not occur "only on paper," at least they can be refined, controlled, and "civilized" there.

Nevertheless, the Decadence was recognized, even among its fin-de-siècle disciples, to be a somewhat shaky vehicle for the affirmation of Truth. The figure of the dandy, a standard bearer of the Decadent Religion of Art, was just as precarious, trying to be an icon of value in a philistine world, a world that constantly threatened to turn his aesthetic uniqueness into simply another exotic commercial object, not unlike department-store kitsch (cf. Williams 71). An emblem and lightning rod for a self-contradictory age, the Decadent dandy was an intrinsically paradoxical figure—incarnating both avant-garde iconoclastic rebellion and reactionary authoritarian order. On the one hand, he was ostensibly an "original," espousing the cult of the individual against received convention and in "subversive disregard for the essentials of aristocracy" (Moers 17). On the other hand, the dandy's arrogant superiority was in support of conservative, traditionalist, hierarchical values—the meticulously disciplined privileging of a sacrosanct higher authority, Art, over "progressive" and "democratic" bourgeois capitalism. In fact, the dandy found his raison d'être precisely in opposing bourgeois philistines and could not exist without them. Despite his claims, the dandy "defines himself against other values" rather than by any specific order of absolute values; indeed, he "would not stand out as an independent phenomenon were it not for a context of general social conventions that he contradicts" (Godfrey 28).

But, even more paradoxically, just as the "progressive" bourgeoisie were very often highly conservative (wishing to preserve for themselves aristocratic privileges), so in many respects the premises of the dandy's Religion of Art did not differ that much from the premises of the bourgeois society he supposedly deplored. In its purist formalism Decadent aesthetics mimicked the bourgeois practice of ordering the world according to social and class distinctions. The Religion of Art's sanctification of ideal beauty and harmonious order—that is, its own conception of beauty and order, which it took to be universal, absolute truth of form and function—is itself a reflection of class, deriving from the social logic its cultural perspective dictates. Baudelaire had allied the dandy's extravagance with the bohemian's dissipation, since he saw both as a revolt against the mundane and trivial propriety of bourgeois life. But many dandies, Beardsley among them, found bohemian squalor too disgusting for their rather bourgeois tastes. Like cleanliness, Christian morality, or any other presumably universal value, Art's spontaneous standards ultimately came to reflect and perpetuate the transcendental values of the

ruling class (see Baudrillard, *Sign* 45). Far from rejecting bourgeois values, most Decadent dandies, including Beardsley, were fundamentally bourgeois intellectuals aspiring to move up in class.

In a sense, the dandy is the ultimate bourgeois consumer, using material goods and social status to define metaphysical values. His meticulous, ritualistic dress and demeanor are presumably a rebuke to the ruling-class culture and thus an agent of progressive change. But historically, the sole purpose of ritual has been to ensure stability, to limit violent change, in the sense that rituals solidify the collective memory and thus continue the privileged demarcations of the status quo. Ironically, insofar as leisure, as a function of privilege, is indicated by the ability to *waste time*, the dandy, even by "doing nothing," serves to highlight a ruling bourgeois standard, that time is money.

The Decadent aesthete extolled ephemeral "fashion" as a way of rejecting the status quo and the bourgeois reverence for permanence and security. But, as Jean Baudrillard has shown, fashion—and more broadly, consumption, which is inseparable from it—actually "masks a profound social inertia": in establishing and demarcating a hierarchical order of stylish and gauche, fashion "speaks to all in order to better return each one to his place" (*Sign* 50-51). As everything springs inevitably from one or another design, the objects with which we surround ourselves constitute not an indication of social freedom and mobility but a social destiny. The dandy professes that Art is "useless" precisely because it is the end to which all else is directed. But by marrying Art and life-style the dandy, in effect, makes Art valuable because it is socially *useful*, reducing Art itself to the status of a craft. Far from having spiritual supremacy, it finds its tangible incarnation in fashionable consumer objects, which can be fashionable only according to preexistent rules and which make desire fulfillable only fetishistically (see Baudrillard, *Sign* 210). As Rosalind Williams puts it, "To reject one lifestyle in favor of another supposedly superior, more refined one is still to acknowledge the dominance of lifestyle in a system of social values" (117). While the dandy's manners and costumes presumably repudiate everything bourgeois, the very care the dandy devotes to making a striking impression belies his acceptance of the same bourgeois materialist values he ostensibly rejects. In a dandiacal world, as we saw in Beardsley's *Lysistrata* drawing and his *Toilet of Salome* (see Figures 5–1 and 5–4), "marginal" details of dress and style displace human relation as life's central preoccupation. It is little wonder, then, that the dandy was often so oddly alluring to the Victorian bourgeoisie, even as he seemed to reject their bourgeois philistinism.

The Grotesque Dandy

Symons suggested that the paradoxical Beardsley "was the dupe of none of his own statements, or indeed of his own enthusiasms, . . . his intellect would never allow itself to be deceived even about his own accomplishments" ("AB" 91–92). Part of this unromantic cynicism, Beardsley's ability to turn his irony even on his own positions, is reflected in his depiction of the dandy. In recognition of the myriad contradictions (and self-contradictions) in the figure, Beardsley often represented the dandy as grotesque—not merely as a misshapen, fey creature

like *The Abbé* (see Figure 3–12) but as something even more disturbing, a monstrous, potentially evil locus of life's vortex of paradox.

In light of Beardsley's fascination with the theater and the grotesque's potential for constant metamorphosis, it is logical that his dandies (and his dandiacal pictures) should frequently manifest their absurd and cunningly "unhealthy" metaphysical dislocations through metaphors of masking. Mikhail Bakhtin calls the mask "the essence of the grotesque," being a playful element closely related to themes of transition, reincarnation, mockery, and the violation of natural boundaries (*Rabelais* 39–40). It is, in effect, the contrary of logocentric certitude; its function is to hide something, deceive, suggest a secret. What Beardsley's pictures ultimately "mask" is an alienating vacuum, askewed signifiers pointing toward a metaphysical nothingness, as is evident in *Enter Herodias*, for *Salome* (Figure 5–8), which Kenneth Clark called "the most evil of all Beardsley's drawings" (90).

The "unmasked" explicit sexual details (e.g., Herodias's huge erect breasts and the right-hand attendant's genitals) at least momentarily divert our attention from (that is, mask perceptually) a flurry of fundamental paradoxes. We might begin with the overly "precious" dandified figure who is literally holding a mask, the effeminate page boy on the right. He carefully cradles a powder puff and case, which suggests that he has recently applied a powder mask to the imposing Herodias, although it seems amusingly clear that hardly anything is masked. He holds in his other hand a black facial mask, an ironic joke, as Fletcher once observed, not only because his uncovered face is not the issue but also because (being nude) he now "masks nothing." Furthermore, although this youth is anatomically male and stands almost touching the godlike femme fatale, he is not aroused by her. It could be that he is homosexual (he is made to appear androgynous) or, following the logic Beardsley employed elsewhere, that the "castrating" femme fatale has already rendered him impotent (although this effect is not shared by the figure on the left), or that he is merely one of those eunuchs traditionally kept at court. Whatever the case, there is posed a paradox: the fact that this "unmasked," worshipful male (however problematic the categorization) is *not* aroused by the ostentatiously sexual Herodias casts at least some doubt on Herodias's presumably pervasive erotic power. In effect, qualities of dandyism here act to vitiate what we might take to be the "normal" responses.

The attendant on the left, another grotesque, is also caught in paradox. His state of sexual excitement is masked by his clothing, but in fact his erection can hardly be ignored. This heated sexual emphasis is underscored by his satyr's hoof and by the flaming candles in the foreground—grotesque (phallic) candles, held erect by animalistic and demonic icons in the punning form of "fantastic prickets" (Reade, *AB* n. 285). Especially since he holds Herodias's train, the left-hand figure's rather demonstrable lust would seem to attest to her sexual power. Yet his stare of concentration is clearly aimed *past* Herodias, which seems to contradict the assumption that she is the source of his excitement and again implicitly impugns her sexual omnipotence. Finally, the drawing is so composed that the creature's "heat of passion" is in the same pen stroke highlighted and humorously undermined: we see that his erection is about to be intersected by the center candle's flame—in effect, he "burns" and is burned in turn. For that matter, consonant with the dandiacal, overdetermined coding of the scene, Herodias

5-8 *Enter Herodias* (proof of an illustration for *Salome*). (Drawing no. 101 [with poem], Albert Eugene Gallatin Collection, Princeton University Library, Princeton, N.J.)

herself extends the dislocating paradoxes. She is clearly an oversexed female, but Beardsley also supplies her with considerable male "coding." She towers over the scene, and except for her bulging, overripe breasts, she has little shape; she is made to seem a stiff and erect pillar, a kind of omnipotent phallus between two less effectual ones. This paradox is, moreover, joined to another: here she appears all-powerful and dominant, yet even dismissing the previous questions about her erotic omnipotence, we know from the text (and the legend) that she will soon be superseded by her daughter.

These various intimations of a basic metaphysical instability, inseparable from the implicit dandifications in the drawing, are underscored by yet another set of paradoxes involving the caricature of the arch-dandy Wilde at the lower right. He should be, arguably, the most stable symbol of authority, both theoretically, as author—holding the text of his play, he is the original "masker" and "unmasker"—and compositionally, as our master of ceremonies for the scene. Ostensibly, his claim is firm. He wears the owl cap of a sage magician or sorcerer, who would presumably know everything about masking. He also carries the caduceus, emblematic of the magic scepters of the herald-god Hermes and of Asclepius, the god of medicine (Wilde being the son of a doctor, even a notoriously lascivious doctor). So it is little wonder that he can confidently give us the showman's gesture of entry into the drawing's secrets. But even the author, the scene's original interpreter, cannot escape the subversive paradoxes of Beardsley's grotesque world, a world where dandies are grotesque. The owl cap's authority is clouded by Beardsley's customary "decadent-phosphorescent" dots and by the bells of a jester's coxcomb. Moreover, the healing physician's caduceus is drawn as a crutch, implicitly impugning the author who "leans on a gospel of 'curing the senses by means of the soul, and the soul by means of the senses'" (Reade, AB n. 285). For that matter, the caduceus has always been an emblem of paradoxical duality, the double serpent (Kravec 31), which we recall God made as an emblem of both punishment and healing (Numbers 21: 4–9), being "the serpents of healing and poison, illness and health, . . . the union of the sexes" (J. C. Cooper 28). Indeed, relating specifically to Wilde's notorious bisexuality, the caduceus is traditionally an icon of androgyny, its representation of mating snakes denoting the correspondence, section by section, of the androgyne's unity with the cosmos (Zolla 76). Most graphically, perhaps, we have the fact that the author's gesturing hand is intersecting (or about to intersect) the flame of the right-hand candle. We realize that imminently he will jerk back the hand in pain, not healing but in need of healing. As with so many of Beardsley's ancillary figures who presumably point the viewer to the central action, here, too, the effect is a bifurcation, not a unifying, of the scene and its meaning. Rather than connecting us to the "central" action, the connecting figure actually diverts the focus to himself, creating two focal points instead of one, and in the process implicitly diminishing the authority (and often the seriousness) of the ostensible primary scene.

Like the inexorable equivocality of the dandy's style, the picture's instability operates on a formalistic level as well. Visually the drawing creates a sense of order and balance, aided by the way the black of Herodias's hair and horizontal sash at the top balance the black stage at the bottom and by the way the vertical lines of the curtain, the human figures, the candles, and the signature are set perpendicular to the horizontal band that is the stage, all of which are enclosed in the familiar three-lined frame. Yet despite this visual order and coherence, we

are made to feel metaphysical disorder and dislocation. The drawing entices, even implores, hermeneutic reading, yet it resists, indeed undercuts, any univocal explanation. Beardsley's stark black-and-white tonality would seem to assist the moral dialectic so many commentators have seen in his pictures. But so often the almost violent, unmodulated contrast of black and white becomes, in fact, an ironic "metaphor of the ambivalence in his images and the tensions in his designs" (Brophy, *Black* 78). The grotesque elements that lie at the foundation of Beardsley's art—often growing out of a deforming, Janus-faced dandyism—give the lie to the assumption that there are firm, logical foundations of meaning. Such elements constantly taunt us with hermeneutic confusion, highlighting our myopia as they twist every reading into paradox. What the picture exposes, both literally and thematically, actually ends up complicating instead of simplifying the problem of interpretation. The "unmasking" feels like another "masking," even an obscuring of the picture's meaning.

In fact, the game is always double-edged and becomes almost endlessly self-subverting. As Georges Bataille has explained, the violation of a taboo—in this case, the exposure of forbidden (or hidden) features or desires—actually only intensifies the sacred or privileged character of that tabooed object or desire (*Death* 33, 42, 61-63). Even the most frivolous joke must, after all, establish a connection, a signification, in order to be understood; or, more accurately, perhaps, it must call upon a prior connection or signification, the one that valorizes the butt of the joke and permits the point to be made. That value attached to the "unmasked" authority cannot be annulled by the joke, because it must exist for the joke to be understood. So every "unmasking" or reciting of desire is unavoidably a re-citing of it, which becomes also a re-sighting and a re-siting of it. The desire's psychological force or authority is not sublated, but at most only shifted, displaced—not replaced but re-placed. As in Jacques Derrida's in-vagination metaphor (*Glas* 160), in which he compares the hymenal effect of his homonyms to turning a glove inside out—transforming a right-hand glove into a left-hand glove but not annulling the utility of the glove—so in Beardsley's highly stylized, dandiacal drawings we often find that the revealing has become a re-veiling. The "unmasking" seems to conceal as much as it reveals, revealing only another mask, and even conceals *more* than it reveals. Beardsley's drawings as a whole are narratives whose meaning seems always deferred to a point behind or beyond what we can see. Each element slides or oscillates, suspending or displacing any "final" meaning, and preventing the resolving of the paradoxes posed, or even the separating of their elements into distinct and "certain" dialectical opposites.

We should not be surprised at this phenomenon, because Beardsley's art—simultaneously dandiacal and grotesque—disseminates the game of understanding beyond the interior dynamics of the drawing, beyond metaphysics to epistemology. His drawings do not merely depict society's masking or unmasking, and raise questions about it, but they also *participate* in the game. That is, the drawings do themselves deceive, play tricks on, the viewer. As we have witnessed repeatedly, even as he calls attention to the lust of the figures in his drawings, Beardsley almost invariably hides various scandalizing sexual shapes or other dislocative elements among the subtly grotesque decorative or structural details. Thus, he masks desire while unmasking desire, exposing deception while deceiving, sometimes scandalizing the viewer twice over. Part of what we sense to be the oscillation or "flickering" of the drawing's meaning

is in fact a hermeneutic "double exposure," creating an image and blurring it at the same time, on two levels, throwing into question not only what is being depicted in the drawing but also the validity of our perception of it. Like the dandy's "presentations," we are made intensely aware of the artificiality of the meaning we are being offered.

Nor can we ever be entirely certain that the joke isn't on us, that what is being exposed isn't our own blindness, or our own voyeuristic desire, or both. In fact, our latent desires, our predispositions—hermeneutic as well as sexual—inevitably implicate us as accomplices in the drawing's narrative. We become an unavoidable part of the ongoing discourse "in" the drawing, and it is a discourse—like the dandy's private in-joke codes—from whose meaning we are necessarily to a significant degree always excluded. Even if the joke isn't on us directly, we can never be sure that the meaning "in" the drawing is "real" and not itself a joke, a mere construction, implying that perhaps all of life's meanings are only jokes, masks, hidden desires, including our own desire for meaning. Through these multiple ironies Beardsley's drawings create fundamental dislocation: they insistently invite readings, establish themes, and yet they throw those themes and readings into question even as they posit them. In this way Beardsley constantly suffused his dandyism into his art.

The subversive and "perverse" fin-de-siècle Decadent dandy was discomforting to most Victorians because he (and rarely, she) was unrelentingly artificial and "unnatural." Part of what was unnatural about the dandy, even beyond his deconstruction of bourgeois values, was a certain antisocial, virtually antihuman quality in his character. Highly disciplined and even rigidly authoritarian with respect to "style," the elitist dandy tended to treat people as so many elements to be controlled in the artistic field—as objects to be molded to an imperious, personal design (see Reed, *Style* 16)—and was thus judged by bourgeois Victorians to be fundamentally cold and inhuman, incapable of normal love and compassion.

The waggish Beardsley was quick to play on these fears, usually depicting his dandies as inhuman in a very graphic sense, symbolizing them as literal grotesque monsters, physically unnatural in a way that implied "twisted" constitutions—in short, confirming the philistine's worst nightmare. A vignette on page 31 of *Bon-Mots* 1894 by Samuel Foote and Theodore Hook (Figure 5–9) portrays the dandy as a savage misfit, in this case an ironically refined form of a notoriously bellicose beast. Sitting in boredom or miffed dejection, the dandy's clawlike pointed fingers support a rhinoceros head, tongue protruding in brazen impudence or stunned stupefaction. Intensifying the dandy's monstrousness still further in another vignette on page 148 of *Bon-Mots* 1894 by Samuel Foote and Theodore Hook (1894) (Figure 5–10), Beardsley makes the figure a grotesque hybrid of indeterminate, or at least mixed, gender. It leans preening on its cane, displaying a poodle's hindquarters, female breasts, and an oversized head, the face of which is gnarled in distortion and the back of which swells with a plethora of Beardsleyan breast shapes. The figure is, all in all, a perverse repository for any number of cultural paradigms and desires. As if reflecting its status as an ontological self-contradiction—passionately passionless, a blasé ideologue—the dandy is made part human, part animal; part ugly hunchback, part cute poodle; part old man, part voluptuous woman; part indifferent dandy, part fetishistic desire. Fundamentally it is only "parts," a grotesquely fragmented paradox. As an added touch, Beardsley segments the head with dotted lines, as if the creature were a specimen presented for anatomical (or psychological) study.

5-9 Vignette on page 31 of *Bon-Mots* (1894) by Samuel Foote and Theodore Hook. (Private Collection)

5-10 Vignette on page 148 of *Bon-Mots* (1894) by Samuel Foote and Theodore Hook.

Moreover, given Beardsley's tendency to identify himself as both Pierrot and a dandy, we should hardly be surprised to find that just as Beardsley's Clown-Harlequin-Pierrots are frequently rather dandified figures, so his dandies often share characteristics with Clown-Harlequin-Pierrot, not least their link with the grotesque and the diabolical. In a vignette on page 81 of *Bon-Mots* 1893 by Charles Lamb and Douglas Jerrold (Figure 5–11), the dandy sneers at the audience, his bald head perched somewhat eerily above the jagged outlines of a black blouse and between ominously pointed shoulders. Typically, Beardsley never makes entirely clear whether the smirking figure's pointed dunce hat, clownish ruffles, and pantalooned trousers are a sarcastic affront to his ridiculous society-audience or an ironic description of the dandy himself. The malicious-jester connotation is amplified in a vignette on page 42 of *Bon-Mots* 1893 by Charles Lamb and Douglas Jerrold (Figure 5–12), where the leering dandiacal

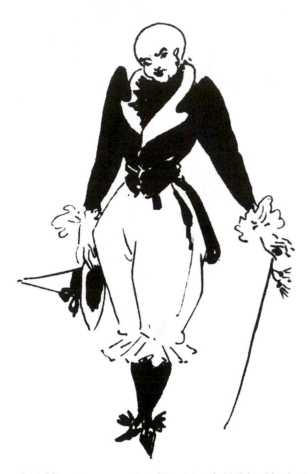

5-11 Vignette on page 81 of *Bon-Mots* (1893) by Charles Lamb and Douglas Jerrold (E.312-1972 [neg. no. HD728], Victoria and Albert Museum, London)

character is even more monstrous. The dandy having become for many Victorians an emblem of Lucifer's sin of confusing will with faith, arrogance with metaphysical truth, Beardsley gives this figure the collar and tie of a joker-clown and the face and pointed ears of Satan. His right hand and foot are the hoofed appendages of a satyr; his left hand and foot have been amputated, replaced by a hook and peg leg respectively—making him a physical (and, presumably, a moral) cripple, one whose human characteristics have given way to the animal or the mechanical.

Inevitably, part of the demonic dandy's link with Clown-Harlequin-Pierrot figures was a link to disease. In a vignette on page 119 of *Bon-Mots* 1893 by Sydney Smith and R. Brinsley Sheridan (Figure 5–13) Beardsley has sinister Mephistophelean skeletal dandies and satyrs visit his invalid surrogate Pierrot. Once again he uses his identifying signature symbolically, this time affixing it to the invalid's armchair. Furthermore, he accents the implicit connection

5-12 Vignette on page 42 of *Bon-Mots* (1893) by Charles Lamb and Douglas Jerrold.

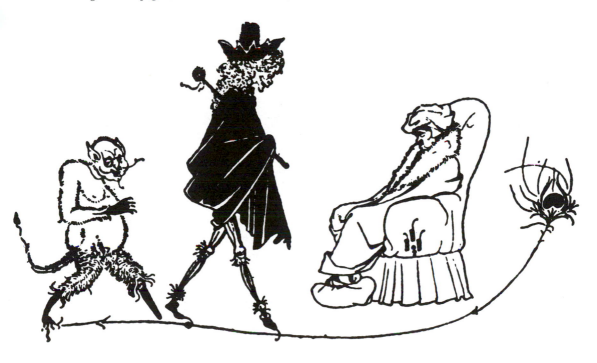

5-13 Vignette on page 119 of *Bon-Mots* (1893) by Sydney Smith and R. Brinsley Sheridan.

between illness, art, and evil by literally underscoring the entire scene with the familiar Decadent peacock's feather. In this regard Beardsley's almost phobic aversion—personal as well as artistic—to the slovenly, the unkempt, or the merely unstylized may reflect more than the dandy's customary repugnance for the unrefined. Given his preoccupation with his own severe illness, such obsessive fastidiousness may intimate also an attempt to flee that even more ominous and natural leveling—decay and death. Beardsley's fellow consumptive Watteau, one of his heroes during this period and the author of so many depictions of the melancholic *Gilles*, was, of course, famous for allegories of transience in his *fêtes champêtres*.

Beardsley's *Et in Arcadia Ego* (Figure 5–14), which he produced while suffering from what he called a chronic "agony of depression" (*Letters* 188–89), plays off not only Watteau's nostalgic pastorals but even more specifically the tradition of Poussin's *Bergers d'Arcadie* (c. 1640–45). In Poussin's famous painting, which hangs in the Louvre, three youthful shepherds and a classically posed woman gaze seriously at a tomb's inscription: "Et in Arcadia Ego." The wording is either an admonition, "Even in Arcadia, there am I," if spoken by Death itself, or an elegiac "Alas, I, too, once lived in paradise," if spoken by the tomb's nostalgic occupant (E. and G. Panofsky 296–300; E. Panofsky 340–67)—and thus the figures try to reconcile why death occurs in Arcadia, the site of presumably eternal bliss. Beardsley makes the pathos of inevitable death doubly ironic, having the issue faced in his pastoral Arcadia by a virtual caricature of the urban, artificial dandy. The juxtaposition is perhaps also a self-reflexive allusion to Beardsley's publisher and patron Leonard Smithers, whose Bond Street bookstore and office in the Royal Arcade bore the same legend, "Et in Arcadia Ego" (Garbáty 610; Reade, *AB* n. 452).

In Beardsley's picture an aging and unsuitably attired dandy tiptoes with pointed, spatted shoes over flowered grass toward the commemorative pedestal and funereal urn of "one who, like himself, had once lived in Arcady" (Reade, *AB* n. 452), seeming to pause in an almost pirouette position to stare at the pedestal's ominous inscription, "Et in Arcadia Ego." The dandy's presumably youthful jauntiness, unruffled confidence, and pretentious elegance are undercut by his distinctly receding hairline; unusually diminutive cane; contorted, vaguely satyric feet; modish coat with a rounded lower portion mimicking a naked derrière and a lapel shaped like a jutting mouth; and by the fact that above and around the pedestal reach out the dark boughs of a yew tree, traditionally symbolic of death. On the one hand, as he contemplates the tomb (or perhaps his own lost youth), the dandy is confronted with the ironic incongruity that his highly controlled and protective life of stylized artifice must necessarily yield to the ravages of death just as surely as does the most careless and prosaically vulgar life. On the other hand, it is a message not likely to be understood by the egoistic dandy, as Beardsley intimates by cleverly arranging the punning letters of the legend to read ET IN ARCADIA / EGO. That is, in a dandy's solipsistic paradise we find only the human ego, blithely unaware of its own implicit clownishness. As Fletcher observes, unlike Watteau's treatments, which dissolve art and nature, the theatrical and the picturesque, "into a sweet and serene visionary whole," Beardsley's picture is in the tradition of the "iconographical caricaturist" who employs grotesque parody "to stem self-pity" (*AB* 122–23).

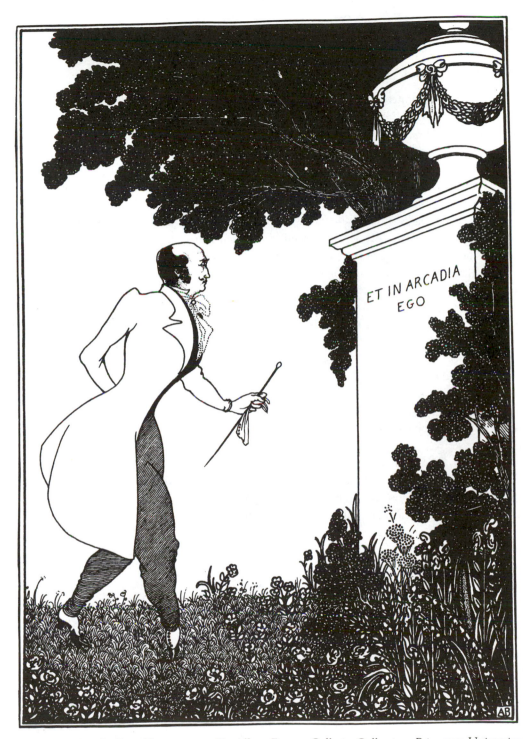

5-14 *Et in Arcadia Ego*. (Drawing no. 53, Albert Eugene Gallatin Collection, Princeton University Library, Princeton, N.J.)

The Caricature of Meaning

The dandy and the grotesque have traditionally met in caricature. Inasmuch as social behavior is mainly, as Freud claimed, an exercise of disguise, a series of univocal gestures masking ambivalent impulses, the grotesque, as the incarnated fracture of univocality, "always designates an unsuccessful masking, a dis-covery or revelation" (Harpham, *Grotesque* 68). That is, it suddenly "unmasks" the metaphysical contradictions underlying society's homogenizing myths and conventions. With Victorians generally and Beardsley particularly, caricature was one of the grotesque's most popular vehicles for this unmasking.

A master of masks and a locus of societal ambivalence, the dandy had long been a favorite target of caricature. Certainly, Regency dandies and their French equivalents, the Incroyables, were the butt of many caricaturists (Lucie-Smith, *Caricature* 74). But since the dandy was also a tacit satirist of bourgeois society, in effect caricaturing society's grotesqueness, the dandy and caricature were actually natural allies, sharing a similar perspective on life. Both assume a certain air of contemptuous superiority and, perhaps even more important, both assume that small details define essential truths. Beerbohm, Beardsley's good friend and a consummate dandy, declared that the perfect caricature fixes precisely the essential character of a subject. It was, in effect, another exacting mode of Decadent secret signification, requiring that viewers possess "a keen faculty of imagination" to recognize and appreciate fully what was the epitome of subtle and economical precision: the perspicacious artist "on a small surface, with the simplest means, most accurately exaggerates to the highest point, the peculiarities of a human being, at his most characteristic moment, in the most beautiful manner" ("Spirit of Caricature" 101–2).

For both Beerbohm and Beardsley, what is "most characteristic" and "most beautiful" is in this case grotesque since, at least according to such seventeenth-century theorists as Giovanni Agucchi, Giovanni Pietro Bellori, and Filippo Baldinucci, successful caricature—from *ritratti carichi* or *caricature* (literally, "loaded portraits")—seeks to find likeness in deformity and "distorts appearances . . . for the sake of a deeper truth," coming "nearer to truth than does reality" (see Kris 198, 189, 175). It is ironic that through grotesqueness caricature claims, like classical art, to reshape the individual into the type, creating a "perfect deformity" that is "more like the person than he is himself," showing how the soul would express itself in the body "if only matter were sufficiently pliable to Nature's intentions" (190–91).

In one of his notable caricatures, a grotesque accompanying a half title after the Introduction, on page 15 of *Bon-Mots* 1894 by Samuel Foote and Theodore Hook (Figure 5–15), Beardsley marshals key "deforming" details to capture what he takes to be Beerbohm's deeper reality (see Small [26], 27–28)—in particular, his precocious youth, his presumed androgyny, and his dandiacal link with risqué decadence. Here Beardsley perches a minuscule version of Max's telltale top hat on the skull of a naked, bat-winged child who has a feminine torso, wears women's pumps, carries a dandy's cane, and is trailing a dog wrapped in a coat.[5] Beerbohm responded in kind with his own caricature of Beardsley (Figure 5–16), which not only accentuates his colleague's distinctive hair, large nose and ears, and skinny frame but also exploits his even more notoriously ambiguous sexuality, portraying him with ostentatiously

5-15 Grotesque accompanying a half title after the Introduction on page 15 of *Bon-Mots* (1894) by Samuel Foote and Theodore Hook.

limp wrists while having his body divide his name at "Bear-. . . ," as if to label the effete dandy ironically as a macho brute. Perhaps even more devastating, Beerbohm tweaks Beardsley's well-known airs of dandiacal pretension. Where Beardsley's naked Beerbohm pulled a super-ciliously dressed real dog, Beerbohm's park-strolling Beardsley (overdressed in a tuxedo) has on his leash not a real poodle but a toy replica, presumably demonstrating the extreme degree to which Beardsley preferred the artificial to the natural. In the end, what both caricatures underscore is the ever-present dissonance between avowed sophistication and all-too-basic (notably physical) shortcomings.

There is good reason why caricaturists exaggerate, as Beerbohm explained, "instinctively, unconsciously" ("Spirit of Caricature" 98). Like other forms of the grotesque, the metamor-phosis that caricature effects has long been understood as an extremely powerful kind of witchcraft or image magic, a pictorial "stealing of the soul" that defines the identity of not

5-16 Mr. *Aubrey Beardsley*, caricature by Max Beerbohm. (Published in *Pall Mall Budget*, 7 June 1894)

only the subject, but the artist as well (see Kris 198–203). As Ernst Kris has noted, caricature, like childish play, seeks to master the environment, particularly the problems of aggression and ambivalence, in order to ward off painful experience. The caricaturist, "instead of disfiguring the face of an opponent in reality," channels hostility and aggression aesthetically into laughter, winning the admiration of amused spectators in the process. In the guise of producing perfect mirror images, the caricaturing artist uses his/her own signature image as a template

by which to represent the subject's distinctive features in a highly distorted effigy, reducing the subject's likeness to a few insulting lines (Kris 175–79, 182–83; see also Lucie-Smith, *Caricature* 41). The caricaturist exposes or unmasks the subject's individuality in order to devalue and dismiss it and, in the process, turns the grotesque into eerie reality:

> Under the surface of fun and play the old image magic is still at work. How otherwise could we account for it that the victim of such a caricature feels "hurt" as if the artist had really cast an evil spell over him? Nor is such a feeling confined to the self-conscious victims of pictorial mockery. If the caricature fits, . . . the victim really does become transformed in our eyes. The artist has taught us how to see him with different eyes, he has turned him into a comic monstrosity. (Kris 201)

In so using incongruous elements for allegorical purposes, the caricaturist is the direct heir of certain religious and popular artists of the Middle Ages, like the authors of the Dance of Death (inspired by the Black Plague of the early fourteenth century and culminating in Hans Holbein's celebrated treatment of it in 1538). These primitive caricaturists juxtaposed the gross and the sublime within the same framework to create a cathartic moral statement—moral satire that focused less on the nature of individuals than on the nature of humanity itself (Lucie-Smith, *Caricature* 31, 19).

It is entirely logical that caricature developed from medieval moral "magic" to Beardsleyan grotesque dandyism. The invention of printing in the fifteenth century secularized the allegorical art of the Middle Ages and actually heightened its impact in the sense that it turned church imagery's "permanent, unalterable statement about the human condition"—fixed in stained glass or church carvings—into portable, expendable, and implicitly provisional critiques (Lucie-Smith, *Caricature* 33). English artists of the eighteenth century combined the graphic skills of their Italian counterparts with the social content of Dutch realist painters to form the modern "cartoon" caricature, a process that was enhanced in the nineteenth century by the invention of lithography and an increasingly active popular press (51, 77). Caricature became a particularly formidable force along the lines Beardsley found appealing once it solidified the premise that physiognomy reflected moral character. Johann Caspar Lavater (1741–1801), whose highly influential physiognomical studies were translated into English in 1789, proposed that it was possible to trace in physiognomy a complete progression from the lowest forms of animal life to humans, and that it was possible to read people's temperaments by noting which animals they resembled (Lucie-Smith, *Caricature* 17). Caricature thus became, ironically, an almost classical art of moral and spiritual taxonomy.

Indeed, Victorians had long been predisposed to immortalize history as character, to exalt character "as the bridge between the human and the divine," even if in some cases the exaggerated characterization located the subject somewhere between the heroic and the comic (Auerbach 196). In a sense, Victorians' keen interest in photography, the death mask, and memorializing portraits in general (the National Portrait Gallery was opened in 1856) was only another side of their fascination with caricature. The often witty and poignant caricatures of such English draftsmen as John Tenniel, Harry Furniss, Charles Keene, and Phil May found much favor with the public, but with Beardsley's emergence in the nineties Victorian caricature

accrued a savage intensity of feeling and a sense of moral outrage. While he was not primarily a caricaturist, his "devastating . . . decorative, bizarre and often shocking effects forced complacent Victorian artists to recognize a new visual language" (Lucie-Smith, *Caricature* 88). It is hardly surprising that Beardsley's very first sketches—mounted in the period's traditional red, clothbound child's scrapbook, with cardboard pages—were not the customary domestic scenes but "a long series of grotesque figures" (E. Beardsley, "AB" 1; Derry [Walker] 3–4), and that his first extant drawings were caricatures.

We find a blending of dandiacal caricature and deforming irony in Beardsley's design for the frontispiece to *Plays* (1894) by John Davidson (Figure 5–17), executed during roughly the same period as the various *Salome* controversies. Intended to illustrate Davidson's early closet drama *Scaramouch in Naxos*, Beardsley seizes on a key dandy motif, the masquerade, to suggest ironies in the lives of several of the nineties' fashionable celebrities, Wilde among them. At the far right in the picture is Adeline Genée, perhaps the most adored dancer of Katti Lanner's elaborate romantic ballets at The Empire Theatre of Varieties (Adlard, "Poetry" 51).[6] Beardsley ironically depicts her as having her back to the audience and being whimsically distracted by Whistlerian butterflies, a sly allusion to Wilde's noted rival. Posing vaingloriously behind the group, seeming lost in narcissistic fantasy (with a phallically erect hat), and caricatured paradoxically as the ostensibly ugly Scaramouch, is Richard Le Gallienne, the minor poet and critic who, Beardsley quipped, was "surely beautiful enough to stand the test even of portraiture" (*Letters* 65). Le Gallienne was a reader for Lane's Bodley Head and no doubt irritated Beardsley by shifting back and forth as the occasion required in his attitude toward the Decadents. At center stage is a caricatured rendering of the corpulent Augustus Harris, the well-known impresario of Covent Garden, Drury Lane, and Her Majesty's Theatre, whom Beardsley accused in a newspaper letter of "ow[ing] me half a crown" (thus the hand sliding into his pocket) for having sold him an already booked theater seat (*Letters* 65). Beardsley may well have known of other reasons to think Harris a little shady, including the fact that years earlier he had served as a courier smuggling pornography for the notorious smut distributor Frederick Hankey (Pearsall 386). Depicted at the lower left in the picture (paradoxically, as a prim, dandiacal, vaguely hermaphroditic satyr) is Henry Harland, fellow tuberculosis sufferer, *poseur*, and co-founder and literary editor of *The Yellow Book*, who was known not only to be somewhat spoiled and mean spirited but also to exhibit conventional tastes that Beardsley found, even in 1894, too concerned with "respectability" (Weintraub, *AB* 95; Syrett 77, 97–98; Beckson, *Symons* 107, 114). Finally, behind the Harland satyr we find a caricature of Oscar Wilde, posed with a nude woman modeled after Beardsley's sister Mabel, whose acting career Wilde was assisting. Wilde is dressed in a leopard skin, perhaps an ironic sexual pun on the cliché that "a leopard cannot change its spots," and has vine leaves in his hair, recalling a favorite Wildean euphemism for being drunk. Despite being so animalistically "primed," he nevertheless seems impervious to the charms of the nude woman pressed against him; in fact, he seems more interested in the flashy impresario at center stage. The implication is that he is heterosexually impotent (a suggestion reinforced by his shackled legs) and, in addition, more titillated by self-promotion than by women.

Beardsley's art often spun a subtle conflation of dandyism and the grotesque, as we have

5-17 Design for frontispiece to *Plays* (1894) by John Davidson. (N04172, Tate Gallery, London)

seen in his favorite caricature, *The Fat Woman* (see Figure 3–7), which lampooned Whistler's wife in a series of cunningly elegant and ironic trompe l'oeils. In Beardsley's work both dandyism and the grotesque came to operate as a kind of metaphysical caricature of life, of traditional meaning. Caricature typically achieves a radical realignment or decentering of signification. What was previously considered central is displaced, perhaps shrinking to virtual insignificance, while what was previously marginal—perhaps only a hint, a trace—suddenly becomes the central key to the figure's (or picture's) character. Every convention, every text, becomes a potential target of caricature, of parody. If Beardsley was truly the nineties' Dandy of the Grotesque, it was in no small part because his art, for all its dandiacal stylistic elegance, effected a "grotesque" realignment of traditional Victorian conventions and values.

The Rhetoric of Parody:
Signing and Resigning the Canon

> Certainly old things are passing away; not the old
> ideals only, but even the regret they leave behind is
> dead, and we are shaping instinctively our new ideals.
> Yet . . . the old cycles are forever renewed, and it is
> no paradox that he who would advance can never
> cling too close to the past.
> —Havelock Ellis, *The New Spirit* 31–32

AVING embraced various strains of Classical, Gothic, and Japanese "revivals" en-
thusiastically, late Victorian art was unusually conscious of the cultural and canonical
foundations on which it rested. Casts of marble were an almost obligatory part of
many artists' studios; indeed, Lawrence Alma-Tadema, who had admired the Elgin Marbles
since his first visit to London in 1862, had a complete, small replica of the Parthenon frieze
running around one room of his Townshend House (Spalding 38). The fin de siècle was in
many respects, however, less a "renaissance" of past values, as it often considered itself, than
a paradoxical "late, hot-house flowering of the tradition" (39), the welding of poetic imagi-
nation to an already well-conditioned taste—that is, an art of parody. Almost by definition,
parody thrives in a technologically sophisticated world where "culture" has replaced "nature"
as the subject of art. It is the paramount art form of "decadence," of life imitating art, self-
consciously and self-critically pointing "both to itself and to that which it designates or par-
odies" (Hutcheon 69). It was an art form tailor-made for Aubrey Beardsley.

A Canonical Avant-Garde

The literary process always draws upon signs that exist prior to it, yet never lies wholly within
those signs; it "continually undermines, parodies, and escapes anything which threatens to
become a rigid code or explicit rules for interpretation" (Culler 114–15). As we have seen,

this quality also characterizes Beardsley's paradoxical art, arguably the most "literary" in history. While Victorians were masters of parody long before Beardsley, nearly everyone marveled how, despite the brevity of his career, he was able to master such widely varying styles as those that appear in his *Morte Darthur, Bon-Mots, Salome, Yellow Book, Savoy, Rape of the Lock*, and *Volpone* "periods"—"a fresh and wonderfully subtle combination of the methods and achievements of others" (Rutter 45–46). Parody became almost inevitably an overarching rubric for Beardsley's dandiacal art, reflecting his bipolar sensibility and drawing together the shared characteristics of the grotesque, caricature, and various other forms of irony.

Like the grotesque, caricature, and irony generally, parody operates on two levels—a primary, surface level, and a secondary or implied background, the final meaning being a product of the superimposition of these disparate levels. As Linda Hutcheon has astutely explained, it is by its nature a fundamentally paradoxical, double-directed discourse, expressing both transgression and reverence for tradition. Derived from the Greek noun *parodia, odos* meaning "song" and *para* meaning "counter" or "against," parody recalls a previous text in order to undermine or counter it. But *para* also means "beside" or "alongside," implying "an accord or intimacy as well as a contrast" (32). Parody is thus a valorizing "trans-contextualization" and ironic inversion that always cuts in opposite directions simultaneously (37, 44, 51–56). On the one hand, parody is revolutionary in demystifying the sacrosanct quality of the original author, text, or convention, appropriated and refashioned for other self-legitimizing needs. But on the other hand, parody is also intensely conservative, implicitly confirming its own limited nature and affirming the power, authority, and literary-historical continuity of the appropriated author, text, or convention (whose institutionalized value must be recognized, incorporated, and reinscribed for the irony to exist at all) (26, 35, 51, 69, 72, 76). Parody thus undermines "in its Oedipal need to distinguish itself from the prior Other" but is "normative in its identification with the Other" (77). In short, it represents the same kind of inherently ambivalent, dialogical discourse that we almost invariably find in Beardsley's art, an art that paradoxically evokes canonical tradition and conventional transcendental concepts of beauty, even as it throws such metaphysical values into question, which deconstructs prized essentialist assumptions only to recuperate them again through conventionally elegant, harmonizing stylizations.[1]

In a fundamental sense, Beardsley's was an aesthetics of *power*, intent on not merely self-expression but domination of the reader's attention, wringing it from the text he was ostensibly illustrating and from the conventions to which he was indebted. As Roger Fry suggested, conditioned society will invariably find initially "noxious and inassimilable" any revolutionary, truly creative art. In order for such art to be "consumable," it must first undergo "disinfection" of the "too violent assertion of its own reality"—a process of recuperation whereby "the travesty of the new," which violates "the rounded perfection of [the average person's] universe of thought and feeling," becomes associated with and then completely assimilated into recognizable past aesthetic expressions (Fry 70–73; see also Benjamin, "Mechanical Reproduction" 224). Historically, part of the work of art's "consumable" utilitarian value was precisely its presumed realism, reinforcing utilitarianism's faith that humans can master the material world and including the notion that a pictorial illustration should be a faithful representation

of the written text. As we have seen (in chapter 2), Beardsley, like many fin-de-siècle artists, operated under the assumption that in a bourgeois consumer culture that fed on endless "recuperation" and co-opting "disinfection," genuine art could logically establish its integrity only by being outrageous, by continuing to break the mold, by an aesthetics of "violation."

The doctrine of "art for art's sake," which denied "any categorizing by subject matter" and rejected what it took to be realism's enslaving subordination of the spirit to materialist utility, was one of the nineteenth century's most notorious revolts against utilitarian "realism" (Benjamin, "Mechanical Reproduction" 224). The artist was freed to use any material object, or art work, as raw material for the creation of an entirely new and independent work, being limited only by the parameters of the artist's own parodic imagination. The evolution of Art Nouveau itself, whose distinctively modern design style valued individual vision over material functionality, only emphasized this nonutilitarian "retreat to ornamental fantasy." In France Art Nouveau went from representing, in the 1889 Paris Exhibition, Prime Minister Jules Ferry's version of "a new universalist church of technological progress" (e.g., stunning examples of civic industrial engineering, such as the Eiffel Tower and the Gallery of Machines) to representing, in the mid-nineties, visionary irregularity and organic, feminized private interiors (epitomized in the stylized hundred-foot statue of *La Parisienne* on the Champs-Elysées, the elegant merchandise of the dealer-connoisseur Siegfried Bing, and the exotic individualistic dances of Loïe Fuller and others) (see D. Silverman 1–10). Not surprisingly, many bourgeois Victorians saw the defamiliarizing tendencies of Beardsley's art to be emblematic of Art Nouveau's "fall" from a Morrisian "English" emphasis on the functional morality of utilitarian crafts to a "French" emphasis on "immoral" stimulation of the viewer.

For all Beardsley's exclamations on behalf of "art for art's sake," his ironical "decadent" art carried much the same tacit purpose as any other satirical (that is to say, social and idealistic) art—to "correct" what it ridicules (see Cottom 106–7; Hutcheon 56).[2] After all, irony, parody, satire, and especially caricature are all overtly propagandistic forms of art, seeking approval in order to justify aggression and implicitly inviting the audience to collude in that policy of aggression (and regression) (see Kris 180). Under a logic that tended to equate the challengingly irreverent with the socially dangerous (often officially labeled "obscene"), the British ruling classes were quick to interpret the eccentric, parodic tendencies of Beardsley and his compatriots as revolutionary actions, moral as well as stylistic. The middle classes felt themselves besieged by an onslaught of things as culturally frightening as they were "new"— "art nouveau," "new freedom," the New Woman, even Grant Allen's New Hedonism, which emphasized sex as the source of inspiration for a new culture. Consequently they came to define the Decadence's embracing of Rimbaud's credo that the artist "must be absolutely modern" ("Adieu," *Une Saison en Enfer*) as a general effort to replace ruling conventionality with anything lawlessly avant-garde. As the critic Hugh Stutfield intoned from the pages of *Blackwood's*, "Much of the modern spirit of revolt has its origin in the craving for novelty and notoriety that is such a prominent feature of our day. A contempt for conventionalities and a feverish desire to be abreast of the times may be reckoned among the first-fruits of decadentism" (844). Or as H. D. Traill explained in *The New Fiction*, "Not to be 'new' is, in these days, to be nothing" (1).

Although the bibliophilic Beardsley was an omnivorous reader who was eager to absorb every useful convention, he often went out of his way to deny his debt to tradition, even claiming disingenuously (despite ample testimony to the contrary) that he had never seen a Japanese print before he created his "japonesque" drawings (Smith 16). He distanced himself from previous mentors and was quick to modify his style continually so that he could, in the words of Max Beerbohm, avoid the "plague" of imitators and be "always ahead of his apish retinue" ("AB" 544).³ Notoriously intolerant of *les vieux*, the academic and old-fashioned, what he considered the "stultifying observance of worn-out laws and principles" (E. Pennell, *Nights* 262–63), Beardsley felt it imperative, as he told *Leslie's Weekly*, "to get out of the conventional—to do something that no other fellow had done" (90). Ever restless, he was quick to change his current style as soon as he felt he had exhausted its possibilities, "fearing lest he found a school" (Small 27). In an 1895 interview with *The Boston Evening Transcript*, in which he disavowed the influence of his former hero Edward Burne-Jones, Beardsley claimed that a reliance on any school of art was, in effect, a failure to be modern: "There are no schools today . . . The point is that all traditions have been lost and everybody is following his own bent" (Smith 16). He advised the novelist Netta Syrett's sister Nell, then an art student, "not to stay too long at school, but to go her own way—as he had done" (Syrett 83–84). We recall that even in his last project (Jonson's *Volpone*), although he was near death and his stature was already well established, he continued to express the need to be "new" and revolutionary, seeking to impress the publisher Leonard Smithers and other friends (and perhaps reassure himself) that the book was one of groundbreaking significance—a "marked departure as illustrative and decorative work from any other arty book published for many years" (*Letters* 409; see also 419–25). As the avant-garde was constantly reminding itself, style, like the fashion-art of the dandy, is something that becomes out-dated almost as soon as it appears. The goal, then, was to continue to transvalue (and demonstrably supersede) canonical icons under a strikingly personal "signature." Edmund Gosse gave Beardsley what the latter no doubt considered the highest praise when he wrote, "You have put your stamp on the age," characterizing him as an unforgettable figure in the art history of the century (ALS to Beardsley, 29 December 1896: 2–3).

Beardsley did indeed seek to make virtually every project a vehicle for his own personal expression of the world, creating what Robert Viscusi has termed a "biogrammatic" art (see 304–19). Strictly speaking, a biogram is an ideogram made out of a single line or character, like Beardsley's symbolic "japonesque trademark." But *biogram* also connotes the creation through style of a functionally independent iconic persona or Yeatsian "mask," as Beardsley attempted through his self-conscious use of idiomatic (and ideogrammatic) styles as well as the promotion of his legend as an idiosyncratic personality. A biogrammatic art had the particular appeal for Beardsley of focusing attention on the *difference* between himself and other artists rather than on their "essential" qualities, allowing him to accentuate his own idiosyncratic, "superseding" distinctiveness while implicitly downplaying the conventionally "intrinsic" virtues of his rivals. Thus, in his rejection or manneristic reformulation of conventions, he constantly threatened to transform the function and meaning of art from a ritual recuperation of appearances into a political intervention and reinvention of those appearances, the

artist's singular gesture. It was a dandyism of style not unlike the "dandyism" so often attributed to Mannerist painters.

Beardsley's efforts to protect his deforming "travesties" from being co-opted are apparent from the very beginning in Dent's *Morte Darthur*, a book whose interest, according to *The Studio*, lay in independent designs "which decorate rather than illustrate its text" (15 February 1894: 183). However "literary" his art, Beardsley invariably refused to defer to, or be limited by, any author's text. Indeed, he did not want to have his drawings called illustrations at all; he referred to them instead as "pictures." On the title page of *Salome* he replaced the customary designation "Illustrated by" with "Pictured by." In the draft of the *Volpone* prospectus, we find him careful to change the word "illustrated" to "embellished" (Princeton MS. 1). When negotiating his appointment as art editor of *The Yellow Book*, he even insisted that the journal's policy state that the literature and the pictures would have no reference to each other (Benkovitz 92; Weintraub, AB 96).[4] By creating pictures that were not "consumable" by the text but even threw the text into question—pictures that were often, by bourgeois tastes, not even pleasant in subject matter—Beardsley sought to avoid bourgeois "disinfection" and to liberate art from its traditional function as a ritual affirmation of ruling cultural values.

In these respects, certainly, Beardsley's constantly changing parodic styles, like the styles of Art Nouveau, were blatant "anti-styles," defining themselves as "the new, the original for its own sake, the desire to shift ground constantly and negate all that has come immediately before" (Amaya 11). And since the first stage in defamiliarizing the perceptions of formal techniques and codes is to expose literary conventions through parody (see Shklovsky 3–24), it was eminently logical that parody should have become Beardsley's favorite means of sloughing off the burden of the cultural canon. Parody's deprivileging, relativizing, stylizing, often camp discourse is inherently subversive, making virtually all gestures into derivative, ironic, self-referential codes. Although parody is (at least from the Romantic perspective) the most parasitic art form (Hutcheon 100), it seeks to create a new set of intellectual assumptions, and it does so less by reshaping than by "misshaping" the traditional shapes of art. Certainly, in his pictorial "travesties" Beardsley "swerves" from and willfully "misreads" his predecessors, ostentatiously *deforming* rather than imitating previous texts and styles in order to distance himself from them and distinguish himself against them—the oedipal dynamic Harold Bloom has described as "the anxiety of influence."

On the other hand, no art can escape its historical and ideological contexts. The drive to become utterly original is always ironic, insofar as originality is inevitably measured against the preexisting traditions it presumably supersedes.[5] As much as Beardsley's art sought to appropriate previous styles in order to undercut them, in another sense his pictures, in highlighting both the parodied subject and the parody itself, acted simultaneously to affirm the authority of the very figures and traditions he was challenging—becoming, paradoxically, a homogenizing, hierarchizing influence as well as a de-normalizing one (see Hutcheon 69, 76). After all, the Latin root for *appropriate* is *proprium* (property). That is, while avant-garde parody pirates, it also implicitly places "a certain value upon the original . . . as a way of both softening and giving meaning to radicalness: the new can shock only when underwritten by the old" (107). Like everything else governed by what Jean Baudrillard has called "the political econ-

omy of the sign," the use of any convention, however transcendental the application of it, evokes the tradition of which it is a part and inevitably, by the operation of *"differential* value," fetters an artist's work to it.[6] As both a dutiful "son" and a joker free to slide playfully among alternative ironies, Beardsley simultaneously emulated and rebelled against many "fathers," mocking them even as he imitated them, seeking to supersede them in the very process of crafting imitative substitutions and affirming his bond to them.

For that matter, as Hutcheon points out, the search for novelty has often had its basis in "the search for a tradition," since parodic repetition, if not all repetition, "inscribe(s) continuity while permitting critical distance and change" (29, 102). Indeed, Beardsley sought less to negate previous styles than to demonstrate his uniqueness by means of his innovative use of them—which meant, of course, that those superseded styles first had to be clearly recognizable in his works. As Jose Ortega Gasset explained, all new art demands the "neat distinctions" of clear border lines, if for no other reason than to demarcate its conquering of the old (31).[7] Thus, Beardsley's modernity, as is often the case with the avant-garde, became what Matei Calinescu describes as a *"parody of modernity* itself": since a person mocks only what is believed to be significant—that is, worth mocking—the artist's caricaturing of the traditional belies a secret admiration for what is ridiculed, conveying (albeit for purposes of criticism) "a degree of resemblance, a degree of faithfulness to both the letter and the spirit of the original" (141). While the object of scorn is ostensibly marginalized, the satirical artist's attacks on it actually authenticate it as a worthwhile center of focus.

Rather than minimizing the influence of previous styles, Beardsley's pictures ostentatiously emphasize his utilization of past and current masters, demonstrating precisely through his own ironic deforming and perverting parodies his knowledge—and transcending mastery—of them. Imitated masters stand, in Beardsley's "caricatures" of their conventions, as self-damning evidence of just how silly and dispensibly tangential he has rendered them. Yet simultaneously, their obvious presence in his art also authenticates it, affirming the "essentialist" quality of both his lineage and his skill. Paralleling the effects of his individual caricatures, Beardsley's art was in general, rhetorically at least, an art of *cultural* caricature, an art that truly could not have existed without having "fathers" to "misread."

Re-signing the Pre-Raphaelites

Typically, when Victorian artists parodied their predecessors, they did so with some reverence, in a fashion that signaled homage to the culture's canonical traditions. But unlike Dante Gabriel Rossetti's romantic efforts to integrate elements of Japanese and Greek art into his paintings, Beardsley's practice was to jumble and deform previous styles, as when in his illustrations to *Lysistrata* he "perverts" Greek eroticism by treating it in the Japanese style (Schmutzler 86), or in *Under the Hill* his overwrought prose jangles a celebration of mythic passion with a ridiculing of Victorian pretentiousness and indiscriminate eclecticism. Almost invariably, Beardsley's parodic pictures are case studies in disruptive mimicry, seeking to *undo* the stultifying effects of ruling-class discourse by *overdoing* its conventions. Nowhere is the

deforming nature of Beardsley's art clearer than in his distortion of the Pre-Raphaelites, that nominally revolutionary but ultimately conservative, antitechnology brotherhood that eventually became the Victorian establishment's model of faith in transcendental values and the "truth of nature."

From his schoolboy days Beardsley tended to identify art with Pre-Raphaelitism. One of the attractions of Brighton's Church of the Annunciation of Our Lady was its stained-glass windows rising above the altar, designed by Rossetti, Burne-Jones, and William Morris. G. F. Scotson-Clark's employer Herbert Trist, a wine merchant whose father owned one of the finest collections of Pre-Raphaelite art in England, inspired Scotson-Clark and Beardsley to gather all the Pre-Raphaelite material they could find (Scotson-Clark, "AB" 5) and no doubt contributed to Beardsley's adoration of Burne-Jones. When an effusive Beardsley wrote to Scotson-Clark in July 1891 about the "GLORIOUS" art collection of Frederick Leyland, the overwhelming majority of the nearly thirty works he singled out (some with exclamation points) were by Rossetti or Burne-Jones (*Letters* 19). But, of course, Beardsley's hero worship was always at least partly alloyed with impish iconoclasm, as indicated by the time he tried his hand at Pre-Raphaelite oils by painting a green-faced, blue-haired Burne-Jonesian head against a purple sun (Scotson-Clark, "AB" 5–6). Even though he frequently invoked the names of Rossetti and Burne-Jones as an endorsement of his artistic pedigree, claiming fidelity to the highest principles of Pre-Raphaelitism (*Letters* 45), his art clearly subverted any number of those principles.

In the first place, Beardsley's very approach to his art was at odds with Pre-Raphaelite assumptions. The Pre-Raphaelites prized easel painting as the supreme form of art, used models either outdoors or in a studio under natural light, and endorsed a properly lighted gallery or parlor as necessary to display the painting's unusually striking colors and painstaking, unreproducible brushwork. Beardsley, on the contrary, always worked indoors, in ordinary domestic rooms, without models, usually at night by artificial light, and was proud to be able to produce an original with "no brush work to prate of," specifically designed to "take a part in everyday existence" and readily discardable after the production of a photographic plate ("The Art of Hoarding" 54, 53).[8] The Pre-Raphaelites objected to economical, industrialized mass reproduction on the grounds that it destroyed not only the natural character of works but also the individuality of both the artist and the consumer. They advocated instead the unique value of handcrafted objects, even if in fact only the wealthy could afford them. As Scotson-Clark explained, however, there was little "dreamy" or sentimental about Beardsley, whose high spirit and keen sense of humor was grounded in a "thorough[ly] practical and commercial outlook" ("AB" 6). Contrary to the Pre-Raphaelites, he accepted the ethical and aesthetic neutrality of process-engraved technology. Rejecting a value based on scarcity, he posited the virtue of a work solely in the quality of its design; if the design was beautiful, replication could only multiply its vitalizing effect. Even Beardsley's "finish" did not extol the "natural" but instead sought a linear rhythm and tonal (or atonal) harmony achievable even if the resulting shape violated the normal features of the natural object that inspired it (Ironside 212). Little could be more devastating to Pre-Raphaelite pretensions about the moral superiority of unique, hand-crafted works of art than Beardsleyan designs, which—while utilizing mechanical mass

reproduction and revolutionary photographic line-block technology—were disguised so suc-
cessfully as old woodcuts (even to the point of using inkblots to mimic wormholes) that the
casual public was no longer concerned about artistic "authenticity."

Nor was Beardsley any more wedded to Pre-Raphaelite principles of book design. Under
the ideal of a totalizing "sacred" Book, such artists as Morris, Ricketts, Shannon and, later,
Whistler often specified and coordinated the design of virtually every element of the finished
work—paper, ink, typography, cover design, title page, illustrations, ornament, binding, and
endpapers. Although Beardsley sought to integrate ornament and content and to incorporate
impressive innovations being made in typography and cover design, he never, even in his roles
as art editor, followed the Morris ideal of designing and supervising the book as a whole. He
generally preferred to tack his designs onto the typography of others, thus accentuating by
their independent position the "oblique satire," the striking effect on the viewer, and the
"latent and contradictory meanings in the text" (Fletcher, *AB* 44). In several of his projects
Beardsley even abandoned title-page design in favor of detachable frontispieces. Far from
"fusing text and illustration in the manner of those who sought to accomplish a union of the
arts," he usually "widened the gap between text and illustration," emphasizing still further the
split between "organic" unity and eccentric virtuosity (Fletcher, "Little Magazines" 197;
A. J. A. Symons 101–2). Indeed, part of Beardsley's "decadence" lay in his ability to "seduce
the eye of the viewer and make it move wherever he wanted," and "so turn the whole concept
of illustration into one of decoration. The page was the thing, not the story. The subject
became secondary to the manner" (White 9).

Beardsley and the Pre-Raphaelites were no less divergent in matters of content than in
their techniques. Influenced by Ruskin's fusion of aesthetics and morality, Pre-Raphaelite art
had sought to satisfy not only the hunger for beauty within ruthlessly industrialized Britain
but also the belief that art spoke a universal language that influenced the moral values of
society. Burne-Jones, Leighton, and G. F. Watts all believed that art should urge humans, in
Watts' words, "on to higher things and nobler thoughts," a quest the Pre-Raphaelites most
frequently associated with medieval romance. Morris sought to aestheticize the ordinary im-
plements of domestic life, recapturing what he presumed to be the medieval integration of
life's spiritual and material elements. While Beardsley's art was implicitly moralistic and he
was admittedly sympathetic to a certain nostalgic medievalism—the editor Lewis Hind even
claimed, "He was not of today: he was a medievalist" ("Memories" 3)—Beardsley's medieval-
ism hinted of the satiric, Rococo bent of the eighteenth century, a century both Morris and
Burne-Jones hated.

It is evident that in even Beardsley's first major project, the borders and illustrations to
the Dent edition of Malory's *Morte Darthur*, his revisionist treatment of Morrisian and Burne-
Jonesian medievalism is addressing an agenda far different from that of his Pre-Raphaelite
masters. Morris and Burne-Jones had discovered Robert Southey's edition of Malory's *Morte
d'Arthur* while they were undergraduates at Oxford. Morris immediately purchased the unusu-
ally expensive book and had it bound in white vellum; Burne-Jones considered it to be "the
book which was to mean more to him than any other," a profound influence "impossible to
overrate" (Fitzgerald 37; Cecil, *Visionary* 108–9). Malory's medievalism—which Morris and

Burne-Jones filtered through their own melancholic versions of Greek, Norse, and Celtic legends—gave focus to their longing for changeless order and their desire to escape bourgeois vulgarity. But Beardsley's *Morte Darthur* illustrations and horror-vacui borders, which the publisher J. M. Dent intended to imitate those of Morris's acclaimed Kelmscott Press edition (to which both Morris and Burne-Jones contributed), came as a rude shock; Morris, as we recall, found Beardsley's highly subjective and satiric parodies of his style to be a near-blasphemous distortion of the clear values and signal morality of his revered Middle Ages (Vallance 363–64; MacFall, *AB* 22–23; *Letters* 44).

The "strength and rhythm" Beerbohm saw in Beardsley's borders, compared with "the muddled and fuddled, tame, weak, aimless, invertebrate, and stodgy page done by Morris" (Beerbohm, *Letters* 95), were virtues that obviously lay in the service of an aim much more subversive than Morris's intent. For instance, while such lines as those defining the King's garments in *How King Arthur Saw the Questing Beast* (Figure 6–1) may imitate the gouging of the needle on copperplate in a fifteenth-century engraving (Slessor 31), Beardsley's strikingly stylized drawing—complete with a mischievous, Medusan-haired Pan, who (until Beardsley) had never before appeared in illustrations to the Arthurian legends (Heyd 148)—does anything but evoke the nostalgic aura of the late Middle Ages. Here Pan, the legendary source of terrifying dreams, has apparently unleashed upon Arthur a plethora of grotesque and ominously sexual images, including a hairy cross-legged bird, salacious vegetation, darting snakes, and various phallic doodles. In so doing, he has reduced the presumably strong and authoritative king to a recoiling, apprehensive figure—recumbent against a decimated ("castrated") tree trunk and anxiously transfixed before the slant-eyed glare of the "Questing Beast," which seems to draw Arthur's eyes irresistibly and whose huge claw descends ominously toward Arthur's genitals.

Walter Crane observed that while many people considered that the "strange decorative disease known as 'L'Art Nouveau'" was an outgrowth of Morris's art, it was actually antithetical to it (*Morris* 232). Art Nouveau may have derived many of its sinuous plantlike lines from Morris's work, but Beardsley emphasized the disparities rather than the similarities between the two styles. Whereas Morris's and Burne-Jones's figures and those of Beardsley share a rigid solidity and sharp clarity reminiscent of enduring classical form, Beardsley often depicts that "frozen moment" as something entrapped or entangled rather than transcendent. He generally replaced the tranquil and delicate foliage of Morris's borders with twisting briar twigs and powerfully unstable plant forms. Furthermore, while Morris's and Burne-Jones's use of rigid drapery, still figures, and masses of black sometimes created a sense of eerie ritual and chill, nightmarish unreality, there was a compensating aura of classical calmness and nostalgia that even in its sadness was familiar and reassuring, particularly to Victorian audiences. On the other hand, Beardsley's willful exaggerations of the same mannerisms were frenetic and disorienting. For example, the primitive projected design for the front wrappers of the parts of *Le Morte Darthur* (Figure 6–2), gratuitously jams together Burne-Jones brambles, Botticelli lilies, misshapen heraldic shields, and a wavy Japanese ground under a title banner that impishly lodges Malory's name in a tree. Such deliberately slapdash alignments were designed to create in the mind of the viewer not only a visual dissonance, jarring as it does the expectation of a

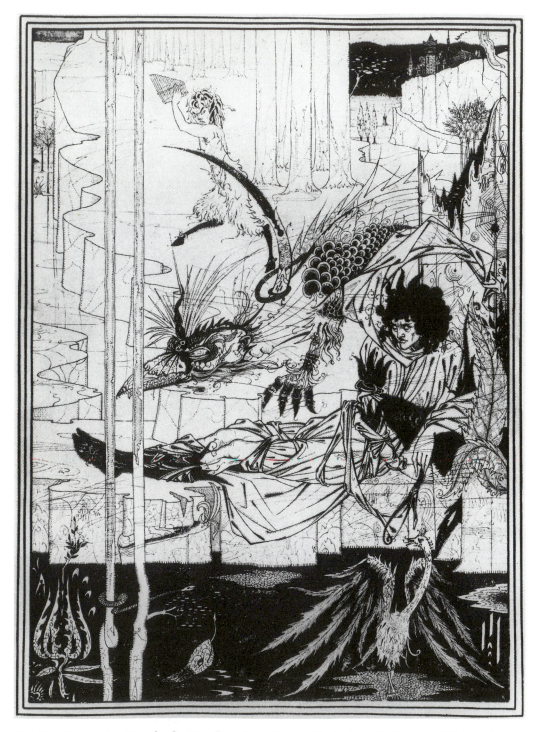

6-1 *How King Arthur Saw the Questing Beast* from chapter 20, book 1 (facing page 20) in *Le Morte Darthur*. (E.289-1972 [neg. no. GK.3 Y19], Victoria and Albert Museum, London)

6-2 Projected design for front wrappers of parts of *Le Morte Darthur*. (Private Collection)

stylistically uniform visual field, but also a corresponding metaphysical dissonance, transvaluing the concept of unity itself, including the verity of medieval "community." In the drawing for the headpiece on the title page of *Le Morte Darthur* (Figure 6–3), Beardsley even embellishes Morrisian and Burne-Jonesian conventions to a degree that makes them grotesque. In fact, the grotesque elements become the central focus in the drawing, disorienting and displacing the entire recuperative effect of the conventions themselves.

In such pictures as *How King Mark found Sir Tristram Sleeping*, from chapter 21, book 9 (facing page 220) in *Le Morte Darthur* (Figure 6–4), Beardsley's demonstrably flagitious and heretical transformation of the conventional, dream-entranced Pre-Raphaelite ideal of beauty clearly vitiates Morrisian Romantic medievalism. Amid his usual ambiguous border foliage (the stem even turning into a dragon's head at the bottom center), Beardsley presents us with a sleeping Tristram, who is in this case nude and androgynous, with wildly pointed hair, knock knees, and genitals that are, amusingly, highly visible but of indeterminate gender. King Mark is hardly less problematical. He is bending sharply over the sleeping Tristram, with his open mouth and outstretched hand focused directly over Tristram's genitalia. It is not certain

6-3 Drawing for headpiece on title page in *Le Morte Darthur*. (Private Collection)

whether the king is shocked or excited by the nude knight, but Beardsley compounds the ambiguity by extending it, as with Tristram, to Mark's personal gender identity. Although Mark is presumably male, the fold of his tunic at his bending groin is oddly drawn as if to approximate a vagina, further confusing the friend/lover, heterosexual/homosexual possibilities. The drawing's disorienting, clandestine erotica gain force from a series of sensational effects: Mark's stiff, exaggerated, right-angle posture; the perceptually wrenching plane of Tristram's body (paralleled by Mark's horizontal upper body); the harsh phallic lettering of the title; and the foreshortened arrow-leaves of the border, which, while accentuating the right angles of the drawing, act virtually as vectors contradicting the kinetic flow established by Mark's body, Tristram's hair, and the tilt of the lower vegetation.

These "pornographic" renderings of traditional conventions are indicative of the assaultive rhetoric of erotic writing, which seeks to "shock the reader into an awareness of the destructive, usually repressed aspect of his own erotic feelings," underscoring in the process the fragility of the very social and artistic conventions it utilizes (Perkins 210). Predisposed to hide salacious details within the structure of other images, Beardsley compounds the illusion (characteristic of pornography generally) that he is taking the voyeuristic reader into his confidence, providing a surreptitious (and often projective) glimpse into the guilty secrets of the text and perhaps even of the author himself (see Charney 7). It was an approach deliciously suited to both the Arthurian legend and to Morris's and Burne-Jones's typically ambivalent Victorian sexual perspectives. Accentuating the possibilities for double readings, Beardsley was what R. A. Lanham defines as an unabashedly "rhetorical" writer, one who aims at play more than truth, who delights in the shifting possibilities of a purely social, purely histrionic world (1-35). His ambiguously allusive art turned the various fetishistic fascinations of Victorians back on themselves, ripping the ruling culture's ideological "suturing" through a visual displacing (and de-forming) "deconstruction" of its own conventions.

As we saw in chapter 3, Morris responded to Beardsley's *Morte Darthur* "usurpations"

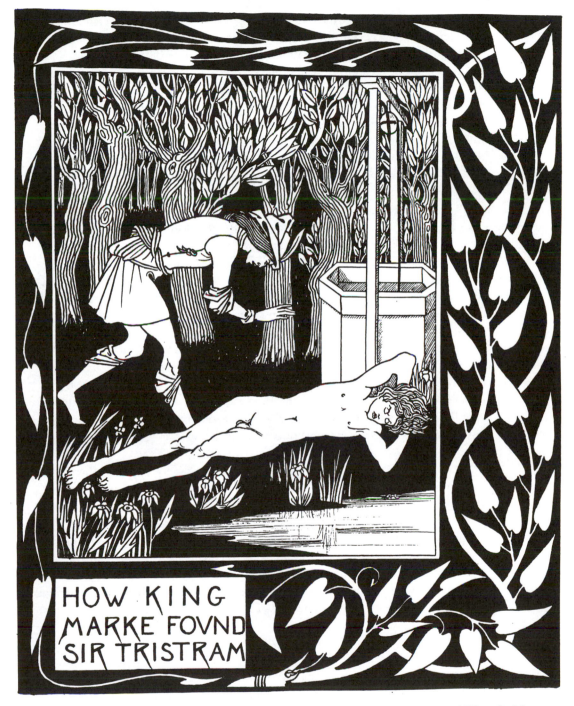

6-4 *How King Mark Found Sir Tristram Sleeping* from chapter 21, book 9 (facing page 220) in *Le Morte Darthur*. (Private Collection)

with protestations to the effect that "a man should do his own work" and not pervert another's; but Beardsley characteristically claimed that it was *Morris's* work that was "a mere imitation of the old stuff," while his own was "fresh and original" (MacFall, *AB* 31; *Letters* 44). Such witty inversions were Beardsley's way of reaffirming his status as part of the avant-garde and elevating the "new" over bourgeois tradition. But such retorts also removed any doubt about whether Beardsley's "disseminated" defamiliarization subverted fundamentally the sanctity of traditional texts and even stable meaning itself. In the end, his hyperbolic parodies of well-known Morrisian and Burne-Jonesian mannerisms went beyond ridiculing Morris and Burne-Jones as old-fashioned paragons of the Establishment; they even impugned the authenticity of their credentials—"un-recuperated" them, in effect—by making them seem the progenitors of the revolutionary Beardsley.

Beardsley's playful iconoclasm in the *Morte Darthur* project was much more fundamental than the implicit spoofing of Morris and Burne-Jones. It also threw into question the univocal world view that their work represented and that was extolled by the traditional Victorian culture—specifically, the reassuring and conservative "medieval" clarity of Malory's text itself. As Muriel A. I. Whitaker has shown, Beardsley's "illustrations" to Malory's work are, in key respects at least, "flat blasphemies" of the text (67–75). Both Malory and Beardsley used parallelism and repetition aesthetically, describing nature in formulaic terms. However, while Malory's tale is full of action, Beardsley's knights languish in passive contemplation; while Malory's knights occupy center stage, Beardsley's share it with angels, satyrs, fatal women, and androgynous nudes; and while Malory's virile knights aggressively rescue passive and subservient maidens, Beardsley's pale and effeminate knights are generally dominated by powerful and threatening sirens. Most significant, perhaps, Beardsley and Malory have clearly differing attitudes toward evil. Malory was a romantic idealist, whose view of morality and religion was perfectly conventional and depicted in conventional medieval images:

> The forest attracts because it is the source of power and glory; it renews the vigour and fame of ageless knights by presenting them with opportunities to overcome evil and restore moral order . . . The thorns with which Tarquin beats his prisoners, severed heads hanging from saddle-bows, knights dangling by the feet from trees are recognizable modulations of the demonic world and act as challenges to the heroes who must restore moral order . . . Devils are presented with every attribute of grotesque horror-blackness, deformity, stench, noise, and tempest . . . Images denoting good and evil are clearly differentiated, with holy ladies and hermits explaining significances at every step. (Whitaker 71–72)

But against Malory's clear polarity of good and evil, pleasure and pain, Beardsley constructs "something so hybrid as to be monstrous" (Gaunt 138). It is a world in which sin may be fascinating and provocative, yet "the leering satyrs pushing their heads through the bushes cannot even arouse a scream or a shudder from their bored victims," and the recurrent symbols are of "mingled beauty and pain," making incongruity the real theme (Whitaker 72–74).

Rather than affirm clear and traditional distinctions between virtue and vice, Beardsley's

sharp black-and-white images ironically confuse those distinctions and even contemplate that confusion with a certain insouciance toward the result. In *The Lady of the Lake Telleth Arthur of the Sword Excalibur*, from chapter 25, book 1 (facing page 25) in *Le Morte Darthur* (Figure 6–5) Beardsley muddles the metaphysical significance of the legend he was presumably illustrating. In the first place, rather than highlight the dramatic moment when Arthur seizes the sword Excalibur from the water, Beardsley archly chooses to divert us to a relatively insignificant preliminary narrative, the depiction of which ironically omits Excalibur, the supposed focus, altogether. But then, as Lorraine Janzen Kooistra has noted, the artist problematizes Malory's traditional coding even further. The scene ostensibly heralds the ascension of Arthur to the throne, but Merlin is made to stand hunched and feeble beside an intimidated Arthur. The presumably heroic king-to-be gazes helplessly into the Lady of the Lake's face and recoils from her upraised right arm, which in forming a strong diagonal in the center of the picture seems to be conveying equivocally both a blessing and a threat (her hidden left hand clutches her throat, prefiguring the beheading she will suffer at the hands of Balin). In the background the white trees with their bifurcated trunks and Beardsley's customary breastlike boles "mime both her uplifted hand and her ultimate martyrdom," such that the "'telling' of the sword Excalibur" becomes a telling of glory followed by eventual violence and death (67–68).

In a sense Beardsley's illustrations reinforce Malory's warning that "the distinction between a 'true knight' and a 'false knight' is a tenuous one" and his uneasiness regarding "a society whose emblem of order is a sword, whose *modus operandi* is the disguise, and whose sexuality is its driving destructive force" (Kooistra 58, 55). But the ways in which Beardsley cuts "through the gloss of chivalric and courtly values to expose the violence and sexual aggressions beneath the text" (Fletcher, *AB* 53)—in particular, his ostentatious blurring of conventional taxonomic and moral distinctions—are clearly inconsistent with Malory's (and Morris's) ideals. In contrast to Malory's (and Morris's) preference for a clear opposition of good and evil, Beardsley's pictures disorient and impugn such accepted cultural demarcations even as he invokes them—as when noble King Arthur takes on the Medusan locks and contemptuous air of the insurgent Beardsley femme fatale, or when the chief counsel Merlin is portrayed in a dependent fetal position (see Figure 3–9). Such role reversals, as Whitaker observes, "would have been unthinkable to Malory—a degenerate parody of chivalric romance" (Whitaker 73).

Beardsley's parodic deformations of Malory's *Morte Darthur* are perhaps most slyly evident in the Tristram and Isoud drawings, where he investigates the love-and-death bonding he would revisit in the *Salome* drawings—a subject that continued to captivate him throughout his life. Barely one-third of the first volume of Malory's *Morte Darthur* deals with the legend of Tristram and La Beale Isoud, yet Beardsley devotes roughly half the full-page drawings for that volume to it (Slessor 32). His interest was no doubt intensified by his fascination with Wagner's adaptation of the legend in his opera *Tristan und Isolde*, first performed in 1865, through which he filtered Malory's version.[9]

In many respects Wagner was a natural idol for Beardsley. Like Beardsley, Wagner was a fierce individualist who freely adapted the ideas of others, combined revolutionary and conservative impulses, viewed sexuality as an elemental and irresistible force of unquenchable

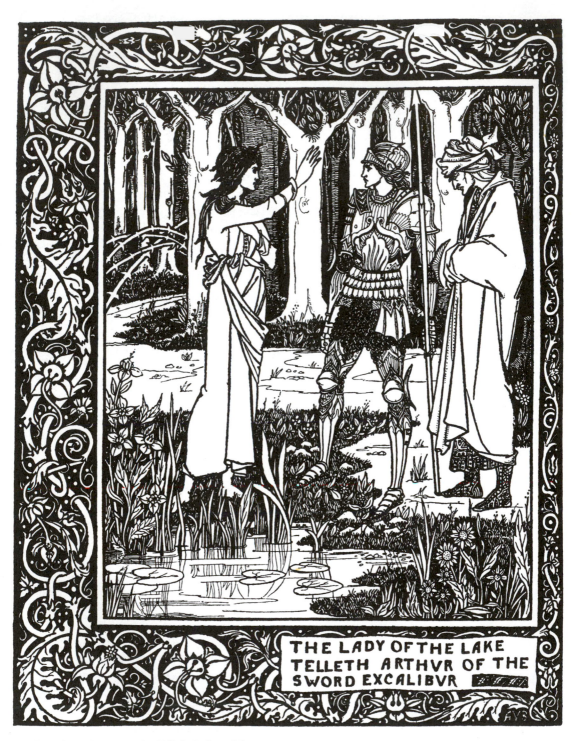

THE LADY OF THE LAKE
TELLETH ARTHVR OF THE
SWORD EXCALIBVR

6-5 *The Lady of the Lake Telleth Arthur of the Sword Excalibur* from chapter 25, book 1 (facing page 25) in *Le Morte Darthur*.

6-6 *The Return of Tannhäuser to the Venusberg* for *The Story of Venus and Tannhäuser*. (Neg. no. FF167, Victoria and Albert Museum, London)

Schopenhauerean yearning, and believed in using exaggeration for emphasis (see Reed, *Style* 197–98). It is quite possible that Beardsley idolized Wagner, in part, for the very quality for which Nietzsche castigated him in *The Case against Wagner* (1888)—a romantic yearning for salvation.[10] Like Wagner, Beardsley perceived the world as a stage for guilt, punishment, and potential—but by no means certain—redemption. Indeed, Kenneth Clark even goes to far as to define Beardsley's "deepest feelings" as "the need for repentance and return" (48), a view seemingly confirmed by the intensity of Beardsley's Wagner-inspired *Return of Tannhäuser to the Venusberg* (Figure 6–6).

　　The drawing clearly incarnates the themes of guilt and alienation, to which Beardsley returned again and again and which Baudelaire had proclaimed as characterizing Wagner's

opera—"the struggle between the two principles that have chosen the human heart as their main battle-ground, the flesh and the spirit, hell and heaven, Satan and God" (SW 341; AR 220). According to the moralistic sixteenth-century version of the legend, which was the one Beardsley utilized, the Christian knight Tannhäuser entangles himself in sin on the Venusberg, seduced by the medieval version of the goddess Venus, a sorceress and succubus (see Fletcher, AB 144; "Verse and Prose" 232–45). Eventually overcome with repentance, Tannhäuser appeals to Venus's rival, the Virgin Mary—signifying that the battle for Tannhäuser's soul is a conflict between Mary and Venus, the virgin and the whore. Mary grants him a temporary return to the world, and he makes a pilgrimage to Rome, throwing himself at the feet of the pope, confessing and asking forgiveness for his sins. The pope denies him absolution, saying Tannhäuser has no more hope than the papal scepter could produce blossoms, and the knight returns to Venusberg in despair. After three days the papal staff does indeed miraculously sprout green leaves; the pope orders a search for Tannhäuser, but he is never found. In Beardsley's picture the wandering and desperate Tannhäuser, now alienated from both Mary and Venus, is set against a dark landscape and trapped in a thicket of menacing briars. He yearns with deprivation-gnarled outstretched hands for fusion with the breastlike Venusberg rising beyond the phallic trees. Beardsley uses the same technique to indicate the texture of Tannhäuser's hair as he uses for the trees and the Venusberg, suggesting "the inescapable continuity of that eroticized world" (Beckson, "Artist" 219) and making all the more poignant Tannhäuser's basic alienation.[11]

Beardsley was no doubt impressed by Wagner's intense and revolutionary quality manifest in what he called his "art of transition": abandoning the separable units familiar to opera—for example, the aria, the duet—in favor of the continual melody of the leitmotif, he concentrated on atomistic motifs that, by their interlocking and recycling growth, subvert traditional form, emphasizing asymmetry and imbalance, and delaying resolution through the continuous melodic lines and the diatonic, chromatic, and whole-tone series of sixth and especially seventh chords (see Reed, *Style* 195–206). Indeed, part of what may have (consciously or unconsciously) fascinated Beardsley about Wagner, and *Tristan and Isolde* in particular, was that the German composer's work portrayed life in the grip of irresistible fatality—a perception Beardsley may well have applied to his own disease-ridden life—and manifested a fundamental attraction to and incarnation of paradox and irresolvability.

Certainly Beardsley exploits such elements in his own treatment of Tristram and Isoud. In *How La Beale Isoud Nursed Sir Tristram* from chapter 9, book 8 (facing page 166) in *Le Morte Darthur* (Figure 6–7), Beardsley couches Malory's version of the legend in Wagnerian paradoxes. Sir Tristram, wounded while slaying the Irish champion Sir Marhaus and having to return in disguise to Ireland (where he received the wound) in order to be healed, has been accepted unknowingly by the Irish King Anguish and placed under the care of the king's daughter La Beale Isoud. The drawing depicts even in its formal structure the theme of passion held in check: "[T]he two figures, themselves drawn with extreme economy, are firmly contained with a box-like grid of lines. In the border, however, by contrast, Beardsley has unleashed a continuous growth of flame-like tree forms, clearly expressive of the powerful natural forces gathering beneath the apparently calm surface of the lovers" (Wilson, AB n. 4; see also

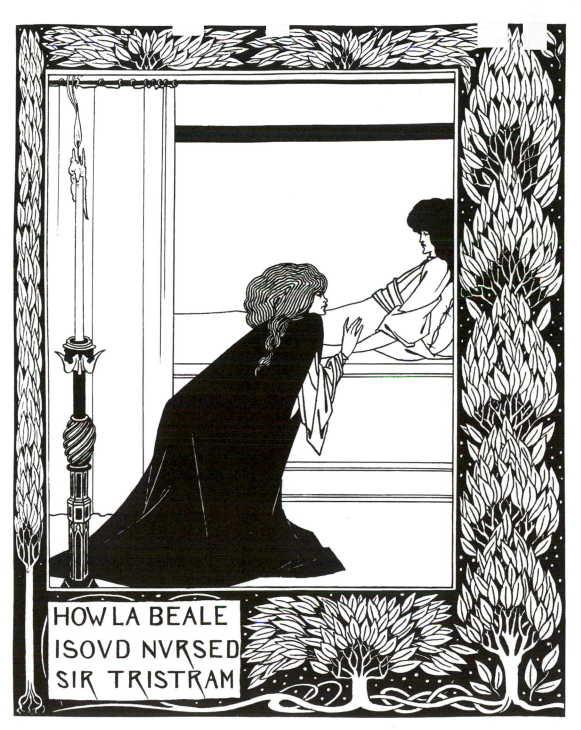

HOW LA BEALE
ISOVD NVRSED
SIR TRISTRAM

6-7 *How La Beale Isoud Nursed Sir Tristram* from chapter 9, book 8 (facing page 166) in *Le Morte Darthur*. (1986.682, Scofield Thayer Collection, Courtesy of The Fogg Art Museum, Harvard University Art Museums, Cambridge, Mass.)

Slessor 37). Yet Beardsley does not render even this dialectical tension of passion and restraint unequivocally. The passion of the expansive flamelike trees in the top, bottom, and right-hand border seems emphasized by their entangled, writhing roots, their detaching leaves, and the seedlike dots of white on the black background. But these elements are drawn in such a way that they can also simultaneously connote imprisonment, disintegration, and the ashes of decay. The negative connotation seems reinforced by the fact that Beardsley counterpoints these flamelike trees with a cramped, tightly wound tree wedged along the left-hand border. In fact, we see that once again both the outside and inside edges of the border are made to press in against the trees, twisting and distorting their shape, a discordant note reinforced by the swordlike tails on the Rs in the inset title.

These equivocal meanings, which exemplify in part not only the war of restraint and passion but also a struggle between Maloryan and Wagnerian emphases, extend to the enclosed thematic core of the drawing. They are embodied metaphorically, by the large ecclesiastical candlestick, which is both cleanly and symmetrically chiseled and yet spirals exotically toward a spiked ornament, and which holds a pure white candle that rises to a grotesque glob of molten wax and whose flame seems about to burn the curtain pole suspended above the potential lovers. The expansive white that surrounds the immobile Tristram, also constituting his body (except for his hair) and his bed, is undercut by the series of parallel horizontal lines outlining the bed, his body, the curtain rod, the upper and lower borders (which also border the compressed trees), and particularly the thick solid black strip above him. Tristram seems almost strapped to the bed by the gathered top edge of the sheet (or, equivocally, his own midriff scarf). Moreover, the vertical border on the right seems to prop him up sharply and uncomfortably, cutting off the back of his hair and pillow, just as the curtain at the left cuts off his feet. Ironically the warrior-hero appears delicate, passive, frail, even androgynous, while the kneeling Isoud, whose large black cloak dominates the picture, appears expressively massive, even masculine when we realize that her awakening passion is implied not only by the upraised hand that is about to touch Tristram's thigh (Wilson, AB n. 4) or even his loin (Fletcher, AB 47) but also by the fact that her cloaked body is made to appear awakened, tense, about to spring, not unlike an emerging phallus intersecting Tristram's torso. Beardsley underscores this vaguely threatening quality by Isoud's hooded eyes, the intense, almost menacing concentration on her face, and the kinetic energy implicit in her grid-lined hair (contrasting the smaller, truncated black blot of Tristram's hair). Isoud embodies beautifully what is (or will be) her paradoxical condition—a joining of love and hate, regeneration and decay, passion and restraint, strength and weakness, resolve and guilt.

Most significant, whereas Malory's version of the legend defines the story's elements in clear (if vexing) moral terms, Beardsley composes the drawing so that we cannot clearly segregate (or advance) one set of thematic polarities over the other, or, for that matter, even identify the dominant gender characteristics of the characters. Instead of Malory's hierarchical moral equations, Beardsley presents us with a world under constant transformation and reformulation, where messages can be altered in the very process of their communication. Just as irony generally refuses semantic univocality, so Beardsley's parodies of Malory (and Wagner) refuse unitextuality. His pictures defamiliarize not so much the world as the assumption that

there are univocal ways of talking about the world. Each parodic element of Beardsley's equivocal narratives only highlights the possibility that every narrative, every scene, is but a conflict of competing discourses.

One of the more extraordinary examples of Beardsley's conflation of wildly different cultural "discourses," again with Wagner as one of the voices, is his pornotopic fantasy *The Story of Venus and Tannhäuser*. Beardsley's novella may have taken a crucial turn when he posed for Jacques-Emile Blanche in the summer of 1895 at the latter's family home in Dieppe. On the walls of the studio were Renoir's 1879 murals of Venus and Tannhäuser, which had been commissioned by Blanche's father, an ardent Wagnerite at a time when Wagner was out of favor in France—in the aftermath of the Franco-Prussian War (Robins 41). Renoir's murals recreated Wagner in the manner of Honoré de Fragonard, depicting a voluptuous nude Venus (surrounded by fluttering cherubs) welcoming Tannhäuser into a vaporous landscape. It is difficult to imagine a prospect more exciting to Beardsley's imagination than that of combining Wagnerian romance with Fragonardian eighteenth-century Rococo frivolity—which is, more or less, exactly what he proceeded to do.

In quite another vein, Beardsley invoked Wagner in two other ingenious stylistic "discourses," *Lady Gold's Escort* and *The Wagnerites*. Here he once again shades parody into caricature in order to summon canonical tradition and yet break the mold that sustained it and the bourgeois ethos generally. Adapting the poetic quality of Whistler's Nocturnes in another key, Beardsley uses masses of black to intimate not only Wagnerian fatality but the dark and sinister quality of Victorian hypocritical high society (Reade, AB n. 363). In *Lady Gold's Escort* (Figure 6–8) we find a meek-appearing old woman (whose name alludes to society's real cultural interest), who is emerging from wide vaults of black. Sketched white lines deftly suggest the cab and coachman, and the old woman is dwarfed ominously by much larger tuxedoed and black-gowned theatergoers, whose distinctly foreign faces accentuate the air of alienation. The escort and the onlooking patrons seem to merge into the black background, being distinguished from it (and each other) only by faintly scratched outlines, as if they are fundamentally defined by menacing darkness—ostensibly humane devotees of the arts but in fact corrupt, vaguely ominous, puffed-up charlatans, who threaten to prey on anything around them and to taint it with their "blackness."

The central irony of *The Wagnerites* (Figure 6–9), which according to Joseph Pennell was inspired by a Saturday night performance Beardsley attended at the Paris Opéra in May 1893 (AB 31; Pennells, *Whistler* 139), is that Wagner's work about idealized love (*Tristan and Isolde*) is being viewed by a group of worldly and vicious-looking women (including, ironically, caricatured love poet Elizabeth Barrett Browning) (Reade, AB n. 364). Many of these dour and ugly women display customarily erotic bare shoulders, yet their sensual lips are pressed together in what appears to be a grimace of repudiation and/or disgust. These rather fierce women surround a contrastingly effete, unsensual, bespectacled bald man—perhaps a familiar nineties' characterization of a "castrated Jew" (Zatlin, AB 87)—whose mouth is open in awe or, perhaps, apprehension. The dominating black mass that forms the lower sixty percent of the drawing seems to absorb the figures almost like the pull of gravity, an effect accentuated by the black masses that form the women's hair. It is Beardsley's commentary on Victorian bourgeois cul-

6-8 *Lady Gold's Escort.* (PP.6 G [neg. no. FF162], Victoria and Albert Museum, London)

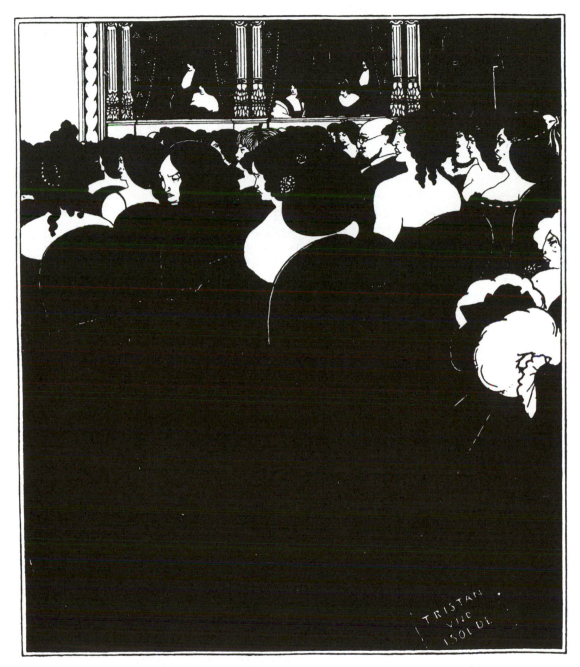

6-9 *The Wagnerites*. (E.136-1932 [neg. no. FF166], Victoria and Albert Museum, London)

tural sensibilities that a moving performance of tragic love, which should transport and en-noble its audience, has instead the effect of exposing that audience's true venality—reinforced, by the picture's permeating darkness. Like *Lady Gold's Escort*, which mocks Victorians' lack of true sympathy with the art they patronize, *The Wagnerites* exposes the hypocrisy and shallowness of Victorian Society—both pictures evoking canonical high culture as the subtextual authority for the irony they reflect.

In defending Beardsley's pictures, Robert Ross claimed that "the grammar of art exists only to be violated" (*AB* 52). Certainly, as we have seen, Beardsley's use of caricaturelike figures in his parodies only intensified their culturally disfiguring effects. Besides their obvious satirical purpose, elements of caricature were seen to be yet another presumptuous assault on the division between "high art" and popular culture. The foregrounding of design in the fin de siècle had undercut the rigid hierarchy between fine and applied art, but it still reinforced the idea of binding universal principles in art. Even Beardsley's topical jibes were "redeemed" by their stylized finish, which bespoke art's traditional claim to timelessness. But caricature had a significantly more corrosive effect. Dating from the early Victorian period, caricature, which was most often mass produced in ephemeral broadsheets and the illustrated penny press, was too closely associated with the working class to be considered "true art" (see Elliott 99 n. 21).[12] Even beyond the customary accusations of insincerity and undue theatricality, caricature's subversive brand of humor gave it a distinctly antiestablishment flavor. Like parody generally, caricature is the scandalizing "counterfeit" of conventional art, not merely by virtue of having "denatured" some original, to adapt Baudrillard's formulation, but also because it extends access to, and democratizes the meaning of, a commodity—in this case, canonical art—whose privileged value and clarity "depended on the restrictions that stamped it" (*SW* 136).

Caricature is also a particularly trenchant version of parody's double-edged discourse. In a formulation that Beardsley would certainly have approved, E. H. Gombrich states that the caricaturist assumes that "the essence of art is not imitation but expression" and "relies not on pre-existent forms, on the schemata of academic art checked and clarified in front of the model, but on configurations arising under the artist's hand as if by accident" (356, 352). It is also true, however, that the apparent ridicule that caricature evokes, rather than effacing the subject, most often works paradoxically as a subtle revalorization. Caricature debunks traditional conceptions and perspectives, creating a waggish cartoon, but it does so in the process of affirming what we must necessarily recognize as some *essential* trait in the subject. While burlesquing its subject, the caricature also reestablishes the value of that subject as an important and valid locus of meaning, reaffirming its central position, or more to the point perhaps, reaffirming the idea of centrality or "essence" itself. The dynamic is, after all, not so different from what operates in the grotesque generally. The reason we respond to the grotesque with horror and revulsion, or laughter and ridicule, is precisely because it represents an "unnatural," unassimilable contradiction that we tacitly want to expel as beyond acceptable limits, also tacitly affirming in the process a more homogeneous, transcending standard or truth (Kayser 30–31, 186–88). Even Beardsley's avant-garde *Bon-Mots* grotesques are not the nonsensical doodles they seem but identifiable parodies of past styles of art and dress, decorating

the sayings of various late-eighteenth and early-nineteenth-century wits—Samuel Foote, Richard Brinsley Sheridan, Charles Lamb, Sydney Smith, and Theodore Hook. Here, too, Beardsley's impish originality is ultimately but another means of giving recognition and authority to cultural conventions, even the conventions he is ostensibly mocking.

However much Beardsley liked to claim that he had discarded the tradition of Burne-Jones and other Pre-Raphaelites, he continued to utilize their well-known conventions, both to establish his lineage from the Pre-Raphaelites and to differentiate himself from them. In his "caricature" of the Pre-Raphaelite ideal woman particularly, Beardsley advertises his indebtedness to the canon's typological icons only to trivialize and destabilize them—both iconographically and stylistically. As if to underscore the intertextual nature of his art, some of Beardsley's spoofs of Pre-Raphaelitism are so specific as to parody recognizable paintings. For instance, in *The Ascension of Saint Rose of Lima* (see Figure 1–10) Saint Rose's shut eyelids and dreamy expression are clearly meant to echo Beatrice's in Rossetti's famous *Beata Beatrix*, except that while Rossetti's ideal woman solemnly dreams of transcendent reunion with her heterosexual lover, Beardsley's is being transported to that heavenly harmony literally, and scandalously, in what appears to be homosexual rapture with the Madonna herself! The pose of the woman in *The Kiss of Judas* (see Figure 4–13) replicates that of the woman in Rossetti's *Pia de' Tolomei* (1880) (see Figure 4–14), except that whereas Rossetti's lover hangs her head in sorrow and fatigue, Beardsley's may actually have been killed off by the attending grotesque "child of Judas."

The Pre-Raphaelite ideal of beauty was the emblem for a hierarchical, unified and univocally ordered world. As John Dixon Hunt has suggested, if the Pre-Raphaelite artist's ideal woman was "soulful," it was because she *was* the image of his soul (Hunt 177–78), and if she seemed vaguely tragic, it was because in her current vexed plight she yearned for the soulful unity and order that she believed existed but was now precluded. However, Beardsley's world is not the univocal and relentlessly just world of tragedy; his parodies often present a beautiful woman whose languorous repose conveys not an ingenuous soul awaiting or nostalgically lamenting an unquestioned order but a defensive veneer masking endlessly jangled nerves and neurasthenic tension. Beardsley's version of the so-called Pre-Raphaelite "stunner," far from being an innocently nurturing or tragically melancholic feminine ideal, is usually a Decadent New Woman, whom he typically depicts as worldly, coy, or disdainful, at times even demonic and predatory.

Burne-Jones regularly placed women on pedestals—sometimes rather literally—as in his famous painting *King Cophetua and the Beggar Maid* (1884) (Figure 6–10), but Beardsley's parody in the bookplate of John Lumsden Propert (Figure 6–11) is an obvious inversion of the Pre-Raphaelite icon. In contrast to Burne-Jones's chivalric idealization of a pure and humble maid revered by a king, Beardsley's picture presents a grotesque and contemptuous woman dwarfing a foolish Pierrot, who prayerfully implores her without effect to soften her acidic attitude. Beardsley's version of the Pre-Raphaelite beauty evokes the question, just what *is* the soul if this is its image? The descending grotesque branch and the ominous waves of the siren's skirt, with its lace trim drawn to approximate either teeth or the white froth of rolling surf, only reinforce the ironic futility of Pierrot's devotion. Moreover, the rhetoric of Beards-

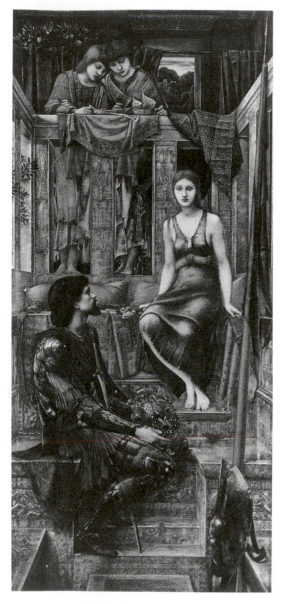

6-10 *King Cophetua and the Beggar Maid* (1884) by Edward Burne-Jones. (N01771, Tate Gallery, London)

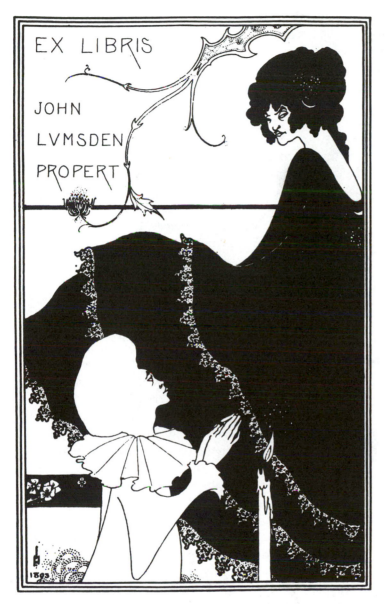

EX LIBRIS

JOHN
LVMSDEN
PROPERT

6-11 Bookplate of John Lumsden Propert. (E.293-1972 [neg. no. HD788], Victoria and Albert Museum, London)

ley's picture accentuates Pierrot's alienation. Not only is Pierrot made to look up from a lower level but "the real dialogue is taking place between the second figure and ourselves, the external onlookers" (Heyd 197). Here, as in most Beardsley drawings, the effectiveness of the picture depends on its allusiveness—the way in which Beardsley suggests an instantly recognizable form, then plunges the previously stable convention or traditional association into a shifting world of irony.

Beardsley undercut still further the Pre-Raphaelite feminine ideal—and the aura of high art—in *The Mysterious Rose Garden* (Figure 6–12), which conflates and refashions three famous Pre-Raphaelite paintings, Rossetti's *Ecce Ancilla Domini!* (1850), Burne-Jones's *Annunciation* (1879), and Holman Hunt's *Light of the World* (1854). The preliminary sketch for this picture as well as Beardsley's disingenuous defense of it—he said it was "the first of a series of Biblical illustrations, and represents nothing more or less than the Annunciation" (*Sketch*, 10 April 1895: 562)—indicate that its original inspiration was The Annunciation (Reade, *AB* n. 367). But Beardsley swerves strikingly from the "annunciations" of his canonical models. In Rossetti's famous *Ecce Ancilla Domini!* (Figure 6–13), Gabriel is suspended in rigid dignity, presenting a symbolic lily of purity to the Virgin, dressed in her bedclothes, who is depicted as solemn if naturally somewhat fearful and apprehensive. In Burne-Jones's *Annunciation* (Figure 6–14), too, the scene is one of high seriousness. The angel floats down from above, hands poised gently in a gesture of reassurance. The Virgin, who is fully dressed and (like Rossetti's Mary) drawing away slightly, putting her hand to her breast in modesty or apprehension, seems to convey a general feeling of calm and harmony. The archway in the background, which contains the traditional scene of the Expulsion from Eden, alludes iconographically to the Christian convention that Mary is the new Eve atoning for the original sin.

In rather scandalous fashion Beardsley's picture conflates the Annunciation with the Temptation of Eve (Heyd 118). He naturally appropriates the familiar allegorical Pre-Raphaelite garden, with its lattice, surfeit of vegetation (in this case, roses symbolic of love), and customary decayed flowers littering the ground. But here Rossetti's and Burne-Jones's modest Virgin becomes a naked (and slightly grotesque) Eve, not ministered to by a holy angel but importuned by a demonic seducer. Nor does Eve's expression suggest either the innocence or the apprehension of the earlier figures; rather, her look seems closer to worldly-wise rumination. Working from the Annunciation premise, Brian Reade has reasonably interpreted the winged messenger to be informing the young girl of her pregnancy and of the dubious prospects for an unwed mother in late Victorian England (*AB* n. 366). It may also be, however, that this nude girl—who in playing nervously with her hair makes frivolous the more modest gesture of Burne-Jones's figure—is not yet pregnant but is being tempted in that direction, being given what Arthur Symons identified as "tidings of more than 'pleasant sins'" ("AB" 101) by the stylish but sinister aesthete. This latter figure is, in fact, Beardsley's satanic inversion of Hunt's Christ, who (carrying the same lantern in *The Light of the World* [Figure 6–15]) sought to light the sinner's path to redemption, not the innocent's path to sin. This transformation of rescuing Christ into tempting Satan (or at least pagan seducer) seems reinforced by the fact that Beardsley gives the figure's robe what appears to be a fringe of fire, which may remind us not only of Rossetti's Gabriel in *Ecce Ancilla Domini!* but also of the flames of hell and the well-

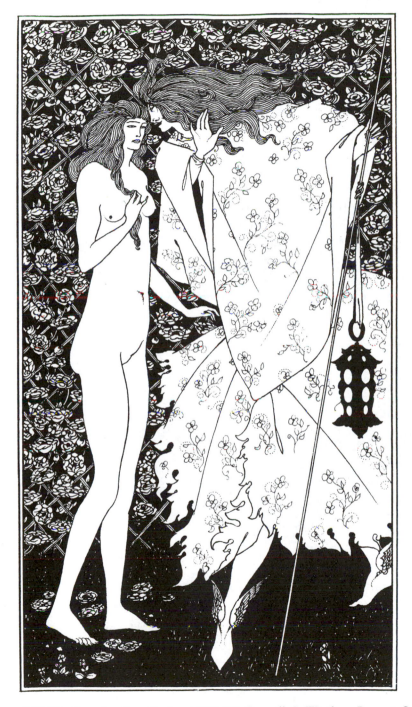

6-12 *The Mysterious Rose Garden*. (1943.633, Grenville L. Winthrop Bequest, Courtesy of The Fogg Art Museum, Harvard University Art Museums, Cambridge, Mass.)

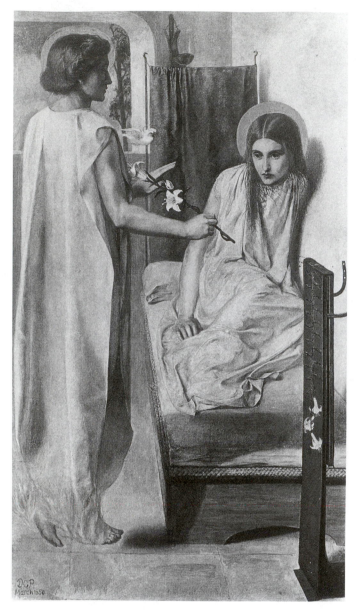

6-13 *Ecce Ancilla Domini!* (1850) by Dante Gabriel Rossetti. (N01210, Tate Gallery, London)

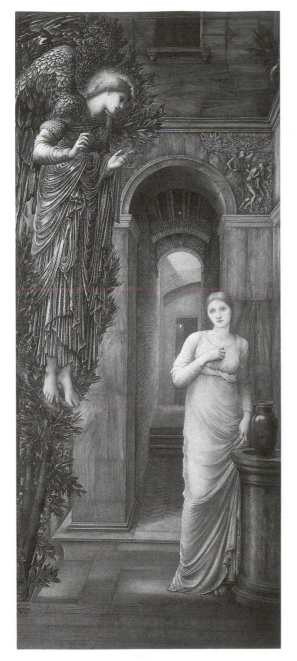

6-14 *The Annunciation* (1879) by Edward Burne-Jones. (Board of Trustees of National Museums and Galleries on Merseyside [Lady Lever Art Gallery, Port-Sunlight, Eng.]. Also preliminary drawings, no. 2023, 1-7 [K.26290-K.26296], Fitzwilliam Museum, Cambridge, Eng.)

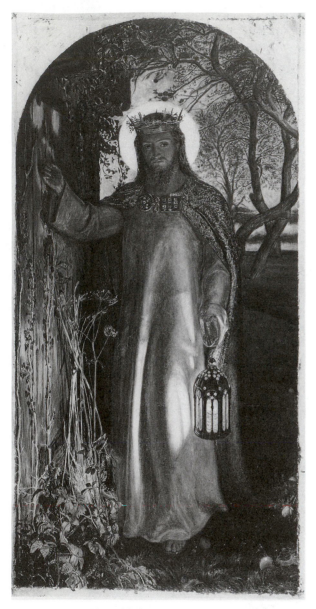

6-15 *The Light of the World* (1854) by William Holman Hunt. (1912.53, Manchester City Art Galleries. Also Keble College, Oxford; larger replica in St. Paul's Cathedral, London)

known Freudian association of fire with sexuality (Fletcher, *AB* 105). Beardsley also furnishes the stealthy figure with the winged sandals of Hermes, who was the cunning and deceitful messenger of the pagan gods and patron of liars—known (like Beardsley himself) for his sly eroticism and his strategic placement of prominent phallic herms—and who was charged by Zeus in Hesiod's *Works and Days* with placing into Pandora "a shameless mind" (7). Moreover, to reinforce visually the sense of metaphysical perversity and distortion, Beardsley skews the proportions of the tempter's body, mounting a tiny head, small hands, and arms of seemingly widely varying length onto a very elongated body. By no means incidentally, he supplies his corrupting seducer with the notorious moustache and head of hair of his rival and problematical father figure Whistler.

Victorian bourgeois culture had successfully "recuperated" the Pre-Raphaelite artistic revolution into an aura of sentimental nostalgia that only reaffirmed a hierarchical, timeless, logocentric world. But where the paintings of Rossetti, Morris, and Burne-Jones seek to mythify and freeze time, Beardsley's pictures convey a sense of nervous temporal instability, the mystery of "what will happen next?" in a semantically skewed world where meaning is in constant transformation. Paradoxically, such jarring disorientation is made all the more striking by Beardsley's use of sharp-edged lines and black-on-white contrasts instead of Pre-Raphaelite hazy outlines and lustrous colors. In contrast to a Burne-Jonesian, painterly emphasis on soft-focus boundaries and an almost incorporeal, spiritual aura, Beardsley's stark, almost dichotomizing lines often sharply demarcate figures that, even when they are made to float ungrounded, seem to be inextricably corporeal, though always at the brink of mental or emotional instability. For all its sharp demarcations, Beardsley's is not a style that affords stability. His restless line lends to his figures an element of asymmetrical unease—often bending to the grotesque—which defines form only in order to deform it. Presenting radical stylistic variations within a recognizable and conventional Pre-Raphaelite "narrative," Beardsley in effect explodes traditional, for the most part unquestioned Pre-Raphaelite (and middle-class Victorian) assumptions into metaphysical ambiguity.

The Natural Order and Decadent Parodies

The Victorian Decadence was in many respects a hothouse built on Pre-Raphaelite foundations, and Beardsley's perversions of Pre-Raphaelite ideals were no less dangerous when they were parodies twice over—that is, parodies of Decadent versions of Pre-Raphaelite paradigms, as we find in his illustrations for the English version of Wilde's *Salome*, which appeared in February 1894. Beardsley had always been fascinated with Salome. After all, he had, unsolicited, illustrated the climactic severed-head scene in his famous *Studio* drawing *J'ai Baisé Ta Bouche Iokanaan* (see Figure 2–8), and had offered to translate Wilde's play. Even after the Wilde debacle, and despite having otherwise sought to distance himself from his nemesis, Beardsley made sure to attend the February 1896 Lugné-Poë production of *Salomé* at the Théâtre de l'Oeuvre (Ellmann 496).

The *Salome* illustrations established that the iconoclastic Beardsley was willing to trans-

value anything. As Aymer Vallance exclaimed, "Who before him had ever used the book he was commissioned to illustrate as a vehicle for ridiculing its author?" (367). While Beardsley's illustrations preserve Wilde's attack on bourgeois sexuality and patriarchal society, they violate the logic of traditional Victorian descriptive representation, not least by creating negative-space backgrounds and by running background lines through images in the foreground (Reade, "AB" 6). Wilde had sought to utilize the rhythms of biblical verse and generally give his text an Eastern "Byzantine" ambience: "My Herod is like the Herod of Gustave Moreau, wrapped in his jewels and sorrows. My Salome is a mystic, the sister of Salammbô, a Sainte Thérèse who worships the moon" (Ricketts 51–52). But playing impishly on Wilde's oft-professed taste for the exotic and oriental, Beardsley proceeded to push the playwright's conception even farther east, into "Japanese grotesque."

Wilde, of all people, could appreciate the commercial value of controversy, as well as the imperative (as he claimed upon confessing to Will Rothenstein his own "theft" of *Salome* from Flaubert) "Dans la littérature il faut toujours tuer son père" [In literature it is always necessary to kill one's father] (W. Rothenstein, *Memories* 1: 184). But however wonderful Wilde may have publicly acclaimed Beardsley's illustrations to be (Ellmann 376), he was clearly not pleased that the popular press judged him to be, in Stanley Weintraub's words, "in the embarrassing position of illustrating Aubrey's illustrations" (AB 58–59). *The Saturday Review* (24 March 1894) called Beardsley a clever young man whose "new form of literary torture" obviously put the play's author "on the rack" (317). *The Studio* (15 February 1894), while finding that Beardsley's "irresponsible personality . . . dominat[ed] everything," thought his "audacious and extravagant" drawings made the published play "one of the most remarkable productions of the modern press," even if there were serious questions as to whether they illustrate Wilde's text (184). Holbrook Jackson concurred that Beardsley's "impertinent" designs "overpower the text" (103); and R. A. Walker concluded that "never had a book been so illustrated with such irrelevant and irreverent and irrational drawings" (*Best of Beardsley* 11). Ironically, what irritated these critics was exactly what Beardsley quite openly intended: to create pictures "simply beautiful and quite irrelevant" (*Letters* 58)—that is, to appropriate and transvalue received conventions through the force of his own unique artistic personality.

However much Beardsley's pictures were attempts at biogrammatic usurpation, they also intentionally played off in the process both Wildean and Pre-Raphaelite conventions to undercut bourgeois Victorian notions of "nature," and particularly, "natural" desire and gender identity. The almost universal confusion regarding the characters in the first illustration of the series, the frontispiece *The Woman in the Moon* for *Salome* (Figure 6–16), is an indication of just how successfully disorienting Beardsley's pictures were. The title derives from the artist's playful problematizing of the moon, turning the conventional "Man in the Moon" into a "Woman in the Moon" by making the moon a caricature of the male author Wilde, who, though married and the father of two sons, was well known (at least, among insiders) to be homosexual—that is, as Beardsley would have it, a "queen." Arthur Symons and numerous other early critics wrongly identified the human figures in the picture to be Narraboth, the Syrian captain, and Salome. While Beardsley hardly felt obliged to "illustrate" Wilde's play literally, his careful placement of the pictures within the produced text indicates a clear in-

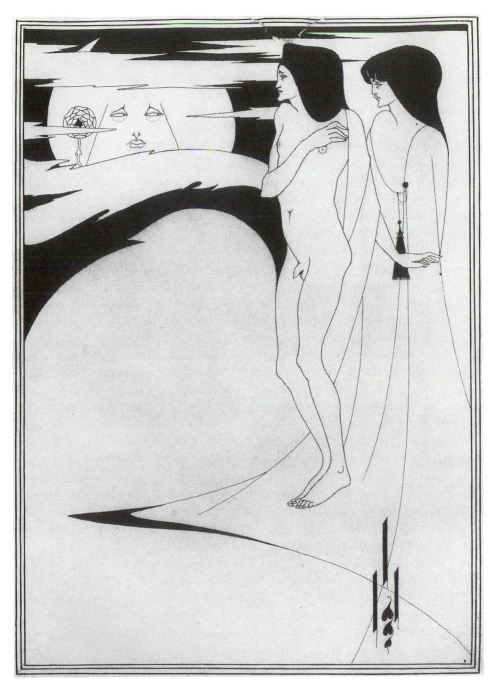

6-16 *The Woman in the Moon* (frontispiece for *Salome*). (1943.643, Grenville L. Winthrop Bequest, Courtesy of The Fogg Art Museum, Harvard University Art Museums, Cambridge, Mass.)

tention for the pictures to correspond in general subject matter and chronology to the events of the drama. Therefore, we can be fairly certain that on a literal level the frontispiece was intended to depict not, as Symons and others assumed, the infatuation of Narraboth with Salome (in fact, the subsequent *Peacock Skirt* does that) but the infatuation that predates it and, as is logical for a frontispiece, also predates the beginning of the play—that is, the homosexual relationship between the page of Herodias and Narraboth. Indeed, biographically, it is far more logical that the Wildean Moon should be gazing sideways—and apparently with longing sadness (reinforced by the emblematic rose next to the face)—at the male victim-to-be Narraboth, rather than at the female victimizer Salome. In fact, that irreverent, subtextual joke concerning Wilde's sexual preference is precisely the main thrust of Beardsley's feminizing caricature.

That this "Salome" is actually Narraboth seems evident not only from the logical order of the picture in the text but also from the fact that the figure's bared chest is portrayed without breasts, anatomical details Beardsley clearly did not neglect when he depicted Salome in his other illustrations. It is also logical that Beardsley would show the apprehensive page attempting to hold back and shield his lover Narraboth from the attractions of "the Moon" (ironically, for the purposes of Beardsley's joke, all the more appropriate if the Moon is a homosexual man). Moreover, it is narratively fitting, since in the play itself the page senses danger and learns (albeit too late) of the need to "hide him from the moon" (*Salome* 393–94, 397, 405). As Ian Fletcher has remarked, the effeminate nature of the page's hand and its provocative position, appearing to brush against Narraboth's "phallic tassel dangling parallel to the page's genitals," also hint at the intimate homosexual relationship between the two figures, as does the "enclosing sweep of Narraboth's robe" (AB77). It is an intimacy still further suggested by the androgynous nature of the hairstyles and the bodies of the figures (the page's distinct genitals notwithstanding). Yet Beardsley obviously goes out of his way to make Narraboth appear female—in effect, to confuse the viewer, blurring conventional gender and cultural distinctions well beyond the strict requirements of the joke, even cutting back and forth across its logic. As Elaine Showalter notes, the "triangular dark" tassel or "fan" hanging down from the right-hand figure "could be either masculine or feminine, phallic or pubic" (152). Beardsley seems to insist on forcing a multiplicity of self-contradictory readings and implying a world that is anything but univocal (or diametrical).

Thus, instead of giving us figures of clearly defined gender, in this frontpiece Beardsley presents us with figures whose gender identities oscillate as we try to decipher them. In accordance with conventional cultural codes, Beardsley ostensibly shows a male youth protecting his female lover. The page obviously has the genital equipment of a male and is protective in his gestures, whereas his companion is ostensibly female, with stylized feminine hair reinforced by a sensuous mouth, delicate features, round shoulders, skirtlike robe, and a posture suggesting that she stands passively behind her protector. Such a feminizing characterization of Narraboth, in addition to assisting the irony of Beardsley's joke on the homosexual Wilde, is in fact consistent with the play, in which the Syrian captain is given a flutelike voice and narcissistic preoccupations with his own reflection (*Salome* 406). The joke, however, is also on the bourgeois viewer and his/her absolutist perceptual categories. The customary and ideologically

serviceable distinctions between male and female identity erode once we are shocked into the recognition that this female companion is actually Narraboth, a male. Moreover, just as the female is also male, so the male page is shown to be also female by virtue of his androgynous physique, effeminate hands, stylized hair, delicate facial features, accented nipples and areolae, and the subtle slit under the navel.

Yet the irony is even more slippery, for Beardsley surely knew when he depicted Narraboth as feminine that the figure would be misinterpreted—as Symons and others have done—as not just any female but as Salome herself. In the play, after all, Salome is the only woman who interacts with all of the other characters, and the Moon is associated with Salome as both a projecting impetus for and reflecting emblem of her lust. Indeed, the attractiveness of the Salome-as-emasculating-woman myth would virtually guarantee an ideologically blinded misreading. The identification of Narraboth as Salome could even be joined to the Wilde caricature as a confirmation of the myth of sexual dichotomy, as it seemed only to reinforce the Wilde-Moon's obsession with perverse desire. But the joke becomes uncomfortable once Salome actually turns out to be Narraboth (and "Narraboth" turns out to be the page). Now the safe mythic dichotomy—between male and female as well as between heterosexual and homosexual—collapses. Suddenly there may be little to choose, not only between male-female and male-male desire but also between the normal and the perverse. What was previously "normal" (heterosexual) desire (if perverse in its attachment to Salome) is now shown to be not even normal: the lovers are of the same gender. And the distinctions between normal and perverse turn out to be just as meaningless as the loaded distinctions between male and female. After all, the perversion of the status quo that the picture specifically presages is in fact, ironically, the destruction of Narraboth's homosexual relationship with the page by his new heterosexual desire for Salome. For that matter, as the picture implies through its Moon/Wilde, Salome/Narraboth, and Narraboth/page conflations, all ostensibly heterosexual desire may be "essentially" homosexual—whether the lover be Wilde or Salome—if desire itself proves to be mostly the narcissistic projection/reflection of the observer's own needs. Even more devastating perhaps, Beardsley's picture is no longer a world where physical facts or personal identities are ultimately reliable at all. Narratively the figures in the picture are the Wilde-Moon, the page of Herodias, and Narraboth. But it matters not. Although Salome is physically absent from the scene, her desire and the desire for her have made her present everywhere. Her absent "presence" takes over the identity of each figure: Narraboth mirrors her appearance, the page is likewise made womanish in his fear of "her Moon," and Wilde is transformed into the "Woman in the Moon." The end result is a relentlessly equivocal world, whose highly stylized tension constantly shifts among varying conclusions, final judgment being always deferred.

The Wildean Moon serves, in fact, as an emblem for this basic interpretive irresolvability. We can read its expression as one of scrutinizing desire, which would apply equally if its object were Salome or Narraboth—although presumably the desire would be for public erotic "contamination" by an agent, in the first place, and for private enjoyment with a lover, in the second. Or the expression may connote ominous warning, reinforced by the jagged borders of the clouds and the hornlike protrusion rising at the upper left—a view, again, applicable to

either Salome or Narraboth (both of whom die from their desire), although again for different reasons. Or the expression may be read as one of sadness, or lament, for the fatal destiny awaiting both Salome or Narraboth. Or the Wildean Moon's sadness may be more personal. If its object is Salome, it could be regret that Salome's death will mean the loss of a valuable vehicle for domination. If the object is Narraboth, it could be self-pity that the captain's suicide will deny the lover-Wilde consummation of his own lust. Or we may apply still other permutations. In the end, however, while we may shift from one interpretation to another, even perhaps trying to synthesize their contradictions, no interpretation can finally rise to dominance or ultimately vitiate the other; we are forced to entertain all of them, in all their paradoxes, as defining the picture's meaning.

Indeed, we see that Beardsley's picture undercuts not only gender distinctions but almost any definitive hermeneutic categorization. After all, the female companion of the protective naked youth in the scene at first appears to wait impassively behind him. When we identify the female as Salome, her impassivity seems equally interpretable as controlled malignity, merciless in its stony-faced hardness. However, when we see the figure as Narraboth, the bedazzled victim, our interpretation of the figure's countenance can only oscillate again, to be read now as perhaps a condition of dazed paralysis. Even at the level of physical facts, the picture gives us little stability. Stylized elegance reverts to indecipherable nonsense when we, for instance, try to trace the lines of the robe. The garment that forms a self-generating carpet for the figures is indeed a shifting ground. If we follow the robe's border up the body of Salome/Narraboth, we discover that it becomes not her/his robe at all but the youth's cloak, which is draped over his left shoulder. That is, garments, like identities and allegiances, oscillate from one owner to another, a part of both but ultimately belonging to neither. Even the picture's stylistic composition pulls us indeterminately between inconsistent alternatives, in this case the circular and the linear—the moon, rose, swirling sea-clouds, and curved hemline, on the one hand, and the horizontal upper clouds, the vertical human figures and signature, and the perpendicular frame, on the other—paralleling the way we are pulled equally without resolution between sinister elements of the sea, moon, and human expressions, on the one hand, and the general aura of frozen calm, on the other (see Fletcher, AB 77).

Beardsley undermines conventional Victorian conceptions of gender identity in an even more humorous fashion in A Platonic Lament for Salome (Figure 6–17). Here he vitiates Pre-Raphaelite nostalgia not only by turning its conventionally clogged, hypernaturalistic landscape into empty, white "negative space" and near-abstract forms but also by slyly giving the Pre-Raphaelite woman's languorous look of longing to Herodias's androgynous male page, who here laments over the corpse of his friend Narraboth, the young Syrian captain. The page's desire, while it may be consonant with Pre-Raphaelite sensuality, is apparently not consonant with either Pre-Raphaelite spirituality or its predominant heterosexuality. Notwithstanding the movement's notorious sexual ambiguity and ambivalence (most notably, perhaps, in the work of Simeon Solomon), the Pre-Raphaelite penchant for androgyny and spiritualized sensuality was generally in the service of heterosexual love, more Neo-Platonic than Platonic, at least as interpreted by the middle class. Here, however, in the face, hair, and body of the page and in the face and gown of Narraboth, Beardsley indulges in Pre-Raphaelite androgyny while

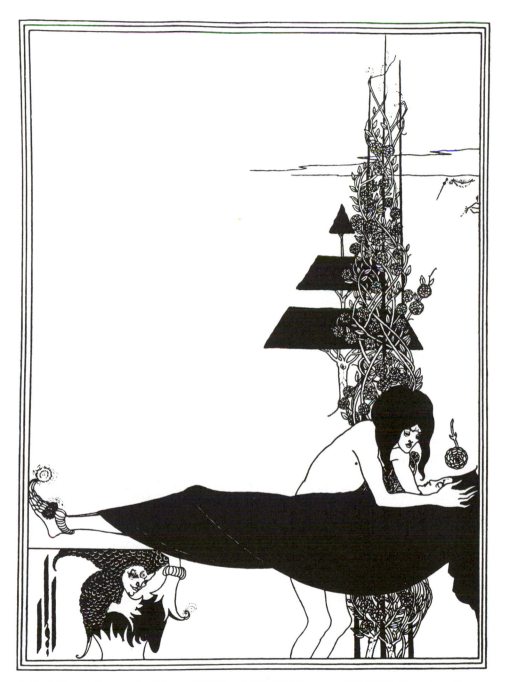

6-17 A *Platonic Lament* for *Salome*. (E.430 and 431-1899 [neg. no. GG.1542], Victoria and Albert Museum, London)

mockingly inverting its customary sexual direction. It is perhaps an indication of bourgeois Victorian fears of gender confusion, and bourgeois homophobia, that here again most contem-. porary viewers (including Arthur Symons) insisted on interpreting this picture as depicting Salome and Jokanaan, despite the fact that Beardsley placed the picture early in the text (long before Jokanaan's death) and immediately *preceding* the illustration *John and Salome* (Reade 290), which shows both protagonists very much alive. Even more tellingly, in *The Platonic Lament* the grieving "Salome" figure is without the Beardsleyan Salome's accentuated breasts and the executed "Jokanaan" figure, illogically, still has his head.

In the picture the page's expression and demonstrably affectionate embrace strongly in-dicate that his friendship with the captain is based on the page's homosexual desire, giving several ironic twists to the characterization "A Platonic Lament." After all, the page's "lament" or grief stems from the fact that the bedazzled Narraboth has killed himself upon discovering Salome's passion for Jokanaan; that is, the page laments that the captain's love was un-Pla-tonic, at least in its gender choice. Nor, for that matter, is the page's love Platonically pure, carrying as it does at least some measure of not-so-idealized lust, a suggestion reinforced by the impassive and ingeniously equivocal moon, which is identified with Salome herself and is in this case once again a caricature of the homosexual Wilde. The caricature of Wilde actually extends Beardsley's blurring of hermeneutic categories in even more subtle ways. Although Wilde claimed to advocate Uranian Love—the term *Urning* having been coined in the fin de siècle by Karl Heinrich Ulrichs to differentiate the idealized homosexual passion of the Ur-anian Venus from the common sensual passion of the more familiar heterosexual Venus—insiders knew that Wilde's own practice of homosexual love was often touched by a rather undistinguished lust. In these various ways Beardsley compounds the extended irony of (and pun on) "A Platonic Lament"; that is, we are led to understand that the page's desire (or poet-lover's "lament") is one that, while it may be Platonic in its homosexual preference, is not Platonically spiritual—any more, Beardsley insinuates, than is the pretentious Oscar Wilde's.[13]

Beardsley's de-centering irony extends to his parodies of the Pre-Raphaelite vined lattice, here severely elongated into an espalier, and the conventional detached flower, here an in-verted rose-gem about to thump the dead Romantic's head. As if to reinforce the disordering themes of his earlier picture, Beardsley has the flower that seems to fall in a direct line from the Wilde-in-the-moon exactly duplicate the one associated with the Wildean Moon in *The Woman in the Moon* (see Figure 6–16). That is, not only does Beardsley waggishly conflate the rose of traditional passion with the "inverted" rose (or possibly the famous green carnation) of the play's dubiously sexed author, but, furthermore, the rose that the Salomean Moon aims "at her victim's head in a travesty of tribute" oscillates within the picture to become the tribute of "one gay to another" (Fletcher, *AB* 82–83).[14] Finally, Beardsley underscores his satire of Pre-Raphaelite (and Decadent) longing by placing on the Syrian captain's foot a jester's slipper and by positioning under the base of the bier an irreverent peacock-plumed dwarf who mimics the page's gaze but appears to stare only into the void of his own incongruous and ultimately indecipherable form.

Beardsley's equivocal images and playful juxtapositions never fully annul more conven-tional readings, but they do incessantly displace and replace them. Homosexuals have often

promoted a camp aesthetic sensibility as a way of deflecting and neutralizing the moral indig-
nation society directs at behavioristic heterogeneity (Sontag, "Camp" 291–92). Beardsley's
camp stylizations of Pre-Raphaelite (and Decadent) conventions similarly signal a fundamental
erosion of traditional values and yet also minimize and deflect our attention from the serious-
ness of the crisis. His designs often construct a sense of aesthetic homogeneity so powerful
that we are seduced into overlooking or "sanitizing" their disturbing elements, even to the
point of misidentifying the subjects of the pictures themselves. Beardsley thus fashions a design
that ruptures traditional forms while bandaging the metaphysical wound, which paradoxically
evokes Pre-Raphaelite nostalgia or Decadent aestheticism (and so posits identifiable readings)
but in a manner that also calls into question the truth of any such univocal reading.

Whether the ostensible subject is a written text, the text's author, or "nature" itself,
Beardsley's highly ornamental, relentlessly parodic art is essentially fetishistic. Often dealing
only marginally with what they are about, his pictures resist the viewer's predisposition to
integrate all elements into one whole, highlighting instead the literal image, the gesture itself.
As in Decadent style generally, the reference "seems to be not to a world of nature but always
to a world already made into artifice" (Spivak 229). It is a style that, "undermining the
comfortable faith in words' reference to things, takes its place within the becoming-self-con-
scious of the ruptures and discontinuities of literary language" (233). The case is perhaps even
more obvious in Beardsley's novella *Under the Hill*. As he conveyed visually in his "irrelevant"
Toilet of Salome (second version), so verbally in *Under the Hill* (or *The Story of Venus and
Tannhäuser*) Beardsley constructs a "wholly artificial world—where masks imitate *powdered*
faces, and false moustaches are dyed bright *green*," a wholly "linguistic" world "entirely fash-
ioned out of archaisms and argot" (Dowling, *Language* 148, 146). It is a world that "reduces,
first of all, the high-art theme ennobled in Wagner's opera and Swinburne's 'Laus Veneris' to
an occasion for pornographic variations, and then turns around to deflate the tumescent pre-
tensions of pornography as well . . . revealing all behavior, including sex, as play" (144–45).
In his novella Beardsley even invents a fictitious foundation of learning—"validating" foot-
notes often more outrageous than the text itself—to authenticate the details portrayed, un-
derscoring not only the self-reflexive artificiality of his world but also the extent to which its
existence depends on prior cultural models. That is, the "modern" world becomes necessarily
a world of parody—indeed, fetishistic parody.

Re-signing the Salon

Most critics agree that Beardsley's favorite age was the eighteenth century. Osbert Burdett said
that the authority-craving Beardsley turned to the eighteenth century because that society was
"the most recent memory we have of a national life in which the ideal and the real, the
profession and the practice, the faith and the result, did not to any undue extent contradict
each other" (124). But the eighteenth century was also the paramount age of satire, the age
that had made parody (and particularly caricature) a vehicle for high art. Certainly Beardsley
appropriated the eighteenth century as an emblem of nostalgic urbanity, Neoclassical decorum,

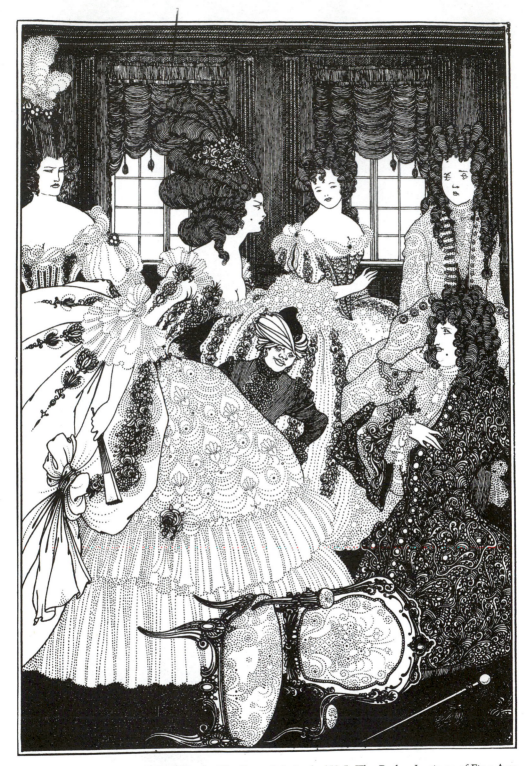

6-18 *Battle of the Beaux and the Belles* for *The Rape of the Lock*. (52.5, The Barber Institute of Fine Arts, The University of Birmingham, Birmingham, Eng.)

licentious exuberance, witty dandyism, and slippery satire—all of which, characteristically, he could playfully both affirm and deconstruct, invoking canonical models and yet biogrammatically deforming them. Turning his pictures into the stylistic equivalent of social gossip, unleashing vague aggression yet sanitizing it by ritualistic conventionality (see Spacks 55–60), Beardsley's parodies defamiliarize canonical conventions only to recuperate them on another level. They introduce shocking content, then mitigate it by means of a reassuring recognition of formal canonical patterns.

A particularly intriguing variation of this double-edged discourse appears in Beardsley's illustrations to Pope's *Rape of the Lock*, written in 1712 following an actual incident in which Lord Petre precipitated a bitter family feud by cutting off a lock of Mrs. Arabella Fermor's hair. Interestingly, these illustrations have been variously described by prominent critics as either Beardsley's finest work (MacFall, *AB* 84–85) or slavish imitations that are "ornate and flaccid," "anxiously segmental," and "tedious" (Fletcher, *AB* [ii], 166). However the quality of Beardsley's pictures is assessed, Pope's poem was perfect parodic raw material for Beardsley— an elaborate satirical fantasy on an erotic theme, written in the severely classical style of heroic couplets. As Gosse remarked, in thanking Beardsley for sending (and having dedicated to him) the deluxe edition of *The Rape of the Lock*, "I do not think you have ever had a subject which better suited your genius, or one in the 'embroidery' of which you expended more fanciful beauty" (ALS to Beardsley, 16 May 1896: 1–2).

We see a good example of Beardsley's biogrammatic revisionism in *The Battle of the Beaux and the Belles* for *The Rape of the Lock* (Figure 6–18), which celebrates the dandified urbanity and precious elegance of the eighteenth-century salon while realigning such conventionality to reflect the artist's own peculiar version of ambivalent Decadent equipoise. The picture is a parody of Louis du Guernier's design for the 1714 edition, which had the same motif of a chair on its side to indicate the battle's violence (Halsband 106). But where du Guernier showed a fierce Belinda with her bared bodkin, threatening to stab the baron, who has fallen to the floor, Beardsley shows her (in the fashion of Charles Alfred Stothard's 1798 illustration) armed only with a folded fan, and glaring angrily at the Baron, who kneels contritely before her. While thus diminishing Belinda's reaction to the baron's "sexual violation," Beardsley nonetheless embellishes Belinda's potent sexuality by having her cleavage (larger than the other maids') and low-cut gown tipped forward, a kinetic thrust reinforced by the posterior darts of her gown, and by having a phallic lock of hair dangle toward her semibare breasts. As the counterpoint to Belinda's sexual potency, the submissive and chastened baron is on his knees, having dropped his phallic cane (and tassel); and his hand, although forming Beardsley's familiar tripartite sexual gesture, is not extended toward Belinda but turned effetely and plaintively back on his own breast. Indeed, physically, the leaning Belinda seems to have swelled in her dominance, and the baron seems almost to have shrunk proportionately, giving us a rather blatant variant of what Heyd calls "a basic motif in Beardsley's world—the little man's fear of the large woman" (81).[15]

Contemporaries said of the faces in Beardsley's *Rape* drawings that "beneath all their elegance and refinement" is "that same expression of vice . . . from which Beardsley so seldom succeeded in escaping" (Strong 92). But, in fact, after introducing potential emotional violence, Beardsley here recuperates it by embedding it in a composition that turns such violence

into merely the subject of another elegant tableau, and another authentication of the canon. The trespassing of personal boundaries, having been exaggerated as rape, is now trivialized as merely an elegant temper tantrum. For that matter, the tantrum itself is "civilized." Belinda's fan, which replaces the potentially deadly bodkin, is not made a weapon; and the expressions on the doll-like faces of the attending belles and beaux betray only comically faint emotion. Beardsley mutes (and mocks) the violence particularly through his absolutely balanced, classical composition. The fallen Rococo chair, completely natural in the circumstances, becomes a brilliant device to connote disorder while blocking off and freezing the action: "The whole scene, instead of rocking with violence, is static, fixed as though in a snapshot—or an embroidery frame" (Halsband 106). Like words and phrases whose connotations have come to mean the opposite of their denotations (e.g., "I could care less"), the semiotically "loaded" accoutrements in Beardsley's drawings come to accrue connotations that run counter to their often sentimental, conventional meanings.

The title picture, *The Rape of the Lock* (Figure 6–19), which Beardsley proudly cited as one of the very best of his *Rape* drawings (*Letters* 115), is perhaps his most devastating Janus-faced parody. The drawing has dense stippling and other elaborate ornamentation to signal refinement, creating a rich, if restrained, sense of space and plenitude consistent with Pope's urbane world. Yet here as elsewhere, Beardsley's distinctive stylizations—including subtly decorative grotesques and calculatedly skewed symmetry—easily wrest the focus from Pope's poem and make the drawing far less an illustration than a misdirecting appropriation. First, while the scene presumably comprises a Neoclassical world of harmonious and decorous types, the accoutrements are not technically fitting. Belinda sits not on a piece of eighteenth-century furniture but on "a Thonet chair with unlikely carvings" (Reade, AB n. 353). The costumes of Beardsley's characters are also inappropriately eclectic, "mainly eighteenth-century French rococo spiced with bits of symbolist decoration and art nouveau" (Halsband 96). The men's clothes, while dating from the first half of the eighteenth century, are "modeled on ballet dancers' costumes . . . the skirts enriched with garlands of roses popular in French court dress of the 1770s"; and the women's clothes postdate the fashions of Pope's poem by at least seventy years (96). Second, Beardsley once again encodes into the drawing his customary ambiguously salacious shapes, as in Belinda's gown, which Robert Halsband describes as resembling "a gigantic *derrière*" (103), and in the suggestively shaped ornaments in her hair, which the Baron seems about to neuter with his scissors.

But there is another, even more striking deforming element in Beardsley's design: he makes the ostensible subject of the illustration itself—the cutting of a lock from Belinda's hair—seem almost incidental, virtually pushing it off the page to the far left-hand margin, even truncating Belinda in the process. More incongruously still, he places at center stage a dwarf who does not even exist in Pope's poem and who with his knowing wink redirects the viewer's attention away from other, presumably more primary incidents in the drawing. In these last two misdirecting elements Beardsley is parodying famous motifs from at least two other artists—and once again his differing use of those motifs is telling.

With respect to the truncation of the drawing's ostensible focus, Beardsley would have been aware of the "cutoff" technique in late-nineteenth-century French art (derived from

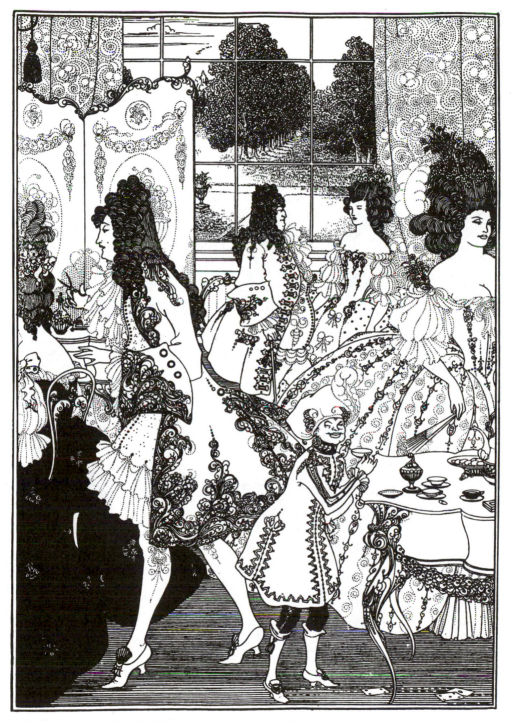

6-19 *The Rape of the Lock* for *The Rape of the Lock*. (Published by Leonard Smithers, London, May 1896)

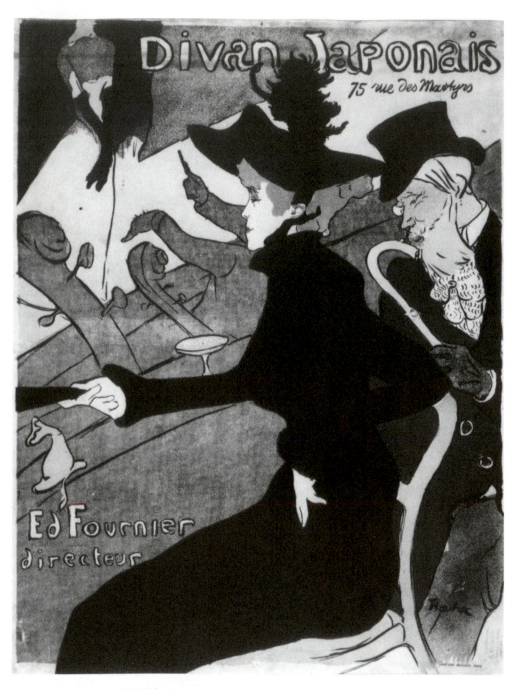

6-20 *Divan Japonais* (1892) by Henri de Toulouse-Lautrec. (1929-6-11-71 [neg. no. PS233263], Copyright British Museum, London)

much earlier Japanese prints)—slicing off part of the image (as in a photographic action snapshot) to intensify an effect, most notably demonstrated in the works of Edgar Degas and Henri de Toulouse-Lautrec.[16] Beardsley was attracted not only to Lautrec's sharp, sophisticated, and stylized art, which gave particular importance to line and arabesque, but naturally also to his meteoric rise to fame and success as an avant-garde artist, despite obvious physical limitations. As it happened, the two artists had much more in common. As schoolboys both filled the margins of textbooks with caricatures of their schoolmasters and fellow pupils; both were devotees of the other's native country, Lautrec an anglophile and Beardsley a francophile; both were doomed by poor health to journey from spa to spa in search of relief; both had a fondness for exciting cabarets and fashionable restaurants like the Café Royal (where Lautrec would write recipes for any new mixed drinks on the backs of envelopes) (Deghy and Waterhouse 16); and both preferred the ironic, detached perspective of "art for the street." Lautrec's caricatured figures seem generally more rooted in concrete reality than do Beardsley's erotic sensual, almost other-worldly grotesques; however, both artists favored compositional designs that drew on Japanese prints, which were characterized by an exceptionally bold linear style and large areas of bright, flat (that is, unbroken and unshaded) color.[17]

In *Divan Japonais* (Figure 6–20), dated 1892, Lautrec blended avant-garde design and theme in precisely the kind of deceptively subtle, if caustic, fashion Beardsley was obviously eager to adopt. The poster depicts the Café du Divan Japonais at 75 rue des Martyrs, one of the French artist's favorite Montmartre *cabarets artistiques* during this period and one that was transformed in 1893 into a *café-concert* with Japanese-style decor by Edouard Fournier. Lautrec, who was asked to design a poster for the opening, decided to employ audacious Japanese principles of composition and cropping. Cunningly, he makes the central focus of the poster not the singer Yvette Guilbert, the cabaret's chief attraction, but a competing celebrity, the dancer Jane Avril, the star soloist of the rival Jardin de Paris and Lautrec's close friend and occasional lover (see Dortu 2: 4).

Yvette Guilbert, known as "La Diseuse Fin de Siècle" [The Reciter of the End of the Century] became one of the most adored entertainers in Paris by developing a distinguishing personal style that emphasized her distinctive physique—small face, round eyes, long nose, wide mouth, long neck, and long thin arms, to which she drew attention by wearing long black gloves when every other woman wore white ones. Moreover, she performed with "a wealth of double meaning" risqué songs by such quality *chansonniers* as Jean Lorrain, Jean Richepin, Jules Jouy, Aristide Bruant, and Xanrof (Léon Fourneau) in a fashion as distinctive as her appearance—half speaking and half singing them in an unusually thin voice while remaining virtually immobile (Fermigier 130). Her natural pallor, which she accentuated with a masklike rice powder and garish red lipstick, and her distinctive mannerisms "lui avaient permis de se transfigurer en caricature, en 'affiche vivante et macabre'" [enabled her to transform herself into caricature, into a "living and macabre poster"] (Roger-Marx [ii]).[18]

Lautrec was much struck by Guilbert when he first saw her at the Divan Japonais (then managed by Jehan Sarrazin) in 1890, and eventually made countless sketches of her, mostly as "stiff and bony, her features twisted like those of a hideous bird" (Visani 20). But during 1892–93, however much Lautrec was intrigued by Guilbert, he was obsessed with Jane Avril

(Jeanne Duval), celebrated as *"La Mélinite"* [dynamite].[19] Avril, who acknowledged that it was Lautrec who made her a star (N. Harris 50), enchanted the artist with her bizarre beauty, her eccentric dancing style (of sideways movements and jerky kicks), which evinced more nervous energy than animal vigor, and her "Englishness"—not only her professional name but her anglophile costumes and "British" reserve. She became, in effect, Lautrec's Salome, exhibiting a type of perversity less directly sensual than that of La Goulue (Louise Weber) but more down-to-earth than Beardsley's heroines (Fermigier 122).

As in Beardsley's treatment of Belinda's "rape," Lautrec showcases in his poster what should logically be a secondary figure, highlighting Avril's sophisticated allure. He silhouettes the elegant dancer against an orchestra pit from which the necks of double basses emerge to sway like two charmed snakes, and has the attention of the music critic and noted Wagnerian Edouard Dujardin—as Beardsley well knew, the founder and coeditor (with Théodor de Wyzéwa) of *La Revue Wagnérienne*[20]—riveted on Avril rather than on the star singer Guilbert. Lautrec also accentuates his marginalization of the logically primary figure by shoving the notoriously tall and immobile Guilbert almost out of the picture at the upper left (she is presumably even half concealed by the stage curtain), cutting off her head and, metonymically, her notoriously distinctive singing voice.[21]

While Beardsley parodied the French genius's playful technique, the effect was in one respect quite different. However ironic it may be, Lautrec's amusing displacement of the properly central figure still works to affirm the authority of traditional metaphysical dialectics. One alluring and entertaining woman is made to replace the seemingly more logical one, but there remains the implicit faith in dualistic polarity, superior versus inferior, primary versus secondary. On the other hand, Beardsley's displacement of the "rape" in his illustration and his introduction of a tangential—indeed, textually nonexistent—figure as a key focus of it not only vitiates the idea of his picture as "illustration" but also throws into question the traditional polar structure of satiric signification itself.

While there is no sarcastic Puck in Pope's poem, Beardsley knew that such a figure did appear in a parallel *Toilette Scene*, plate 4 of *Marriage à la Mode* (1743–45) by William Hogarth (engraved by S. Ravenet, after Hogarth) (Figure 6–21), which portrays the degeneration of two families of different classes perversely joined through their own passions and dissipations. In fact, besides Puck and the similarity in the general conception of the scenes, Hogarth's series (c. 1742–43) provided Beardsley with a number of details for his *Rape of the Lock* illustrations—a group toilette, a screen, cards on the floor, people drinking tea, and, perhaps most obviously, the chair thrown to the floor.[22] It is not impossible that Beardsley's attraction to Hogarth was originally filtered through the Pre-Raphaelites, who also admired him (Adams 28); but there were several other reasons why Beardsley might find a strong kinship with Hogarth. Both artists were satirists, designed work for mass reproduction, and flouted academic convention. Both were fond of Pope—indeed, Hogarth began his artistic career at age twenty with an engraving from Pope's *Rape of the Lock* (Meier-Graefe 1: 56–57). Both relied on caricature and the caricaturist's technique of irrational juxtaposition, replacing a logical, representational unity of action with a purely symbolic one (Lucie-Smith, *Caricature* 57). Both artists had intensely erotic imaginations and liked to focus on vice and its punishments; Ho-

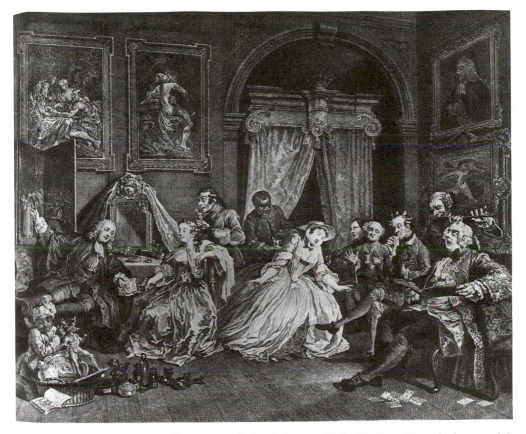

6-21 *Toilette Scene*, plate 4 of *Marriage à la Mode* (1743–45) by William Hogarth (engraved by S. Ravenet, after Hogarth). (The Whitworth Art Gallery, University of Manchester, Manchester, Eng.)

garth called his engravings "modern moral subjects" (Gowing 28; Webb 145). And both were particularly literary artists, thinking of themselves as authors and conceiving their pictures "as writers do" (Hogarth 216, 209, 229), as texts "to be read, detail by detail" (Lucie-Smith, *Caricature* 58).

Following common practice in eighteenth-century art, Hogarth often used black servants as icons of deviant sexuality, signifying the perversities of prurient activity in a corrupt society (Gilman, "Hottentot" 79, 81, 92).[23] In this Hogarth engraving a clever black servant boy— socially marginal and likewise set off marginally at the lower left in the picture[24]—satirizes the atavistic lubricity and self-deluding hypocrisy of his "betters." Signaling the viewer directly, the servant boy holds up and points to a lewd figurine of Actaeon, whose fate was sealed by libidinous presumption. The figurine's horns signal that the count will soon become a cuckold, and its broken-off weapon hand symbolizes the count's impotence and foretells that, like Actaeon, he will soon die as a consequence of his own surreptitious actions. The coarse sensuality and tasteless depravity of the company is generally reinforced by such figurative

details as the newly acquired pretentious kitsch arrayed beside the servant boy, scattered cards, supercilious foreign artists (such as the *castrato* singer—probably a conflation of famous performers like Farinelli (Carlo Broschi), Francesco Senesino (Bernardi), and Giovanni Carestini—who wears in his cravat the same diamond cross as Pope gave to Belinda's necklace), an effeminate dandy in curl papers, a racy French parody of *Tales of the Thousand and One Nights*, an impending masquerade-cum-tryst depicted on the screen, and amusingly appropriate erotic paintings on Lady Squander(field)'s boudoir walls (that is, *Ganymede and the [castrating] Eagle* [after a sketch by Michelangelo] above the *castrato* singer, *Jupiter and Io* [after Antonio Allegri Correggio] above the wanton countess, and Bernardo Cavallino's *Lot and His Daughters* above the seducing lawyer Silvertongue) (see Cowley 100–121).

In both Hogarth's and Beardsley's drawings a runty subordinate pokes fun at the situation, and both contain the same symbols of concealment, romance, and decadent diversion—in particular, littered playing cards, an ornate dressing screen, and other trappings of ostentatious fashion. Indeed, Beardsley positions his dwarf servant's fingers to make "the sign for cuckold" (Zatlin, *AB* 189). The figure of a dwarf page boy was clearly a key figure for Beardsley in the *Rape of the Lock* illustrations, since he uses it in five of the seven full-page drawings. In part, it functions as Beardsley's affectionate caricature of Pope himself, "who was only four and a half feet tall, [and] sometimes referred to himself as a dwarf" (Halsband 109). Certainly, as if a stand-in for both Pope and Beardsley, the provocateur dwarf delivers much of the drawings' ironic thrust, taking over the traditional function of the court spy or "clever fool" and undercutting the oversentimentalization of most of the other characters with his own derisive poses and sardonic smiles (Heyd 80, 81, 87).

But once again, Beardsley commandeers a familiar canonical convention in a fashion that produces a much different, generally more equivocal, effect. Whereas Hogarth's imp is clearly a tangential figure, satirizing folly but obviously subordinate to the folly he mocks, Beardsley's servant is assigned a central position, taking his tea as another exotically dressed member of the party. He appropriates our attention, looking directly at the reader, and not to direct our vision to Belinda or some other clear focus but only to fix it on himself, giving a knowing, if highly ambiguous, wink (or smirk?) that complicates more than clarifies the meaning of the picture. Is he signaling foreknowledge of (or amusement at) what the baron is about to do? Is his foreknowledge (or amusement) focused on the baron's action, or Belinda's response? Or both? Or neither? Or is it that he just *thinks* he knows (whatever the subject) and is actually implicated in the delusion? Or is it that the "joke" is really on us, the readers, who think we get the point, when in fact the picture has suspended signification among undecidable alternatives? Indeed, by making a marginal character the ostensible deciphering commentator of the scene, turning the ancillary into the decoding key (but one that mystifies itself in the process), Beardsley makes irony itself the endless subject of the picture, impugning the very authority of such morally laden distinctions as primary and secondary, sense and nonsense.

For that matter, the overall design of Beardsley's drawing ironically impugns the very premise of social discord that is presumably the drawing's central theme. While subtle details like the screen, scissors, or littered cards might intimate some clandestine violation of social equipoise, equally subtle details of symmetry and balanced design (culminating, perhaps, in

the highly formalized *allée* of trees seen through the central window) misdirect and realign the reader's line of vision, pulling our attention in three or four separate directions, causing us to lose sight of the supposed subject. We are unable to stabilize a clear signifying focus, paralleling in a sense the positions of the beaux and belles themselves, who face at divergent angles, stiffly and impassively unaware of or unconcerned with the significance of what is happening. The end result is not so much sharpened irony as a satiric point subsumed in a plethora of stylistic flourishes, so that the only clarity that remains is the aesthetic elegance itself.

But this last irony is perhaps the most persistently ideological one in Beardsley's work. Paradoxically, the unhinging of hermeneutic certainty serves to slip metaphysical authority in through the back door. Beardsley's parodic styles work to interrupt the "normalization" of the canon, yet in the process they also pose an alternative coherence and "redemptive" order. While many of the individual objects and figures in his drawings may be grotesque and jarring by classical standards, their impact is strangely mitigated by the forcefully centralizing harmony and beauty of his countervailing design (Yuan-ning 455). Indeed, the viewer's inability to pin down precisely the ambiguous content of the picture establishes the preeminence of style, suggesting, in effect, that style, and perhaps style alone, can transcend obviously "ugly" scenes (or elements) and recuperate, at least partially, the disorienting effects of Beardsleyan grotesques. Needless to say, such stylistic suturing exemplifies and validates the redemptive nature of the Decadent Religion of Art. Beardsley willfully dominates—and disorients—the viewer's attention, wringing it from the text he is ostensibly illustrating and even from the artistic conventions to which he is indebted, in order both to undercut the traditional significance of those conventions and to affirm, ironically, that the only significance there is lies in convention, style, art.

The Rhetoric of the Grotesque

While elegance of style may, to a degree, transform discord into harmony, if it is highly self-conscious, as in Beardsley's parodic art, it also reveals the contingent, context-dependent nature of what we thought were immutable ontological categories such as "nature" and "evil." After all, the clever manipulation of avant-garde style—of what is in fashion—is itself, like androgyny, a game of paradox mastery, a means of having it both ways. The true meaning of the fashion can be whatever the ruling class interprets it to be, or the obverse of it, or both—what is gauche becomes stylish (precisely because it is gauche). The result is that the dialogical discourse of recuperative and deconstructive elements continues to clash paradoxically, each parodically highlighting the existence and operation of the other, but neither ultimately able to supplant the other entirely.

Classical (and Neoclassical) art sought to achieve the image of perfect proportion and equipoise. But while Beardsley utilizes this same system of classical forms, within those classical parameters he gives us not the perfect, the complete, but the misaligned, or even the grotesque, a sense of the restless, the unsettled, the problematical. Even as he seeks to demonstrate the hegemony of style, his carefully situated grotesque images critique the very recuperation his

stylization implicitly achieves. As Reade remarks, for all the stylistic elegance of Beardsley's art, "we are left at the mercy of all kinds of suggestions, . . . a curiosity which obliges us to wait and to watch, as though someone were climbing a precipice and might fall" ("AB" 13). The irony of Beardsley's work is less an irony that exposes error than an irony that suggests unrelenting paradox, an inherently disconnected or fragmented relationship embedded in the elements of life itself, or at least our apprehension of life. Similarly, his stylizations seem less concerned with resolving oppositions than with momentarily controlling the irresolvable paradoxes he reveals.

On one level Beardsley's stylized irony recuperates the dislocations it reveals, serving to reinforce the anesthetizing effects of his harmonizing aesthetic techniques, adding another veneer of "style" to distance and mitigate the dissonant metaphysical implications his works expose. On another level the metaphysical dissonance of that irony ever fractures the harmonizing elements of his style. Whichever voice seems dominant in the interpenetrating dialogical discourse of Beardsley's work, there is always the trace of that other oscillating feature of it, the "obverse" feature that gathers back ironic dissemination or scatters recuperative conservation, as the case may be. We recall that in any text the very act of demarcation (or *writing*, as Derridian grammatology puts it) involves an irremediable splitting or lack of equilibrium between what is set down and what it is possible for any reader to make of it. That is, there can never be a hermetically sealed "voice" or universal "Word." Part of what Beardsley's art does is to accentuate this inescapable schism—in particular, turning the fetishistic fascination of Victorian bourgeois ideology against itself, ripping the culture's suturing, through a "dis-placing" (and de-forming) deconstruction of its own conventions. While Beardsley may have been unavoidably locked within his culture's semiotic chain (including Pope, Hogarth, Morris, the Pre-Raphaelites, Burne-Jones, and others) and unable to escape the evoking powers of his own culturally indebted "signature"—indeed, in many ways he did not wish to escape it—he did fully intend, through his highly personalized and deeply ironic stylistic "signing," to "menace" the traditions he inherited.[25]

Nietzsche argued that the strategy of decadence is typically the strategy of the liar who deceives by imitating truth and by making his lies even more credible than truth itself. In its hatred of life—the attempt to redeem "natural" life by refining it—decadence masquerades as admiring a higher life, seductively disguising itself as what it is not (Nietzsche, *Wagner* 164, 190–92; see also Calinescu 180). Beardsley's parodies convey just such a world of polarized dialectics (still another of Nietzsche's traits of decadence), a world where the imitating "mask" is set forth as redeeming the original "truth" it embellishes. It is a tissue of discourses, a world where reality is ever distanced by language, a function of the scene of its reading, of competing conventions where, absent any truly transcendent or metaphysical truth, everything collapses into structurality. In such a world, as Calinescu observes, all demarcations dissolve into a negotiation of perspective: "It is no longer possible regularly to contrast opposites, sexes, possessions; it is no longer possible to safeguard an order of just equivalence; in a word, it is no longer possible to *represent*, to make things *representative*, individuated, separate, assigned" (216). Beardsley's viewer becomes an accomplice not of this or that character but of the

discourse itself, its impurity of communication. Indeed, having dissolved absolute truth, the discourse itself becomes the "hero" of the narrative.

Highly stylized art, given its break with naturalist illusion, made the Victorian bourgeois public self-conscious, and they generally greeted it with suspicion. Certainly Beardsley's pictures, in their profound and paradoxical ambiguity, were caricatures of the traditional logocentric modes of meaning that Victorians prized. But by couching his stylizations in the familiar form of comic parodies, Beardsley also gave the British public some measure of comfort, an illusion of comprehensible caricature, even as he threw into question their cultural and ideological assumptions. His stylistic defamiliarizations were a strategy, albeit unconscious, to salvage transcendental truth by positing the ultimate authority of Art—style untrammeled by preclusive meanings. Yet at the same time his pictures inscribed the philosophical crisis confronting the age—that is, the possibility that all presumably validating sources, all logocentric "texts," were only fictions whose meaning oscillates, subject to and at the mercy of manipulations that are no more "the final word" than the sources they refashion. Such a strategy was itself an imploding paradox and one that, while it heralded much of twentieth-century art, only intensified rather than alleviated the fears of High Victorian culture and the ambivalence characterizing the Decadence itself.

We recall that near the very end of his life, in one of the last works he produced, Beardsley wrote enthusiastically of Volpone's mastery of "disguise," his ability "to be imposing, to play a part magnificently . . . the blood of the mime is in his veins," such that the "pitiless unmasking of the fox" at the end of Jonson's play made the play more a tragedy than a comedy ("Notes on *Volpone*," *Miscellany* 87). If Beardsley's own drawings demonstrate an obsession with "masks," with deferring any final meaning, it may have been out of the sheer joy of the game, or it may have been out of an unconscious fear that to stop the game might mean unmasking the ultimate horror, that there was no meaning or joy in the world beyond the game. Beardsley's art was scandalous by Victorian standards not only because of its "pornographic" elements but also because it implicitly undercut the authority of a world of logocentric meaning.

When Beardsley himself labeled as "indecent" his "strange hermaphroditic creatures wandering about in Pierrot costumes" (*Letters* 43), he was being more metaphysically accurate than he probably realized, because his grotesques incarnate what is a fundamentally paradoxical view of meaning. They are metaphors for a world—especially the overfilled, overdetermined spaces of the Decadent hothouse—where meaning oscillates ceaselessly among indeterminate alternatives, even polarities; where no value can ultimately be authenticated, no truth made finally secure; where the very foundations of meaning are the shifting sands of paradox. In the final analysis, perhaps one of the keenest insights into Beardsley's art was made by Oscar Wilde, who shared with Beardsley many of the same psychological, if not literal, prisons: "His muse had moods of terrible laughter. Behind his grotesques there seemed to lurk some curious philosophy" (Wilde, *Letters* 410).

Notes

Chapter 1 Aubrey Beardsley, Emblem of the Victorian Decadence

1. Except where otherwise noted, references to any manuscript, article, or book titled (or substantially titled) "Aubrey Beardsley" are henceforth abbreviated "AB" (in the case of manuscripts and articles) or *AB* (in the case of books).

2. Among the artists on whom Beardsley had a significant influence, according to scholars, were such varied figures as Will Bradley, Leon Bakst, Marcus Behrens, Franz von Bayros, Henri de Toulouse-Lautrec, Sergei Diaghilev, Alistair [Hans Voight], Thomas Theodor Heine, Otto Eckmann, Heinrich Vogeler-Worpswede, Gustav Klimt, Edvard Munch, Paul Klee, Wassily Kandinsky, Charles Rennie Mackintosh, Margaret and Frances MacDonald, Paul Poiret, Laurence Housman, Alan Odle, Eric Gill, Edward Gordon Craig, Arthur Rackham, Arthur Lett Haines, Djuna Barnes, Edward Burra, and Pablo Picasso (see Schmutzler 184; Clark 12–14, 34; Weintraub, *AB* 251–53; and E. Cooper 154, 158, 198).

3. Arthur Symons's famous obituary essay "Aubrey Beardsley" originally appeared in the *Fortnightly Review* 63 n.s. (1898): 752–61, and was published in an expanded form in, among other places, volume 9 of *The Collected Works of Arthur Symons* (London: Secker, 1924), 87–106. This expanded version has been most recently reprinted in Karl Beckson's *Memoirs of Arthur Symons* (University Park: Penn State UP, 1977). All references to Symons's landmark essay are to the *Collected Works* edition, cited as "AB."

4. As Hugh Kenner notes, before 1870 the great English novelists had been best-selling authors, but by the late Victorian period novelists like Meredith, James, and Hardy were by no means popular hits in the manner of Mrs. Henry Wood, Marie Corelli, and other favorites of the new demand-driven marketplace (11–15).

5. Max Beerbohm's famous "In Defence of Cosmetics," which appeared in the initial issue of *The Yellow Book*, put forth a position that, while consonant with many of Beerbohm's liberal aesthetic views, directly contradicted rather conservative personal preferences. For example, his defense of cosmetics notwithstanding, we know that Cissy Loftus captivated him chiefly *because* she wore no makeup, and he would "have been outraged if [his sisters] Constance and Agnes had taken to rouge" (Cecil, *Max* 99–101).

6. Less charitable characterizations of the Decadence's approach to the world, which appear to be extensions of the typical, all-too-familiar moralistic judgments traditionally made about the period, can be found in A. E. Carter's and R. K. R. Thornton's assessment that decadence is identifiable by its ultimately unsuccessful attempt to synthesize fundamentally opposed ideas (Carter 6). Thornton's formulation of what he calls "the Decadent Dilemma" is particularly moralistic:

> Decadent literature is a literature of failure: of a failure to provide a literary synthesis for the disintegration of life; of an expression of that disintegration and failure in elegant cadences; of a fleeing into an artificial world or an ideal world to escape from the consciousness and consequences of that disintegration; of a somewhat indulgent melancholy at the contemplation of that failure; and of a wistfully gay self-mockery at the beauty and vanity of the attempt to escape that failure. (188)

7. For discussions of Beardsley's polarized life, see particularly Malcolm Easton, *Aubrey and the Dying Lady*, 57–76, 160–61; Stanley Weintraub, *Beardsley*, 1–15, 133–240; Miriam J. Benkovitz, *Aubrey Beardsley*, 17–30, 127–34, 136; Brigid Brophy, *Beardsley and His World*, 5–38. 87–112; and Ian Fletcher, "A Study in Black and White: The Legend and Letters of Beardsley," *TLS* 14 Jan. 1972: 25–28.

8. Beardsley valued MacFall's opinion so much that he occasionally sent him advance copies of his work for comment and even (shortly before Beardsley died) asked him to write an assessment of his career (ALS MacFall to Walker 1).

9. MacFall's *Aubrey Beardsley: The Man and His Work* (London: The Bodley Head, 1928) is a slightly revised edition of *Aubrey Beardsley: The Clown, The Harlequin, The Pierrot of His Age* (New York: Simon and Schuster, 1927), which had been given a much expanded layout.

10. For the record, when the Wilde scandal broke (with the incorrect newspaper headline "Arrest of Oscar Wilde, *Yellow Book* under his arm"), the publisher John Lane was in New York, having left his general manager, Frederic Chapman, in charge of The Bodley Head. Through a series of frenetic and sometimes cryptic cables, Lane learned that, in the wake of the scandal, William Watson and Wilfred Meynell were urging that Lane sever himself from both Beardsley and Wilde, apparently agreeing with *The National Observer* that to "the Decadents, of their hideous conception of the meaning of art, there must be an absolute end" (6 April 1895: 547). The crisis culminated in an ultimatum from Watson, signed by six authors, that Lane either remove Beardsley from *The Yellow Book* or they would take their books elsewhere. Mrs. Humphrey Ward also threatened "to give the matter into the hands of my friend, William Ewart Gladstone, with instructions to take the matter up with his friend, the Public Prosecutor." Although protesting the ultimatum against Beardsley, Lane ultimately wired that he left the decision to Chapman, with the suggestion that he take the advice of Watson and Meynell, which was the same as sealing Beardsley's fate. Chapman dismissed Beardsley, installing Patten Wilson as the replacement editor, and removed Beardsley's drawings from the forthcoming issue (Mix 142–47; anon., commentary on *Cover Design*).

11. For convenience, in citing a drawing I have generally tried to use, wherever possible, the title given to the drawing in Brian Reade's standard collection *Aubrey Beardsley* (New York: Viking, 1967).

12. I want to thank Reverend Canon Ronald Bullivant, retired vicar of The Church of the Annunciation of Our Lady, and Reverend Canon David Wostenholm, the current vicar, for the gracious hospitality and assistance they extended to me during my research in Brighton.

13. It was common for Smithers to be entertaining his camp of followers in the elegant Café Royal, only to have his assistant race in and inform him that the police were showing fresh interest in his collection of erotica. Smithers would then hurriedly exit, gather his more questionable material into suitcases, scatter them among the left-luggage offices of various railway stations, and return to the fashionable restaurant until the crisis passed (Deghy and Waterhouse 67).

14. Smithers's unsavory reputation was hardly mitigated—although he had been dead for some ten years—when in 1919 his onetime partner Harry S. Nichols (allegedly no novice himself at pornography and blackmail) set up at the Anderson Galleries in New York a special, highly publicized exhibition in order to attempt to sell blatant forgeries as newly discovered Beardsley works. Nichols sold several works and conned a gullible press, but A. E. Gallatin and others exposed the hoax in short order. Toward the end of his life Smithers had met the Irishman John Black, a struggling barrister, at The Green Dragon pub in Fleet Street (opposite the Law Courts near Black's rooms in the Temple), and upon discovering that Black, whom he nicknamed "John Peter," was a clever amateur black-and-white artist, Smithers soon hired him to make painstaking copies of Beardsley's erotic work, using "a magnifying glass to ensure absolute accuracy," and even to create new "Beardsley drawings" (Rider 6–8).

15. It may indicate the esteem in which Beardsley held Smithers, and the treatment Smithers gave him, that while Ellen Beardsley felt

the publisher had cheated her son and exploited him after his death, Beardsley's sister and confidante Mabel remained a close and sympathetic friend to Smithers, even when his looming bankruptcy drove him to use her dead brother's work and reputation in dubious ways (E. Beardsley, "Recollections" 4; M. Beardsley, ALS to Smithers 1–4).

16. Ernst Kris cites "*conjunctive* ambiguity" as also characteristic of epigrams, puns, and jokes, which were vehicles of irony much utilized by Beardsley and the Decadence as a whole (247).

17. Beardsley avidly read the autobiography of Teresa of Avila, also a Baroque saint, and may have fashioned his Saint Rose of Lima, at least in part, after the mystic passion of Teresa's persona (Brophy, *Black* 24).

18. Georges Bataille argues that since ordered human society is traditionally sustained by reducing heterogeneous elements to fixed rules reflecting various concepts of the basic unity or homogeneity of life, society must ultimately either assimilate or reject any disparate element doing violence to that intellectually comprehensible unity (*SW* 98–99, 137–38, 141).

19. An indication of the effectiveness of Beardsley's drawing in conveying an ironic double corruption, and particularly the paradoxical conflation of innocence and worldly sophistication, can be seen in Max Beerbohm's reaction to it, which he detailed in a letter of 16 March 1894 to Reggie Turner:

> A fat elderly whore in a dressing-gown and huge hat of many feathers is reading from a book to the sweetest imaginable little young girl, who looks before her, with hands clasped behind her back, roguishly winking. Such a strange curved attitude, and she wears a long pinafore of black silk, quite-tight, with the frills of a petticoat showing at the ankles and shoulders: awfully like Ada Reeve, that clever malapert, is her face—you must see it. It haunts me. (*Letters to Turner* 92)

20. As Anne Deneys has pointed out in analyzing one of Beardsley's favorite novels—Choderlos de Laclos's *Liaisons Dangereuses*, which Baudelaire praised as being "as moral as the most moral" (*Oeuvres* 1228)—even dandified libertin-

ism is less a transgression of social law than "the maximal expression of conformity to that law" (Deneys 48). Libertines protest the absence of an authentic morality by highlighting that absence. They are actually ascetics, "attenuat[ing] the dangers of the flesh by establishing a 'method' based on principles and rules," "a method of adaptation for the purposes of a social war, and not as the negation of social law" (55, 51, 53).

21. I use the term *defamiliarize* in Victor Shklovsky's well-known sense that true art is the "making strange" of objects, an essential means of renewing our perception and understanding of the world (12). It is, according to Shklovsky, by wrenching our already "received," culturally preconditioned, perceptions of things that we are made to confront and reexperience our world in its existential freshness and terror.

Chapter 2 The Urge to Outrage: The Rhetoric of Scandal

1. Nietzsche was one of Beardsley's many enthusiasms. In October 1896, he asked Smithers to send him all of Nietzsche's available works, and he then wrote Raffalovich, citing the collected writings as one of the reasons he had returned to "feeling quite gay this morning" (*Letters* 175, 180).

2. Commenting on Beardsley's lasciviously shocking decor, the contemporary art sage Julius Meier-Graefe noted:

> At Beardsley's house one used to see the finest and most explicitly erotic Japanese prints in London. They hung in plain frames against delicately coloured backgrounds, the wildest phantasies of Utamaro, and were by no means decent, though when seen from a distance delicate, proper and harmless enough. . . . To talk with Beardsley among these pictures was to enter into a new world of thought, and the pictures seemed as natural to the room as the grandparents' portraits over the sofa of a middle-class citizen. (2: 252)

3. Indeed, one of the earliest influences that excited Beardsley's interest in drawing was

Fred Barnard's sketches of the actor Henry Irving, whom Beardsley went on to draw (à la Barnard) "in a dozen different positions and characters . . . almost as though he expressed hi[s] emotions that way" (Scotson-Clark, "AB" 1–2).

4. Citations from Wilde's original text (in French) are from *The First Collected Edition of the Works of Oscar Wilde, 1908–1922*, in fifteen volumes, edited by Robert Ross (London: Dawsons of Pall Mall, 1969), first issued by Methuen in 1908. For convenience, citations of the English text (translated by Alfred Lord Douglas, with massive corrections by Wilde himself) are from *The Portable Oscar Wilde*, edited by Richard Aldington and Stanley Weintraub (1946; New York: Viking, 1987). In this and subsequent quotations entirely in a foreign language, I italicize only those words in the titles.

5. In any citation of Reade's edition of Beardsley's drawings (as here, plate no. 262) the numbers refer to the *plate* number given to each illustration in that text, *not* page numbers of the text (which are usually not indicated). The numbering refers to the *second* of two numbers given to each picture in Reade's text (i.e., the number appearing in parentheses after the title), which corresponds to the numbering of Reade's descriptive notes and commentary. Usually the two plate numbers are identical, but sometimes they are not, because of problems caused by the book's layout. An "n" before a number signifies the author's note corresponding to that plate (e.g. "n. 262" is the note to plate 262, without reference to the page on which the note appears). The same method is used in citations of Simon Wilson's collection of Beardsley prints.

6. Public outrage might have been stronger still except that, subjected to John Lane's "microscope" as well as to the 1857 censorship law, Beardsley was forced to expurgate or omit entirely several of his lewder *Salome* pictures. *Salome on Settle, or Maîtresse d'Orchestre* was suppressed altogether because it was thought Salome's baton would be interpreted as a dildo (Reade, AB n. 289). *John and Salome* was also omitted from the 1894 volume, presumably because of Salome's grotesquely displayed nudity. *The Toilet of Salome* (first version) had to be replaced, perhaps less for its overt nudity than for its masturbating seated

youth (Reade, AB n. 288). Beardsley flatly refused to alter the first version of *Enter Herodias*. In a compromise that highlighted his mischievous rebellion, however, he made the drawing acceptable by placing a fig leaf over the right-hand attendant's exposed genitals (Reade, AB n. 285) but making it so prominent, so ostentatiously attached (with a neat little bow), that the viewer's attention would be drawn inevitably to the censored area and thus to the act of censorship itself.

7. Pat Barnett points out that Beardsley's candles have "a useful double meaning, suggesting simultaneously the dim religious world of church and worship, and also the dim Decadent world of secret affairs and artificial lights" (33).

8. Milly Heyd provides additional evidence of the shifting historical uses of the figure, noting among other examples that in the Judeo-Christian mystical tradition, evinced in the works of Jacob Boehme and Johann Wilhelm Ritter, Adam Kadmon was made bisexual to symbolize his prelapsarian innocence, and that in the nineteenth century the hermaphrodite represented first (at the beginning of the century) complete political and social equality and then (at the end, in the works of such people as Abbé Boullan) the widest possible promiscuity and discord (94–95).

9. In the case of designs from *Le Morte Darthur* by Sir Thomas Malory, the page numbers cited (as here, p. 226) are from the fifth edition (1893; reprint ed. London: Dent, 1988). Beardsley sometimes utilized the same picture in several places; when I cite a drawing from *Le Morte Darthur*, I try to refer to its first appearance in the text.

10. In classical times a term (i.e., a bust appearing to rise from the pillar supporting it)—after Terminus, the Roman god of boundaries and landmarks—was used as a milestone, signpost, or other boundary marker (similarly for a herm denoting a bust of the Greek god Hermes). It is perhaps indicative of Beardsley's iconoclastic playfulness that he should employ a term in a manner that patently eradicates rather than demarcates gender and other "boundaries."

11. Beardsley intended this substantially altered drawing (Figure 2–12) to be the new title page, but John Lane ultimately preferred to use an expurgated version of the original title page, em-

ploying Beardsley's second one as the Border for the List of Pictures (Benkowitz 84).

12. Havelock Ellis, friend of many nineties Decadents, wrote on the sexual connotation of pears in his "diary of ideas" for 17 November 1913, published in *Impressions and Comments* (1914):

> It has long been a little puzzling to me that my feeling in regard to the apple and the pear, and their respective symbolisms, is utterly at variance with tradition and folk-lore. To the primitive mind the apple was feminine and the symbol of all feminine things, while the pear was masculine. To me it is rather the apple that is masculine, while the pear is extravagantly and deliciously feminine. In its exquisitely golden-toned skin, which yet is of such firm texture, in the melting sweetness of its flesh, in its vaguely penetrating fragrance, in the subtle and ravishing various curves, even, if you will, in the tantalizing uncertainty as to the state of its heart, the pear is surely a fruit perfectly endowed with the qualities which fit it to be regarded as conventionally a feminine symbol. (230–31)

13. Beardsley's penchant for scandalous impishness in such *Morte Darthur* drawings was surely not eroded by the fact that running concurrently with the *Morte Darthur* project was a commission for sixty small vignettes illustrating three volumes of *Bon-Mots*, collections of sayings by noted wits and *bon viveurs*, including the poet Richard Sheridan and the humorist Sydney Smith. These latter drawings, which were actually completed during one feverish ten-day period, consisted mostly of wild grotesques and caricatures and could only have encouraged Beardsley in his puckish predilections.

14. Among the sources of sexual slang that Professor Zatlin cites are J. S. Farmer and W. E. Henley's *Slang and Its Analogues, Past and Present* 2: 301, 3: 207, 246, 259, 4: 300, 337, 340, 351, 5: 288–90, 6: 25, 7: 58–59, 77–79; Claude Rudigoz's *Systématique Génétique de la Métaphore Sexuelle* 100, 145, 187, 202, 205, 208, 230, 255, 285, 296, 313, 321, 381, 426, 463–73, 502, 635; Richard Payne Knight's *Symbolical Language of Ancient Art and Mythology* 45, 54, 124, 149, 159; Francis Os-

good's *Poetry of Flowers and Flowers of Poetry* 261–64; and *The Pearl: A Journal of Facetiae and Voluptuous Reading* 32, 627.

15. During the late nineteenth century, English publishers imported (and pirated, translated, and republished) much pornography from France, including nearly two hundred original stories, reissuing particularly such works by Pietro Aretino and André-Robert Andrea de Nerciat. In addition, French illustrations to "underground" works were more sophisticatedly obscene than those generally available in England, except for the more highly coded works of William Hogarth, Thomas Rowlandson and James Gillray (Kearney 88–89, 108–15; Zatlin, AB 169–83). If Beardsley was not thoroughly acquainted with the graphic priapic worship (and other variations) of such illustrators as Antoine Borel, Pierre-Louis (Henri) Grévedon, Achille Devéria, Charles Eisen, J.-A. Chauvet, and Paul Elluin (and he may well have been), he was certainly familiar with the work of Félicien Rops, including his winged penises and his use of dogs and monkeys as male surrogates (*Letters* 223; Zatlin, "Rops and AB" 167–69; AB 183).

16. One such system of allegorical coding, applied to ornamentation, was "the language of flowers," which matched flower names with associated meanings, using the terminology of the love affair. This elaborate flower iconography had developed early in the nineteenth century, finding its full expression in Charlotte de La Tour's *Langage des Fleurs* (1819), and had been copied repeatedly in such books as the anonymous *Language of Flowers* (Edinburgh, 1849) (Seaton 257–59; Haass 241–42). It had influenced numerous Victorian artists, particularly the Pre-Raphaelites and Burne-Jones, whose conventions (as we shall soon see) Beardsley employed extensively.

17. Historically there was no small amount of concern over Art Nouveau's tendency to foreground sensuality and what was feared to be unstable and "neurotic" forces, if we are to judge from the reaction to its changing icons. As Debora Silverman points out, many people in the Paris of the 1890s were upset when the elegant and stylized hundred-foot statue of *La Parisienne* on the Champs-Elysées—embodying the feminizing interiority, organicism, "overwrought masonry," and

"miniaturized iron materials" of a supposed "re-treat to ornamental fantasy"—became the new emblem of Art Nouveau, supplanting the most-cited previous emblem, the technological and monumental Eiffel Tower, which represented the "youth, virility, production, and democracy" of "a new universalist church of technological progress" (4, 5).

18. In large degree Beardsley's drawings ex-emplify Jacques Derrida's world of the "double mark," where every signifier inevitably has no message that is not its concomitant "trace" or "supplement." Like the basic "undecidability" of the Derridan *pharmakon*, which by embodying both poison and its antidote (medicine) upsets even the ability to decide the effect—the very sys-tem of decidability, the opposition of poison and medicine itself—so Beardsley's exotic, conflated images deconstruct conventional meaning by transporting objects (and their connotative asso-ciations) across recognized traditional boundaries, particularly through their erotic union of the or-namental and the genital.

19. Angus Fletcher has noted that in the his-tory of rhetoric the term *ornament* was gradually extended to include figures of speech (128). More-over, he finds that the oldest term for ornamental diction is *kosmos*, suggesting that the decorative is itself a "world-view," and that ornament and allegory in fact refer to different aspects of the same symbolizing process, dealing with the rela-tion between part and whole, the assumption that the part implies the whole, that part and whole are complementary (112–13; see also Ulmer, "Op" 51–56).

20. Schmutzler discusses how Rossetti and Whistler, two of Beardsley's early idols, used frames in revolutionary ways. He points out, for example, that in the Peacock Room Whistler had designed for the Liverpool shipowner Frederick Leyland at 49 Prince's Gate the artist "went so far as to treat a whole room as an enlarged frame for his *Princesse du Pays de la Porcelaine* and to adapt the form and color of the room to this painting, even though the old and valuable Spanish leather on the walls had to be painted over, and the bor-der of a Persian rug had to be cut away as the colors were unsuitable" (76). It was not a lesson lost on Beardsley, who waxed enthusiastic when

he saw this famous tour de force in the summer of 1891 (Weintraub, AB 25–26; Letters 19–20).

21. In his landmark *Art and Illusion*, E. H. Gombrich describes the more fundamental, visual level of this phenomenon, noting that we can in-terpret the famous London Transport "bull's-eye" symbol as a head facing us, a button, or a letter, but "what is difficult—indeed impossible—is to see all these things at the same time. . . . We can train ourselves to switch more rapidly, indeed to oscillate between readings, but we cannot hold conflicting interpretations" (236).

22. For the photographic line block, a pen-and-ink drawing is photographed in reverse onto a zinc plate covered with a sensitized gelatin film. The lines are protected against the action of acid, which is used to eat away the white or unprotected parts of the design, and are thus left raised in relief to receive the ink, in the same way as metal type (and unlike etchings, in which the inked lines are cut and sunk below the surface, with the white surface wiped clean). The zinc plate is then backed with wood to strengthen it and raise it to the required height, so that it can be set with type for printing.

23. Beardsley was not the only artist to blur the distinctions between high and low art, or to broaden art's moral decorum. As John Barnicoat has noted, Jules Chéret went to some lengths to graft the recognizable scale and style of masters like Tiepolo onto the technique of the litho-graphic book illustrator and the new popular id-iom of folk art (12). Furthermore, by invariably posing his favorite models (such as the Danish ac-tress and dancer Charlotte Wiehe) as "irrepressi-bly happy, dancing, laughing and irresponsible," a look countless young fin-de-siècle girls sought to imitate (20), Chéret appeared to some viewers to be perverting the conventions of high art in order to promote mere vulgar amusement, even encour-age moral corruption—a charge that was leveled also at Beardsley. Certainly Beardsley was influ-enced by Chéret's early work, which features the striking use of black and interlocking flat shapes that challenge traditional interpretations of solid form and illusions of depth.

24. Relating the hoax, Beerbohm reported Beardsley's delight in its success ("AB" 544), and Penrhyn Stanlaws, having called on Beardsley just

after the unmasking of Broughton and Forschter, confirmed, "I never, before or after, saw him in such a happy frame of mind" (*Book Buyer* 17.3 [Oct. 1898]: 214).

Chapter 3 The Craving for Authority: Authentication and Redemption

1. Jackson applies this characterization to most of the English Decadents. Karl Beckson details the degree to which these artists, specifically Rhymers Club poets, rejected *l'art pour l'art* in his *Arthur Symons: A Life*, 62–64.

2. Beardsley's mother, Ellen Agnus Pitt Beardsley, considered the liveliest and most headstrong of her father's three daughters, met her husband, Vincent Paul Beardsley, without introduction, on Brighton pier, and the two carried on their courtship by meeting clandestinely in the Royal Pavilion gardens (see Brophy, AB 11–14). Ellen Beardsley ultimately judged herself to be a well-bred woman of a gentry family—both her father and paternal grandfather were medical doctors—who made the error of marrying a tradesman of the lower classes. Despite her reduced circumstances after her marriage, her politics were consistently High Tory. Fond of the exiled Stuarts, she even claimed that her family nanny, "old Mrs. Pendrill," was a descendant of the sea captain who carried Charles II to safety in France after his escape from the Battle of Worcester (Walker, "Notes" 104–105).

Heir to a small estate, Vincent Beardsley considered himself (as he had written in the marriage registry) a London "Gentleman"—that is, one with no pressing need of employment—who made the error of marrying a pretentious but poor provincial. At nineteen he had inherited from his Welsh maternal grandfather (a grocer) a legacy of £350 and one-fourth of an estate valued at some £3000. His long-deceased father, Paul Beardsley, had been a manufacturing goldsmith, a craft and business Vincent did not pursue. Shortly after his marriage, Vincent Beardsley was reported to have (1) been forced to settle a significant sum of money on a widow who claimed he had promised to marry her, and (2) otherwise dissipated the rest

of his inheritance (see Brophy, AB 12–14). (Significantly, perhaps, Aubrey Beardsley's 1889 short story "Story of a Confession Album," which appeared in *Tit-Bits*, has as its subject a breach of promise).

3. Beardsley's mother related the nature of her children's life with their aunt as follows:

> They rose when it was light & they went to bed when it grew dark. They had no toys, no books except Green's "Short History of England" from which Aubrey immediately began to compile an ambitious History of the Spanish Armada. Their chief interest was in going to Church. . . . My father went in to see them one day (it was when I was very ill in London, in a nursing home in fact) and found them sitting on their little high-backed chairs with nothing in the world to do. "The children can't be happy like that," he said. My aunt assured him that they were as happy as birds. (E. Beardsley, "AB" 2; "Recollections" 3)

4. Beardsley sought relief at one time or another from doctors Symes-Thompson, Jones, Harsant, Phillips (Raffalovich's personal physician), Lamarre, Prendergast, Caron, and Dupuy, among others. Among the prescribed "cures" administered to Beardsley were wet compresses; hot air; compressed-air baths in an iron chamber; waterbaths under hydraulic pressure; doses of arsenic, oxide of zinc, spermaceti, bismuth, "acetates of lead," or combinations thereof; blistering the skin and keeping the blisters open for prolonged periods; predawn walks; wet sea air; dry mountainforest air; bracing winter air; turpentine baths; and "clean-outs" with creosote (Easton 67–109). It goes without saying that treatment for tuberculosis during the nineties was still in a very primitive state, despite the fact that Robert Koch had identified the tuberculosis bacillus some ten years before. Having to undergo such torturous treatment, with little permanent improvement, could hardly have alleviated Beardsley's insecurities.

5. A partial list of Beardsley's changes of residence, excluding the many incidental holidays to France and elsewhere, should be sufficient to explain his feelings. He was born in August 1872 in his maternal grandfather's house at 12 (now 31) Buckingham Road (at the corner of West Hill

Place) in Brighton and apparently lived there until age seven, when he began a rather peripatetic existence, moving as follows: September 1879, to boarding school at Hamilton Lodge, Hurstpierpoint, Sussex, near Brighton; 1881, to a lodging house at 2 Ashley Villas (now 37 Ashley Road), Epson; 1883, to London; August 1884, to his aunt Sarah Pitt's at 21 Lower Rock Gardens, Brighton; January 1885, to the dormitory next door to Brighton Grammar School (during school sessions); July 1888, to London; late 1888, to a lodging house at 32 Cambridge Street, Pimlico; early 1891, to a lodging house at 59 Charlwood Street, Pimlico; June 1893, to 114 Cambridge Street, Pimlico; early July 1895, to a lodging house at 57 Chester Terrace (S.W.), near Chester Square, Pimlico; August 1895, to 10–11 St. James's Place, London; February 1896, to the Hôtel Saint Romain at 7 rue Saint Roch, Paris; March 1896, to the Hôtel de Saxe, Brussels; May 1896, to 17 Campden Grove, Kensington; late May 1896, to the Twyford guest house, Crowborough, Sussex; late June 1896, to the Spread Eagle Hotel, Epson; mid-August 1896, to the Pier View guest house, Boscombe; late January 1897, to the Muriel guest house in Exeter Road, Bournemouth; 8–9 April 1897, to the Windsor Hotel, London; April 1897, to the Hôtel Voltaire, Paris; May 1897, to the Pavillon Louis XIV, rue de Pontoise, Saint-Germain; early July, to the Normandy Hotel, Paris; mid-July 1897, to the Hôtel Sandwich, rue Halle au Blé, Dieppe; late August 1897, to the Hôtel des Estrangers, rue d'Aguado, Dieppe; mid-September 1897, to the Hôtel Foyot, rue Tournon, Paris; mid-November 1897, to the Hôtel Cosmopolitain, Menton, until his death on 16 March 1898. He was buried in what is now called the old-cemetery section of Arabuques Cemetery in Menton. As if emblematic of the displaced character of his life, he was, although a Catholic, assigned a Protestant grave in the English section of the cemetery.

For evidence of Beardsley's deep-seated feelings of insecurity or restlessness, see Benkovitz 19, 24–25, 44, 47, 51, 54, 130–31, 137, 142; Weintraub, AB 38; Brophy, AB 14–15; Letters 23, 28; R. Ross 15–16; Dent, Memoirs 67–69; MacFall, AB 26–27; Mix 28–31; and A. W. King, AB 23.

6. Many scholars have suggested that even Beardsley's erotic details were derived from museum models. He certainly studied the British Museum's erotic Greek and Roman vases and quite possibly scrutinized there also the collection of phallic objects and detailed drawings of stylized-vulva amulets (Webb 64–65; Zatlin, AB 183), books and engravings, including Richard Payne Knight's An Account of the Remains of the Worship of Priapus (1786), and the Mannerist artist Giulio Romano's sexually explicit Sedici Modi of 1524, twenty drawings engraved by Marcantonio Raimondi (Raphael's favorite engraver) and embellished with erotic sonnets by Spinello Aretino (Melville 19).

7. His farce "A Brown Study" was produced for charity at the Royal Pavilion not long after he left Brighton Grammar School. His poem "The Valiant" appeared in his school magazine Past and Present (June 1885); two other poems, "A Ride in an Omnibus" and "A Very Free (Library) Reading with Apologies to W. S. Gilbert," were published in the local paper Brighton Society (9 July 1887; 14 April 1888); and his short story "The Story of a Confession Album" appeared in the 4 January 1890 issue of Tit-Bits.

8. Beardsley's boyhood sketchbooks contain illustrations for Madame Bovary, Manon Lescaut, and the Contes Drôlatiques, and well before he had published even his first drawing, he had made illustrations for works of Dickens, Swift, Marlowe, Ibsen, Virgil, Congreve, Abbé Prévost, Dumas fils, Daudet, Flaubert, Balzac, Racine, Shelley, Shakespeare, and Dante (Gallatin 12, 105). Not surprisingly, Beardsley expressed "infinite delight" when he was able meet his literary idols in person, as when he persuaded Symons and Jacques-Emile Blanche to take him to Puy to see the author of La Dame aux Camélias, Alexandre Dumas fils (Blanche, Sous la Colline 17; MacFall, AB 83). Beardsley was buried with the copy of that novel, which Dumas fils had given him (Blanche, Portraits 94).

9. Beardsley's chronic financial need notwithstanding, his extant letters record almost forty times within one eighteen-month period when he wrote for books by some two dozen different masters. When shortly before his death Beardsley asked Smithers to sell some of his books, his partial catalogue included thirty volumes of Voltaire,

six volumes of Racine, and twenty volumes of Balzac (*Letters* 430). He once asked a Bournemouth bookseller to store his traveling library "for a short time," noting "there will be about 230 volumes to look after" (243).

10. It is indicative of the rejection Beardsley felt from his father that, except for "sending his love" to him in several letters as a six- and seven-year-old and referring to a valentine that "I think . . . was from Papa" (*Letters* 6–13), he mentioned his father only twice, and then not favorably, in all the rest of his letters. The first time was in a letter of 1891 to Scotson-Clark, in which Beardsley wryly reported, "I and my pater are alone in London and not having a particularly lively time of it" (24); and in the second instance, an 1892 letter to his former house master Arthur William King, Beardsley cited his parents' opposition to his giving up his clerk's job to pursue an artistic career, explaining sarcastically, "There were ructions at first but of course now I have achieved something like success and getting talked about they are beginning to hedge and swear they take the greatest interest in my work. This applies however principally to my revered father" (38).

11. While the design of *The Yellow Book* may have been refined at the Pennell soirées, it is generally accepted that the journal was officially conceived by Henry Harland and Beardsley (some versions add other witnesses) on New Year's Day 1894, at Harland's home, although Beerbohm claimed the event occurred in late autumn 1893, and D. S. MacColl claimed to have suggested the idea in Dieppe in the late summer of 1893 (Mix 67–71; MacColl, "Memories" 291). Among the many ideas for *The Yellow Book* that Pennell reportedly suggested or approved were financial independence for the quarterly, the color of the cover, the change in cover design with every number, and the concept of literary and artistic coeditors (E. Pennell, *Pennell* 273).

12. In late May 1892, buoyed by his "new method of drawing," Beardsley carefully stocked a new morocco-leather portfolio with pictures, solicited letters of introduction (including one from Burne-Jones), and set off to Paris, specifically, among other things, to win an endorsement from Puvis de Chavannes. Beardsley may have been encouraged to seek out Puvis not only by Burne-

Jones's recommendation but also by the successful experience of Charles Ricketts and Charles Shannon, who had journeyed to Paris to get the master's advice in 1887. The resulting "triumph," as Beardsley bragged to Scotson-Clark, A. W. King, and his former headmaster E. J. Marshall, was that he "never saw anyone so encouraging" as Puvis, who "introduced me to one of his brother painters as 'un jeune artiste anglais qui fait des choses étonnantes!' [a young English artist who does astonishing things]." Beardsley exulted: "I was not a little pleased, I can tell you, with my success" (*Letters* 34, 37, 43–44).

13. Burne-Jones, at the time occupied with designs for Morris's Kelmscott Press, showed Beardsley his economical method of converting rough drawings into hard outlines with the use of tracing paper (Harrison and Waters 186), a technique (though without the tracing paper) that Beardsley proceeded to make a key element of his own unique drawing method.

14. Beckson discusses additional oedipal connections in this picture, the most persuasive relating to Ibsen, whose *Ghosts* Beardsley saw and based a picture on in 1890. The play's protagonist, of course, is destroyed by a disease inherited from his father ("Artist" 208).

15. Ellen Beardsley claimed that, after Dent's plea for her to intervene, she was responsible for getting Beardsley to finish the *Morte Darthur* project by importuning Robert Ross to intercede with her son and appeal to principle (M. Ross 27-28). If it was principle that moved him, however, Beardsley apparently did not feel the same obligation toward several other projects that he dropped unfinished during his career. As Miriam Benkovitz has pointed out, Beardsley was not too principled to renege on similar commitments, one being for *Lucian's True History*, during the very same period (76–77).

16. It is entirely possible that later Beardsley, as "co-editor," also played a role in the snub Alfred Lord Douglas (and Wilde indirectly) received from *The Savoy*. After Wilde's incarceration Stuart Merrill, an American poet who lived in Paris and wrote in French, circulated among French writers—without success—a petition addressed to Queen Victoria calling for clemency for Wilde. Douglas, disgusted at the lack of support, subse-

quently sent to the avant-garde *Savoy* a sonnet dedicated to those French writers "who refused to compromise their spotless reputations or imperil their literary exclusiveness by signing a merciful petition in favour of Oscar Wilde." Not only was the poem not published; Douglas's letter was not even acknowledged, nor was the manuscript of his sonnet ever returned to him (Hyde, *Douglas* 96).

17. As it happened, Beardsley had several reasons to be offended by Lane's efforts. Like Wilde, Beardsley had suffered previously from Lane's opportunistic, fair-weather friendship. When in 1892 Aymer Vallance had first shown Beardsley's work to Lane, in the hope that he might publish it, Lane was so ostentatiously unimpressed that Beardsley was insulted and considered it particularly sweet vindication when Lane eagerly sought after him the following year (MacFall, *AB* 32–33). Given that history, Beardsley was incensed when Lane sought to sanitize the artist's involvement with *The Yellow Book* (and, not incidentally, gloss over Lane's injustice to him) by suggesting that Beardsley's only "defect" as art editor of *The Yellow Book* was that he "would not take himself seriously" and, moreover, that it was Beardsley who "severed his connection with the magazine" and not the other way around (Lane, "Publisher's Note" 22). Even though it meant being linked once again with Wilde, Beardsley would not countenance any suggestion that his art, even at its most playfully salacious, was not serious and that he was "really being 'quite respectable'" (MacFall, *AB* 70).

18. The editors of Beardsley's letters—Henry Maas, J. L. Duncan, and W. G. Good—argue that Beardsley's ostensible rejection of Wilde probably resulted from Raffalovich's hostility to him (*Letters* 409–10, n. 2). Raffalovich's intense animosity toward Wilde likely dated from Wilde's 27 March 1885 review of four books of poems, including Raffalovich's *Tuberose and Meadowsweet*, in *The Pall Mall Gazette*. In that review Wilde playfully chided Raffalovich's metrics (to which Raffalovich responded testily with a letter to the editor on 30 March, entitled "The Root of the Matter"). Wilde hardly eased matters when he later joked that the wealthy, French-educated Russian had come to London to found a salon and only succeeded in founding a saloon (Wilde, *Let-*

ters 172–73 n. 4). Raffalovich avenged himself by, among other things, his scathing *L'Affaire Oscar Wilde* (1895), at least parts of which Beardsley had read in manuscript (*Letters* 84–86, 109–110; Benkovitz 128, 180–81). While attributing Beardsley's snubs of Wilde to Raffalovich may be an oversimplification, it is true that Raffalovich originally found Beardsley repugnant—guilty of "some hardness, much affectation" (Raffalovich, "AB" 609)—at the time he was associating with Wilde, and it was apparently only after Beardsley had, in effect, denounced Wilde that Raffalovich found the boy "arrested me like wrought iron and like honeysuckle" ("AB" 610). It may be more than coincidence that these two of Beardsley's surrogate fathers adopted the name of Saint Sebastian (Raffalovich upon entering the third order of Dominicans, Wilde as his alias after prison) and that no small part of Raffalovich's enmity toward Wilde grew out of Wilde's previous association with (and feared continued "corruption" of) another Raffalovich protégé and his eventual companion John Gray (Benkovitz 127–28; Ellmann n. 71; McCormack 46–49; 148–49; 156–57).

19. Whistler ultimately chose to forgo his Sunday brunches at the Café in the wake of a quarrel with Wilde, initiated when Wilde asked Whistler for his opinion of one of Wilde's poems, and Whistler answered, balancing the tissue-thin manuscript, "It's worth its weight in gold." But even after Whistler gave up his weekly "audiences" at the restaurant, he continued occasionally to entertain big parties, and skewer victims verbally, in a specially screened corner of the Café (Deghy and Waterhouse 59–60).

20. Edward William Godwin, one of the leaders of the Aesthetic Movement and the earliest architect in famous Bedford Park, was almost equally noteworthy as an designer of striking houses, especially ones with simplified, stark white interiors. On Tite Street in Chelsea, Godwin built Whistler's "White House" (No. 13 [now demolished]; 1878–80); "Keats House," which Wilde shared with Frank Miles (No. 3; 1880); and a house for Wilde and his wife, Constance (No. 16 [now 34]; 1884) (Woodring 237).

21. Considering Whistler's notoriously limited knowledge of music, Beardsley may indeed have been even more malicious here than he

seemed. As a skilled musician himself, he could well have found especially arrogant and pretentious Whistler's practice of giving to his paintings the titles of musical compositions.

22. There is other evidence that Whistler softened in his attitude toward Beardsley, especially as Beardsley's illness grew more grave. Whistler joined Pennell and others in visiting a severely ailing Beardsley in Dieppe in late summer 1897; and in May 1898, two months after Beardsley's death, Whistler set aside space for a large number of Beardsley drawings at the first Exhibition of International Art at Prince's Skating Club in Knightsbridge, over which Whistler presided (J. Pennell, AB 44–45; Pennells, *Whistler* 220–22).

23. Beardsley was fascinated with gambling as something that admitted the possibility of magically mastering time, of reversing past misfortune and recouping everything in one frozen unifying moment. Although Beardsley himself could hardly afford to wager money at the casinos he loved, Symons related how "at night he was almost always to be seen watching the gamblers at *petit chevaux*, studying them with a sort of hypnotized attention for . . . the sense of frivolous things caught at a moment of suspended life, *en déshabillé*" ("AB" 88).

24. According to Freud, under the repetition compulsion we ceaselessly struggle against and seek to master not only our various ego needs (generally established by parental and societal demands) but also the guilt from being unable to master them, the struggle for mastery becoming more compulsive and persistent the more difficulty we encounter. Specifically, we fixate on and constantly repeat an old action or experience, deliberately placing ourselves in distressing situations by returning to the symbolic nexus of original unresolved conflicts, and in the process we become psychologically active manipulators in our own powerlessness ("Beyond," CW 18: 63–64).

25. As early as May 1895, Vallance could write to Ross, "By the way, Raffalovich (I don't know how to spell it) is financing Beardsley to any amount" (M. Ross 38).

26. On at least one occasion, Ellen Beardsley was so uninformed about the family finances that, believing erroneously that they had no money, she

wrote to Robert Ross (who apparently sent some immediately), only to have to apologize upon learning her error. She swore him to secrecy for fear that if Beardsley ever learned of her indiscretion, "we should have to part, he would think me treacherous and never trust me again" (ALS to R. Ross, 19 Nov. 1896; quoted in Easton 102–3). As we have seen, Beardsley already trusted her even less than she knew.

27. In this regard Beardsley could hardly have been unaware of Wilde's famous comments on artists and things Japanese in "The Decay of Lying":

> No great artist ever sees things as they really are. If he did, he would cease to be an artist. . . . Now, do you really imagine that the Japanese people, as they are presented to us in art, have any existence? If you do, you have never understood Japanese art at all. The Japanese people are the deliberate self-conscious creation of certain individual artists. If you set a picture by Hokusai, or Hokkei, or any of the great native painters, beside a real Japanese gentleman or lady, you will see that there is not the slightest resemblance between them. . . . In fact the whole of Japan is a pure invention. There is no such country, there are no such people (CW 4: 47–48).

28. That Wilde and Beardsley intended this meaning was borne out by Alfred Lord Douglas's testimony in defense of Pemberton Billing (against the dancer-actress Maud Allan's charges of criminal libel) in 1918. Douglas testified that in the scene in question Salome was supposed to be working herself up to a state of "orgasm . . . the culmination of sexual excitement" (Hyde, *Douglas* 225).

29. Scotson-Clark related how he and Beardsley were so "very full of spirit" and so failed to "take instruction seriously" that Henry Earp, their grammar-school painting teacher "of the old school," told them "firmly but kindly that we were only wasting our time there, that we neither of us had any talent for drawing and that we were not to attend his class any more" ("AB" 4). Even when Burne-Jones advised Beardsley that he needed to learn the technical grammar skills of his art, Beardsley's ostensible attempts to do so at

the Westminster School of Art were hardly conventional. According to Scotson-Clark, Beardsley worked mostly at "Japanesy" grotesques and was very lucky to have as his instructor the open-minded, young Fred Brown, who "encouraged Beardsley to persevere in his own line and instead of making him draw from the cast, helped him develop his own natural talent" (14).

30. Alfred Gurney had formerly been a curate at the high St. Paul's Church in Brighton, where Ellen Beardsley had met him (Brophy, AB 42), and in London the independent Gurney continued to spread his Roman beliefs at St. Barnabas's Church, built in 1847 as one of the "correct" Gothic churches by the Pugin-influenced architect Thomas Cundy (assisted by William Butterworth), chiefly with funds donated by wealthy Belgravians on behalf of the Pimlico poor (Summerson 30). At St. Barnabas's, Gurney restored ecclesiastical music (after three centuries of silence) and supported it with a glorious choir trained by Reverend Thomas Helmore, who championed plainsong out of his own *Psalter Noted*. The incense-laden atmosphere resonated to Gregorian chants, the priest-organist being G. H. Palmer (a special friend of Beardsley's), who edited a celebrated collection of Office Hymns and Sequences (Easton 164).

Chapter 4 The Rhetoric of the Grotesque: Monstrous Emblems

1. Ironically, Beardsley's friend and benefactor Frederick Evans, remembered less as a bookseller than as a talented cathedral photographer, recoiled from some of Beardsley's later work. Far from evincing Beardsleyan ironic detachment, Evans was an aesthete in the Morrisian Romantic mold who served tea in Morris-designed teacups, received Kelmscott Press books directly from Morris himself, and sought as a photographer to record "emotional rapprochement" with and "the vital aspect and feeling" of his subject (Fuller 6). Not surprisingly, in an introduction to the work of James John Garth Wilkinson, Evans ultimately judged Beardsley's works to be "dreadful inventions":

There are aeons of hell, of vice, behind them; sin . . . with an awful latent misery, a weary cruelty behind its mask of pleasure. Debased as some of Beardsley's intimates were in their confirmed erotomania, they would not account for the curiously ages-old whoredoms so many of his subjects revelled in, vivid living realities of sin and vice that only the irresistible obsession of some foul old spirit can account for. (12)

2. Although Hegel consistently used the word *grotesque* as a derogatory term—as an unjustified fusion and distortion of different realms of being—his implication that the grotesque was a splicing of the individual form onto something supernatural (*Aesthetic* 13: 301ff.; see also Kayser 101–2) only reinforced the view that the grotesque captured a more profound reality. Beardsley's fixation with the grotesque is logical in the sense that the form originally grew out of the desire to evoke a particular mood, to follow the weird and exotic, which so often inspired Beardsley as well as such movements as the Victorian Gothic Revival (see E. Panofsky 221).

3. Yeats saw both Beardsley and Baudelaire as emblematic of the Yeatsian Thirteenth Phase, "the most intellectually subjective phase," where "the subjective intellect knows nothing of moderation" and collapses all contraries into "expression for expression's sake," preoccupied with the "most strange and most morbid" in its surrender to sensation (*Vision* 129–30).

4. Ian Fletcher has noted that in many of the *Salome* drawings Beardsley kindles a similar uneasiness in the spectator by an unbalancing of the conventionally "central" characters, "placing a major figure too near the frame of the drawing, while minor characters are sometimes precariously stationed on its very edge" (AB 95–96).

5. John Ruskin (e.g., *Stones* 161–62) and Charles Baudelaire (e.g., *SW* 148–50; *CE* 379–82) both associated the grotesque with the mythic, anticipating Mikhail Bakhtin's assertion that the "material bodily principle" of the grotesque is universal, representing "the collective ancestral body of all the people" (*Rabelais* 19). Bakhtin cites as an indication of the grotesque's mythic character that the great majority of its traditional gestures and "jokes"—hanging tongues, popping eyes,

sweating, spasms, convulsions—mimic (often transforming and conflating) the three main acts of life: sexual intercourse, birth, and death (353–54). Moreover, unlike individual and national history, the world of the grotesque tends not to oppose life and death as contrary principles but treats death as always related to birth or renewal (50).

6. John Stokes has discussed how the playwright Alfred Jarry, an acquaintance of Beardsley's who greatly admired his work and whose portrait Beardsley drew, felt that the grotesque artist "paints what really is" and generally shared with Beardsley the view that " 'Déformation' was the means by which an underlying reality could be revealed by violating the conventional forms of representation." The Symbolist painter Charles Filiger thus became for Jarry "un déformateur, c'est bien là le conventionnel nom du peintre qui fait ce qui EST et non . . . ce qui est conventionnel" [a deformer, if that's the right word for a painter who paints what really IS . . . and not just what is conventionnel] (Jarry 1: 1024; Stokes, "Beardsley/Jarry" 57–58).

7. Beardsley knew Redon's work not only from his initial Paris excursions in the summers of 1892 and 1893 but also from a London exhibition of Redon's work in November 1893 (see *Letters* 58–59). Beardsley's spider grotesque in the vignette on page 41 of *Bon Mots* (1893) by Sydney Smith and R. Brinsley Sheridan (Reade, *AB* 176) recalls Redon's lithograph *L'Araignée*.

8. Fletcher cites numerous sources through which Beardsley became familiar with the dwarf as a useful artistic trope, among them *The Arabian Nights*, *Le Morte Darthur* (where a dwarf betrays Tristram and Iseult), Edmund Spenser, Domenico Zampieri, Raphael Sanzio, Diego Velasquez, and Sandro Botticelli ("Grammar" 147).

9. Brian Reade identifies "X.L." as Field, an American educated at Harrow and Oxford, who produced "several collections of occult stories in a Satanist vein published in Paris and London during the 1880s and 1890s" and in later years lived mainly "on blackmail and the proceeds of embezzlement." As Reade states, there is no evidence that Field meant anything to Beardsley or that Beardsley shared his satanism ("Beardsley Remounted" 119–20).

10. The French periodical *La Plume*, one of Beardsley's favorites, devoted its issue of 15 September 1892 to the world of mime, and one of the poems in that issue, Angelin Ruelle's "Fin-de-Siècle," describes the death of Pierrot, drawing an analogy between his death and that of the century (Heyd 35).

11. Beardsley's joke is particularly trenchant in this case because, as Otto Fenichel has noted, like dwarfs, clowns are phallic substitutes, the clown being a figure that exacts surreptitious revenge for the ridicule to which he is exposed (*CP* 1: 12–13).

Chapter 5 The Beardsleyan Dandy: Icon of Grotesque Beauty

1. Although "The Painter of Modern Life" (*Le Peintre de la Vie Moderne*) first appeared on 26 and 29 November and 3 December 1863 in the columns of *Le Figaro*, it was written sometime between November 1859 and February 1860. Appropriately, in keeping with the essay's call for modernity and revolt against bourgeois categories, Baudelaire selected as his ostensible subject and model Constantin Guys (1805–92), an eccentric artist and art correspondent for *The Illustrated London News*, probably knowing that he would suffer widespread criticism for choosing such a marginal figure as the subject for so important a treatise. The essay comprises pages 390–435 in *Selected Writings on Art and Artists* and pages 49–110 in *L'Art Romantique*.

2. In a discussion particularly germane to the dandy's social "masks," Ernst Kris explains how in all humans, but especially entertainers, the movements of the facial musculature that form the "smile"—originally uncoordinated responses to pleasurable stimuli—evolve under the reality principle of the adult world into an all-purpose ritual defense, "appropriate signals" used "for an effective mastering of the outside world," to disguise real anxieties and discharge any number of unpleasant social responses (223). In "artful" confrontations, just as in works of art, the smile, which is the universal sign (and good omen) for "normality" and "access," becomes a means of controlling potential danger and keeping safe a

person's true identity—a "triumph of the ego" (228–29). Like the smile of a dancer or an acrobat or any other entertainer, the smile (or impassive countenance, for that matter) of dandies is "artificial and empty" in order "to heighten the effect of their performance by giving the impression that it is effortless, . . . a mask, i.e. a pathognomic substitutive act" (230), affirming the force of the dandy's art while at the same time protecting his inner self. Interestingly, John A. Lester, Jr. cites Beardsley specifically as one for whom dandyism served the very real function of shielding the private self (141).

3. Ideological as ever, Barbey even claimed that d'Orsay "was not a Dandy" (n. 60). Ellen Moers sets forth some of the differences between George (Beau) Brummell and Alfred Guillaume Gabriel Count d'Orsay. While both styles of dandyism centered on dress, Brummell's austerity was foreign to d'Orsay's nature. Brummell's dressing paraphernalia were solid silver; d'Orsay's were gold. In riding apparel d'Orsay's hat was taller, slimmer, glossier; the curve of its brim was more exaggerated and more dashing. The buttons of his blue coat were gilt, not Brummell's sturdy brass, and its lapels were very wide and arching. While Brummell's coat had a firm and square line, buttoning trimly over the chest and showing only the cravat and a trifle of shirt front, d'Orsay's coat was rarely buttoned but was thrown back recklessly over his shoulders to cover scarcely more than the upper arm. Inside the opening of the coat could be seen the curve of the waistcoat lapels, a curve accentuated in turn by a gold watch chain that was looped through a buttonhole and swagged expansively across his chest (Brummell's chain revealed but two links). d'Orsay's neck cloth, often of the shiny black satin abhorred by Brummell, was not starched but rippled softly through the open curve of the waistcoat. Against Brummell's clean-shaven image of the reticent gentleman, d'Orsay resembled a bearded god—six-foot-three, with a pretty feminine face and the magnificent body of an athlete, his bright auburn hair worn in a mass of waves and ringlets and his curling beard circling his chin from ear to ear. d'Orsay's style of costume included all the elements Brummell disdained—shimmering pastel colors, soft velvets and silks, perfumes, jewels. Less eccentric, less in-

dependent, less cold, and less exclusive than Brummell, d'Orsay had a superabundance of charm. Amiable and prone to infectious laughter, he never seemed anxious or bored and made others forget their worries (153–55).

4. Linda Dowling suggests that Beardsley gravitated toward eighteenth-century subjects—and an accompanying new style—not only because he admired what he saw to be the century's licentious freedom, ambiguous effeminacy, elegant surfaces, and rhetorical impersonality, but also because the earlier era represented for him a haven from both Victorian seriousness and Wilde's romanticism ("Aesthetes" 358–59, 369). Interestingly, Wilde found Beardsley's frontispiece "fascinating," although confessing that he didn't think Beardsley's *Volpone* illustrations were "up to his former work" (*More Letters* 177).

5. Emphasizing the role of caricature as an artistic tool rather than merely a spiteful weapon, Reade explained that "Beardsley had a habit of caricaturing his friends and acquaintances without real malice" (AB n. 283). While in a sense that was true, Beardsley's friends were surely required to be unusually good sports, as in the case of the grotesque vignette on page 23 of *Bon-Mots* (1894) by Charles Lamb and Douglas Jerrold (see Figure 1–19), which was reputedly a caricature of Beerbohm (Reade, *AB* n. 216), the atypical scowl notwithstanding.

6. Katti Lanner, whose ballets cost as much as £10,000 each, directed Genée and Lydia Kyasht at the Empire Music Hall. She had learned her art from Fanny Elssler, famous dancer and mistress of Napoleon's exiled duke of Reichstadt. At the end of each evening's performance, the choreographer Lanner would take a bow, dressed in stiff and heavy brocade, hiding her gray hair under a flaxen wig, and wearing the gold chain that Elssler had given her as a child (Deghy and Waterhouse 80).

Chapter 6 The Rhetoric of Parody: Signing and Resigning the Canon

1. Given the many paradoxes of the Decadence, it is important to remember that the word *paradox* has, like parody, a double meaning. It de-

rives from *doxa*, meaning "opinion," as in "accepted opinion," and from *para*, meaning both "against" and "beside." The first two meanings in the *OED* are (1) "A statement or tenet contrary to received opinion or belief; . . . sometimes with unfavourable connotation, as being discordant with what is held to be established truth . . . ; sometimes with favourable connotation, as a correction of vulgar error"; and (2) "A statement or proposition which on the face of it seems self-contradictory, absurd, or at variance with common sense, though, on investigation or when explained, it may prove to be well-founded. . . ." That is, ironically, like Beardsley's ambivalent pictures, which manifest both the urge to outrage and a craving for authority, paradox itself stands as both a contradiction and a confirmation of truth.

2. Prefiguring Oscar Wilde's positivist merger of aestheticism with a rather anarchic utopian socialism, the second issue of Anatole Baju's journal *Le Décadent* (17 April 1886) proclaimed that *Décadisme* united revolutionary aestheticism and social involvement, being simply the awareness and acceptance of modernity—what the staff writer Pierre Vareilles called "la marche ascensionelle de l'humanité" [the upward march of humanity] (1). As Matei Calinescu notes, Decadence and modernity "coincide in their rejection of the tyranny of tradition" (170–71).

3. One of the most obvious examples of Beardsley's restlessness was his increasing boredom with the long *Morte Darthur* project, despite his many stylistic experiments within it. Haldane MacFall relates that Dent was so anxious over Beardsley's "exasperating procrastination" in delivering the later drawings that he finally enlisted Beardsley's mother to help prod the artist. Beardsley's reported response on this occasion was apparently typical: "Mrs. Beardsley went upstairs at once to see Beardsley, who was still in bed, and to remonstrate with him on Dent's behalf. Beardsley, but half awake, lazily answered his mother's chiding with a characteristic limerick:

There was a young man with a salary
Who had to do drawings for Malory:
When they asked him for more, he replied,
 "Why? Sure

You've enough, as it is, for a gallery."
 (AB 40–41; see also Lane, ALS to E.
 Beardsley, n.d)

Coincidentally, Colin White theorizes that Beardsley's shift from the fine details of the early *Morte Darthur* drawings to a more abstract and decorative style later in the project reflected his boredom, specifically his practical need to save time and energy that the detailed work of the earlier style precluded (6). Ironically, Beardsley's rapid development and shifts of style often led him to parody even himself, in the sense that by the time he had completed a project "he had so outdistanced the phase of his development in which he had begun it that he had to create forgeries of his earlier style in order to complete the work" (Weintraub, AB 81).

4. Beardsley was surely familiar with Philip Gilbert Hamerton's acclaimed and controversial series of five Platonic dialogues, which had run in his journal *Portfolio* in 1888 and which discussed the competition between illustrations and the illustrated text—the same Philip Gilbert Hamerton whom Henry Harland and Beardsley later asked to review (separately) the letterpress and pictures of the first number of *The Yellow Book*. Certainly Beardsley kept up with the running debate the controversy generated in various art journals in the early nineties (see Shewan 133–35). It may, in fact, have been another indication of Beardsley's cunning talent for political extremism that in the first issue of *The Yellow Book* he persuaded his coeditor, Harland, to title the two contents pages "Letterpress" and "Pictures"—a division that, instead of implying an equality between the two elements, actually demeaned literature. As Hamerton pointed out in the second issue, " 'letterpress' is usually understood to mean an inferior kind of writing, which is merely an accompaniment to something else, such as engravings, or even maps" (179).

5. Psychoanalysis has revealed that even rebellious and ridiculing "play" is a tacit acknowledgment of, and an attempt to dominate, the ruling outer world—an attempt, furthermore, ultimately "founded on the approval of those in authority" (Kris 211).

6. Baudrillard notes that just as the artist's

"signature" style evokes his own *oeuvre* and activates the *oeuvre*'s semiotic dominance over the particular meaning of any one work, so the artist's use of canonical convention necessarily evokes and asserts the dominance ("perpetual commentary") of past masters (*Sign* 102–5). Like so many avant-garde artists of the fin de siècle, Beardsley in effect mirrored Jacques Derrida's version of Thoth, the mythical Egyptian god of wisdom and learning, who "takes its shape from the very thing it resists and substitutes for":

> In distinguishing himself from his opposite, Thoth also imitates it, becomes its sign and representative, obeys it and *conforms* to it, replaces it, by violence if need be. He is thus the father's other, the father, and the subversive movement of replacement. . . . Sly, slippery, and masked, an intriguer and a card, like Hermes, he is neither king nor jack, but rather a sort of *joker*, a floating signifier, a wild card, one who puts play into play. (*Dissemination* 93)

7. In this connection Ortega notes that the word *author* derives "from *auctor*, he who augments. It was the title Rome bestowed upon her generals when they had conquered new territory for the City" (31).

8. An 1897 letter to Smithers makes clear how much Beardsley appreciated the fact that photographic line-block reproduction made the original drawing superfluous: "Once blocks are made I don't worry any longer about possible loss of or accident to drawings. It will also leave you free to dispose of them at any moment. I beg of you to do this. I quite understand your delay in announcing the immortal fact of my working on *Volpone*. After Christmas will be more sensible and you can send a prospectus with the announcement. Have it all over the place" (*Letters* 404).

9. Beardsley loved Wagner's music, dating from his early London years going to Wagnerian opera with Frederick Evans and from his association with Alfred Gurney, Wagner devotee and High Church parson at Saint Barnabas's in Pimlico (Weintraub 36; Reade, "AB" 15). Beardsley once claimed, "I would do anything and go anywhere—if I could—to hear Wagner's music," and Beerbohm confirmed that Beardsley rarely missed a "'Wagner night' at Covent Garden" (A. Lawrence 196; Beerbohm, "AB" 546). Beardsley had

particular opportunity to indulge his ardent enthusiasm in the summer seasons of 1892–94, which marked the London debut of Wagner sung in German. During the special-subscription "German season" (each Wednesday night) of June–July 1892, the Covent Garden manager Augustus Harris produced the entire Nibelungen Ring, in addition to performances of *Tristan and Isolde* and *Fidelio*, starring Max Alvary in the principal male roles. The series began on 8 June with *Siegfried*, followed on 15 June by *Tristan*. Alvary and the famous Hungarian-born soprano Katherina Klafsky were so well received that two performances of *Tannhäuser* were specially arranged on 16 and 22 July for them to sing together again (Rosenthal 246–49). Beardsley made drawings commemorating Alvary's and Klafsky's performances (Reade, AB 32 and 28), in addition to exercising his passion for Wagner in such pictures as *Siegfried, Act II* (Reade 164). In May 1893 Beardsley was present for at least one Wagner performance (of *Tristan*) in Paris and made sure to return to London in time for the beginning of the June-July season, which presented *Tannhäuser, Der fliegende Holländer,* and *Die Meistersinger* in Italian and *Tristan und Isolde, Die Walküre,* and *Siegfried* in German, again with Alvary. While there was no German opera at Covent Garden in 1894, Beardsley likely attended the series of performances Harris arranged at Drury Lane with a company that included Alvary and Klafsky (Rosenthal 256–57).

10. Nietzsche considered the "need for redemption"—whether expressed through Christianity or revolution or aestheticism (or all three simultaneously)—to be the vile "quintessence of all Christian needs" and, not incidentally, "the most convinced, most painful affirmation of decadence" (*Wagner* 164–65, 191). But such a "decadent" need for salvation was apparently no more "vile" to Beardsley than to Wagner. In addition to his love of the music, Beardsley's passion for Wagner was evident in the fact that he eagerly sought (and later explicitly prohibited Smithers from selling) the four-volume prose works of Wagner. In fact, when ill and lonely, he would write to Smithers that "Wagner alone consoles me somewhat" (*Letters* 162–64, 171, 380).

11. Another of Beardsley's heroes, Baudelaire, wrote in "Richard Wagner et Tannhäuser à Paris" (1861), which Beardsley may well have

seen reprinted in *L'Art Romantique* (1868), that Wagner rendered "all that is excessive, immense, ambitious in both spiritual and natural man. . . . languorous delights, lust at fever heat, moments of anguish, and a constant returning towards pleasure, which holds out hope of quenching thirst but never does, raging palpitation of heart and senses, imperious demands of the flesh" (*SW* 332, 342; *AR* 208, 221). In Wagner, said Baudelaire in a passage that Beardsley surely would have appreciated, "the enjoyment of the flesh must lead, by an inescapable satanic logic, to the delights of crime" (*SW* 342–43; *AR* 222).

12. Edward Burne-Jones's prejudice against caricature was typical. His youthful artistic "practical jokes" notwithstanding, Burne-Jones's dreamy romanticism and nostalgic languor admitted little tolerance for the grotesque, the macabre, or the satirical. He beseeched his son Philip, who drew excellent caricatures, never to exhibit them publicly—on the ground that they were too low a form of art (Cecil, *Visionary* 140).

13. Malcolm Easton suggests that Beardsley was probably more than a little irritated by Wilde's self-deluding Olympian hypocrisy about the "pure" love of Michelangelo and Praxiteles. In the first place, even ignoring Wilde's lower-class rendezvous, there was little "beautiful" or "fine" about the temperamental Douglas, whom (because of the fiasco surrounding the *Salome* translation) Beardsley had particular reason to dislike. Second, Beardsley may have been among those who found it ironic that

> the connoisseur himself had elected to live in what would then have been described as a "bijou town residence" (No. 16 Tite Street, with Godwin's white woodwork wriggling round it), at the same time, demonstrating his taste in pictures by hanging up for contemplation Simeon Solomon's "Triumph of Love," a Monticelli and a favourite self-portrait from the brush of a mediocrity called Pennington. (53)

14. Milly Heyd cites another likely source for Beardsley's tossed rose, a scene from one of his favorite children's books, Kate Greenaway's *Under the Window*, in which the mother throws down a rose from the window to her child below (102). Beardsley here twists mother-child love into an ironic homosexual Pietà, assisted perhaps by the

equivocal coding that associated the rose with the female body, while associating the rosebud (like the narcissus) with "both self-eroticism and homosexuality" (Kuryluk 116).

15. In this autobiographical sense, the figures in Beardsley's *Rape* drawings may have been even more "biogrammatic" than they seem. Jacques-Emile Blanche, who did a portrait of his friend in 1895, described the two beauty marks on Beardsley's face as similar to those decorating the faces of society ladies or the "jeune héros" of Hogarth (*David* 117); and the mole on the cheek of the kneeling baron is very much like Beardsley's own facial mole.

16. The popularity among the Impressionists of the "cut-off" technique, which approximated the "misframed" action snapshot in photography, may have resulted in no small part from their friendship with Nadar (Félix Tournachon), one of the leading photographers of the time and whose premises on the boulevard des Capucines was used for the epoch-making Impressionist exhibition of 1874.

17. While Beardsley and Lautrec were in no way close (they first met only in 1895), their mutual admiration was clear. Lautrec openly praised Beardsley's work; and Beardsley's childhood friend Charles Cochran, whom George Moore introduced to Lautrec at the Café Royal, attests that Lautrec "was very interested in Beardsley" (*Showman* 66). Maria Cionini Visani reports that it was in Lautrec's studio that Beardsley first tried hashish [in February 1896], and Lautrec was one of the people Beardsley singled out to be sent a copy of his *Book of Fifty Drawings* (Visani 11). Visani is here almost surely confusing Henri de Toulouse-Lautrec with his first cousin (and frequent contributor to the avant-garde magazine *Le Courrier Français*, Gabriel de Lautrec (see *Letters* 231; *The Letters of Ernest Dowson*, 345). Beardsley's drawings had often appeared in the pages of *Le Courrier français*, and Gabriel de Lautrec, a Beardsley friend, gave *The Savoy* (and Beardsley's work particularly) many enthusiastic notices; his rave review of the initial issue cited Beardsley's "frail and tormented grace, a light and sometimes caricatural sensuality" [la grâce frêle et tourmentée, la sensualité légère et parfois caricaturale] that "seems to hide a haunting and perverse secret" [semble cacher un secret obsédant et pervers] (*Le Courrier*

Français, 2 February 1896: 8). Since Henri and his cousin Gabriel were good friends and almost inseparable companions during much of the early nineties, Visani's confusion is in this case probably insignificant.

18. Many writers of the time saw Yvette Guilbert as "the incarnation of decadence, the muse of the fin-de-siècle period, at once tragic and comic, vulgar and refined"—a hermaphroditic symbol described by dramatist Henri Lavedan as "une grande affiche macabre et insolente qui fait froid dans le dos . . . une dame en cire d'Edgard Poë qui aurait un phonographe dans le ventre" [a great, ghastly, impudent poster which sends a shiver down your back . . . a waxwork woman from a story by Edgar Poe, with a phonograph inside her] (quoted in Guilbert and Simpson 229).

19. Claire Frèches-Thory suggests that the young Jeanne Duval may well have taken her new name, Jane Avril, "from the heroine of a novel by Robert de Bonnières, *Jeanne Avril*, Paris, 1887" (*Toulouse-Lautrec* 291 n. 1).

20. Beardsley had Blanche present Dujardin with a copy of his celebrated picture *The Wagnerites* in the hope that it might interest him (Blanche, *Portraits* 96). Dujardin, whom Beardsley saw often in Dieppe, appearing "fantastic in 1830s clothes—crimson waistcoat, brass buttons, tight dove grey trousers strapped under varnished leather pumps" (Blanche, *More Portraits* 162), was also Beardsley's model for the inquisitive boy in 1830s costume in his poem "The Three Musicians" (Robins 41).

21. Lautrec followed this poster with an illustration for *Le Figaro Illustré* (July 1893), *Aux Ambassadeurs: Gens Chic*, which depicts Charles Conder and a female companion seated at a café table, with Guilbert appearing once again as a subordinate figure distantly on stage at the extreme left of the picture. The irony of both posters is enhanced by the fact that at the beginning of the nineties, each evening prior to her performances at the Divan Japonais, Guilbert sang at the Moulin Rouge, one of whose rival attractions (and the person who would soon replace her as the evening's entertainment) was Jane Avril. There is evidence that Beardsley had Lautrec's poster in mind when he conceived his title drawing. Beardsley had been a fan of Guilbert's and had sent her a presentation copy of *The Rape of the Lock*, with a card bearing the inscription "à mademoiselle Yvette Guilbert / hommage de Aubrey Beardsley," following her appearance at the Empire Theatre on 6 May 1896 (*Letters* 132). Arthur Symons was a close friend of Guilbert's and had earlier sent her a copy of the second issue of *The Savoy*, which contained the title drawing *The Rape of the Lock*, whereupon Guilbert conveyed to Beardsley "toute mon admiration" and lavishly praised his "élégance," "talent of conception," and "*distinction dans les lignes de ses dessins*" (ALS, Rylands Library).

22. There is little doubt that Beardsley was familiar with this particular Hogarth series. Indeed, Jacques-Emile Blanche was quick to compare his friend with "the young hero in *Marriage à la Mode*" (*Portraits* 95).

23. Comte Georges de Buffon, the French naturalist whose monumental thirty-six-volume *Histoire Naturelle* (1749–88) would lay the foundation for later studies in biology, zoology, and comparative anatomy, attributed to black-skinned people "a lascivious, apelike sexual appetite," thus "introducing a commonplace of early travel literature into a pseudoscientific context" (Gilman, "Hottentot" 83).

24. The engravings of Hogarth's *Marriage à la Mode* were etched onto the copper plate with the same orientation as in his famous *Marriage à la Mode* paintings (now in the National Gallery, London). Consequently, the engravings, when printed, appeared as the reverse of the paintings. My locational directions regarding various figures and details in the picture refer to the engraving, reproduced as Figure 6–21.

25. Jacques Derrida points out that if every concept (and convention) belongs to a systematic socio-linguistic chain, no concept being of itself "metaphysical," then any workable "deconstruction" of it must effect "a *reversal* of the classical opposition *and* a general *displacement* of the system"; otherwise, the "deconstruction" would be only repeating (re-citing) the ruling order's "sentence" ("Signature Event Context" 195). Beardsley's art is a particularly intriguing record of the fin de siècle's attempt to grapple with this age-old dilemma.

Works Cited

A.K. "Aubrey Beardsley." *Outlook* 3 (8 April 1899): 323–24.

Adams, Steven. *The Art of the Pre-Raphaelites.* London: Quintet, 1988.

Adlard, John. "Poetry and the Stage-Doors of the Nineties." *Review of English Literature* 7 (Oct. 1966): 50–60.

Althusser, Louis. *For Marx.* Trans. Ben Brewster. New York: Pantheon, 1969.

Altick, Richard D. *The Shows of London.* Cambridge: Harvard UP, 1978.

Amaya, Mario. *Art Nouveau* (1966). London: Studio Vista, 1971.

Anon. Commentary on drawing no. 43 (cover design for *The Yellow Book*, vol. 2 [July 1894]) in John Lane Sale, 22 Nov. 1926. AM 19783, Box 1, A. E. Gallatin Collection of Aubrey Beardsley. Published with permission of the Manuscripts Division, Department of Rare Books and Special Collections, Princeton University Libraries, Princeton, N.J.

————. Review of *The Yellow Book*, vol. 1. *Academy* 28 April 1894: 349.

————. Review of *The Yellow Book*, vol. 2. *Academy* 28 July 1894: 67.

————. Review of *The Yellow Book*, vol. 2. *Daily Chronicle* 12 July 1894: 3.

————. "Mr. Aubrey Beardsley."*Leslie's Weekly* 83 (6 Aug. 1896): 90.

————. Rev. of Beardsley's art in *The Studio. London Figaro* 20 April 1893: 13.

————. Rev. of *The Yellow Book*, vol. 1. *National Observer* 11.283 (21 April 1894): 588–89.

————. "A Xanthopiate." Rev. of *The Yellow Book*, vol. 3. *National Observer* 13.313 (17 Nov. 1894): 23.

————. Report of Wilde's arrest. *National Observer* 13.333 (6 April 1895): 547.

————. Rev. of *Salome. Public Opinion* 24 Nov. 1893: 660.

————. Rev. of *The Yellow Book. Queen* 21 April 1894: 628.

————. "*Salome*." Rev. of *Salome* pictures. *Saturday Review* (London) 77 (24 March 1894): 317.

————. Rev. of *The Yellow Book*, vol. 3. *Saturday Review* (London) 78 (27 Oct. 1894): 469.

————. Rev. of *The Rape of the Lock. Saturday Review* (London) 83.2164 (17 April 1897): 426.

————. "Apostle of the Grotesque." *Sketch* 9.115 (10 April 1895): 561–62.

————. "What the 'Yellow Book' Is to Be." *Sketch* 5.63 (11 April 1894): 557–58.

————. "New Publications." Rev. of *Le Morte d'Arthur* and *Salome. Studio* 2 (15 Feb. 1894): 183–85.

————. "Arrest of Mr. Oscar Wilde." *Times* (London) 6 April 1895: 10.

————. Beardsley obituary.*Times* (London) 18 March 1891: 10.

————. Rev. of *Salome* pictures. *Times* (London) 8 March 1894: 12.

————. Rev. of *The Yellow Book. Times* (London) 20 April 1894: 3.

————. "The New Master of Art: Mr. Aubrey Beardsley." *To-Day* 12 May 1894: 28–29.

————. "Aubrey Beardsley: In Memoriam." *Westminster Budget* 11.18 (25 March 1898): 9–10.

————. "The *Yellow Book*." *Westminster Gazette* 18 April 1894: 3.

————. Review of Beardsley's *A Book of Fifty Drawings. Westminster Review* 147.5 (May 1897): 596.

Armour, Margaret. "Aubrey Beardsley and the Decadents." *Magazine of Art* (Nov. 1896): 8–12.

Arnold, Matthew. "The Function of Criticism at the Present Time," *Lectures and Essays in Criticism.* Vol. 3 of *The Complete Prose Works of Matthew Arnold.* Ed. R. H. Super. Ann Arbor: U. of Michigan P, 1962. 258–85.

Ashwin, Clive. "Graphic Imagery, 1837–1901: A Victorian Revolution." *Art History* 1.3 (Sept. 1978): 360–70.

Auerbach, Nina. *Woman and the Demon: The Life of a Victorian Myth.* Cambridge: Harvard UP, 1982.

Bakhtin, Mikhail. *The Dialogic Imagination: Four Essays.* Ed. Michael Holquist. Trans. Caryl Emerson and Michael Holquist. Austin: U of Texas P, 1981.

————. *Rabelais and His World.* 1965. Trans. Hélène Iswolsky. Bloomington: Indiana UP, 1984.

Balzac, Honoré. "Traité de la Vie Élégante." In *Oeuvres Diverses II.* Vol. 39 of *Oeuvres complètes.* Ed. Marcel Bouteron and Henri Longnon. 40 vols. Paris: Conard, 1938. 152–85.

Barbey d'Aurevilly, Jules. *Dandyism.* Trans. Douglas Ainslie. London, 1897; New York: PAJ, 1988.

Barnam, R. ALS to John Lane. Bilsby House, Alford, Lincolnshire, 17 November 1920. AM 18622, Box 5, A. E. Gallatin Collection of Aubrey Beardsley. Published with permission of the Manuscripts Division, Department of Rare Books and Special Collections, Princeton University Libraries, Princeton, N.J.

Barnett, Pat. "Some Aspects of Symbolism in the Work of Aubrey Beardsley." *Antigonish Review* 1.4 (1971): 33–45.

Barnicoat, John. *Posters: A Concise History.* London: Thames and Hudson, 1972.

Barthes, Roland. *S/Z.* 1970. Trans. Richard Miller. New York: Hill and Wang, 1974.

Bataille, Georges. *Death and Sensuality: A Study of Eroticism and the Taboo.* 1962. New York: Ballantine, 1969.

————. *Visions of Excess: Selected Writings, 1927–1939.* Ed. and intro. Allan Stoekl. Trans. Allan Stoekl, Carl R. Lovitt, and Donald M. Leslie, Jr. Minneapolis: U of Minnesota P, 1985.

Baudelaire, Charles. *Oeuvres Complètes de Charles Baudelaire.* Ed. Y.-G. Le Dantec. Paris: Gallimard, 1961.

————. *L'Art Romantique.* Vol. 3 of *Oeuvres Complètes de Charles Baudelaire.* Ed. M. Jacques Crépet. 19 vols. Paris: Conard-Lambert, 1922–65.

————. *Curiosités Esthétiques.* Vol. 2 of *Oeuvres Complètes de Charles Baudelaire.* Ed. M. Jacques Crépet. 19 vols. Paris: Conard-Lambert, 1922–65.

————. "Pierre Dupont." *Baudelaire as a Literary Critic.* Ed., intro., and trans. Lois Boe Hyslop and Francis E. Hyslop. University Park: Penn State UP, 1964. 51–61.

————. *Selected Writings on Art and Artists.* Trans. and intro. P. E. Charvet. Harmondsworth, Eng.: Penguin, 1972.

Baudrillard, Jean. *For a Critique of the Political Economy of the Sign.* Trans. Charles Levin. St. Louis: Telos, 1981.

————. *Selected Writings.* Ed. and intro. Mark Poster. Stanford: Stanford UP, 1988.

Bazarov, Konstantin. "An Aroma of Sin." *Art and Artists* 14 (May 1979): 34–39.

Beardsley, Aubrey. "The Art of Hoarding." *New Review* 11 (July 1894): 53–55. [MS (donated by Mrs. Belloc Lowndes), Box 2, A. E. Gallatin Collection of Aubrey Beardsley. Published with permission of the Manuscripts Division, Department of Rare Books and Special Collections, Princeton University Libraries, Princeton, N.J.

————. "Aubrey Beardsley Will." MS. 160/3/1 [Copy from Somerset House, 16 Jan. 1933]. University of Reading Library, Reading, Eng.

————. "The Ballad of a Barber." *Savoy* 3 (July 1896): 90–93.

————. *A Beardsley Miscellany.* Ed. R. A. Walker. London: Bodley Head, 1949.

————. Illustrations in *Le Morte Darthur.* By Sir Thomas Malory. 1893. 5th ed. London: Dent, 1988.

————. *The Letters of Aubrey Beardsley.* Ed. Henry Maas, J. L. Duncan, and W. G. Good.

Rutherford, N.J.: Fairleigh Dickinson UP, 1970.

————. "Notes for *Volpone* prospectus." MS, Box 2, A. E. Gallatin Collection of Aubrey Beardsley. Published with permission of the Manuscripts Division, Department of Rare Books and Special Collections, Princeton University Libraries, Princeton, N.J.

————. "The Story of a Confession Album." *Tit-Bits* 4 January 1890: 203.

————. "The Story of Venus and Tannhäuser." MS. EL4\.B368u. Rosenbach Museum and Library. Philadelphia, Penn.

————. *The Story of Venus and Tannhuser.* Aesthetes and Decadents of the 1890s. Intro. and notes Karl Beckson. Chicago: Academy Chicago, 1981. 11–46.

————. "Table Talk."*Under the Hill and Other Essays in Prose and Verse by Aubrey Beardsley.* 1904. Intro. Edward Lucie-Smith. London: Paddington, 1977. 81–83.

————. *The Uncollected Work of Aubrey Beardsley.* Ed. and intro. C. Lewis Hind. London: John Lane, Bodley Head, 1925.

————. "*Under the Hill.*" *Savoy* 1 (January 1896): 151–70; 2 (April 1896): 187–97.

————. "Volpone Prospectus." *Beardsley Miscellany.* Ed. R. A. Walker. London: Bodley Head, 1949. 86–88. [Published form of Princeton MS]

————. Beardsley, Ellen Agnus. ALS to Mabel Beardsley. 32 Montpelice Street, Brighton, 10 Dec. [1904]. AM 14617, Box 1, J. Harlin O'Connell Collection. Published with permission of the Manuscripts Division, Department of Rare Books and Special Collections, Princeton University Libraries, Princeton, N.J.

————. ALS to John Lane, n.d. [1920s]. Lane Archives. University of Texas at Austin.

————. ALS to Robert Ross, Wednesday, n.d. Privately owned by J.-P. B. Ross.

————. ALS to Robert Ross, September 1893. Privately owned by J.-P. B. Ross.

————. ALS to Robert Ross, 19 November 1896. Privately owned by J.-P. B. Ross.

————. "Aubrey Beardsley."*A Beardsley Miscellany.* Ed. R. A. Walker. London: Bodley Head, 1949. 75-83. [Published form of the two Princeton MSS "Aubrey Beardsley" and "Recollections"]

————. "Aubrey Beardsley Aug 21st 1872 / March 16th 1898." MS, Box 5, A. E. Gallatin Collection of Aubrey Beardsley. Published with permission of the Manuscripts Division, Department of Rare Books and Special Collections, Princeton University Libraries, Princeton, N.J.

————. "Recollections of Mrs. Beardsley's Conversation at 8 Lancaster Gate Terrace, Dec: 23rd, 1920" [recorded by R. A. Walker]. TS. AM 18622, Box 5, A. E. Gallatin Collection of Aubrey Beardsley. Published with permission of the Manuscripts Division, Department of Rare Books and Special Collections, Princeton University Libraries, Princeton, N.J.

Beardsley, Mabel. ALS to Leonard Smithers. Gaiety Theatre, Hastings, 3 Oct. [?] AM 15516, Box 5, A. E. Gallatin Collection of Aubrey Beardsley. Published with permission of the Manuscripts Division, Department of Rare Books and Special Collections, Princeton University Library, Princeton, N.J.

Beckson, Karl. *Arthur Symons: A Life.* Oxford: Clarendon, 1987.

————. "The Artist as Transcendental Phallus: Aubrey Beardsley and the Ritual of Defense." *Reconsidering Aubrey Beardsley.* Ed. Robert Langenfeld. Ann Arbor, Mich.: UMI Research P, 1989. [207]–26.

————. *Henry Harland: His Life and Work.* London: Eighteen Nineties Society, 1978.

Beerbohm, Max. "Aubrey Beardsley." *Idler* 13.4 (May 1898): [539]–46. (Rpt. in *The Incomparable Max: A Collection of Writings of Sir Max Beerbohm.* New York: Dodd Mead, 1962. 85–93.)

————. "Dandies and Dandies."*The Incomparable Max: A Collection of Writings of Sir Max Beerbohm,* 1–17. New York: Dodd Mead, 1962.

————. "A Defense of Cosmetics." *Yellow Book* 1 (April 1894): 65–82.

————. "Ex Cathedra V: Mr. Beardsley's Fifty Drawings." *To-morrow* 3 (1897): 28–35.

————. "First Meetings with W. B. Yeats." *Listener* 53 (6 Jan. 1955): 15–16.

————. *The Letters of Max Beerbohm, 1892–*

1956. Ed. Rupert Hart-Davis. New York: Norton, 1988.

————. *Max Beerbohm's Letters to Reggie Turner*. Ed. Rupert Hart-Davis. Philadelphia: Lippincott, 1964.

————. "The Spirit of Caricature." *The Incomparable Max: A Collection of Writings of Sir Max Beerbohm*. New York: Dodd Mead, 1962. 94–103.

————. *The Works of Max Beerbohm*. New York: Scribner's, 1896.

Benjamin, Walter. *Charles Baudelaire: A Lyric Poet in the Era of High Capitalism*. Trans. Harry Zohn. London: New Left Review, 1973.

————. "The Work of Art in the Age of Mechanical Reproduction." Trans. Harry Zohn. *Illuminations*. Ed. and intro. Hannah Arendt. New York: Schocken, 1969. 217–51.

Benkovitz, Miriam J. *Aubrey Beardsley*. New York: Putnam's, 1981.

Bird, Alan. *The Plays of Oscar Wilde*. New York: Barnes and Noble, 1977.

Birnbaum, Martin. "Aubrey Beardsley." *Introduction: Painters, Sculptors, and Graphic Artists*. New York: Sherman, 1919. 3–14.

————. *Jacovleff and Other Artists*. New York: P. A. Struck, 1946.

Blanche, Jacques-Emile. *De David à Degas*. Paris: Editions Emile-Paul Frères, 1927.

————. *More Portraits of a Lifetime, 1918–1938*. Trans. and ed. Walter Clement. London: Dent, 1939.

————. *Portraits of a Lifetime: The Late Victorian Era: The Edwardian Pageant, 1870–1914*. Trans. and ed. Walter Clement. New York: Dent, 1937.

————, ed. Preface. *Sous la Colline*. Paris: Floury, 1908. 13–31.

Bloom, Harold. *The Anxiety of Influence*. 1973. New York: Oxford UP, 1975.

Blunt, Hugh F. "Aubrey Beardsley—A Study in Conversion." *Catholic World* 134.804 (March 1932): 641–50.

Borland, Maureen. *Wilde's Devoted Friend: A Life of Robert Ross, 1869–1918*. Oxford: Lennard, 1990.

Bradbury, Malcolm. "The Eighteen Nineties: Two Interpreters." *ELT* special series 4 (1990): 35–42.

Brophy, Brigid. *Beardsley and His World*. New York: Harmony, 1976.

————. *Black and White: A Portrait of Aubrey Beardsley*. 1968. New York: Stein and Day, 1970.

Burdett, Osbert. *The Beardsley Period*. 1925. New York: Cooper Square, n.d.

Burne-Jones, Edward. TLS to Aubrey Beardsley. West Kensington, n.d. MS. 160/1. University of Reading Library, Reading, Eng.

Busst, A. J. L. "The Androgyne." *Romantic Mythologies*. Ed. Ian Fletcher. New York: Barnes and Noble, 1967. 1–95.

Calinescu, Matei. *Faces of Modernity: Avant-Garde, Decadence, and Kitsch*. Bloomington: Indiana UP, 1977.

Carnochan, W. B. "Swiftiana: Beardsley's Illustrations of Swift." *Scriblerian* 9 (1976): 57–60.

Carter, Alfred Edward. *The Idea of Decadence in French Literature, 1830–1900*. Toronto: U of Toronto P, 1958.

Cecil, David. *Max: A Biography*. 1964. Boston: Houghton Mifflin, 1965.

————. *Visionary and Dreamer, Two Poetic Painters: Samuel Palmer and Edward Burne-Jones*. Bollingen Series 35: 15. Princeton, N.J.: Princeton UP, 1969.

Chamberlin, J. E. "From High Decadence to High Modernism." *Queen's Quarterly* 87 (1980): 591–610.

————. *Ripe Was the Drowsy Hour: The Age of Oscar Wilde*. New York: Seabury, 1977.

Charney, Maurice. *Sexual Fiction*. London: Methuen, 1981.

Charteris, Evan. *The Life and Letters of Sir Edmund Gosse*. London: Heinemann, 1931.

Clark, Kenneth. *The Best of Aubrey Beardsley*. New York: Doubleday, 1978.

Clarke, Isabel C. "The Last Days of Aubrey Beardsley." *Thought* 7 (1933): 548–59.

Clayborough, Arthur. *The Grotesque in English Literature*. 1965. Oxford: Clarendon, 1967.

Cochran, Charles B. "Aubrey Beardsley at School." *Poster and Art Collector* 1 (Aug.–Sept. 1898): 102–5.

————. *The Secrets of a Showman*. New York: Holt, 1926.

Collins, Richard Wayne. *A Toy of Double Shape: The Hermaphrodite as Art and Literature in Nine-*

teenth-Century Britain. Ann Arbor: University Microfilms International, 1986.

Cooper, Emmanuel. *The Sexual Perspective: Homosexuality and Art in the Last 100 Years in the West.* New York: Routledge, 1986.

Cooper, J. C., ed. *An Illustrated Encyclopedia of Traditional Symbols.* London: Thames and Hudson, 1978.

Cortissoz, Royal. "Art: Aubrey Beardsley's Place in the Artistic History of the Nineties." *New York Herald Tribune* 31 Jan. 1928: 16.

Cottom, Daniel. *Text and Culture: The Politics of Interpretation.* Minneapolis: U of Minnesota P, 1989.

Cowley, Robert L. S. *Marriage à-la-Mode: A Review of Hogarth's Narrative Art.* Manchester, Eng.: Manchester UP, 1983.

Crackenthorpe, David. *Hubert Crackenthorpe and English Realism in the 1890s.* Columbia: U of Missouri P, 1977.

Cramer, Thomas. *Der Groteske bei E. T. A. Hoffmann.* Munich: Fink, 1966.

Crane, Walter. *An Artist's Reminiscences.* New York: Macmillan, 1907.

———. *William Morris to Whistler.* London: Bell, 1911.

Crawford, Ian. "The Café Royal of the Nineties." *The Café Royal Story.* Ed. Leslie Frewin. London: Hutchinson Benham, 1963. 21–29.

Culler, Jonathan. *Ferdinand de Saussure.* 1976. New York: Penguin, 1977.

Deghy, Guy, and Keith Waterhouse. *Café Royal: Ninety Years of Bohemia.* London: Hutchinson, 1955.

Dellamora, Richard. "Traversing the Feminine in Oscar Wilde's *Salome.*" *Victorian Sages and Cultural Discourse: Renegotiating Gender and Power.* Ed. Thaïs E. Morgan. New Brunswick, N.J.: Rutgers UP, 1990. 246–64.

Deneys, Anne. "The Political Economy of the Body in the *Liaisions Dangereuses* of Choderlos de Laclos." *Eroticism and the Body Politic.* Ed. Lynn Hunt. Baltimore: Johns Hopkins UP, 1991. 41–62.

Dent, J. M. *The Memoirs of J. M. Dent.* London: Dent, 1928.

Derrida, Jacques. *Dissemination.* Trans., intro., and notes Barbara Johnson. 1972. Chicago: U of Chicago P, 1981.

———. *Glas.* Paris: Editions Galilée, 1974.

———. "Signature Event Context." *Glyph 1.* Ed. Samuel Weber and Henry Sussman. Baltimore: Johns Hopkins UP, 1977. 172–97.

Dortu, M. G., and J. A. Méric. *Toulouse-Lautrec: The Complete Paintings.* 2 vols. Trans. Hilary E. Paddon and Catherine Atthill. London: Granada, n.d.

Douglas, Alfred. *Oscar Wilde and Myself.* New York: Duffield, 1914.

Dowling, Linda C. "The Aesthetes and the Eighteenth Century." *Victorian Studies* 20.4 (Summer 1977): 357–77.

———. *Language and Decadence in the Victorian Fin de Siècle.* Princeton, N.J.: Princeton UP, 1986.

———. "Nature and Decadence: John Gray's *Silverpoints.*" *Victorian Poetry* 15.2 (Summer 1977): 159–69.

———. "*Venus and Tannhuser*: Beardsley's Satire of Decadence." *Journal of Narrative Technique* 8 (1978): 26–41.

Dowson, Ernest. *The Letters of Ernest Dowson.* Ed. Desmond Flower and Henry Maas. Rutherford, N.J.: Fairleigh Dickinson UP, 1967.

Easton, Malcolm. *Aubrey and the Dying Lady.* Boston: Godine, 1972.

Elliott, Bridget J. "Sights of Pleasure: Beardsley's Images of Actresses and the New Journalism of the Nineties." *Reconsidering Aubrey Beardsley.* Ed. Robert Langenfeld. Ann Arbor, Mich.: UMI Research P, 1989. 71–101.

Ellis, Havelock. *Impressions and Comments.* London: Constable, 1914.

———. *The New Spirit.* 1935. New York: Kraus Reprint, 1969.

Ellmann, Richard. *Oscar Wilde.* New York: Knopf, 1988.

[Evans, Frederick H.] F. H. E. "James John Garth Wilkinson: An Introduction." *Homoeopathic World* 1 Jan. 1912: 7–18.

Farmer, John Stephen, and W. E. Henley, eds. *Slang and its Analogues Past and Present; A Dictionary, Historical and Comparative, of the Heterodox Speech of all Classes of Society for more than Three Hundred Years, with Synonyms in English, French, German, Italian, etc.* 1896. 7 vols. New York: Kraus Reprint, 1965.

Fenichel, Otto. *Collected Papers.* 2 vols. New York: Norton, 1953–54.

Fermigier, André. *Toulouse-Lautrec.* New York: Praeger, 1969.

[Field, Julian Osgood] X.L. "The Kiss of Judas." *Pall Mall Magazine* July 1893: 339–66.

Fisher, Gerald H. "Who Overlooks *The Fat Woman?*" *British Journal of Aesthetics* 8 (Oct. 1968): 394–401.

Fitzgerald, Penelope. *Edward Burne-Jones: A Biography.* London: Michael Joseph, 1975.

Fletcher, Angus. *Allegory: The Theory of a Symbolic Mode.* 1964. Ithaca, N.Y.: Cornell UP, 1970.

Fletcher, Ian. *Aubrey Beardsley.* Boston: Twayne, 1987.

————. "Decadence and the Little Magazines." *Decadence and the 1890s.* Ed. Ian Fletcher. London: Edward Arnold, 1979. 172–202.

————. "A Grammar of Monsters: Beardsley's Obsessive Images and Their Sources." *English Literature in Transition, 1880–1920* 30.2 (1987): 141–63.

————. "Inventions for the Left Hand: Beardsley in Verse and Prose." *Reconsidering Aubrey Beardsley.* Ed. Robert Langenfeld. Ann Arbor, Mich.: UMI Research P, 1989. 227–66.

————. "A Study in Black and White: The Legend and Letters of Beardsley." *Times Literary Supplement* 14 Jan. 1972: 25–28.

Freud, Sigmund. "Beyond the Pleasure Principle." Vol. 18 of *Standard Edition of the Complete Psychological Works of Sigmund Freud.* 24 vols. Trans. James Strachey, Anna Freud, Alix Strachey, and Alan Tyson. Ed. James Strachey. London: Hogarth Press and Institute of Psychoanalysis, 1957. 1–64.

————. "The Theme of the Three Caskets" (1913). *On Creativity and the Unconscious.* Ed. Benjamin Nelson. New York: Harper and Row, 1958. 63–75.

Fry, Roger. *Vision and Design.* 1920. New York: Meridian, 1956.

Frye, Northrop. *The Modern Century.* 1967. New York: Oxford UP, 1969.

Fuller, John. "Frederick H. Evans as Late Victorian: Cathedral Photography Amid the Fin de Siècle." *Afterimage* 4 (Oct. 1976): 6–7, 18.

Gallatin, A[lbert]. E[ugene]. *Aubrey Beardsley: Catalogue of Drawings and Bibliography.* New York: Grolier Club, 1945.

Garbáty, Thomas Jay. "The French Coterie of the *Savoy,* 1896." *PMLA* 75 (1960): 609–15.

Gardner, Joseph H. "Beardsley And The Post-Romantic Venus." *Denver Quarterly* 13.4 (1979): 3–14.

Gaunt, William. *The Aesthetic Adventure.* 1945. New York: Schocken, 1967.

Gilbert, Elliot L. "'Tumult of Images': Wilde, Beardsley, and *Salome.*" *Victorian Studies* 26.2 (Winter 1983): 133–59.

Gilbert, John Selwyn. "Aubrey Beardsley: 'His Most Beautiful Pictures Brought about his Downfall.'" *Listener* 107 (21 Jan. 1982): 10–11.

————, writer and producer. "*Beardsley and His Work.*" Consultant Brian Reade. Transcript of BBC 2 broadcast 19 January 1982 [also 22 January 1982]. Box 1, A. E. Gallatin Collection of Aubrey Beardsley. Published with permission of the Manuscripts Division, Department of Rare Books and Special Collections, Princeton University Libraries, Princeton, N.J.

Gilman, Sander L. "The Hottentot and the Prostitute: Toward an Iconography of Female Sexuality." *Difference and Pathology: Stereotypes of Sexuality, Race, and Madness.* Ithaca, N.Y.: Cornell UP, 1985. 76–108.

————. "Sexology, Psychoanalysis, and Degeneration." *Difference and Pathology: Stereotypes of Sexuality, Race, and Madness.* Ithaca, N.Y.: Cornell UP, 1985. 191–216.

Girard, Réne. *Violence and the Sacred.* 1972. Trans. Patrick Gregory. Baltimore: Johns Hopkins UP, 1977.

Godfrey, Sima. "The Dandy as Ironic Figure." *Sub-Stance* 36 (1982): 21–33.

Gombrich, E. H. *Art and Illusion: A Study in the Psychology of Pictorial Representation.* 1960. Princeton, N.J.: Princeton UP, 1969.

Gomez Carrillo, Enrique. *En Plena Bohemia.* Vol. 16 in *Obras Completas.* 26 vols. Madrid: Editorial "Mundo Latino," n.d. [c. 1918–21].

Gordon, D. J. "Aubrey Beardsley at the V. & A." *Encounter* 27.4 (Oct. 1966): 3–16.

————. "Dilemmas: *The Studio* in 1893-4." *Studio International* April 1968: 175–84.

Gosse, Edmund. ALS to Aubrey Beardsley. 29 Delamere Terrace, Westbourne Square, W., 16 May 1896. Box 3, A. E. Gallatin Collection of Aubrey Beardsley. Published with permission of the Manuscripts Division, Department of Rare

Books and Special Collections, Princeton University Libraries, Princeton, N.J.

———. ALS to Aubrey Beardsley. 29 Delamere Terrace, Westbourne Square, W., 29 December 1896. Box 3, A. E. Gallatin Collection of Aubrey Beardsley. Published with permission of the Manuscripts Division, Department of Rare Books and Special Collections, Princeton University Libraries, Princeton, N.J.

———. ALS to [A. E. Gallatin]. 17 Hanover Terrace, Regents Park, N.W., 19 June 1902. Box 5, A. E. Gallatin Collection of Aubrey Beardsley. Published with permission of the Manuscript Division, Department of Rare Books and Special Collections, Princeton University Libraries, Princeton, N.J.

Gowing, Lawrence. *William Hogarth.* London: Tate Gallery, 1971.

Grasset, Eugène. *Méthode de Composition Ornementale.* Paris: Librairie Centrale des Beaux-Arts, n.d.

Gray, John. "Aubrey Beardsley." *The Selected Prose of John Gray.* Ed. Jerusha Hull McCormack. Trans. Alan Anderson. Greensboro, N.C.: ELT Press, 1992. 125–29. (Originally appeared in French in *La Revue Blanche* 16 (1898): 68–70.)

———, ed. Introduction. *The Last Letters of Aubrey Beardsley.* London: Longmans, 1904. v–ix.

Guilbert, Yvette. ALS to Arthur Symons. London, 6 May 1896. Box FR, John Rylands University Library, Manchester, Eng.

Guilbert, Yvette, and Harold Simpson. *Yvette Guilbert: Struggles and Victories.* London: Mills and Boon, 1910.

Haass, Sabine. " 'Speaking Flowers and Floral Emblems': The Victorian Language of Flowers." *Word and Visual Imagination.* ed. Karl Josef Höltgen, Peter M. Daly, and Wolfgang Lottes. Erlangen: Universitätsbibliothek Erlangen-Nurnberg, 1988. 241–67.

Halsband, Robert. *The Rape of the Lock and Its Illustrations, 1714–1896.* Oxford: Oxford UP, 1980.

Hamerton, Philip Gilbert. "*The Yellow Book*: A Criticism of Volume I." *Yellow Book* 2 (July 1894): 179–90.

Harland, Henry. "Aubrey Beardsley." *Academy* 55 (10 Dec. 1898): 437–38.

———. "To Edmund Gosse." Paris, Sunday [5 May 1895]. *Transatlantic Dialogue.* Ed. Paul F. Matthieson and Michael Millgate. Austin: U of Texas P, 1965. 231.

Harpham, Geoffrey Galt. "The Incompleteness of Beardsley's *Venus and Tannhäuser.*" *English Literature in Transition, 1880–1920* 18.1 (1975): 24–32.

———. *On the Grotesque: Strategies of Contradiction in Art and Literature.* Princeton, N.J.: Princeton UP, 1982.

Harris, Frank. *Oscar Wilde: His Life and Confessions.* New York: Covici, Friede, 1930.

Harris, Nathaniel. *The Art of Toulouse-Lautrec.* New York: Excalibur, 1981.

Harrison, Fraser. *The Dark Angel: Aspects of Victorian Sexuality.* 1977. New York: Universe, 1978.

Harrison, Martin, and Bill Waters. *Burne-Jones.* London: Barrie and Jenkins, 1973.

Hauser, Arnold. *Naturalism, Impressionism, the Film Age. Vol. 4 of The Social History of Art,* 1958. New York: Vintage, 1985.

Hegel, G. W. F. *Vorlesungen über die Aesthetik. Vol. 13 of Sämtliche Werke: Jubiläums-Ausgabe.* 26 vols. Stuttgart: Frommann, 1949–59.

Hemmings, F. W. *Culture and Society in France, 1848–1898: Dissidents and Philistines.* London: Batsford, 1971.

Heyd, Milly. *Aubrey Beardsley: Symbol, Mask, and Self-Irony.* New York: Peter Lang, 1986.

Hicks, Granville. *Figures of Transition: A Study of British Literature at the End of the Nineteenth Century.* New York: Macmillan, 1939.

[Hind, C. Lewis] Q.R. "Bookman's Memories." *Christian Science Monitor* 17 May 1921: 3.

Hind, C. Lewis. Introduction. *The Uncollected Work of Aubrey Beardsley.* London: Bodley Head, 1925. v–xxii.

———. Letter: "Aubrey Beardsley." *Evening Post* (New York) 31 May 1919: 8.

Hofstätter, Hans M., ed. *Aubrey Beardsley.* 1977. Trans. Pamela von Nostitz. New York: Barron's, 1979.

Hogarth, William. *"The Analysts of Beauty" with the Rejected Passages from the Manuscript Drafts and "Autobiographical Notes."* Ed. Joseph Burke. Oxford: Oxford UP, 1955.

Holland, Norman N. *The Dynamics of Literary Response.* New York: Oxford UP, 1968.

Hopkins, R. Thurston. "Aubrey Beardsley's

School Days." *The Bookman* March 1927: 305–7.

Hugo, Victor. "Preface to Cromwell." *Dramas.* Vol. 3 of *The Works of Victor Hugo.* Boston: Little Brown, 1909. 3–54.

Huneker, James Gibbons. "The Seven Arts." *Puck* (New York) 76 (28 Nov. 1914): 17.

Hunt, John Dixon. *The Pre-Raphaelite Imagination, 1848–1900.* Lincoln: U of Nebraska P, 1968.

Hutcheon, Linda. *A Theory of Parody: The Teachings of Twentieth-Century Art Forms.* New York: Methuen, 1985.

Hyde, H. Montgomery. *Lord Alfred Douglas.* London: Methuen, 1984.

———. *Oscar Wilde: A Biography.* New York: Farrar Straus, 1975.

[Ironside, Robin]. "Aubrey Beardsley." *Apollo* 101 (1975): 208–14.

Jackson, Holbrook. *The Eighteen Nineties.* 1913. New York: Capricorn, 1966.

Jarry, Alfred. *Oeuvres Complètes.* Paris: Gallimard, 1972.

Jepson, Edgar. *Memories of a Victorian.* London: Gollancz, 1933.

Jullian, Philippe. *Dreamers of Decadence.* London: Pall Mall, 1971.

Kant, Immanuel. *Kritik her Urteilskraft.* Vol. 5 of *Immanuel Kants Werke.* Berlin: Cassirer, 1922.

Kayser, Wolfgang. *The Grotesque in Art and Literature.* Trans. Ulrich Weisstein. 1957. New York: Columbia UP, 1981.

Kearney, Patrick J. *A History of Erotic Literature.* London: Macmillan, 1982.

Kenner, Hugh. *A Sinking Island: The Modern English Writers.* Baltimore: Johns Hopkins UP, 1987.

King, A. W. [Arthur William]. *An Aubrey Beardsley Lecture.* Intro., and notes R. A. Walker. London: R. A. Walker, 1924.

Knight, Richard Payne. *The Symbolical Language of Ancient Art and Mythology; An Inquiry.* 1818. New York: Bouton, 1876.

Kooistra, Lorraine Janzen. "Beardsley's Reading of Malory's *Morte Darthur:* Images of a Decadent World." *Mosaic* 23.1 (Winter 1990): 55–72.

Krafft-Ebing, Richard. *Psychopathia Sexualis: A Medico-Forensic Study.* Rev. trans. Harry E. Wedeck. New York: Putnam's, 1965.

Kravec, Maureen T. "Wilde's *Salomé.*" *Explicator* 42.1 (Fall 1983): 30–32.

Kris, Ernst. *Psychoanalytic Explorations in Art.* New York: International UP, 1952.

Kuryluk, Ewa. *Salome and Judas in the Cave of Sex.* Evanston, Ill.: Northwestern UP, 1987.

Lago, Mary, ed. *Burne-Jones Talking: His Conversations, 1895–98, Preserved by His Studio Assistant Thomas Rooke.* Columbia: U of Missouri P, 1981.

Landow, George. *Victorian Types, Victorian Shadows: Biblical Typology in Victorian Literature, Art, and Thought.* Boston: Routledge, 1980.

Lane, John. ALS to Ellen Beardsley. Bodley Head, Vigo Street, n.d. AM 14617, Box 3, J. Harlin O'Connell Collection. Published with permission of the Manuscripts Division, Department of Rare Books and Special Collections, Princeton University Libraries, Princeton, N.J.

———. "Notes." TS, Box 5, A. E. Gallatin Collection of Aubrey Beardsley. Published with permission of the Manuscripts Division, Department of Rare Books and Special Collections, Princeton University Libraries, Princeton, N.J.

———. "Publisher's Note." *Under the Hill and Other Essays in Prose and Verse by Aubrey Beardsley.* 1904. Intro. Edward Lucie-Smith. London: Paddington, 1977. [19]–25.

Langer, Susanne K. "The Comic Rhythm." *Feeling and Form.* New York: Scribner's, 1953. 326–50.

Lanham, R. A. *The Motives of Eloquence: Literary Rhetoric in the Renaissance.* New Haven, Conn.: Yale UP, 1976.

Lautrec, Gabriel de. Review of *The Savoy,* No. 1. *Courrier Français* 2 February 1896: 8.

Lavers, Annette. "Aubrey Beardsley, Man of Letters." *Romantic Mythologies.* Ed. Ian Fletcher. New York: Barnes and Noble, 1967. 243–270.

Lawrence, Arthur H. "Mr. Aubrey Beardsley and His Work." *Idler* 11 (March 1897): 188–202.

Lawrence, D. H. "Edgar Allan Poe." *Studies in Classic American Literature.* 1923. New York: Viking, 1971. 65–81.

Leach, Edmund. "Genesis as Myth." *"Genesis as Myth" and Other Essays.* London: Cape, 1969. 7–23.

Le Gallienne, Richard. "Considerations Suggested by Mr. Churton Collins' 'Illustrations of Tennyson.'" *Century Guild Hobby Horse* 7.27 (July 1892): 77–83.

Leighton, Frederic. ALS to Aubrey Beardsley. 16

Aug. [1896]. AM 14617, Box 3, J. Harlin O'Connell Collection. Published with permission of the Manuscripts Division, Department of Rare Books and Special Collections, Princeton University Libraries, Princeton, N.J.

Lester, John A., Jr. *Journey Through Despair, 1880–1914: Transformations in British Literary Culture.* Princeton, N.J.: Princeton UP, 1968.

Lévi-Strauss, Claude. *The Savage Mind.* Chicago: U of Chicago P, 1966.

Longaker, Mark. *Ernest Dowson.* Philadelphia: U of Pennsylvania P, 1945.

Lucie-Smith, Edward. *The Art of Caricature.* Ithaca, NY: Cornell UP, 1981.

————. "Aubrey Beardsley and *Under the Hill.*" *Under the Hill and Other Essays in Prose and Verse by Aubrey Beardsley.* 1904. London: Paddington, 1977. 5–15.

MacColl, D. S. "Aubrey Beardsley." *A Beardsley Miscellany.* Ed. R. A. Walker. London: Bodley Head, 1949. 17–32.

————. "The Beardsleys." *Manchester Guardian* 18 March 1948: 3.

————. "Memories of the 'Nineties: Two Summers with Conder." *London Mercury* 39 (Jan. 1939): 287–96.

MacFall, Haldane. ALS to R. A. Walker. 1 Perham Crescent, West Kensington, London, W., 14 Jan. 1921. Box 5, A. E. Gallatin Collection of Aubrey Beardsley. Published with permission of the Manuscripts Division, Department of Rare Books and Special Collections, Princeton University Libraries, Princeton, N.J.

————. *Aubrey Beardsley: The Man and His Work.* London: John Lane, Bodley Head, 1928.

Malory, Sir Thomas. *Le Morte Darthur.* Illus. Aubrey Beardsley (1893). 5th ed. London: Dent, 1988.

Marillier, H. C. "Aubrey Beardsley." *Critic* 34: 442.

McCormack, Jerusha Hull. *John Gray: Poet, Dandy, and Priest.* Hanover, N.H.: University Press of New England, 1991.

McMullen, Roy. *Victorian Outsider: A Biography of J. A. M. Whistler.* New York: Dutton, 1973.

Meier-Graefe, Julius. *Modern Art; Being a Contribution to a New System of Aesthetics.* 2 vols. Trans. Florence Simmonds and George W. Chrystal. London: Heinemann, 1908. Rpt. New York: Arno, 1968.

Melville, Robert. *Erotic Art of the West.* London: Weidenfeld and Nicholson, 1973.

Michelson, Peter. "Beardsley, Burroughs, Decadence, and the Poetics of Obscenity." *Tri-Quarterly* 12 (1970): 139–55.

Miller, J. Hillis. *Versions of Pygmalion.* Cambridge, Mass.: Harvard UP, 1990.

Mix, Katherine Lyon. *A Study in Yellow.* Lawrence: U of Kansas P, 1960.

Moers, Ellen. *The Dandy: Brummell to Beerbohm.* 1960. Lincoln: U of Nebraska P, 1978.

Morley, John. *Death, Heaven, and the Victorians.* Pittsburgh, Penn.: U of Pittsburgh P, 1971.

Muddiman, Bernard. *The Men of the Nineties.* New York: Putnam's, 1921.

Muecke, D. C. *Irony and the Ironic.* 1970. London: Methuen, 1982.

Nietzsche, Friedrich. *The Birth of Tragedy and the Case Against Wagner.* Trans. with commentary Walter Kaufmann. New York: Vintage, 1967.

Nochlin, Linda. *Realism.* 1971. New York: Penguin, 1977.

Nordau, Max. *Degeneration.* 1895. New York: Fertig, 1968.

Ormond, Leonée, and Richard Ormond. *Lord Leighton.* New Haven, Conn.: Yale UP, 1975.

Ortega y Gasset, José. *The Dehumanization of Art and Other Essays on Art, Culture, and Literature.* 1925. Trans. Helene Wehl. Princeton, N.J.: Princeton UP, 1968.

Osgood, Francis S., ed. *The Poetry of Flowers and the Flowers of Poetry.* New York: Derby and Jackson, 1859.

O'Sullivan, Vincent. *Aspects of Wilde.* New York: Holt, 1936.

————. "Literature in France." *Dublin Magazine* 6.4 (Oct.–Dec. 1931): 47–57.

Oxford English Dictionary. New York: Oxford UP, 1971.

Palmer, Jerry. "Fierce Midnights: Algolagniac Fantasy and the Literature of the Decadence." *Decadence and the 1890s.* Ed. Ian Fletcher. London: Edward Arnold, 1979. 89–106.

Panofsky, Erwin. *Meaning in the Visual Arts.* 1955. Harmondsworth, Eng.: Penguin, 1983.

Panofsky, Erwin, and Gerda Panofsky. "The *Tomb in Arcady* at the *Fin de Siècle.*" *Westdeutsches Jahrbuch für Kunstgeschichte* 30 (1968): 287–304.

Partridge, Eric. *Origins: A Short Etymological Dic-*

tionary of Modern English. 1956. New York: Greenwich, 1983.

Pater, Walter. The Renaissance: Studies in Art and Poetry (1893). Ed. and notes Donald L. Hill. Berkeley: U of California P, 1980.

————. "Style." Appreciations. 1889. London: Macmillan, 1890. 1–36.

Payne, H. A. ALS to A. E. Gallatin. Brighton Grammar School, 6 Aug. 1902. Box 5, A. E. Gallatin Collection of Aubrey Beardsley. Published with permission of the Manuscripts Division, Department of Rare Books and Special Collections, Princeton University Libraries, Princeton, N.J.

The Pearl: A Journal of Facetiae and Voluptuous Reading. 1879–1900. New York: Grove, 1968.

Pearsall, Ronald. The Worm in the Bud: The World of Victorian Sexuality. New York: Macmillan, 1969.

Pearson, Hesketh. The Life of Oscar Wilde. 1946. London: Methuen, 1949.

Pennell, Elizabeth Robins. The Life and Letters of Joseph Pennell. Vol. 1. Boston: Little Brown, 1929.

————. Nights: Rome, Venice in the Aesthetic Eighties; London, Paris, in the Fighting Nineties. Philadelphia: Lippincott, 1916.

Pennell, E. R. and J. The Life of James McNeill Whistler. 2 vols. London: Heinemann, 1908.

————. The Whistler Journal. Philadelphia: Lippincott, 1921.

Pennell, Joseph. Adventures of an Illustrator. Boston: Little Brown, 1925.

————. "A New Illustrator: Aubrey Beardsley." The Studio 1.1 (April 1893): 14–19.

————. Aubrey Beardsley and Other Men of the Nineties. Philadelphia: Pennell Club, 1924.

————. "Mr. Aubrey Beardsley: An Appreciation." Letter to the editor, Daily Chronicle 17 March 1898: 3.

Perkins, Michael. The Secret Record: Modern Erotic Literature. New York: Morrow, 1976.

Pierrot, Jean. The Decadent Imagination, 1880–1900. Trans. Derek Coltman. Chicago: U of Chicago P, 1981.

Plato. The Symposium. Trans., intro., and notes Walter Hamilton. 1951. New York: Penguin, 1979.

Pope, Alexander. The Poems of Alexander Pope.

Ed. John Butt. 1963. New Haven, Conn.: Yale UP, 1969.

Preston, John Hyde. "Aubrey Beardsley—Man and Artist." Virginia Quarterly Review 4.3 (1928): 420–31.

Prickett, Stephen. Victorian Fantasy. Bloomington: Indiana UP, 1979.

[Raffalovich, Marc-André.] Michaelson, Alexander. "Aubrey Beardsley." Blackfriars 9.103 (Oct. 1928): 609–16.

————. "Oscar Wilde." Blackfriars 9.105 (Dec. 1928): 701.

Raymond, E. T. "Aubrey Beardsley." The Living Age 307.3989 (18 Dec. 1920): 725–29.

Reade, Brian, ed. Aubrey Beardsley. New York: Viking, 1967.

————. "Aubrey Beardsley." Introduction to Aubrey Beardsley. London: V & A, 1966. 1–12.

————. "The Beardsley Foreground." Antigonish Review 1.1 (1967): 3–26.

————. "Beardsley Re-Mounted." Reconsidering Aubrey Beardsley. Ed. Robert Langenfeld. Ann Arbor, Mich.: UMI Research P, 1989. [103]–30.

Reed, John R. Decadent Style. Athens: Ohio UP, 1985.

Rhys, Ernest. Everyman Remembers. New York: Cosmopolitan, 1931.

Ricketts, Charles [and Jean Paul Raymond]. Oscar Wilde: Recollections. London : Nonesuch, 1932.

Rickman, John. "On the Nature of Ugliness and the Creative Impulse (Marginalia Psychoanalytica II)." The International Journal of Psycho-Analysis 21 (1940): 294–313.

Rider, Daniel J. "Adventures with Frank Harris." TS, University of Reading Library, Reading, Eng.

Rimbaud, Arthur. "Adieu." Une Saison en Enfer. 1873. Paris: Champion, 1979. 51–53.

Robins, Anna Gruetzner. "No Ordinary Visitors: Dieppe at the Fin de Siècle." The Dieppe Connection: The Town and Its Artists from Turner to Braque. Brighton, Eng.: Herbert, 1992.

Roger-Marx, Claude. "Introduction." Yvette Guilbert Vue par Henri Toulouse-Lautrec. Paris: Au Pont des Arts, 1950.

Rosenthal, Harold. Two Centuries of Opera at Covent Garden. London: Putnam, 1958.

Ross, Margery, ed. Robert Ross: Friend of Friends. London: Cape, 1952.

Ross, Robert. *Aubrey Beardsley*. London: John Lane, Bodley Head, 1909.

Rothenstein, John. *The Life and Death of Conder*. London: Dent, 1938.

———. *A Pot of Paint: The Artists of the 1890's*. 1928. Freeport, N.Y.: Books for Libraries P, 1970.

Rothenstein, William. Holograph MS of untitled "dialogue." bMS Eng 1148.2 (73), Will Rothenstein Papers. Published by permission of the Houghton Library, Harvard University, Cambridge, Mass.

———. *Men and Memories: A History of the Arts, 1872–1922, Being the Recollections of William Rothenstein*. 2 vols. in one. 1931. New York: Tudor, n.d.

Rudigoz, Claude. *Systématique Génétique de la Métaphore Sexuelle*. Lille: U de Lille 3, Atelier Reproduction des Thèses, 1978.

Ruskin, John. *Modern Painters*. Vol. 5 of *The Works of John Ruskin*. Ed. E. T. Cook and Alexander Wedderburn. London: Allen, 1903–12.

———. *The Stones of Venice*. Vol. 11 of *The Works of John Ruskin*. Ed. E. T. Cook and Alexander Wedderburn. London: Allen, 1903–12.

Russett, Cynthia Eagle. *Sexual Science: The Victorian Construction of Womanhood*. Cambridge, Mass.: Harvard UP, 1989.

Rutter, Frank. "The Art of Aubrey Beardsley." *To-Day* 16 Nov. 1904: 45–46.

Salerno, Nicholas A. Preface to the Bibliography: "Beardsley Under the Microscope." *Reconsidering Aubrey Beardsley*. Ed. Robert Langenfeld. Ann Arbor, Mich.: UMI Research P, 1989. 269–80.

Schmutzler, Robert. *Art Nouveau*. Trans. Edouard Roditi. New York: Abrams, 1962.

Scotson-Clark, G[eorge]. F[rederick]. "The Artist of 'The Yellow Book.'" *The Bookman* 7 (April 1895): 158–61.

———. "Aubrey Beardsley—Prior to 1893." TS, A. E. Gallatin Collection of Aubrey Beardsley. Published with permission of the Manuscripts Division, Department of Rare Books and Special Collections, Princeton University Libraries, Princeton, N.J.

Seaton, Beverly. "Considering the Lilies: Ruskin's 'Proserpina' and Other Victorian Flower Books." *Victorian Studies* 28.2 (Winter 1985): 255–82.

Shattuck, Roger. *The Banquet Years: The Origins of the Avant Garde in France, 1885 to World War I*. 1955. New York: Vintage, 1968.

Shaw, George Bernard. *The Collected Letters of George Bernard Shaw, 1874–1897*. Ed. Dan H. Laurence. New York: Dodd, Mead, 1965.

Sheridan, Ronald, and Anne Ross, eds. *Gargoyles & Grotesques: Paganism in the Medieval Church*. Boston: New York Graphic Society, 1975.

Shewan, Rodney. "Love, Death, and Criticism: Three of Beardsley's Culs-de-lampe." *Reconsidering Aubrey Beardsley*. Ed. Robert Langenfeld. Ann Arbor, Mich.: UMI Research P, 1989. 131–65.

Shipley, Joseph T. *Dictionary of Word Origins*. New York: Philosophical Library, 1945.

Shklovsky, Victor. "Art as Technique." *Russian Formalist Criticism: Four Essays*. Ed. and trans. Lee T. Lemon and Marian J. Reis. Lincoln: U of Nebraska P, 1965. 3–24.

Showalter, Elaine. *Sexual Anarchy: Gender and Culture at the Fin de Siècle*. New York: Viking, 1990.

Siegel, Sandra. "Literature and Degeneration: The Representation of 'Decadence.'" In *Degeneration: The Dark Side of Progress*. Ed. J. E. Chamberlin and S. Gilman. New York: Columbia UP, 1985. 199–219.

Silverman, Debora L. *Art Nouveau in Fin-de-Siècle France: Politics, Psychology, and Style*. Berkeley: U of California P, 1989.

Silverman, Kaja. "Fragments of a Fashionable Discourse." *Studies in Entertainment: Critical Approaches to Mass Culture*. Ed. Tania Modleski. Bloomington: Indiana UP, 1986. 139–52.

Sitwell, Osbert. *Noble Essences; or Courteous Revelations*. Vol. 5 of autobiography series *Left Hand, Right Hand!* London: Macmillan, 1950.

Slessor, Catherine. *The Art of Aubrey Beardsley*. Secaucus, N.J.: Chartwell, 1989.

Small, Herbert. "Aubrey Beardsley." *Book Buyer* 12.1 (February 1895): [26]–29.

Smith, J. Walter. "A Chat with Beardsley." *Evening Transcript* (Boston) 12 Feb. 1895: 16.

Smithers, Jack. *The Early Life and Vicissitudes of Jack Smithers*. London: Martin Secker, 1939.

Sontag, Susan. "Notes on Camp." *Against Interpretation*. 1961. New York: Dell, 1966. 277–93.

———. *Illness as Metaphor*. New York: Farrar Straus, 1978.

Spacks, Patricia Meyer. *Gossip*. New York: Knopf, 1985.

Spalding, Frances. *Magnificent Dreams: Burne-Jones and the Late Victorians*. New York: Dutton, 1978.

Spivak, Gayatri Chakravorty. "Decadent Style." *Language and Style* 7 (1974): 227–34.

Stanford, Derek. *Aubrey Beardsley's Erotic Universe*. London: New English Library, 1967.

———. *The Vision and Death of Aubrey Beardsley*. Bristol, Eng.: Redcliffe, 1985.

Stanlaws, Penrhyn. "Some Personal Recollections of Aubrey Beardsley." *Book Buyer* 17.3 (Oct. 1898): [212]–14.

Steig, Michael. "Defining the Grotesque: An Attempt at Synthesis." *Journal of Aesthetics and Art Criticism* 29.2 (Winter 1970): 253–60.

Stokes, John. "Beardsley/Jarry: The Art of Deformation." *Reconsidering Aubrey Beardsley*. Ed. Robert Langenfeld. Ann Arbor, Mich.: UMI Research P, 1989. [54]–69.

———. *In the Nineties*. Chicago: U of Chicago P, 1989.

Storey, Robert F. *Pierrot: A Critical History of a Mask*. Princeton, N.J.: Princeton UP, 1978.

Strangman, Edward. ALS to Ellen Beardsley. 21 Trentishoe Mansions, Charing Cross Road, W.C., 17 March 1898. AM 14617, Box 4, J. Harlin O'Connell Collection. Published with permission of the Manuscripts Division, Department of Rare Books and Special Collections, Princeton University Libraries, Princeton, N.J.

Strong, Henry Melancthon. "Aubrey Beardsley." *Westminster Review* 154.1 (July 1900): 86–94.

Stutfield, Hugh E. M. "Tommyrotics." *Blackwood's Edinburgh Magazine* 157.956 (June 1895): 833–45.

Summerson, John. *The Architecture of Victorian London*. Charlottesville: U of Virginia P, 1976.

Symons, A. J. A. "An Unacknowledged Movement in Fine Printing." *Fleuron* 7 (1930): 83–119.

Symons, Arthur. Preface and introductory essay. *The Art of Aubrey Beardsley*. New York: Boni and Liveright, 1918. 15–36.

———. "Aspects of Cornwall." *Freeman* 6 (18 Oct. 1922): 131–32.

———. "Aubrey Beardsley." *Studies in Seven Arts*. Vol. 9 of *The Collected Works of Arthur Symons*. 9 vols. London: Martin Secker, 1924. 87–106.

Sypher, Wylie. *Rococo to Cubism in Art and Literature: Transformations in Style, in Art and Literature from the Eighteenth to the Twentieth Century*. New York: Vintage, 1960.

Syrett, Netta. *The Sheltering Tree*. London: Bles, 1939.

Thomson, Philip. *The Grotesque*. London: Methuen, 1972.

Thornton, R. K. R. *The Decadent Dilemma*. London: Edward Arnold, 1983.

Thorpe, James. *English Illustration: The Nineties*. New York: Hacker, 1975.

Toulouse-Lautrec, Henri de. *Toulouse-Lautrec*. Eds. Richard Thomson, Claire Frèches-Thory, Anne Roquebert, and Danièle Devynck. New Haven, Conn.: Yale UP, 1991.

Traill, H. D. *The New Fiction*. London: Hurst and Blackett, 1897.

Ulmer, Gregory L. "Op Writing: Derrida's Solicitation of *Theoria*." *Displacement*. Ed. Mark Krupnick. Bloomington: Indiana UP, 1983. 29–58.

Vallance, Aymer. "The Invention of Aubrey Beardsley." *The Magazine of Art* 22.7 (May 1898): 362–68.

Vareilles, Pierre. "Aux Jeunes." *Le Décadent* 2 (17 April 1886): 1.

Visani, Maria Cionini. *Toulouse-Lautrec*. 1968. London: Thames and Hudson, 1979.

Viscusi, Robert. "Max and." *English Literature in Transition, 1880–1920* 27.4 (1984): 304–19.

[Walker, R. A.] Derry, Georges. *An Aubrey Beardsley Scrap Book*. London: R. A. Walker, 1920.

Walker, R[ainforth]. A[rmitage]. *The Best of Beardsley*. London: Bodley Head, 1948.

———. "Notes on the Family of Aubrey Beardsley." *A Beardsley Miscellany*. London: Bodley Head, 1949. 95–106.

Webb, Peter. *The Erotic Arts*. 1975. New York: Farrar Straus, 1983.

Welsford, Enid. *The Fool: His Social and Literary History*. 1935. Gloucester, Mass.: Peter Smith, 1966.

Weintraub, Stanley. *Aubrey Beardsley: The Imp of the Perverse*. University Park: Penn State UP, 1976.

———. *Beardsley*. New York: Braziller, 1967.

Whitaker, Muriel A. I. "Flat Blasphemies—Beardsley's Illustrations for Malory's *Morte Darthur.*" *Mosaic* 8.2 (1975): 67–75.

White, Colin. "Thomas MacKenzie and the Beardsley Legend." *Journal of Decorative and Propaganda Arts* 7 (Winter 1988): 6–35.

Wilde, Alan. *Horizons of Assent: Modernism, Postmodernism, and the Ironic Imagination.* Baltimore, Md.: Johns Hopkins UP, 1981.

Wilde, Oscar. *Intentions and the Soul of Man under Socialism.* Vol. 4 of *The First Collected Edition of the Works of Oscar Wilde, 1908–22.* Ed. Robert Ross. 15 vols. 1908. London: Dawsons, 1969.

————. *The Letters of Oscar Wilde.* Ed. Rupert Hart-Davis. New York: Harcourt Brace, 1962.

————. *More Letters of Oscar Wilde.* Ed. Rupert Hart-Davis. London: Murray, 1985.

————. *Salome. The Portable Oscar Wilde.* Ed. Richard Aldington 1946. New York: Viking, 1987. 392–429.

————. *Salomé.* Vol. 5 of *The First Collected Edition of the Works of Oscar Wilde, 1908-22.* Ed. Robert Ross. 15 vols. 1908. London: Dawsons, 1969. 1–82.

Williams, Rosalind H. *Dream Worlds: Mass Consumption in Late Nineteenth-Century France.* Berkeley: U of California P, 1982.

Williamson, George C. "Aubrey Beardsley: A Few Memories." *Carmina* 9 (1931): 278–80.

Wilson, Edmund. "Late Violets from the Nineties" (1923). *The Shores of Light: A Literary Chronicle of the Twenties and Thirties.* New York: Farrar, Straus, 1952. 68–72.

Wilson, Simon. *Beardsley.* 1976. Oxford: Phaidon, 1983.

————. "Decadent Art." *The Erotic Arts.* By Peter Webb. 1975. New York: Farrar Straus, 1983. 175–85.

Wölfflin, Heinrich. *Principles of Art History: The Problem of the Development of Style in Later Art.* 1932. New York: Dover, 1950.

Wollen, Peter. "Fashion/Orientalism/The Body." *New Formations* 1 (Spring 1987): 5–33.

Woodring, Carl. *Nature into Art: Cultural Transformations in Nineteenth-Century Britain.* Cambridge, Mass.: Harvard UP, 1989.

Wratislaw, Theodore. "The Salome of Aubrey Beardsley." *The Artist* 2 April 1894: 100–101.

Yeats, William Butler. *The Autobiography of William Butler Yeats.* 1916. New York: Collier, 1965.

————. *Essays and Introductions.* New York: Macmillan, 1961.

————. *The Letters of W. B. Yeats.* Ed. Allen Wade. London: Hart-Davis, 1954.

————. *Memoirs: The Original Unpublished Text of the Autobiography and the Journal.* Ed. Denis Donoghue. 1972. London: Macmillan, 1974.

————. *Uncollected Prose.* 2 vols. Ed. John P. Frayne and Colton Johnson. New York: Columbia UP, 1976.

————. *A Vision.* 1937. New York: Collier, 1969.

Yuan-ning, Wen. "A Note on Aubrey Beardsley." *T'ien Hsia Monthly* (Shanghai) 5 (1937): 451–55.

Zatlin, Linda Gertner. "Aubrey Beardsley Counts the Ways." *Victorian Newsletter* 67 (Spring 1985): 1–6.

————. *Aubrey Beardsley and Victorian Sexual Politics.* Oxford: Clarendon, 1990.

————. "Félicien Rops and Aubrey Beardsley: The Naked and the Nude." *Reconsidering Aubrey Beardsley.* Ed. Robert Langenfeld. Ann Arbor, Mich.: UMI Research P, 1989. 167–205.

Zolla, Elémire. *The Androgyne: Reconciliation of Male and Female.* New York: Crossroad, 1981.

Index

N.B.: Page numbers in italics refer to illustrations.